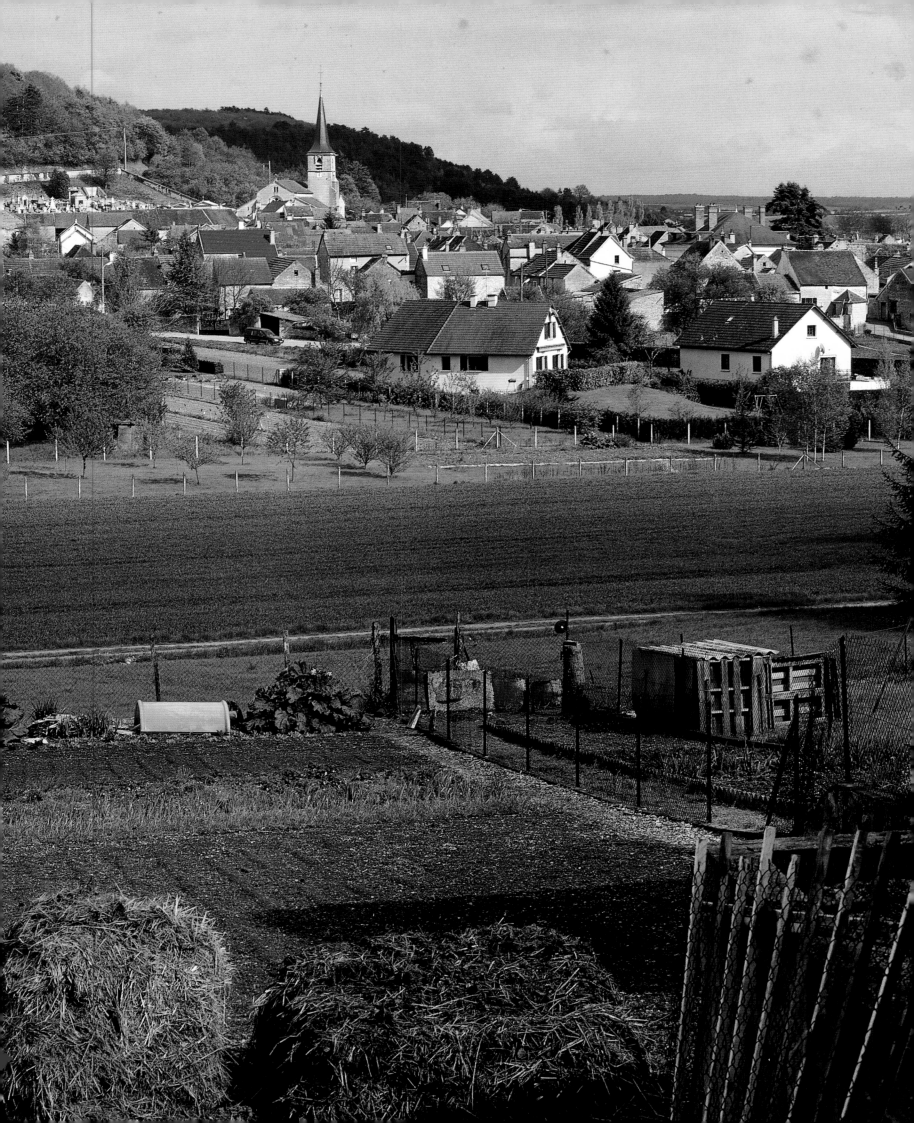

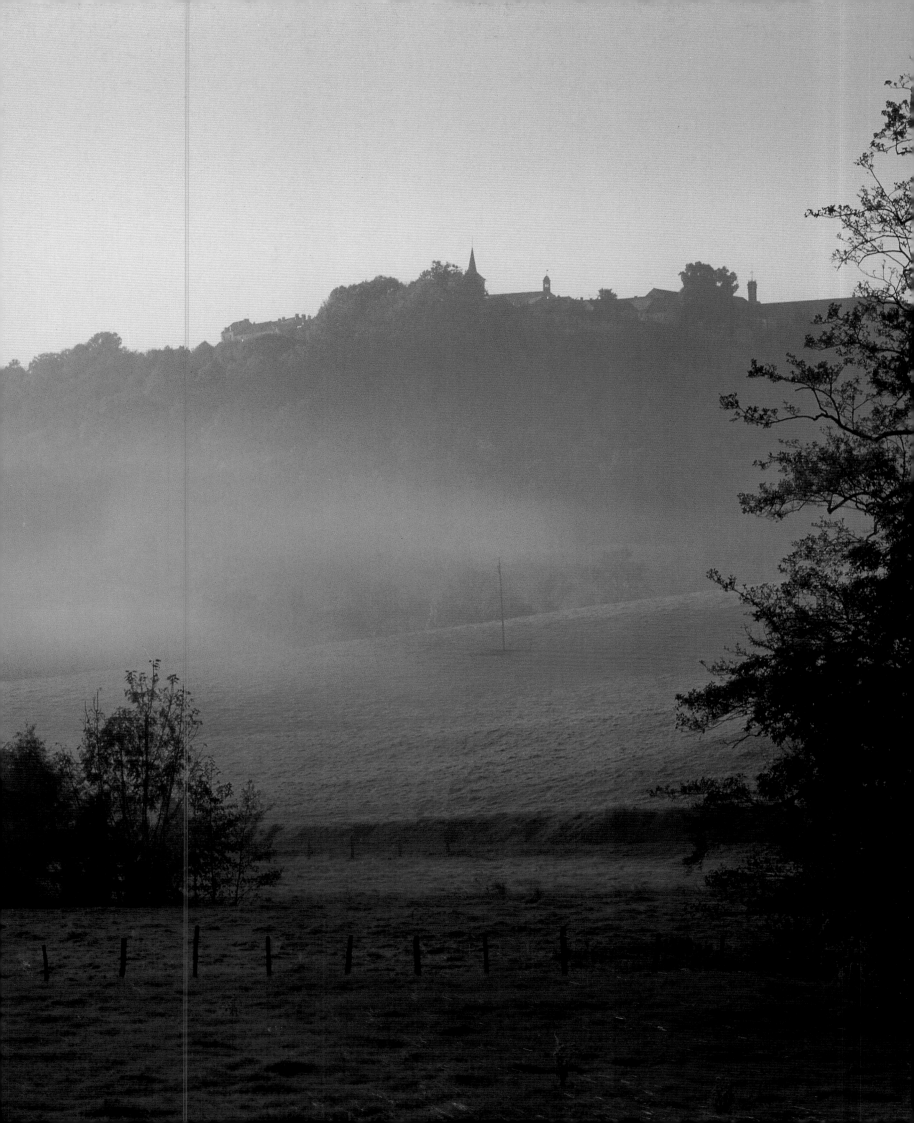

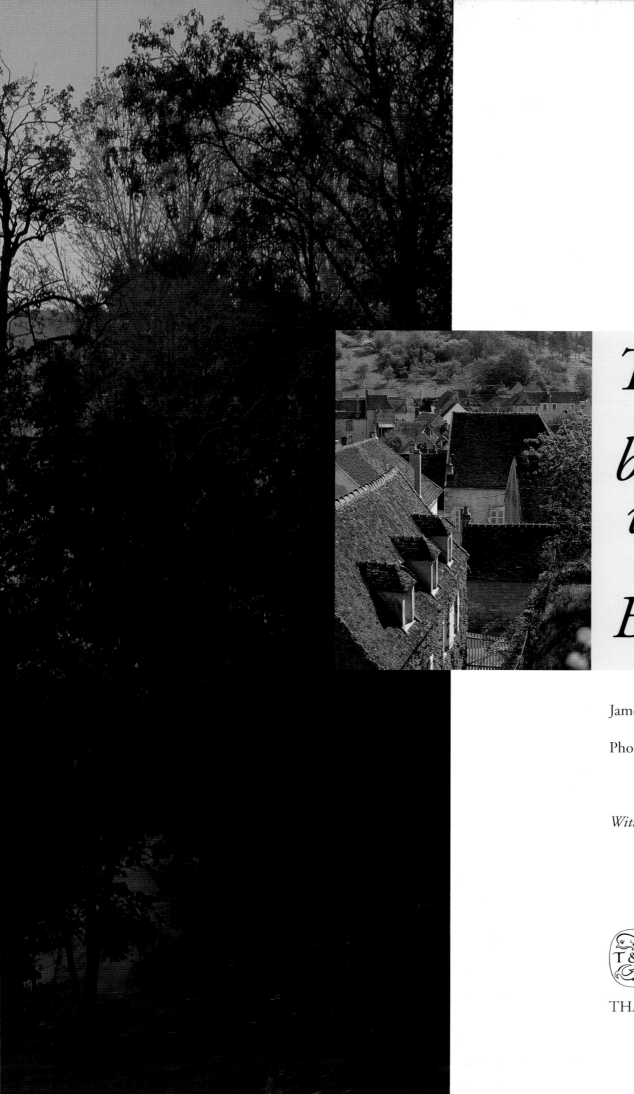

The most beautiful villages of Burgundy

James Bentley

Photographs by Hugh Palmer

With 270 color illustrations

THAMES AND HUDSON

HALF TITLE
Seen here from the north, Ancy-le-Franc in Yonne sits placidly, sheltered topographically by a gentle hill, militarily by its historic château, and spiritually by a church which was founded in the late twelfth century.

TITLE PAGES
Flavigny-sur-Ozerain, one of the prettiest villages in France, rises on a plateau in Côte d'Or, an entrancing ensemble of buildings medieval, Gothic and Renaissance in style.

Beautifully-tiled, steep roofs top houses with dormer windows in Châtel-Censoir, one of the most beautiful villages in the Yonne département.

Designed by Lawrence Edwards

© 1998 Thames and Hudson Ltd, London
Text © 1998 James Bentley
Photographs © 1998 Hugh Palmer

First published in hardcover in the United States of America in 1998 by Thames and Hudson Inc., 500 Fifth Avenue, New York, New York 10110

Reprinted 1999

Library of Congress Catalog Card Number 98-60038
ISBN 0-500-01862-6

Printed and bound in Singapore

Contents

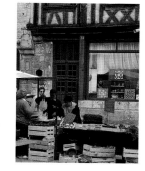
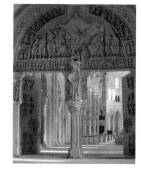

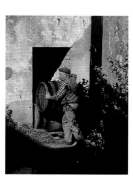
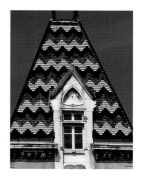
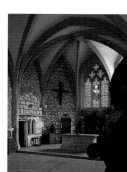

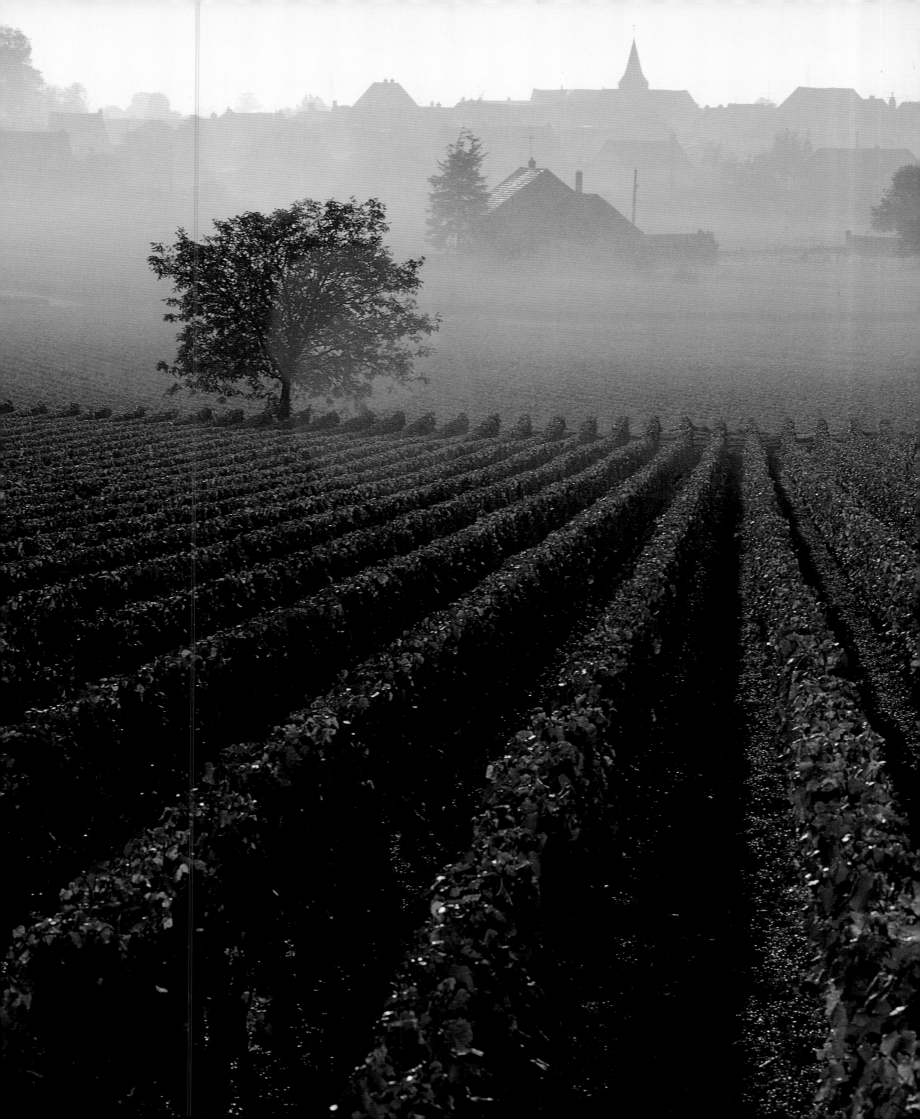

Introduction

Present-day Burgundy is made up of four *départements*: Yonne, Nièvre, Côte d'Or and Saône-et-Loire. These lands represent a good part of the former Duchy of Burgundy, which also extended into parts of what is now Rhône-Alpes and into Champagne country. And, of course, they resonate with the names of the finest vineyards in the world: Chablis, Côte de Beaune, Côte de Nuits, the Mâconnais, Pouilly-Fuissé, and so on. The *département* of Yonne is now Burgundy's link with Champagne, with the Île de France and therefore with Paris. We have assumed that many visitors will approach Burgundy from the direction of the capital city; so, in organizing the material for this book, we have commenced with the villages of Yonne and ended with those of Saône-et-Loire.

Although they are essentially political entities, the four *départements* have their own diverse characteristics. The southern regions of Yonne nurture rich and extensive forests. Its wines are reputed. Its religious and secular buildings are superb; apart from the fine churches, it enjoys a legacy of half-timbered houses, fortresses and fortifications. Its delightful waterways include the majestic river Yonne, the lovely Canal de Bourgogne and the gentle Canal de Briare. The Yonne, along with the Loire and the Cure, also flows through forested Nièvre, yet another *département* bearing the name of a river. Much of the natural park of the Morvan lies here, an area of forest, hill and mountain, with its own traditions and customs and its isolated villages.

Côte d'Or is so strongly identified with the production of the world's most famous wines that it is often forgotten that it consists of much more than the hallowed Côte de Beaune and Côte de Nuits. Plains

One of the most celebrated wine villages of the famous Côte, Puligny-Montrachet (OPPOSITE), sits amongst its vineyards eleven kilometres south-west of Beaune - quintessential Burgundy.

and valleys, narrow gorges through rocky cliffs, streams and rich pastureland make it a topographical delight. Its architecture, Romanesque and Gothic, churches, châteaux, and whole villages, testifies to a fabulously rich patrimony. But it is, of course, from the incomparable wines that the villages of the region chiefly derive their fame and wealth, from Fixin to Nuits-Saint-Georges, from Pommard to Santenay.

The southernmost of the *départements*, Saône-et-Loire, is one of the largest in France and takes its name from two of the country's mightiest rivers, the Saône which joins the Rhône on its way to the Mediterranean, and the Loire on its long journey to the Atlantic. Here, too, are extensive lakes, while the plain of Bresse, part of the forested Morvan, and the vineyards of the Mâconnais add even further attractions to the bounty of the region.

The historical heritage of Burgundy is famously rich. In the Middle Ages the Dukes of Burgundy rivalled in power the Kings of France. They profited from international commerce with Flanders and the Mediterranean, and from the national trade route between Paris and Lyons. In spite of the depredations of the Hundred Years War, Burgundy emerged from the conflict still wealthy and well-connected, particularly with Flanders, and with a formidable army. Two fourteenth- and fifteenth-century rulers, Philippe le Hardi and Philippe le Bon, conducted courts which placed Burgundy in the forefront of European artistic achievement.

But the Burgundian heritage is much older. Archaeologists began excavating at Solutré (Saône-et-Loire) in 1866 and uncovered the remains of horse-hunters of the Upper Palaeolithic age. At Couches, also in Saône-et-Loire, stands a series of Late Neolithic

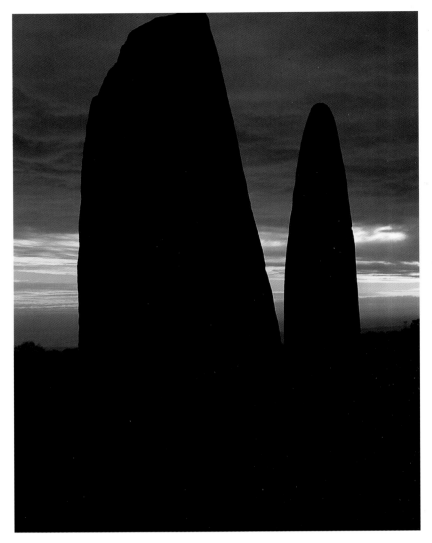

The Burgundian historical heritage goes back to ancient times: Late Neolithic menhirs at Epoigny.

menhirs, the largest of which is the highest in eastern France. As for the people of the Iron Age, their most precious legacies are the burial furnishings of a princess of Vix, including jewels and a golden diadem. Discovered in 1953 in a tomb at the foot of Mount Lassois, they can be seen at Châtillon-sur-Seine (Côte d'Or).

A splendid Gaulish *oppidum* tops Mont Beuvray, on the border between Nièvre and Saône-et-Loire. Here in 52 B.C. the Gauls made Vercingetorix their commander-in-chief, to lead them in a vain attempt to defeat Julius Cæsar. Vercingetorix was besieged at Alésia-en-Auxois (now Alise-Sainte-Reine), captured and executed. One can still explore other remains of these years; for example, there are the ruins of an extensive Gallo-Roman town at Les Bolards, near Nuits-Saint-Georges. And Roman remains proliferate elsewhere in the region. It was under Roman patronage that a wandering tribe from the Danish island of Bornholm was allowed to settle in this region of Gaul in A.D. 433. Converting to Christianity, adopting Roman ways, they became known as Burgundarholmers and eventually gave Burgundy its name.

The Duchy of Burgundy itself was not created until the end of the ninth century. Subsequently, among its greatest rulers were Robert, second son of King Robert II le Pieux of France, who became hereditary duke in 1031, Capetian dukes, and Philippe le Hardi, who inherited the duchy in 1364. Their territory spread across most of what is today Belgium, as well as the Netherlands and Luxembourg. Burgundy was united with the French crown only in 1477 on the death of Charles le Téméraire.

Other rulers were the clerics, the masters of the great abbeys of this part of France. From the eleventh century these monastic houses sheltered men whose

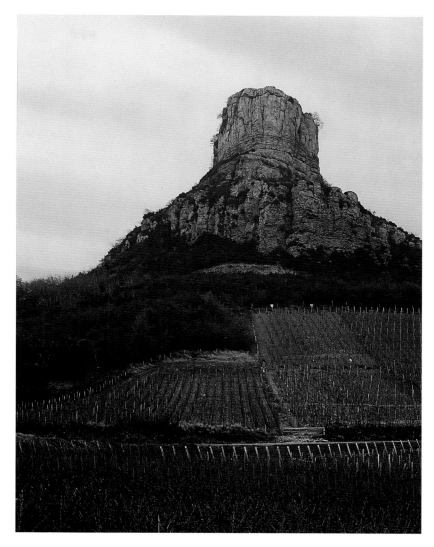

The site of the prehistoric settlement at Solutré, Saône-et-Loire.

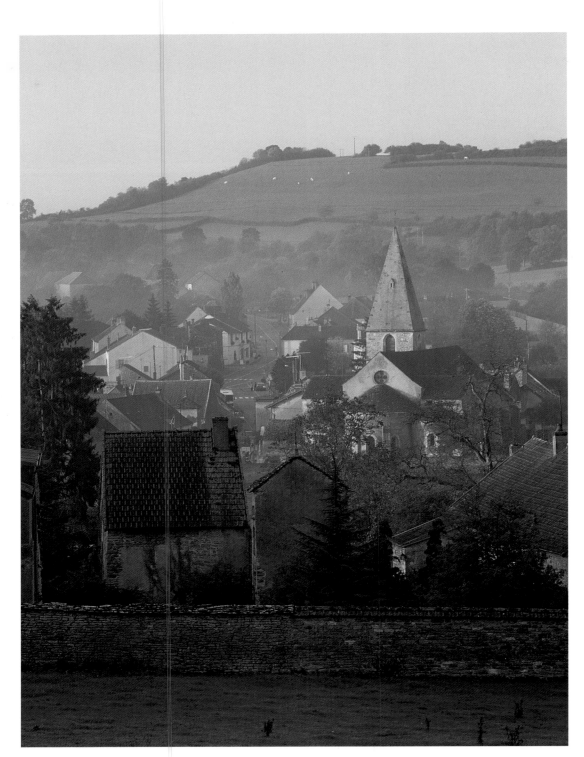

chief work was to pray, but whose secondary works were to build and to care for the land, especially by planting vines. Two monastic orders particularly enriched Burgundy. The legacy of the Benedictines, followers of the rule of the fifth-century St. Benedict, includes Cluny. That of the Cistercians, a group founded in 1098 by twenty monks from the Benedictine abbey of Cîteaux and dedicated to a stricter observance of the rules of St. Benedict than that of their contemporaries, includes the twelfth-century abbey of Fontenay. Pioneering agriculturists, vintners and breeders of fish, they also promoted a magically austere form of religious architecture. Their religious houses were staging posts for pilgrims, and thus brought further wealth to Burgundy.

To speak of the secular architecture of Burgundy is to describe fortresses and splendid châteaux, some of them warlike, others transformed through the centuries into delightful dwelling-places. But it is also necessary, as this is the aim of this book, to walk through the ensembles of village architecture, which are enthralling. The novelist Colette, who was born in 1873 in the village of Saint-Sauveur-en-Puisaye in the Yonne, spoke of just such pleasure, following paths bordered by yellow flowers and burning roses. In many Burgundy villages, little has changed since the date of her birth.

Blessed by an ancient church, shaded by trees, a typical Burgundy village slumbers in the haze of summer (ABOVE). A corner of the Monday market

(OPPOSITE) at Nolay, Côte d'Or, is sheltered by the early fifteenth-century market-hall, another testimony to the rich produce of this part of France.

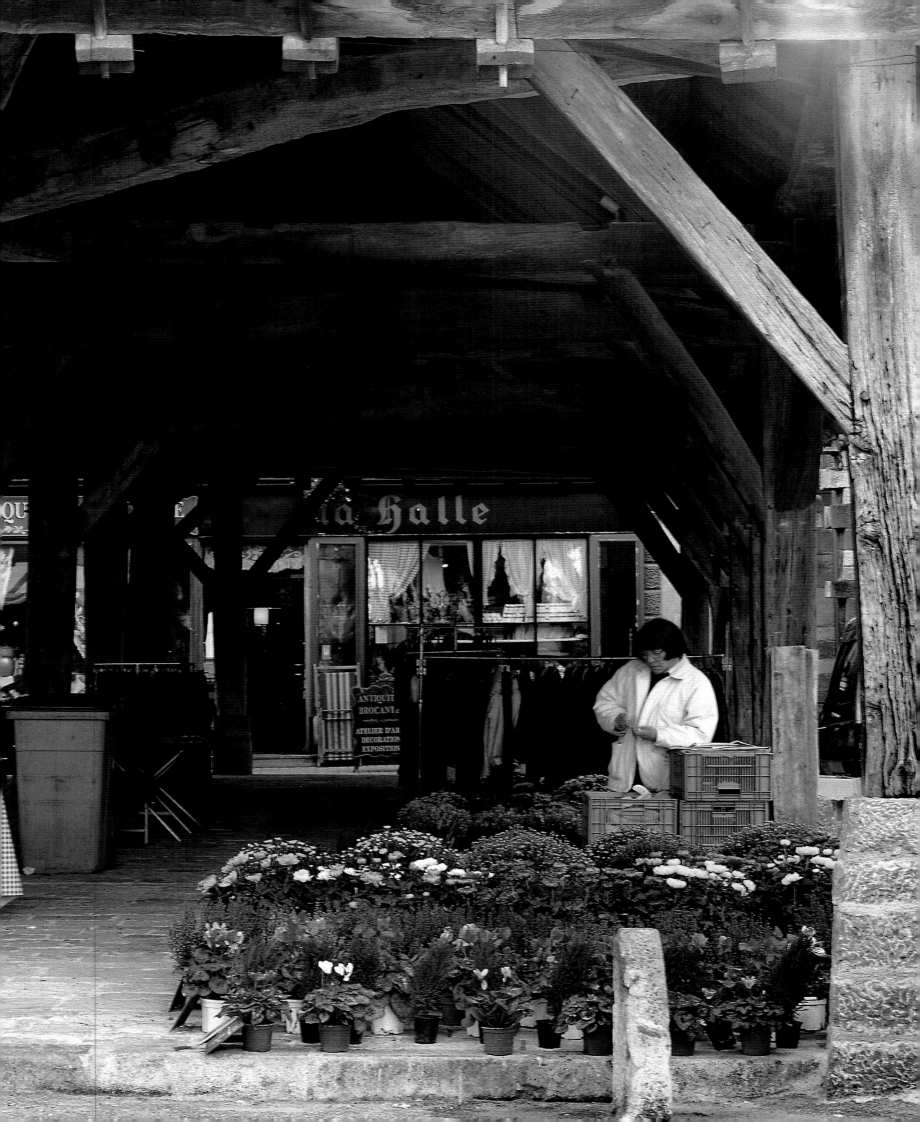

Yonne

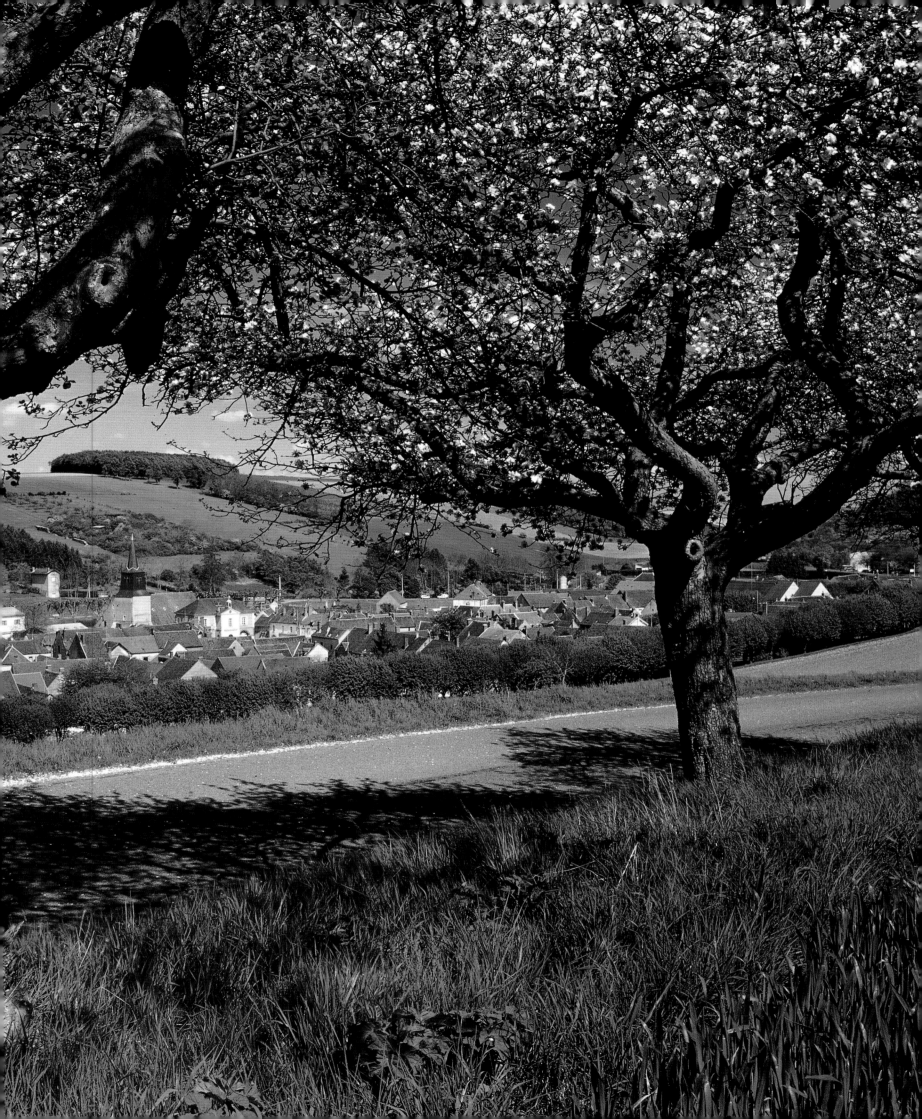

Here, as Victor Hugo put it, art and history combine. At Sens, one of the two large towns of Yonne, St. Bernard condemned Abélard. Thomas Becket took refuge here. As for Auxerre, its other large town, the abbey-church of Saint-Germain boasts the oldest frescoes in France, while its crypt has sheltered the bones of St. Germain since the fifth century. The southern regions of the Yonne nurture rich and extensive forests. Their wines are reputed, with Chablis the centre of the trade. For centuries the vineyards of the region have produced red and white wines, and their proximity to the capital city of France, as well as the ease of transport because of the many waterways which flow into the river Seine, helped them to flourish. Here, family vineyards still exist, though a major *coopérative* is responsible for over a sixth of the production of the *département*.

The communes producing Chablis wines range from Pouilly-sur-Serein in the south-east to Ligny-le-Châtel in the north, and from Viviers in the east to Préhy in the west. The splendid white wines are matched by equally fine, though less well-known reds. As for their quality, the finest whites are vinified from vines grown on limestone soils. Pale and bright, they are classified - in ascending order of quality - as Chablis, Chablis *grand cru* and Chablis *premier cru*. The second has more gold in its colour than the other two, while Chablis *premier cru* often glints with green. In this region the sole grape is Chardonnay, but in the region of Auxerre it is supplemented by Pinot Noir and Gamay. The reds from the Auxerre area are created from the César grape, often blended with Pinot Noir and classified under the *appellation* Bourgogne-Irancy.

The religious architecture of this region is superb. At Vézelay the Romanesque decoration of the interior of the basilica of Sainte-Madeleine is world-renowned, and no visitor to Burgundy should miss it. Nearby Saint-Père-sous-Vézelay almost matches Vézelay in picturesqueness. As for châteaux, those of Tanlay and Ancy-le-Franc are superb.

The Renaissance château of Tanlay, begun in the fifteen-fifties on behalf of the powerful François de Coligny d'Andelot and rebuilt in the sixteen-sixties, is a magnificent example of the secular architecture of Burgundy. Its exterior décor is rich, with sculpted chimneys, friezes, windows and dormer-windows. During the Wars of Religion François d'Andelot espoused the Protestant side, and the château frequently welcomed Protestant leaders during this period. After his death, successive owners added the so-called Petit Château, and the whole complex was completed in the mid seventeenth century by the architect Pierre le Muet, a disciple and translator of Palladio.

Natural parks further enhance the region. Near Treigny is the natural park of Boutissaint, its woodlands and lakes teeming with wild boar, stags, fallow deer, roe deer, wild sheep, swans and birds of prey. Another idyllic area is the valley of the river Cousin, which flows beside the magical town of Avallon, with its fifteenth-century ramparts and its marvellous twelfth-century collegiate church of Saint-Lazare. There are also substantial man-made parks. Lawns and trees designed by the great Le Nôtre surround the château of Ancy-le-Franc. Forty hectares of wooded garden, crossed by a canal, enclose the château at Tanlay.

(PREVIOUS PAGES) Set in the verdant valley of the river Serein, Noyers (INSET) is a comfortable medieval village, with a number of exceptionally fine Renaissance and eighteenth-century houses and a flamboyant Gothic church. Much of its ancient fortifications still stand, a reminder of the wars which in past times forced the villagers of this tranquil spot to take stringent measures to protect themselves from their enemies. Cerisiers (MAIN PICTURE) in the Sens valley, another exquisite village set in the rolling Yonne countryside, also preserves the remains of its former fortifications.

The Yonne countryside is among the most striking in the whole of France, ranging from dramatic river gorges to easy, rolling meadowland and woodland (OPPOSITE).

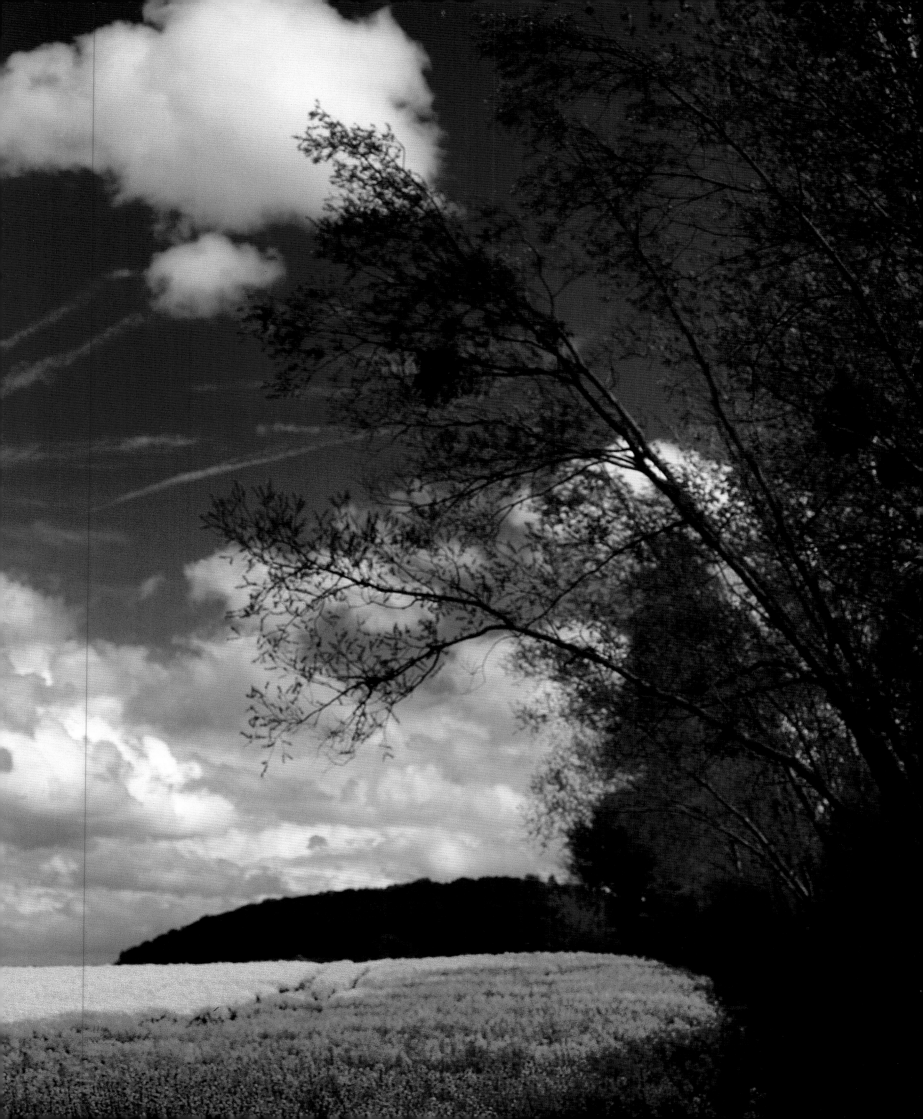

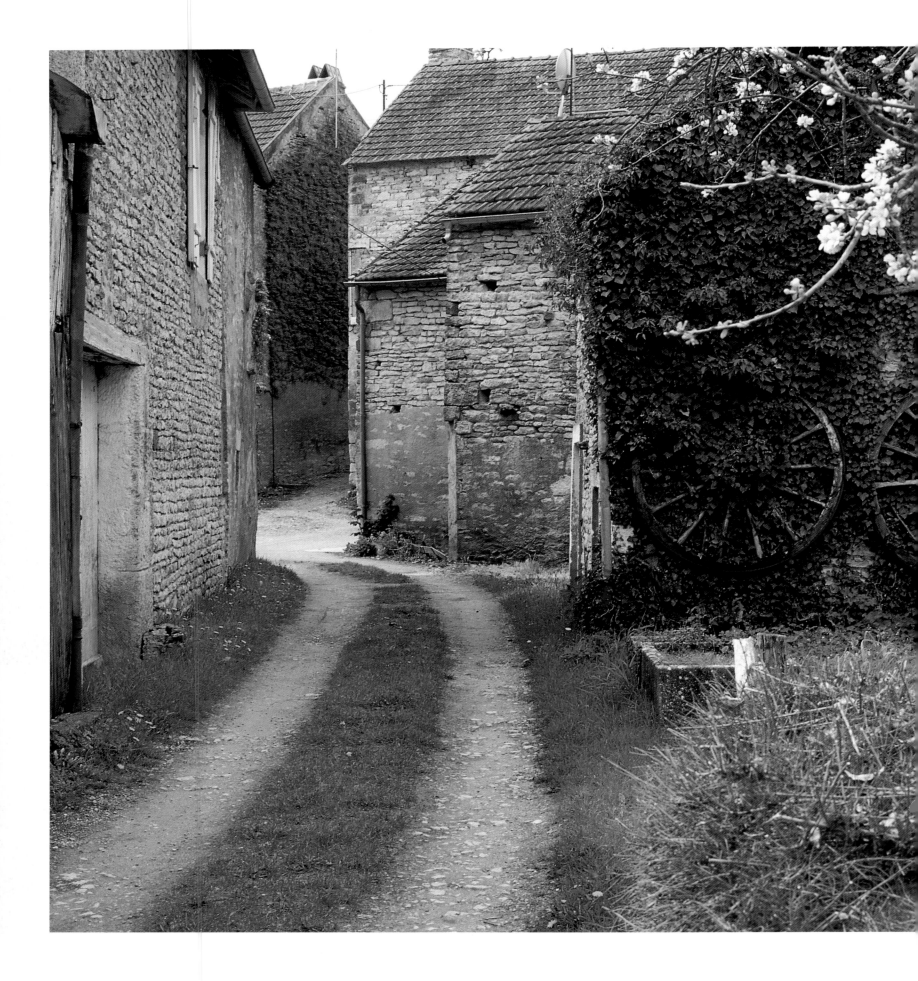

Yonne is a land of magnificent contrasts: villages of ancient stonework and winding lanes are punctuated by the towers and façades of some of the grandest houses of France. Here, a secret corner of Noyers (LEFT) expresses a different facet of the architectural heritage of Burgundy from that of the grand château.

The gatehouse of Tanlay (BELOW) is an essay in elegant decoration and striking grandeur.

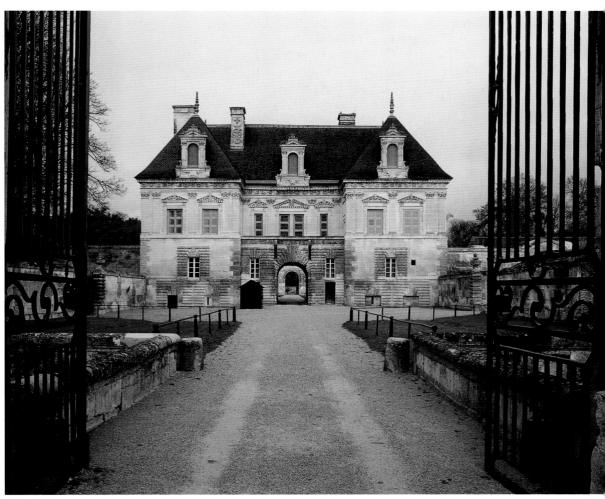

Ancy-le-Franc

*I*talian architects and artists working at the court of François I under the direction of Sebastiano Serlio created the château of Ancy-le-Franc for Antoine III de Clermont (brother-in-law of Diane de Poitiers and Comte de Tonnerre) in 1546, after an earlier château was destroyed by the Burgundians in 1472. Serlio's plans for a massive quadrilateral and symmetrical structure around a courtyard are humanized by pilasters and dormer-windows in high slate roofs and niches. The splendid apartments are for the most part still furnished and include a chapel, a kitchen and a library, with a couple of galleries decorated with wall-paintings.

For the most part, the interior decoration was also the work of Italians, Francesco Primaticcio and Niccolò dell' Abbate. The hall of the Caesars has portraits of the first twelve Roman emperors. Blue, red and gold are the dominant colours of the room of the king, where Louis XIV slept. The room of Diana is equally luxuriously decorated, with the *Judgment of Paris* and *Diana Seen Bathing by Actaeon*. The room of Judith has a cycle depicting the woman decapitating Holofernes. Most remarkable of all is the chapel dedicated to St. Cecilia, with its *trompe-l'œil* depiction of the twelve apostles.

One of the few Renaissance châteaux in Burgundy, the house sits in a fifty-hectare park, originally designed in its present form by the seventeenth-century master André Le Nôtre, with later additions in the nineteenth century. Its alleys, lawns and waters are shaded by lime trees. In 1761 a further delight was created, in the form of a folly. The village of Ancy-le-Franc has a parish church with a late twelfth-century choir. It also offers a perfect example of the way the French nobility, unlike many of their English counterparts, built their great houses inside or close by a village, instead of siting them in the open countryside.

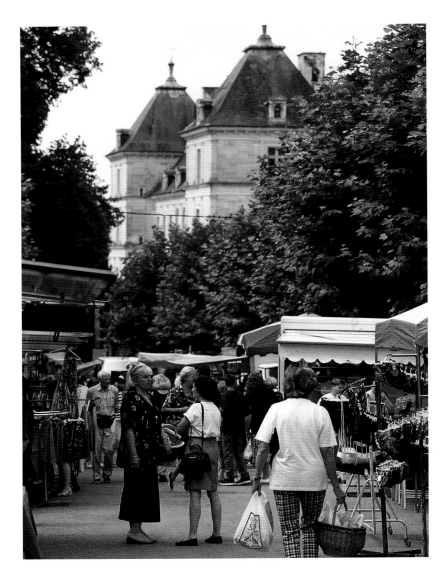

The Thursday market at Ancy-le-Franc (ABOVE) offers a chance for villagers not only to buy local produce but also to keep abreast of local gossip. They shop overlooked by the village's powerful yet elegant château. Here, children play outside the splendid west portal and rose-window of their parish church (OPPOSITE ABOVE). In a quieter corner of the village, a citizen treads his way homeward with local produce (OPPOSITE BELOW).

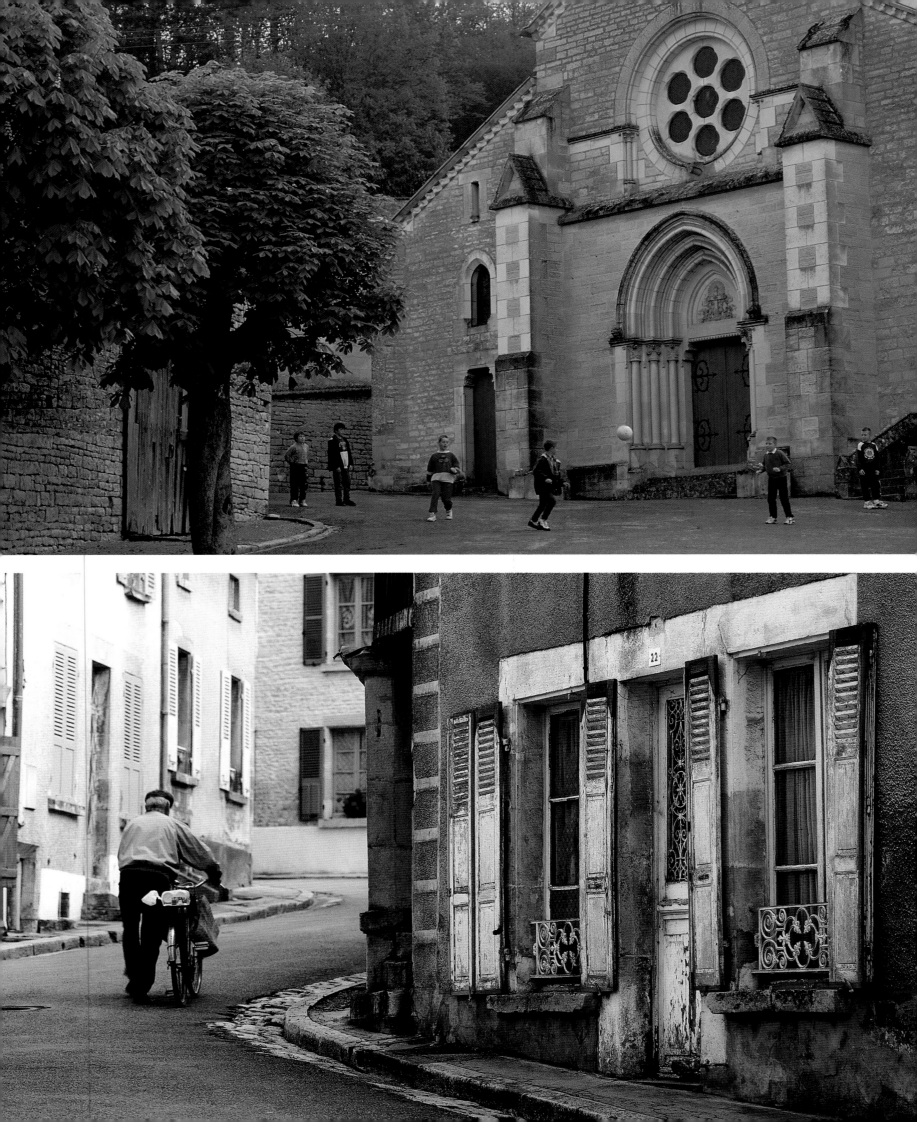

At Ancy-le-Franc the château, viewed here from the north (ABOVE), is a rare French example of a house in the Italian Renaissance style. Begun in the mid sixteenth century, designed by a Bolognese architect, its façades were modified in the next century. Its roofs are tall, enlivened with dormer-windows, its quadrilateral form likewise enlivened by four square corner pavilions. The interior is well-preserved and greatly varied: the Salle des Gardes (ABOVE RIGHT) and the Galerie de la Pharsale (RIGHT).

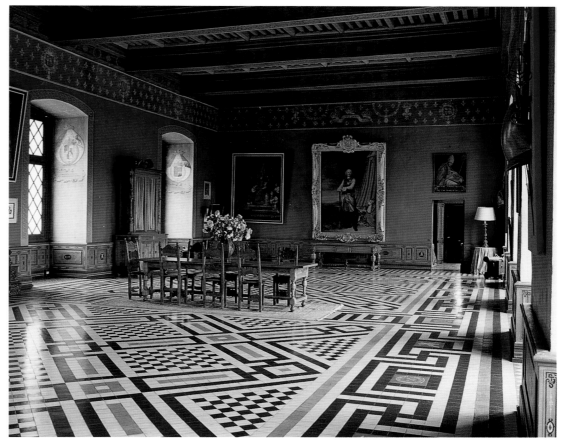

The Salles des Gardes is the largest hall of the château; it was decorated in 1580 to receive Henri III, the last Valois king of France, whose equestrian portrait is over the elaborate fireplace. This lavishly ornate room later served for a time as the château's theatre.

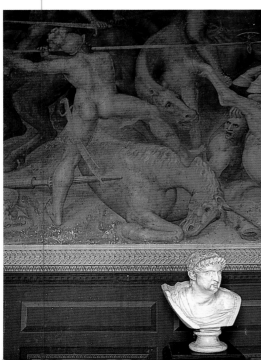

A corner of the Galerie de la Pharsale: this monumental gallery is strikingly decorated with scenes of the battle of 48 B.C. at Pharsalia between Julius Caesar and Pompey, after which Pompey fled to Egypt. Some experts attribute the paintings to Nicolò dell'Abbate; others detect the influence of Paolo Uccello.

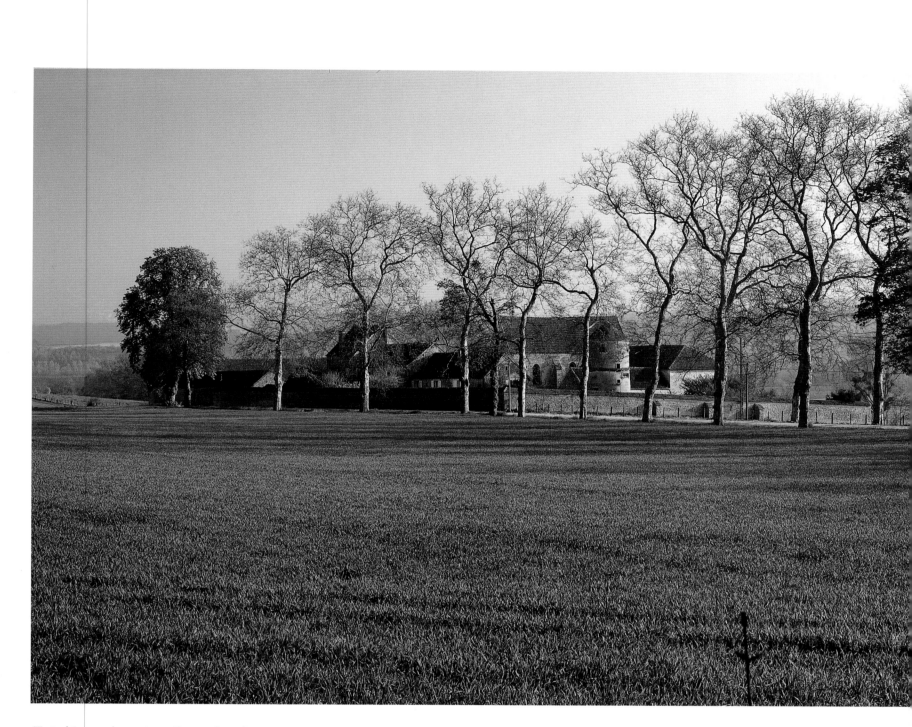

Typical ironwork graces this corner of Ancy-le-Franc (OPPOSITE). Not far away is the village of Nuits (ABOVE); like Ancy-le-Franc it lies in the valley of the Armançon. This tiny spot once marked the border between *Burgundy and Champagne, as is indicated by an obelisk on the bridge of 1740 which spans the river here. Its church is dedicated to Saint-Cyr and Sainte-Juliette, and its château rests in a shady park.*

Cerisiers

Sitting in the Sens valley on the ancient Roman road between Sens and Avrolles, Cerisiers displays its past in the remains of its fortifications and, in the Place de l'Hôtel de Ville, the elegant house which the Knights Templar set up here in the twelfth century. The Hôtel de Ville itself dates from 1830.

Cerisiers' chief glory, however, is its church of St. John the Baptist, begun in the twelfth century. The southern of its twin naves ends in a circular apse. The patterns of its vaults are graceful. Its treasures include a thirteenth-century tomb and a sixteenth-century carved Pietà. A square tower tops the church, while the Romanesque doorway is surmounted by a statue of its patron saint.

Cerisiers is noted for the forests which surround it and above all for its fine plane trees. It is also the centre of an industry creating parquet flooring.

South-east of Cerisiers is the enchanting village of Brienon-sur-Armançon, washed both by the river Armançon and the Canal de Bourgogne. Here St. Loup, Bishop of Sens, died in 623, hence the dedication of Brienon's former collegiate church, today a late sixteenth-century Renaissance building which boasts a choir screen and a choir and ambulatory built in the same era. Its stone statue of the crowned Virgin Mary also dates from the sixteenth century. Caryatids carry the roof of the choir, and the windows have sixteenth-century stained-glass. The west tower and porch were restored after eighteenth-century fires.

Brienon is graced by lime-tree-shaded walks, by ancient houses incorporating wine-cellars, by a seventeenth-century washing-place and by a grain-hall built in the following century. As with Cerisiers, its principal industry is based on the wood from the surrounding forests.

Cerisiers is a place of characterful detail and more expansive perspectives: a crumbling but still substantial wall defends houses (ABOVE) which further defend themselves with shutters. A view of the village from the west (RIGHT) shows its pleasant siting. The sturdy tower of its church, close by the Hôtel de Ville, dominates this place, which nestles under a gentle hill topped by a copse. The textures and signs of the village have their own fascination (OVERLEAF), while its outskirts have delightful walks and views.

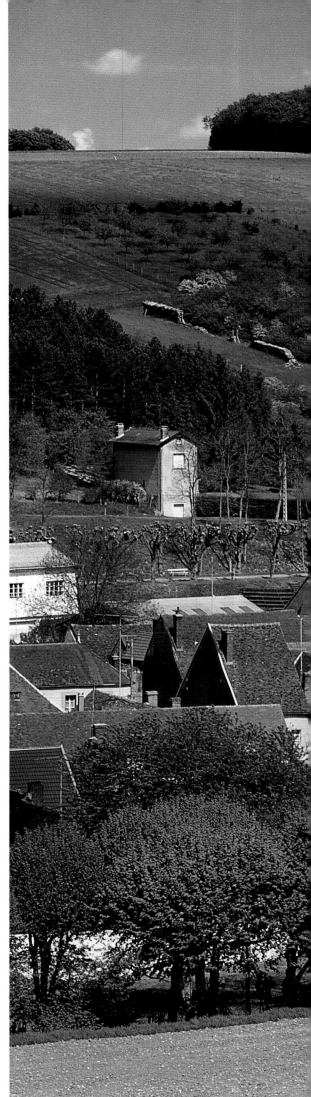

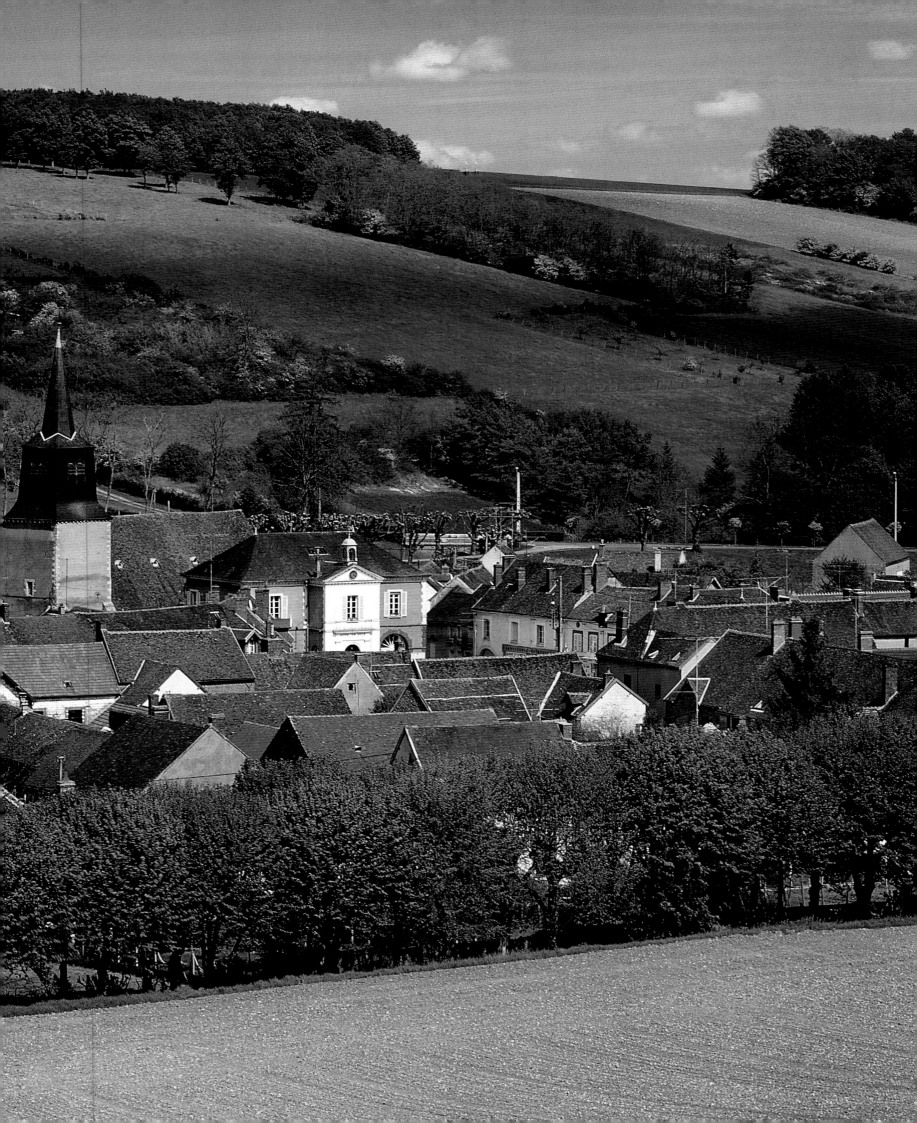

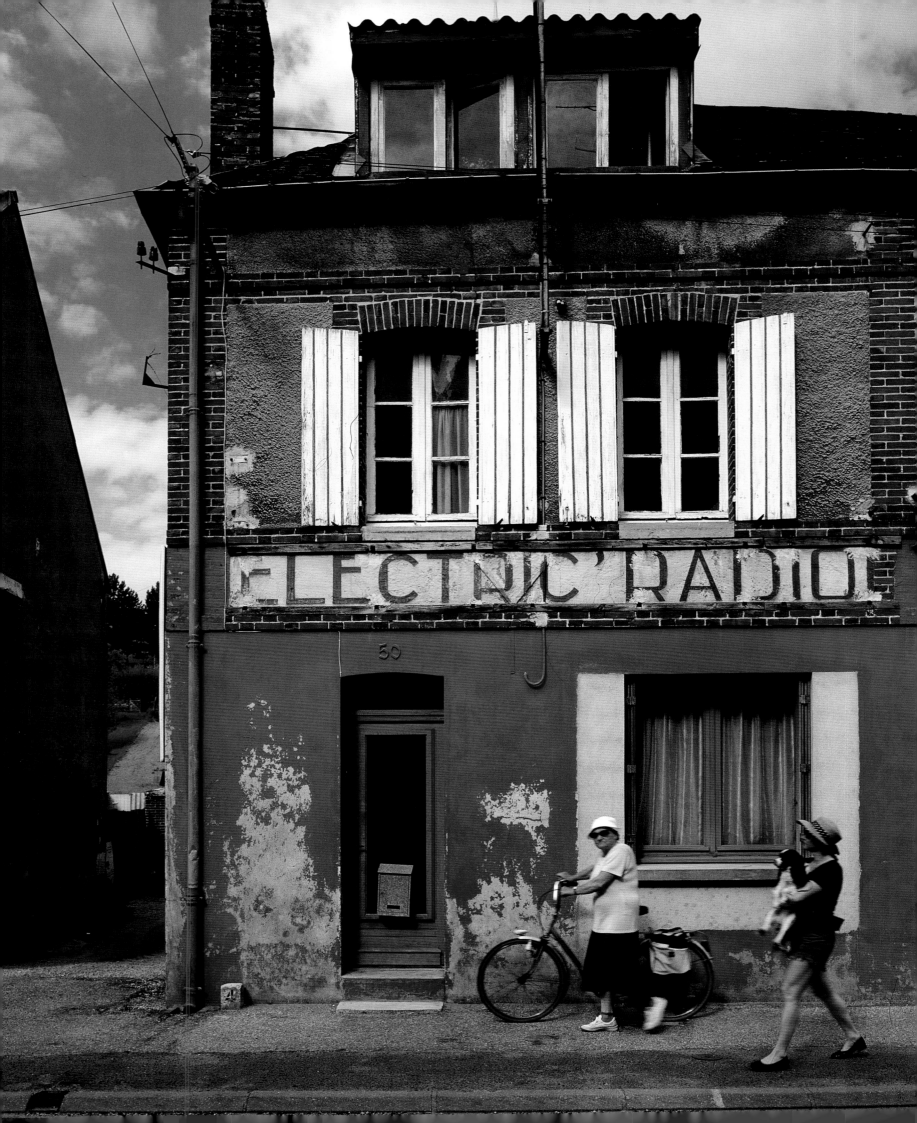

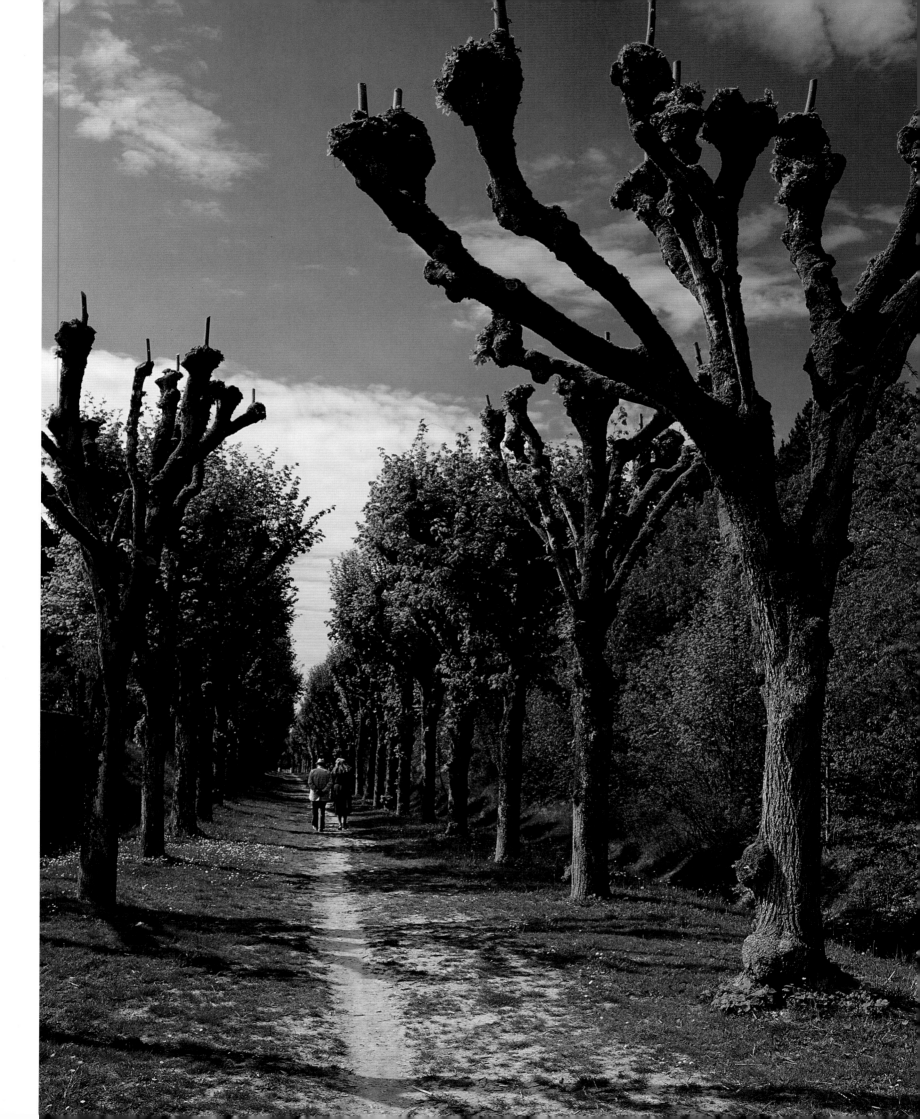

Chablis

Naturally, Chablis boasts a Maison de la Vigne, since its white wine is the most celebrated in the world. In flight from the Norman invaders, carrying relics of their patron saint, Martin of Tours, monks took refuge here in 867 and founded a monastery on land given them by the Emperor Charles le Chauve. Around it grew the village. Two rings of walls, one built in 1403 with twenty-nine towers and three gates, the later one surrounding the outlying parts, did not prevent the Huguenots from capturing Chablis in 1568 and burning much of it.

A further blow was a bombardment of 1940 which destroyed the old half-timbered houses at the heart of the village. Yet its ancient self is still in many respects intact; picturesque narrow streets are lined by lovely fifteenth- and sixteenth-century houses. Some remnants of the old fortifications still stand, among them the Porte de Noël with its two towers. Still standing also are the houses in which the monks lived, and their provost's home.

The church of Saint-Martin is a delicious early Gothic building, begun in the twelfth century, finished in the next and housing sixteenth-century choir stalls with misericords, as well as thirteenth-century statues and seventeenth-century paintings. Its choir has a pilgrim's ambulatory. Its main doorway was rebuilt in the eighteenth century. Among its fine paintings is one of the death of St. Joseph, probably painted by Pierre Mignard.

Nearby Épineuil is a typical wine village set on a hillside, with a church built from the twelfth to the sixteenth centuries. A second wine village near Chablis, one also set on a hillside, is Maligny, with an ancient château, a venerable market-hall and a church, begun in the twelfth century, which has preserved sixteenth-century stained-glass.

The villagers and the humble, quiet streets of the famous wine village of Chablis seem oblivious to that fame. A second glance, however, reveals that many of these houses are beautifully proportioned (ABOVE RIGHT), some protected by the towers of the Porte de Noël (RIGHT).

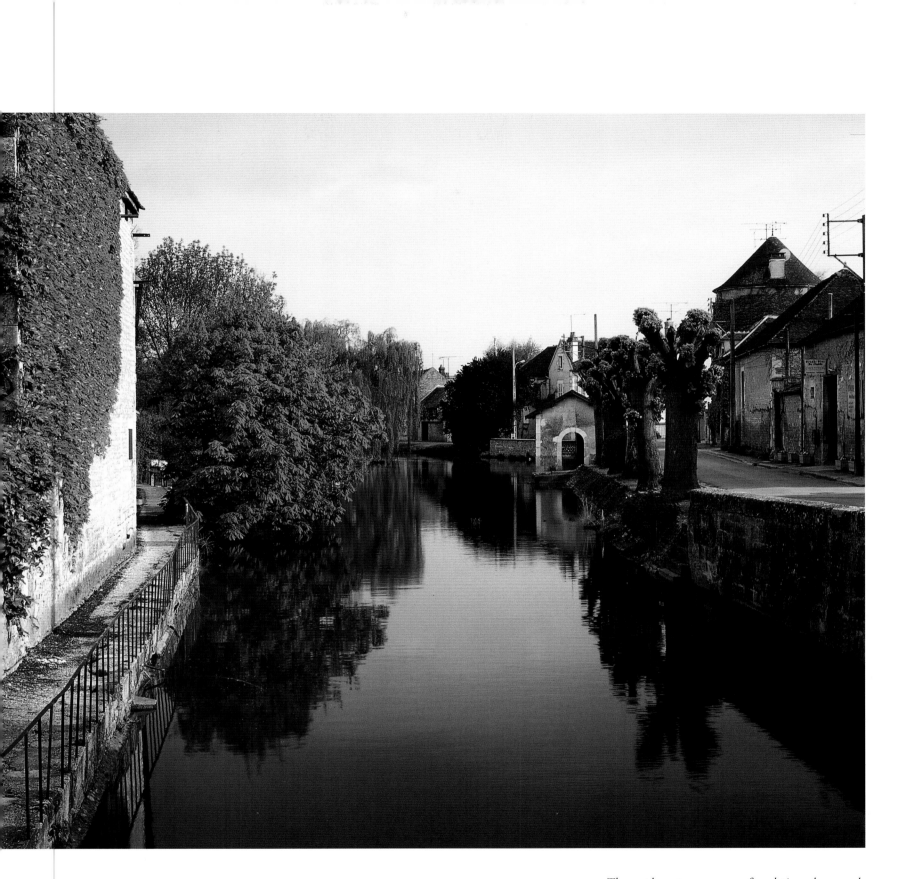

The ample water available in Chablis (ABOVE) was probably a major factor in the establishment of a monastery here in the ninth century, a foundation whose monks later administered justice in the names both of the monarch and of their patron saint and founder, Martin of Tours.

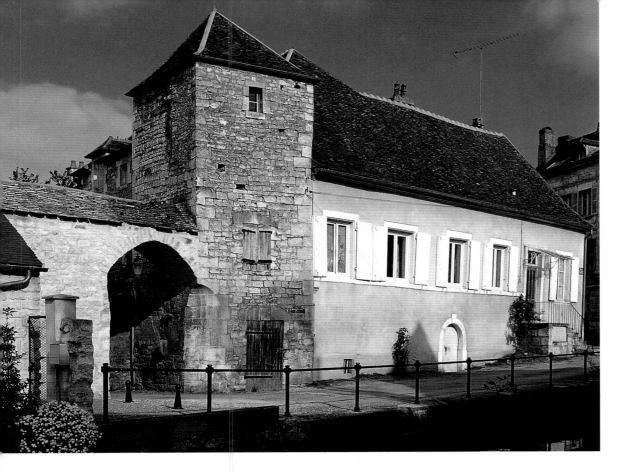

A skilled vigneron *tends the vines (*BELOW*) of the* grand cru *vineyards of Chablis (*OPPOSITE*), where the early spring growth still leaves the contours of the land around the village clearly visible.*

*Another ancient gateway into Chablis (*ABOVE*), recognizable by its rough-hewn stones, abuts a more modern home. Yet neither building has too many openings, indicating a concern with matters of defence and security. A typical flight of steps leads up to the second storey of the house on the right; wine could readily be stored in the lower.*

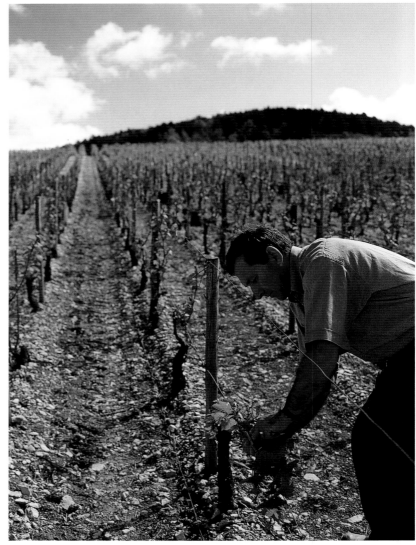

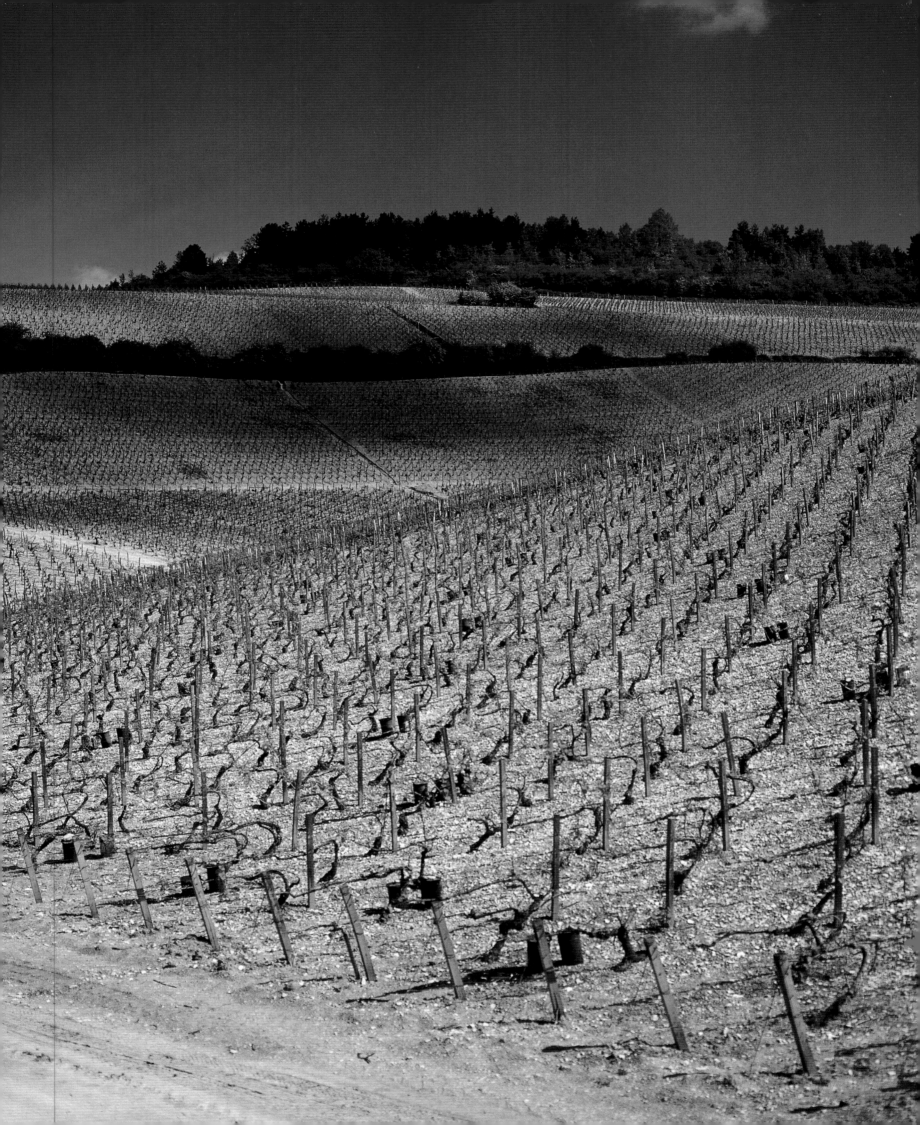

Châtel-Censoir

*I*n the fifth century there was a Bishop of
Auxerre named Censure (hence Censoir), who
was later canonized. He founded a church on the
site of the present village, replacing a pagan temple
(for excavations have revealed that there was a
Bronze Age settlement here) and served by a col-
lege of canons. The present church of Châtel-
Censoir, Saint-Potentien, dates from the eleventh
century, but was largely rebuilt in the sixteenth. Its
square tower dates from 1541, but its choir
remains from the first building, a Romanesque
delight; the capitals of its pillars are sculpted with
animal and vegetable forms. The relics of Saint-
Potentien ensured that Châtel-Censoir remained a

pilgrimage centre until the time of the French
Revolution. The chapter house was built in the
twelfth century, the crypt in the thirteenth. A cou-
ple of sixteenth-century sculptures of, respectively,
Mary and Anna and The Last Supper, still remain.
Once, a château overlooked the village, but all that
remain today are parts of its walls and a tower.

This village is beautifully situated in wood-
lands beside the river Yonne. Each Thursday a
market is set up in the village square. Ten kilo-
metres north in the Yonne valley is the enchanting
village of Mailly-le-Château, with its ruined fif-
teenth-century fortress and thirteenth-century
Gothic church of Saint-Adrien.

*The intimate feel of this
striking shopfront
(RIGHT) in Châtel-
Censoir contrasts
(OPPOSITE) with the
elegance of more
imposing houses. Here
there is time to stand
(or, rather, sit) and
stare. Although much of
the older village was
destroyed during the
sixteenth-century Wars
of Religion, quite
evidently the villagers
rallied round to recreate
this Burgundian gem.
Water is a constant
theme running through
the heart of the village
(OPPOSITE), a pleasant
element among the
splendidly textured roofs
and walls which enfold
and define this place.*

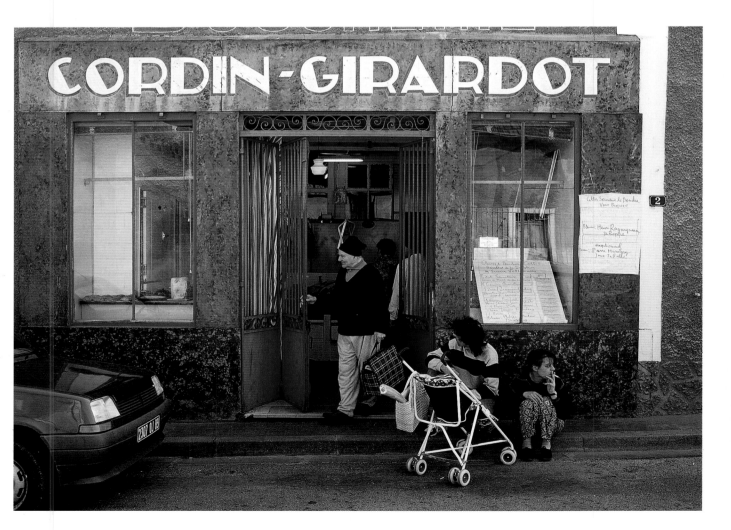

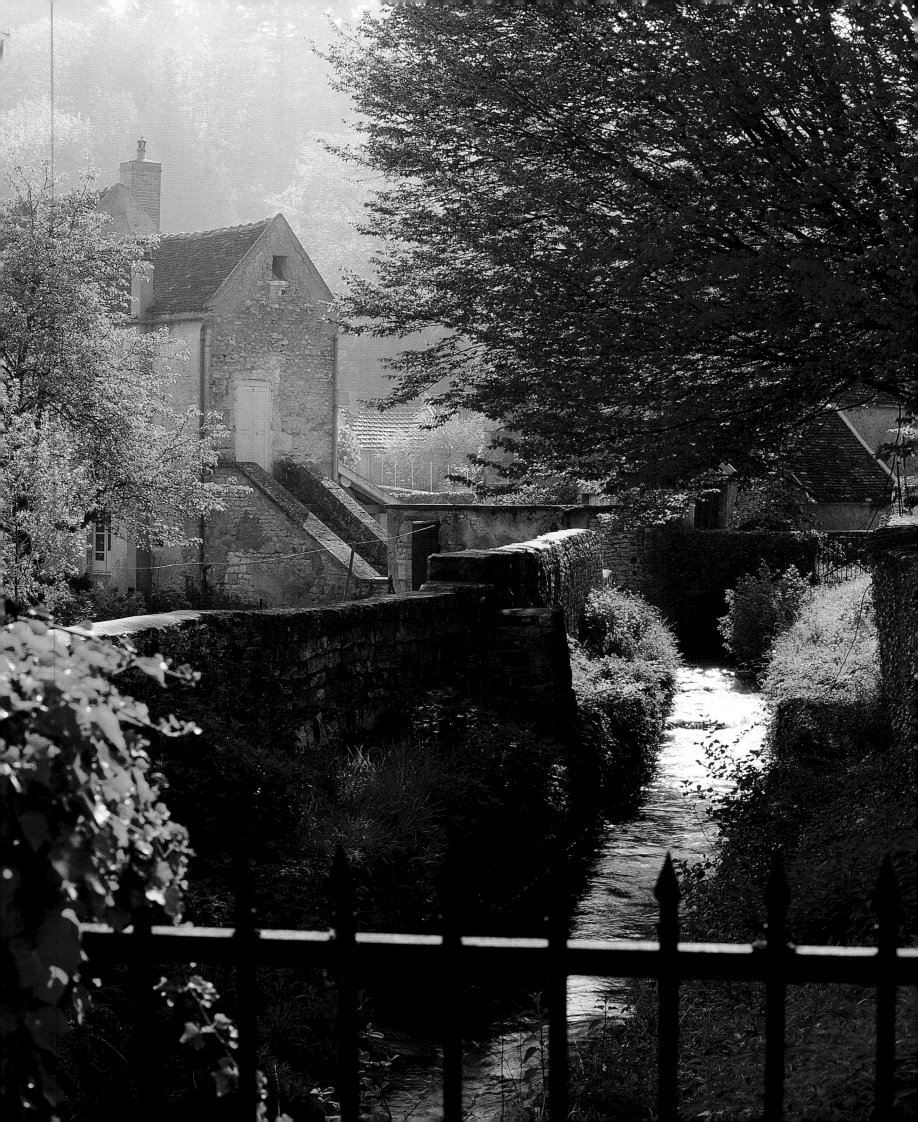

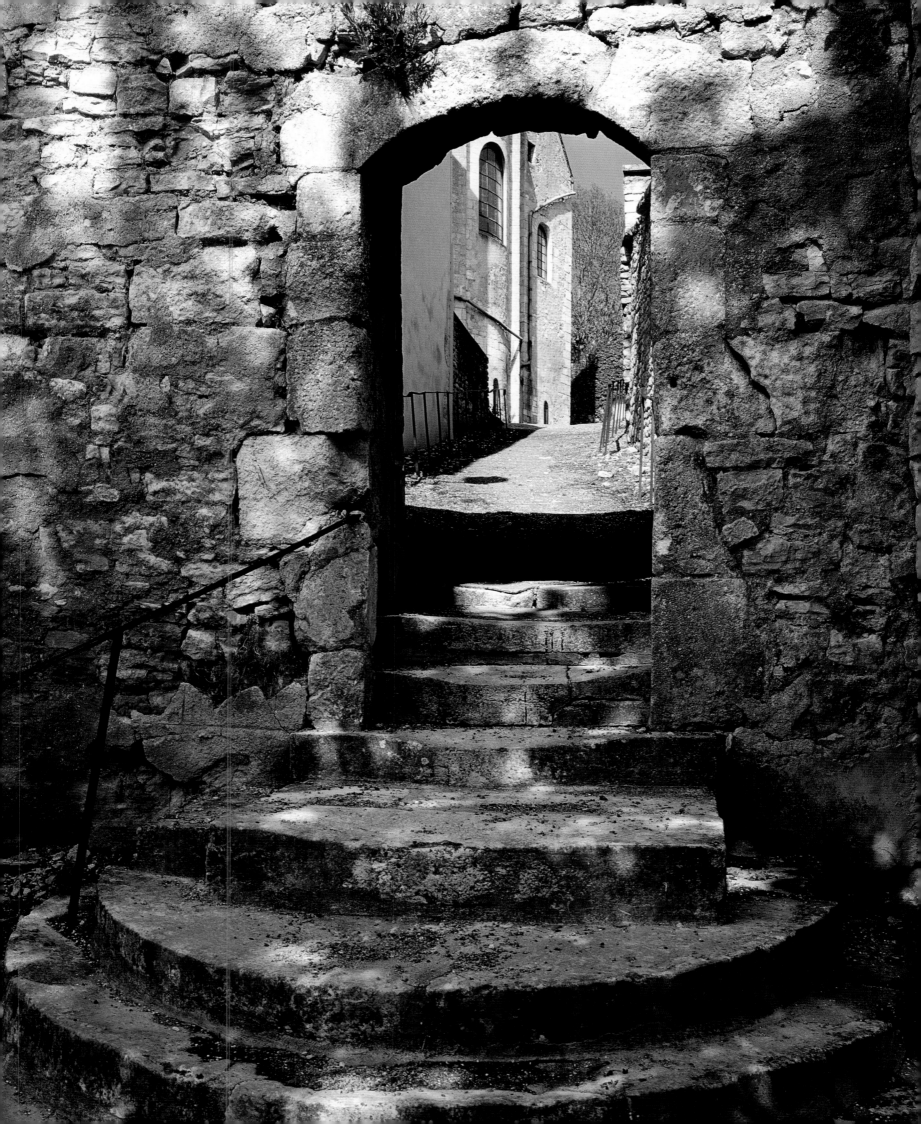

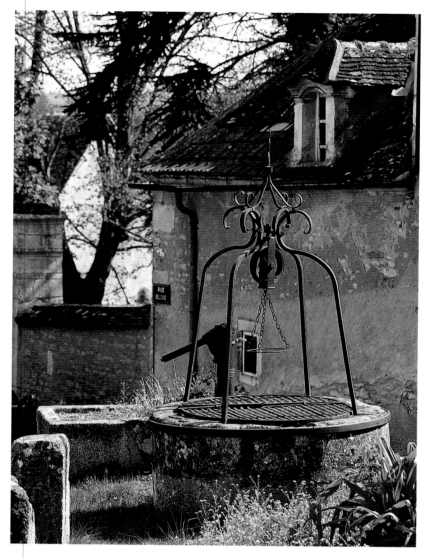

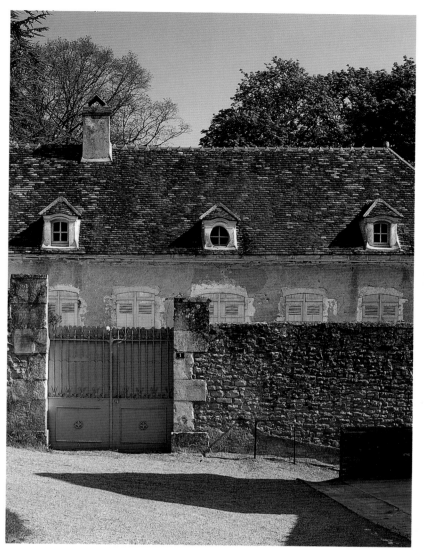

The theme of water seems inescapable here, whether overground or underground. Here, a splendid well-head (ABOVE) stands near the walls of the venerable houses it once served.

Secret corners seem to be a speciality of this village: a powerful wall and sturdy gate (ABOVE) enclose a beshuttered house.

These irregular steps and this charming archway (OPPOSITE), whose rough-hewn stones indicate its antiquity, open into a secretive lane which leads up to the church of Saint-Potentien at Châtel-Censoir.

Montréal

*T*he medieval village of Montréal, as unspoilt a spot as any in Burgundy, overlooks the opulent valley of the river Serein. Its former collegiate church dates from the twelfth and thirteenth centuries, and gives a ravishing view of the valley. The village's narrow and sometimes steep streets have houses dating from the fourteenth, fifteenth, sixteenth and seventeenth centuries, some of them with external staircases. A couple of medieval defensive gates remain, that of En-Haut and that of En-Bas, at either end of the fortifications.

This little spot has seen many historic occasions. Legend has it that Queen Brunehaut, wife of Sigbert of Austria and for a time herself ruler of the whole Merovingian kingdom, lived here in the sixth century. The Normans captured its fortress in 883. An Augustinian priory was founded here in the eleventh century, its chapel the predecessor of the present church. In 1291 Montréal was reunited with Burgundy. In 1348 Comte Amédée of Savoy and Duke Eudes V of Burgundy came here to sign a treaty of alliance. Twelve years later Edward III of England was master of Montréal. After many further vicissitudes, Henri IV ordered the demolition of the château.

The parish church of Notre-Dame, formerly an Augustinian collegiate church, one of the earliest Gothic churches of Burgundy, was renovated by Viollet-le-Duc in the nineteenth century; it has a rose-window above an elegant arched and sculpted double entrance. The interior is crammed with treasures, including a twelfth-century stone tribune, a fifteenth-century alabaster reredos with scenes from the life of the Virgin Mary, a wooden sixteenth-century reredos and oak stalls sculpted in 1522 with animated scenes from the Old and New Testaments. In these last the sculptors (said to be the two brothers Rigolley from Nuits-sous-Ravières) have brilliantly depicted, among other subjects, the river Jordan flowing around the legs of Jesus and John the Baptist during Jesus's baptism. And in this land of wine one of the most celebrated carvings depicts a couple of contented drinkers seated at table.

A panorama of Montréal from the south; in spite of many depredations over the centuries, this hill-top village has managed to preserve much of its medieval inheritance - some of its fortifications, ancient houses, a fine church. Montréal's pastures and fields nourish animals, cereals and vegetables to enrich the famed gastronomy of Burgundy.

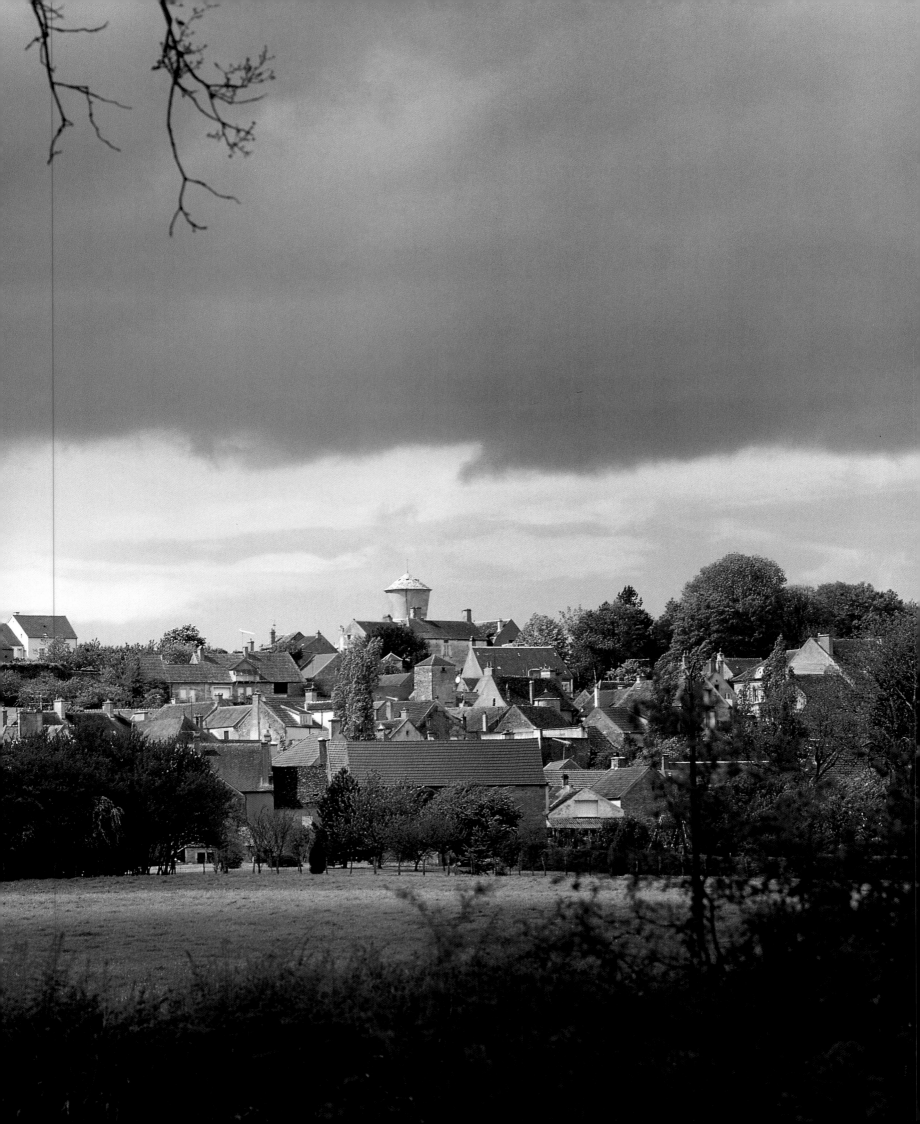

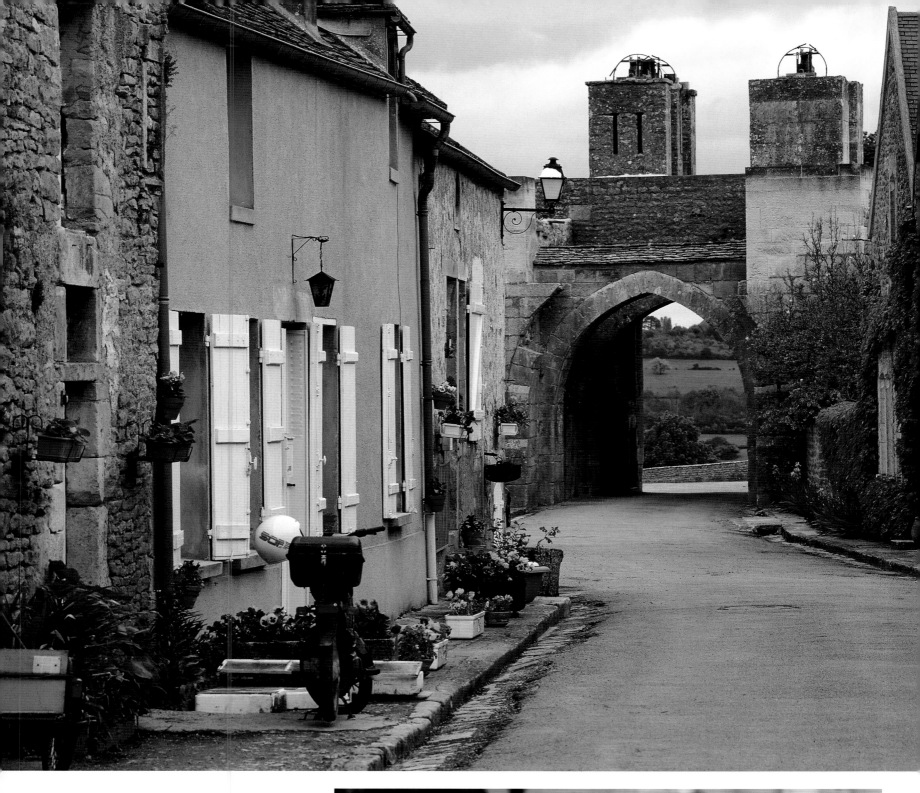

The picturesque streets
of Montréal (ABOVE)
must once have
welcomed the protection
afforded by its ancient
fortifications. In its
church the choir stalls
are of meticulously
carved oak; this early
sixteenth-century one
(RIGHT) fittingly depicts
two inhabitants enjoying
the local beverage.

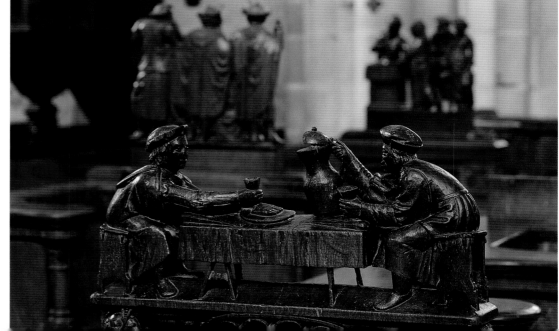

The early thirteenth-century west façade (RIGHT) of the former collegiate church of Notre-Dame is a masterpiece of late Romanesque Burgundian architecture. Its double doorway, surmounted by a superb rose-window leads to an early Gothic interior.

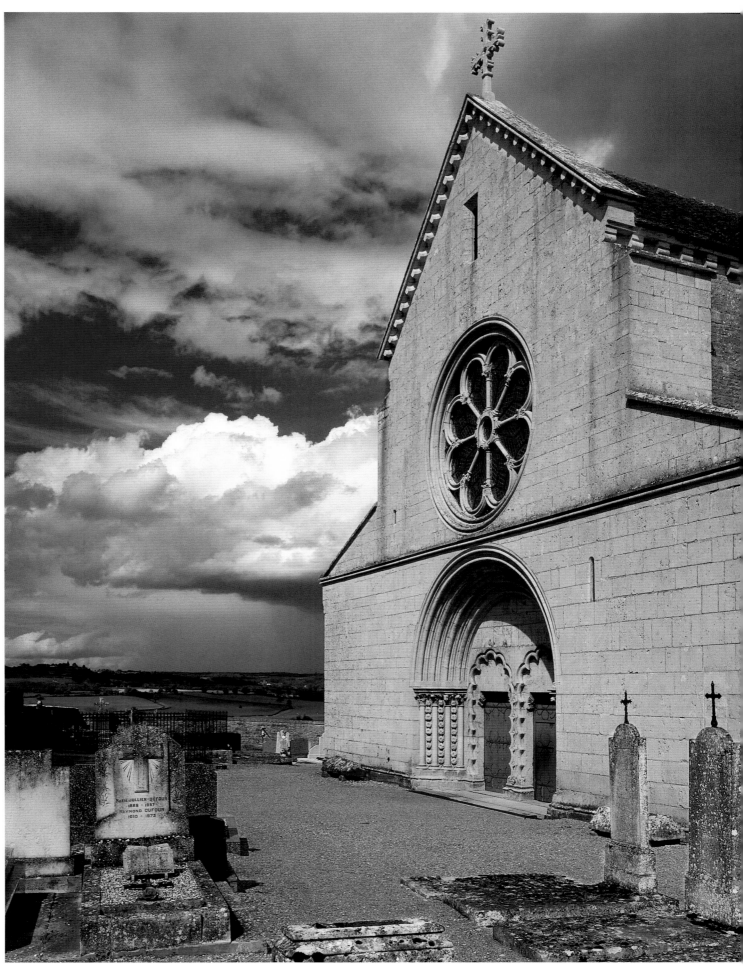

Noyers

Vaulted passageways, enchanting houses, tiled roofs, fountains and a flamboyant Gothic church dedicated to our Lady and dating from the thirteenth, fourteenth and early sixteenth centuries characterize Noyers (pronounced 'Noyère'), which sits in a meander of the river Serein. Some of the houses have arcades, particularly in the main square. Some are Renaissance in style, others classical. Many are half-timbered and a number have external staircases. The names of streets and squares testify to the commerce of past and present times: the Petite-Étape-aux-Vins, the Grenier-à-Sel, the Marché-au-Blé (surrounded by superb houses), the Poids-du-Roy. The red roof of the parish church contrasts delightfully with the white stones of the walls.

In the twelfth century the Bishop of Auxerre, Hugues de Noyers, was responsible for transforming the château into a powerful fortress (vestiges of which still remain), as well as for building the ramparts of Noyers, which proved formidable enough to withstand several sieges. In the sixteenth century the village became a stronghold of Protestants, who remained secure here until they were finally defeated by the forces of the Catholic Catherine de Médicis in 1599. Towers and gateways still stand from the ancient fortifications.

On the third Thursday of each month this normally peaceful village springs into life with its ancient fair. Another festival, on 14 July, commemorates the granting of a charter to the village in 1231. A third festival, celebrated on the feast of the Assumption of the Blessed Virgin Mary (15 August), is held around a statue of the Madonna and Child, holding grapes, which signify not only the wine of the region but also the blood of Jesus. A statue of the Madonna also adorns the northern Porte de Tonnerre.

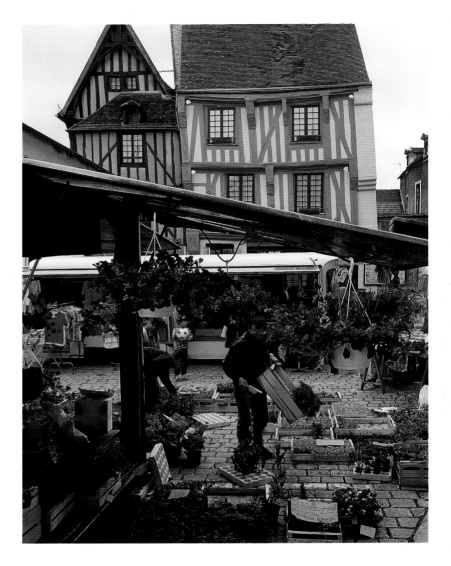

A real Burgundian gem, Noyers has evolved over centuries into an intriguing and complex arrangement of arches, sudden views and a wealth of half-timbering (OPPOSITE). Every corner is alive with delightful detail, while the Wednesday market invigorates the main square (ABOVE).

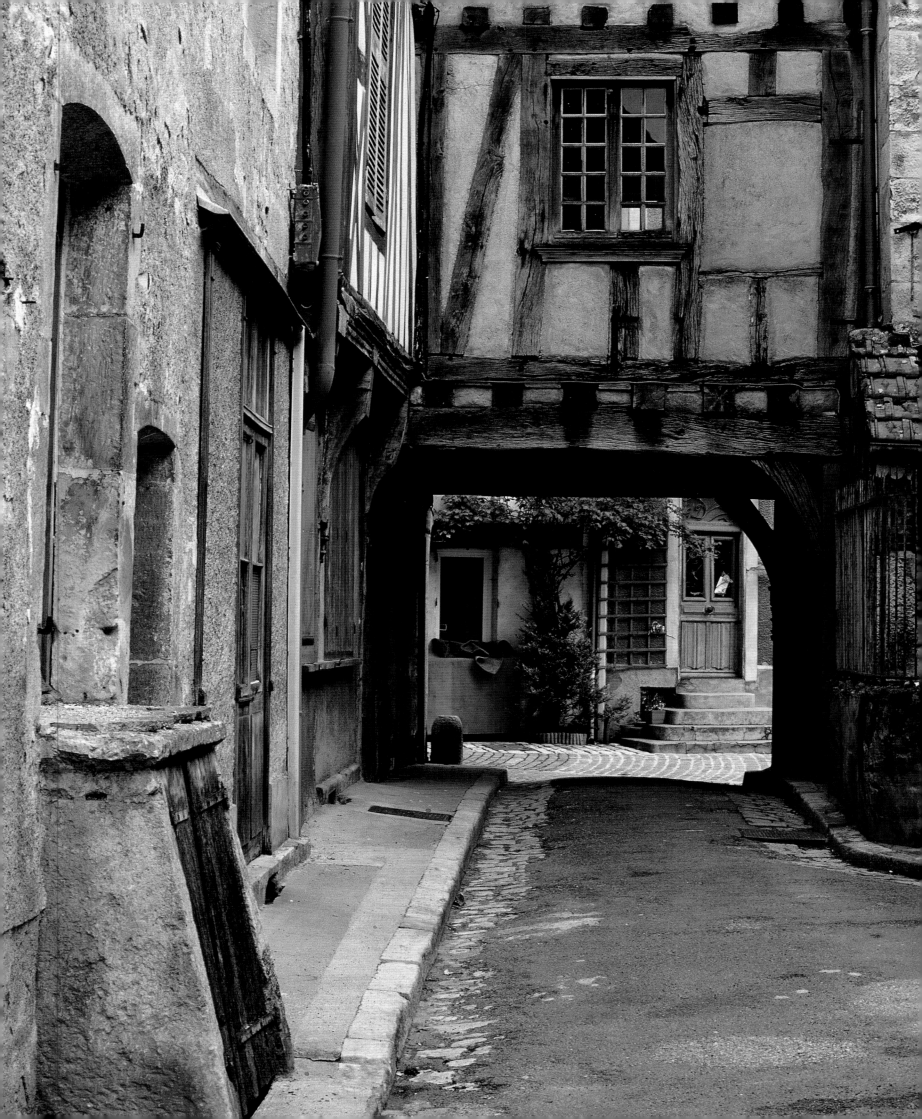

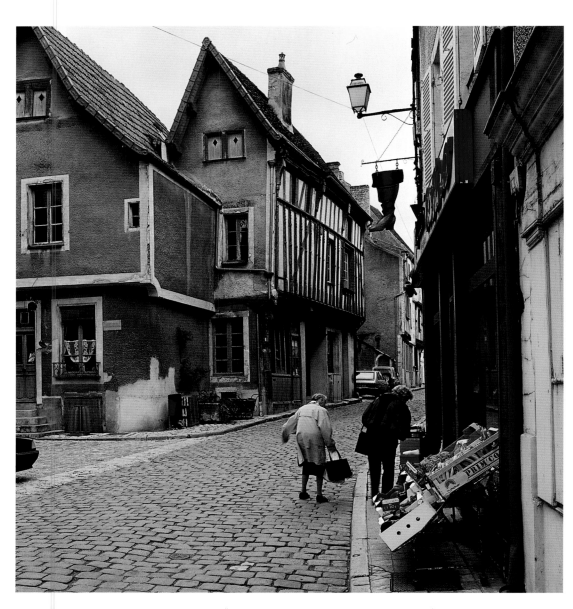

The streets of Noyers are kind to pedestrians, protected by the overhanging upper floors of ancient houses, and offering produce which is a delight to eye and palate (ABOVE). House façades are picked out with plants which complement the forms of their old window shutters and doors (RIGHT).

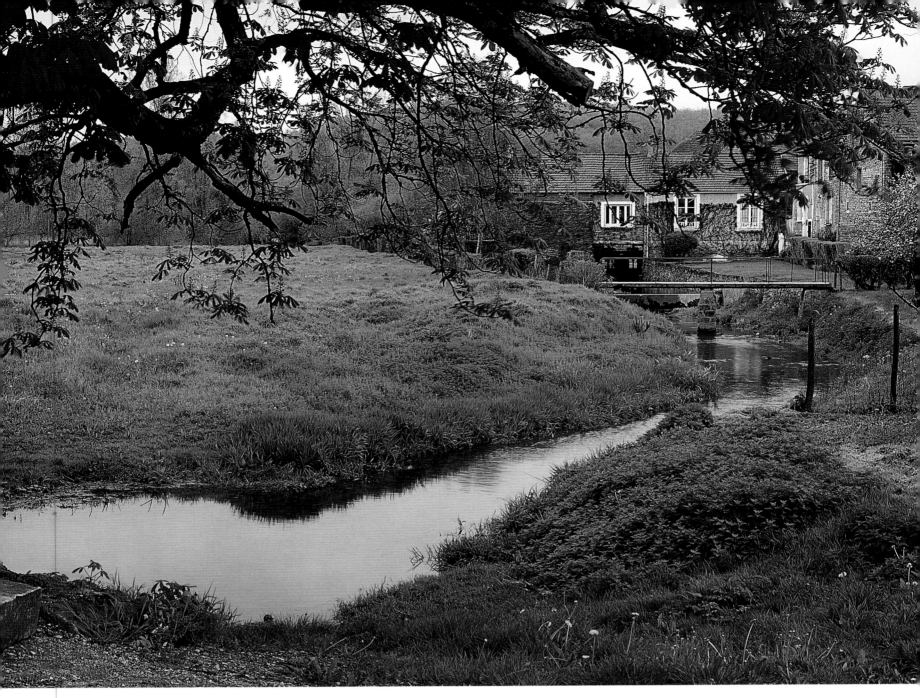

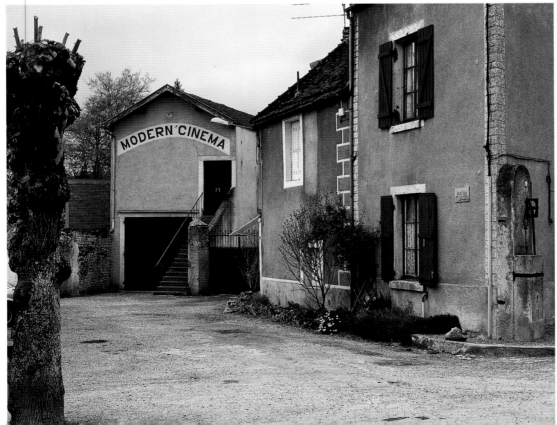

Not all the street details of Noyers are centuries-old; here, a typically discreet village street leads to the delightfully named 'Modern Cinema' (LEFT). Streams nourish the landscape (ABOVE), as does the river Serein, its dampness perhaps accounting for the dereliction of some of the former fortifications. Note that this mill at neighbouring Massangis bears several markings indicating the level of flooding in past years.

Saint-Fargeau

*O*n a spot where a tenth-century fortress once stood beside the river Loing, the present château of Saint-Fargeau was largely rebuilt by François Le Vau (brother of the court architect Louis Le Vau) on behalf of the cousin of Louis XIV, Anne-Marie-Louise d'Orléans, better known as Mlle de Montpensier and exiled there in 1652. One of the finest châteaux of Burgundy, this exquisite pink brick building with slate roofs is rectangular and defended by six round towers, topped with turrets. The most powerful of these towers, built in the fifteenth century, is named after the celebrated merchant Jacques Cœur (who had bought the château in 1450 and died as a fugitive, accused of poisoning the king's mistress, Agnès Sorel). The château has a chapel as well as a north-west wing dating from the second decade of the eighteenth century. Its central courtyard is again built of brick, with stone embellishments adding an air of sumptuousness.

The château also has an exquisite park. Covering approximately a hundred hectares of the valley of the Bourdon, enlivened by water, the park was designed by Le Vau and transformed in the early nineteenth century. Pines, oaks, fir trees, hornbeams, beeches and lime trees lend it their shade.

The medieval village itself is protected by a fifteenth-century brick and stone clock-tower, once one of its three fortified gateways. Its thirteenth-century parish church of Saint-Ferréol is splendid, housing a polychrome Pietà, sculpted in stone in the fifteenth century, and a triptych of the Passion, carved of wood in the same era, as well as boasting three flamboyant Gothic windows and a lovely rose-window in the west façade. Graceful ogival and lierne vaulting supports the ceilings of its nave and aisles. The elegant town-hall of Saint-Fargeau was built in the seventeenth century as an Augustinian convent.

This deliciously curving, cobbled street (BELOW) passes under the archway of the Tour de l'Horloge. In this village the houses display much variety in style, and also display their owners' pride in the form of floral decoration. In past times this fifteenth-century archway served as the main gateway to the village.

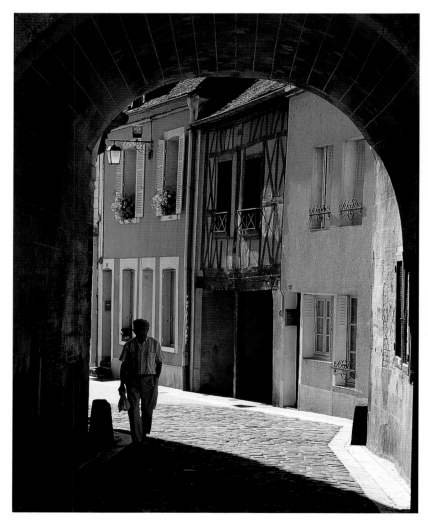

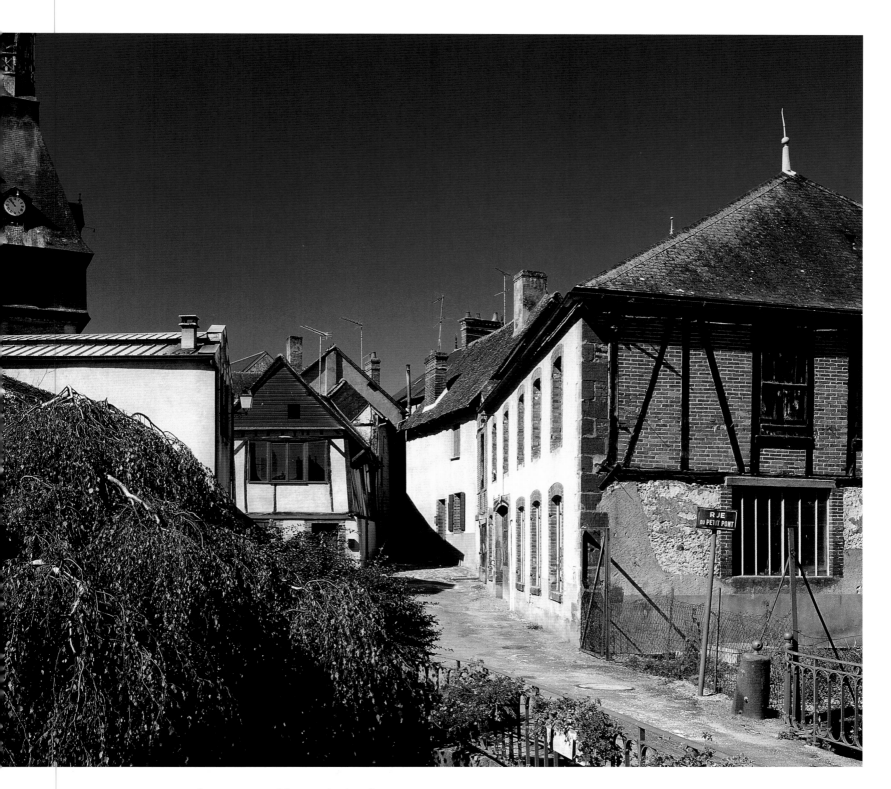

Looking up a peaceful Rue du Petit-Pont, with its ancient and varied houses, you see the church of Saint Ferréol (which was built on the site of a Celtic holy place) and, rising beyond it, the mighty Tour de l'Horloge, whose arches cast sudden shade over yet another charmingly curving street.

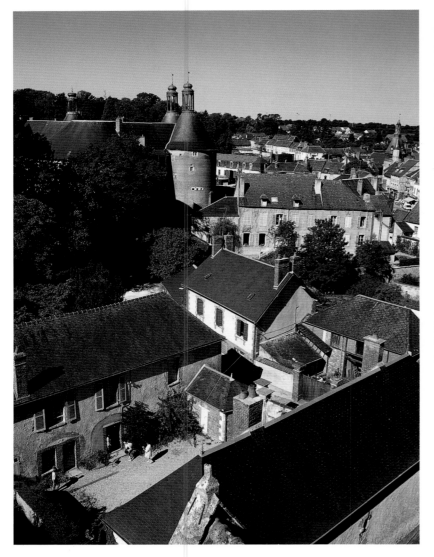

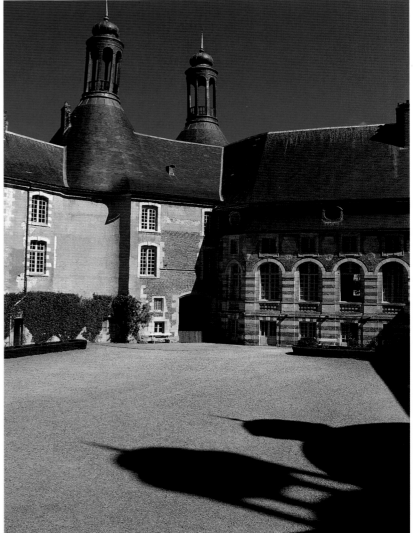

Seen from the belfry of
the village church,
Saint-Fargeau (ABOVE)
is revealed in all its
glamour. In the distance
rises its seventeenth-
century château, with
round towers. The view
gives a wonderful sense
of the architectural
structure of the village,
of the interaction of
roof and wall, street
and court.

The courtyard of the
château (ABOVE) is in
an excellent state of
preservation, its brick
and stone buildings
gleaming in the
sunlight. Two of its
gigantic towers
(OPPOSITE) amply
convey the massive
nature of the structure.

Treigny

The village of Treigny is surrounded by the Boutissaint natural park; some four hundred hectares of forest shelter its varied fauna - fallow deer, wild boar, stags, roe deer, wild sheep, European bison, birds of prey and swans - all of them completely free. The place itself offers a panorama over the Puisaye. It is blessed with the priory of Saint-Langeur, which has a delightful twelfth-century statue of the Virgin Mary, patroness of pilgrims, carved in wood. The nearby yellow sandstone Château de Ratilly is defended by a moat and was begun in the thirteenth century and finished in the sixteenth. This château has a homely, unthreatening look, though it is surrounded by quadrilateral defences whose six round towers are powerful enough, the whole still redolent of the Middle Ages.

Treigny's church, dedicated to St. Symphorien, is described, on account of its size, as the cathedral of the Puisaye. Built in the fifteenth century (its choir added early in the next century), this late Gothic church has a side altar dating from the mid seventeenth century and a monumental high altar of 1675. The square belfry rises on the left-hand side of the church.

This village is noted for its pottery, ceramics and glassworks, the first two developed since the seventeenth century, the last since the sixteenth century. The former canonry of the village (the Maison du Chanoine) is now a pottery museum. Treigny is also notable for a fine variety of sixteenth-century houses, some in the Gothic style, others Renaissance, some with Latin inscriptions, others with French.

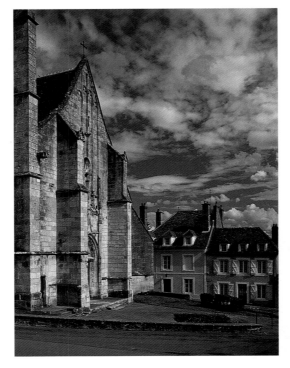

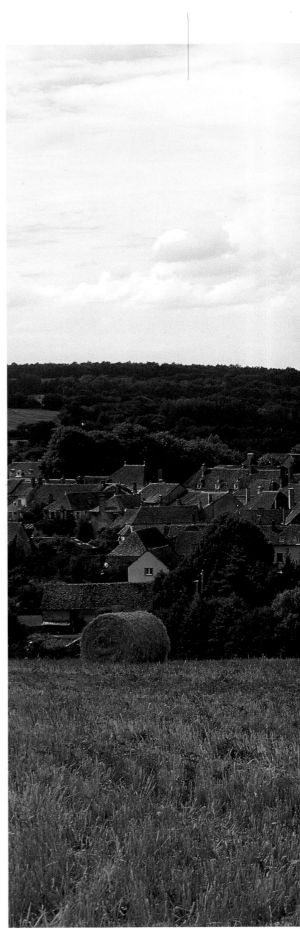

The formidably buttressed church of Treigny rules majestically over its own square (ABOVE). The village (RIGHT), viewed from the south across fields of newly-mown hay, seems almost overpowered by the majestic church of Saint-Symphorien, with its square tower - a church unusually large for this part of France.

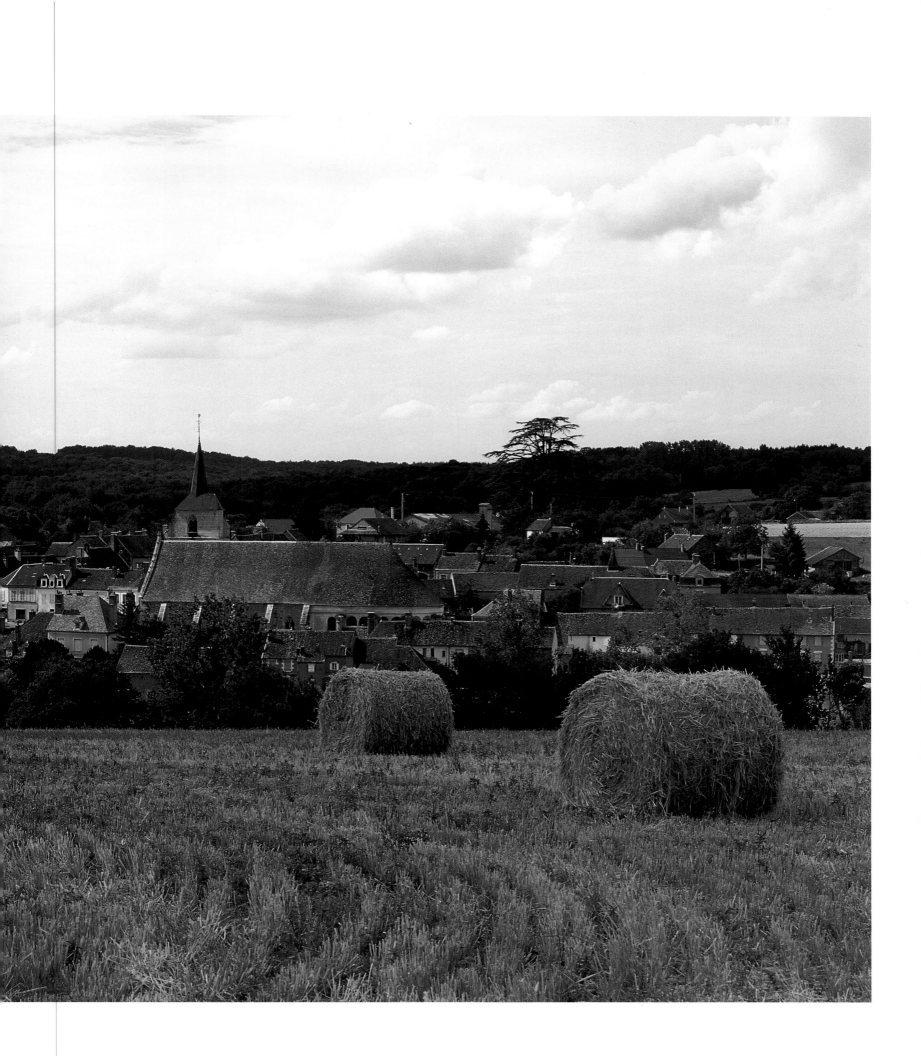

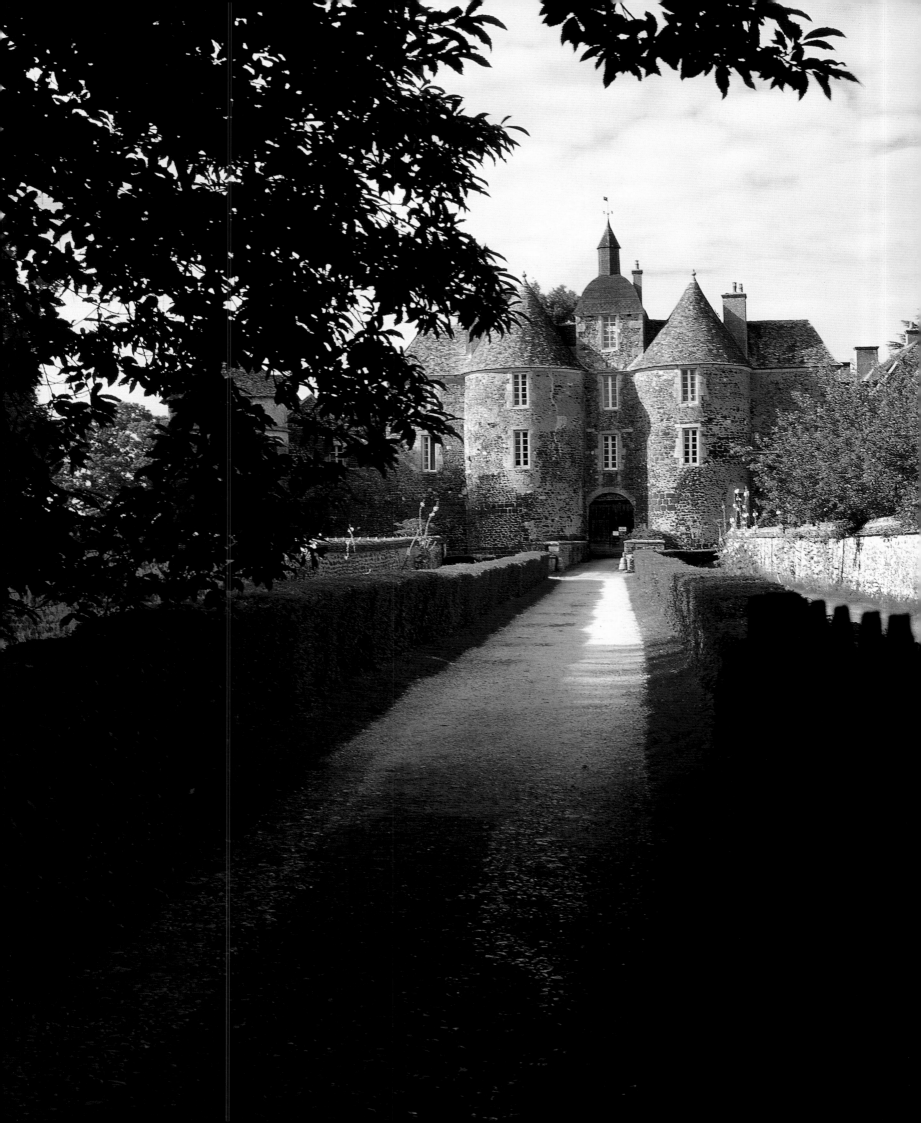

The severity of the sandstone towers of the Château de Ratilly (OPPOSITE), west of Treigny, is alleviated by the elegance of their long windows.

The nave and apse of the 'cathedral of the Puisaye' (RIGHT): the three aisles of Saint-Symphorien at Treigny are separated by ogival arches. Though the choir and sanctuary were added to the fifteenth-century nave at the end of the sixteenth century, side altars were built around 1650 and the imposing Corinthian-style high altar dates from the third quarter of the seventeenth century, the whole remains remarkably harmonious.

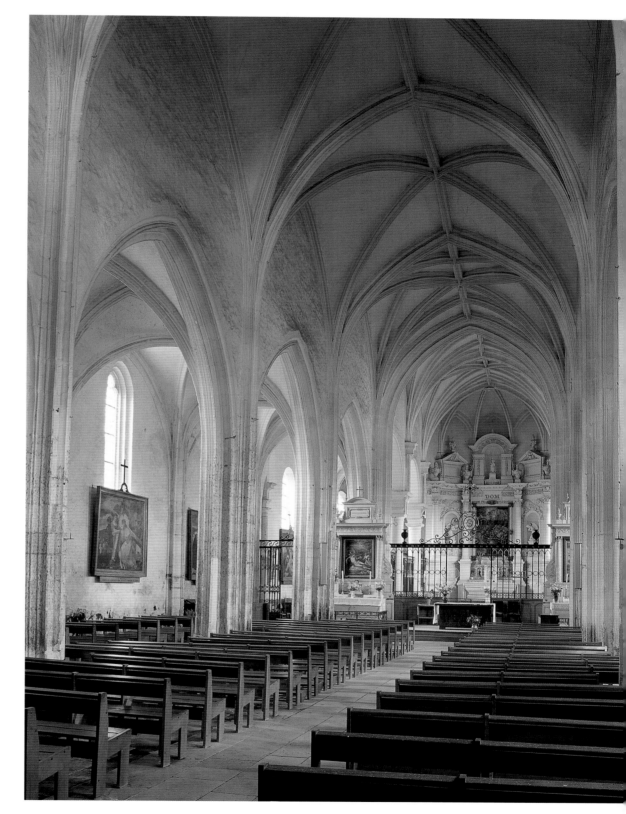

Vézelay

A Gallo-Roman named Vitellus gave his name to this spot, a name later transformed into Vézelay. But the village, set on the summit of a hill, began to flourish only with the arrival of the monks who built an abbey here, sheltered by the hills, overlooking the river Cure and a powerful defence against the attacks of the Normans.

Somehow, in the eleventh century, the monks found some relics claimed to be those of St. Mary Magdalen, and the abbey began to attract increasing numbers of pilgrims, eventually becoming one of the most celebrated pilgrimage spots in the western Christian world. Around it the village expanded to house these pilgrims, who often lived here in basements which still exist, fine examples of domestic Romanesque architecture. Vézelay became more and more important, and in 1146 St. Bernard came here to advocate the Second Crusade. It was here, too, that Richard Cœur de Lion and Philippe-Auguste gathered their armies together for the Third Crusade.

When rival relics of St. Mary Magdalen turned up at Saint-Maximin in Provence, Vézelay began to decline, suffering more during the Hundred Years War, the Wars of Religion and the Revolution. But in the mid nineteenth century the basilica of Sainte-Madeleine, of which the church and the chapter house survived, was splendidly restored by Viollet-le-Duc.

Today visitors admire not only these buildings, particularly the church (with its fabulously sculpted tympanum, depicting Christ in glory, and its exquisitely carved capitals) but also the lovely houses in the village, dating from the thirteenth to the eighteenth centuries. The former homes of clerics, bourgeoisie, *vignerons* and labourers, their walls varying in colour from red ochre to white and pink, line entrancing narrow streets. Many of their roofs are steep and tiled in the colourful Burgundy fashion, as they climb the steep hill towards the holy shrine which crowns it.

Three scenes from the streets of Vézelay (THESE PAGES and OVERLEAF): steps lead up to one home, a typical feature of this partly medieval village, which stretches up the rising line of its hill; towers are another feature, as are vaulted wine cellars and wells. As these photographs reveal, a delightful variety characterizes the houses. Some are built of rough stone and seemingly designed for self-defence; others are painted and shuttered; others set in gardens.

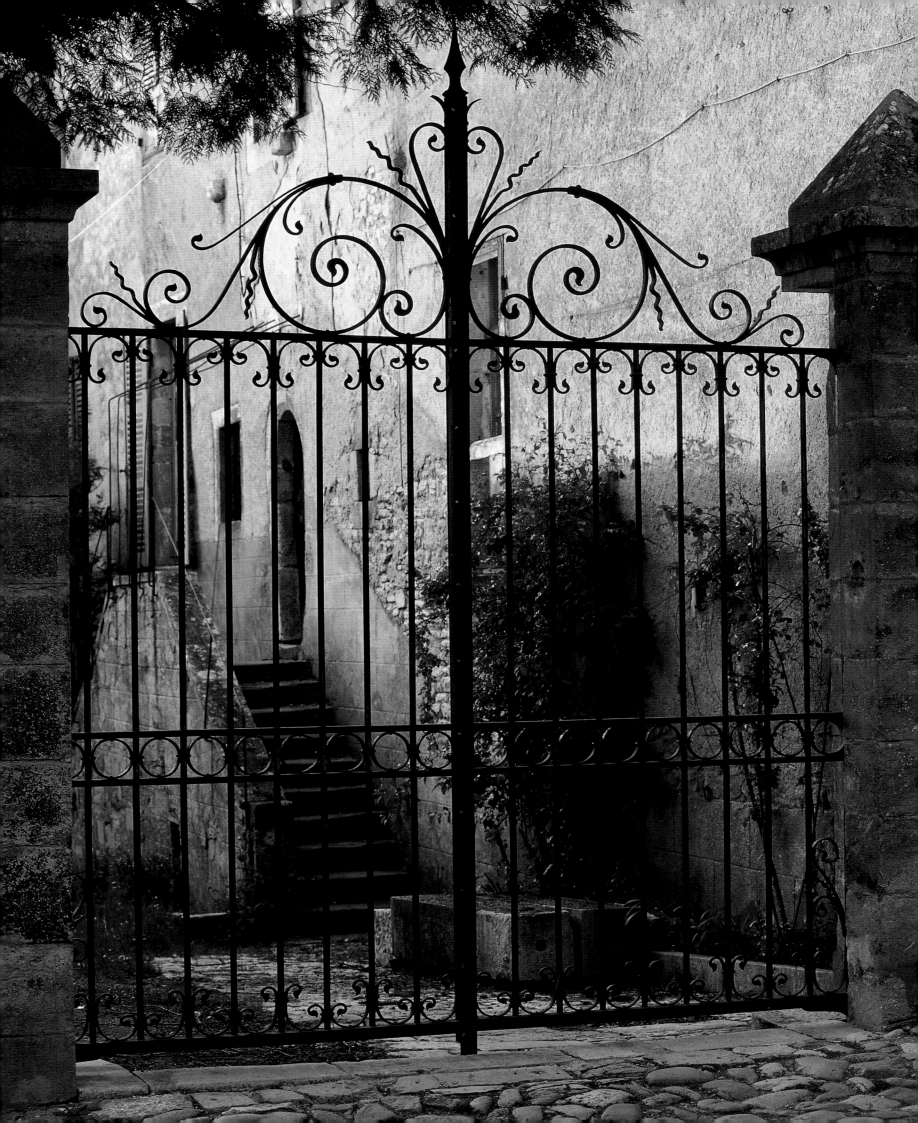

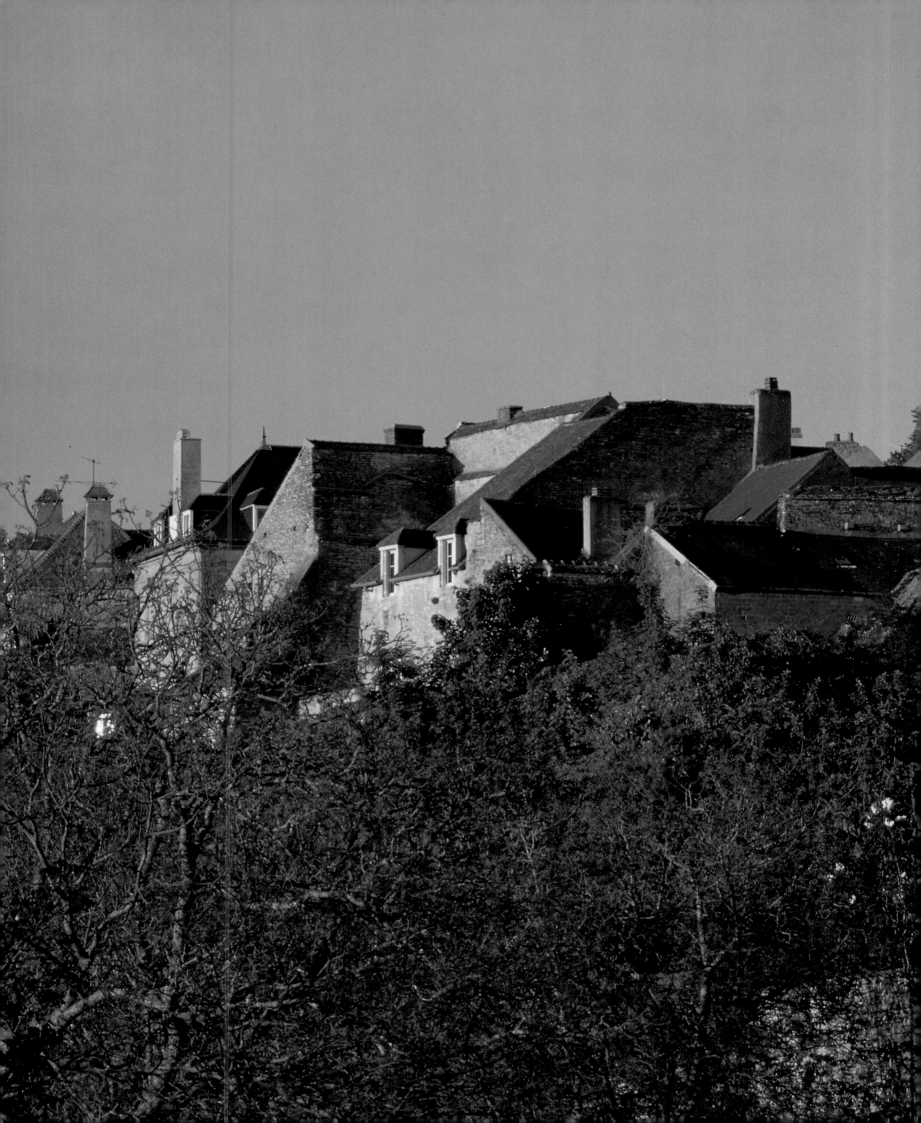

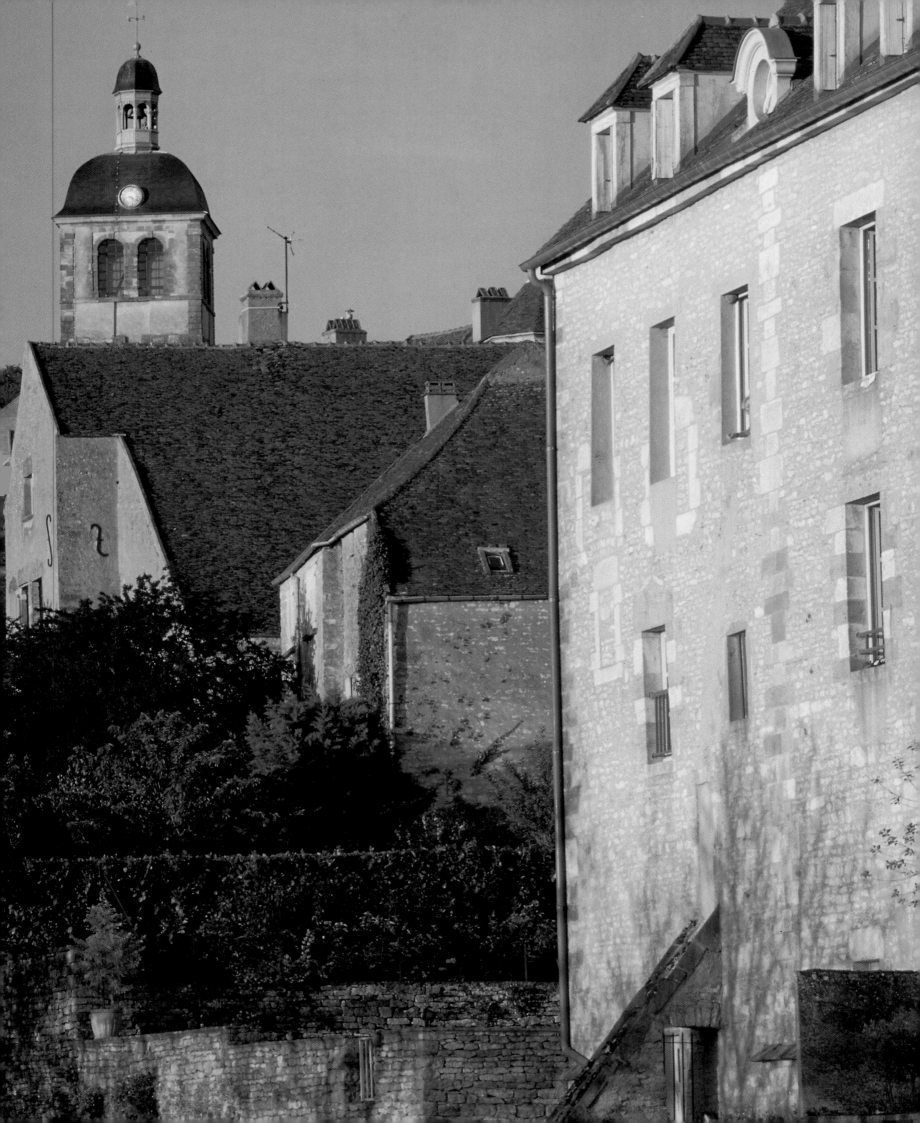

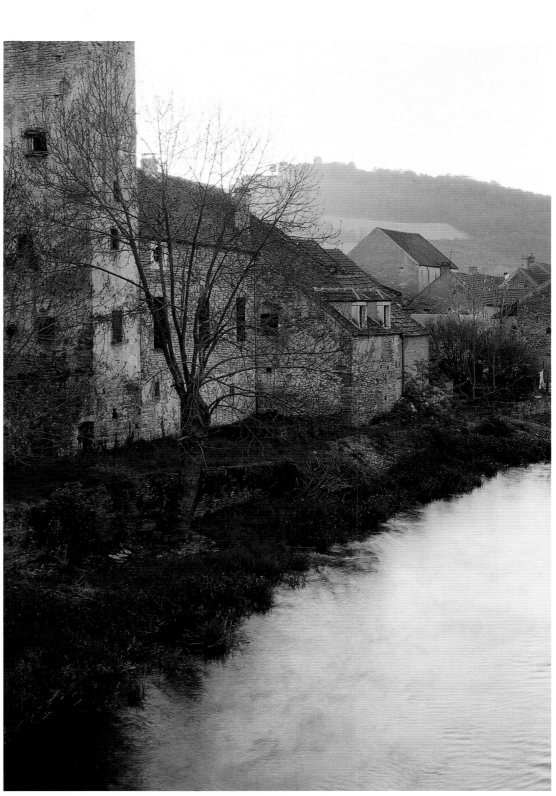

Looking up to Vézelay (LEFT) one has a breathtaking view of the abbey-church of Sainte-Madeleine, with its massive main tower rising above the mid twelfth-century west façade and its secondary one. Below the village is Saint-Père-sous-Vézelay (ABOVE), its history intricately entwined with that of Vézelay itself, its church of Notre-Dame another miracle of Burgundian Gothic, the walls of its ancient houses washed by the river Cure.

Villeneuve-l'Archevêque

At the beginning of the twelfth century the Comte de Champagne founded this fortified village, calling it Villeneuve-sur-Vanne because of its site on the banks of the river Vanne. In 1172 it passed into the possession of Archbishop Guillaume aux Blanches Mains of Sens (brother of the then Comte de Champagne), hence its present name. Today the fortifications are no more, having suffered during the Hundred Years War and the sixteenth-century Wars of Religion and been replaced by tree-shaded promenades, but the village has retained its chequerboard pattern.

The glory of the village is the church of Notre-Dame, begun in the twelfth century and finished in the seventeenth. The ornamented west doorway dates from the thirteenth century, as does the nave and another lavishly sculpted doorway. Inside are capitals carved with foliage and imaginary animals. The complex apse was built in the Renaissance era. Discover inside an Entombment, carved in stone in 1528, taken from the Abbey of Vauluisant. The high altar is late seventeenth-century.

Undoubtedly the jewel of this church is the Coronation of the Virgin Mary carved on its tympanum. But the church of Notre-Dame has another claim to glory. Here the King of France, Louis XI (Saint-Louis), received from the Venetians what was alleged to be Jesus's crown of thorns. The king transported the crown of thorns to Paris and there commissioned the building of the Sainte-Chapelle as its shrine. The crown of thorns is remembered at Villeneuve-l'Archevêque by a model beneath its sepulchre.

The houses (RIGHT and LEFT) of Villeneuve-l'Archevêque have an elegance which belies the smallness of the place. They line streets laid out in chequerboard fashion, a characteristic of new towns and villages created in France in the twelfth and thirteenth centuries, in part so that the inhabitants could speedily reach the fortifications should any enemy appear. The count who founded this charming village certainly expected Villeneuve-l'Archevêque to be attacked more than occasionally, since it lay at the western extremity of his lands and was founded specifically to defend this vulnerable border.

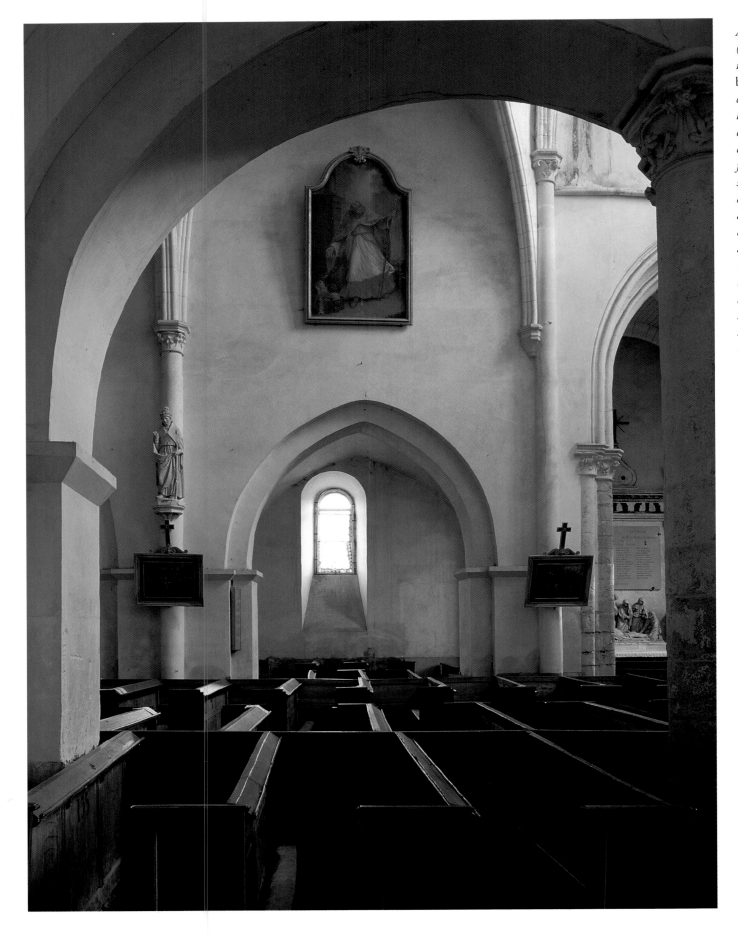

A vignette of village life (OPPOSITE): local inhabitants playing boules *outside the church of Villeneuve-l'Archevêque on Sunday evenings. This exquisite church (*LEFT*), dating from the twelfth to the sixteenth centuries, dominates the village, and houses a magical collection of religious art, including tombs (the earliest dating from the thirteenth century), sixteenth-century stone statues and a choir screen made in the eighteenth century.*

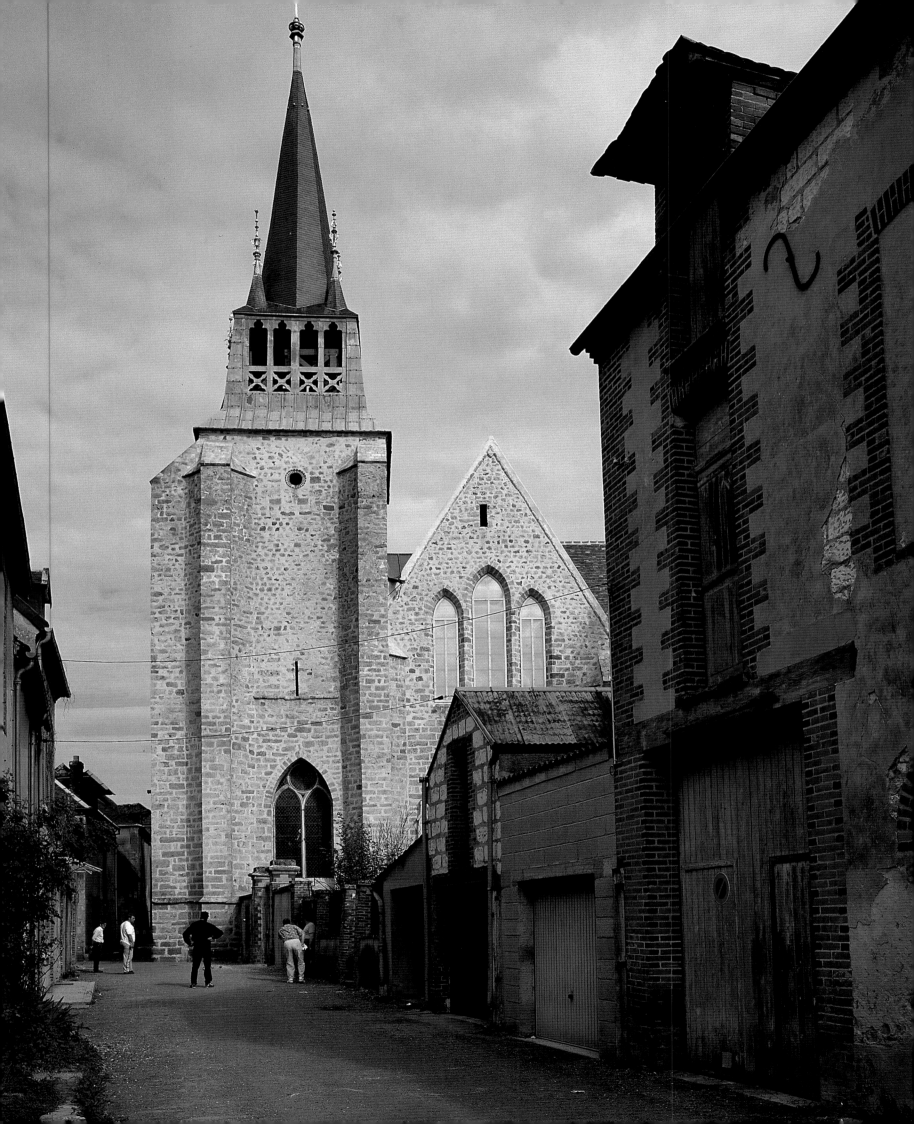

At close-by Brienon-sur-Armançon (THESE PAGES) picturesque houses with gables adorn this historic wine centre, many of them with wine-cellars, some of the most splendid of which are in the local château. Lime trees shelter the promenades of the village. The former collegiate church of Saint-Loup dates for the most part from the late sixteenth century.

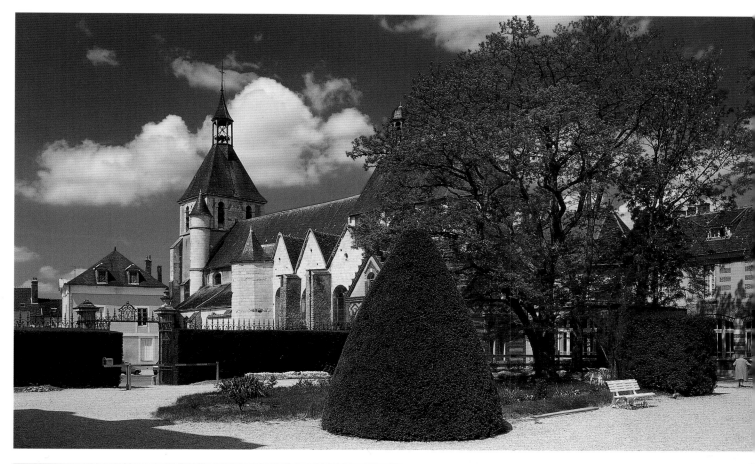

Villeneuve-sur-Yonne

The Gothic aspect of
Notre-Dame (RIGHT)
makes a forceful
statement in stone, seen
from the north-west.

*T*he medieval village of Villeneuve-sur-Yonne was indeed a new village when Louis VII founded it in 1163 to recruit loyal families who would support him in his strife against Thibaut II of Champagne. Evoking its long history of sieges, some of its fortifications still remain, notably the thirteenth-century Sens gate and the Joigny gate, which was strengthened in the sixteenth century, as well as a massive twelfth-century tower (the Tour Louis le Gros), two other towers and the remains of the ramparts. In spite of these defences, Villeneuve-sur-Yonne was frequently captured, among its conquerors the English in 1420 and the Huguenots in 1594.

Half-timbered houses, some of them with Renaissance doorways and many dating from the fifteenth and sixteenth centuries, enhance its streets. Other mansions survive from the eighteenth century, notably the former post-office (known as the House of Seven Heads). A thirteenth-century bridge spans the Yonne, eleven of its fourteen Gothic arches original.

But the supporters of Louis VII were not the first to inhabit this spot. Evidence of the antiquity of the village is the nearby menhir of La Pierre-Fritte, as well as a former Roman camp (at Camp du Château) and, flanking the left bank of the Yonne, the Roman road from Sens to Auxerre.

The Gothic church of Notre-Dame boasts thirteenth- to sixteenth-century stained-glass as well as furnishings and statues dating from the fourteenth to the sixteenth centuries. Its choir was built in the mid thirteenth century, its nave a century later, and its delicious Renaissance façade dates from the same era. The Porte de Sens now houses an archaeologial museum.

The Renaissance west front (RIGHT) of the church of Notre-Dame, viewed from the Rue Joseph-Joubert (which is named after a moralist who was a friend of Chateaubriand). This impressive architectural delight was created by the architect Jean Chéreau in 1575. Did the Huguenots who captured the village in 1594 destroy the statues which must once have graced the now empty sockets of the pediments?

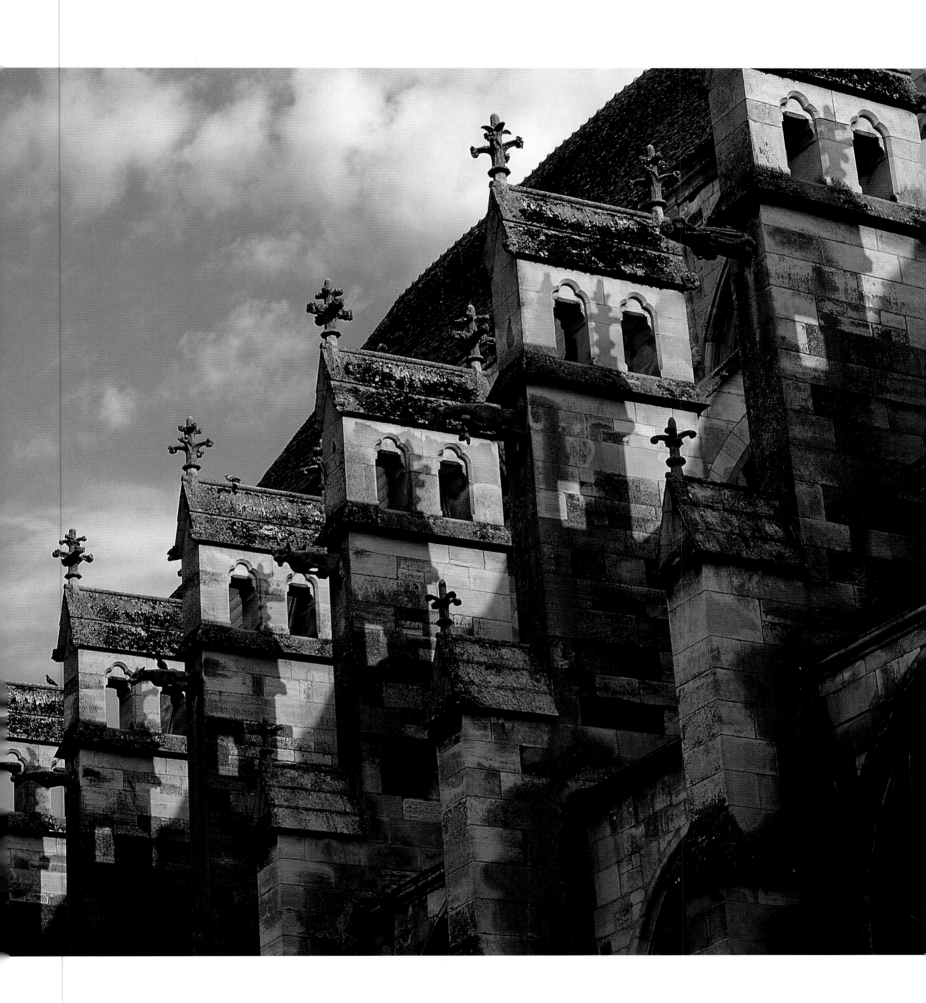

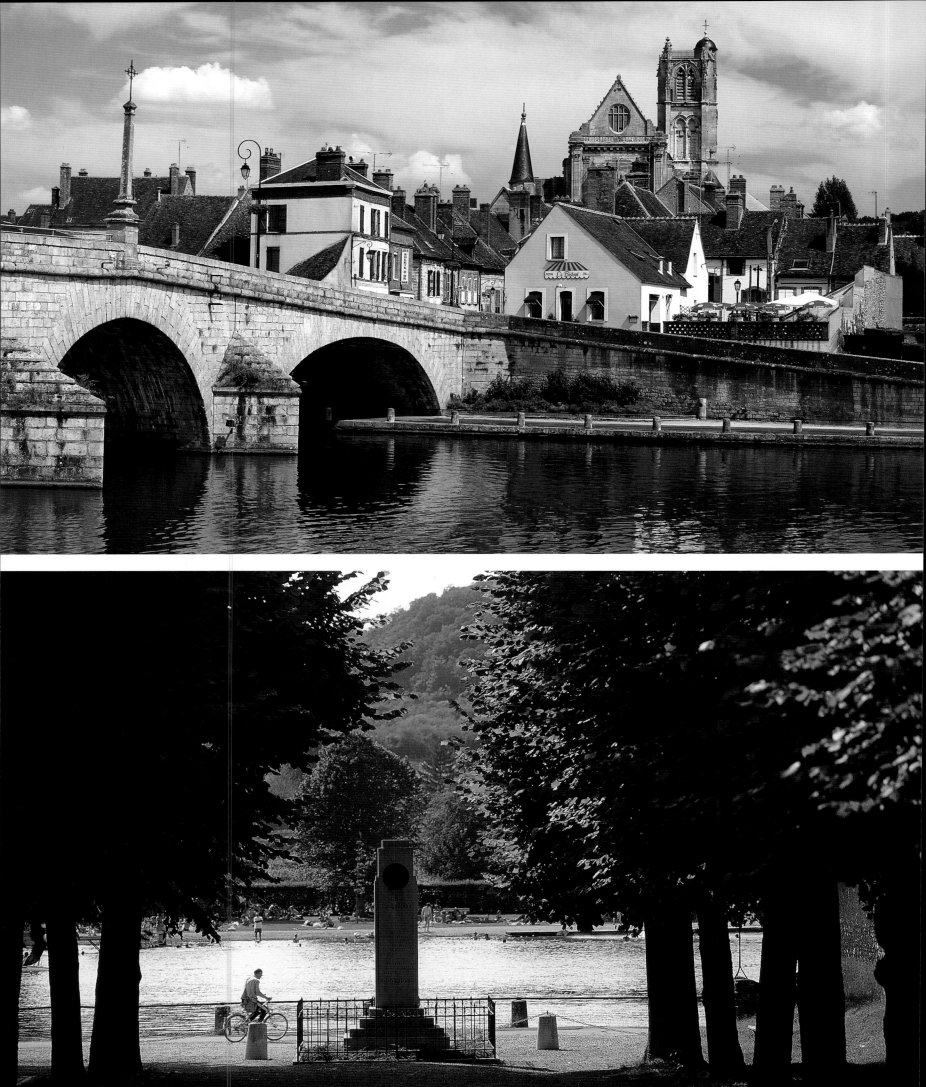

The village is seen here from the west bank of the river (OPPOSITE ABOVE), with the Pont sur l'Yonne, eleven of its fourteen arches dating from the thirteenth century. Almost overwhelming the rest of the village is the church of Notre-Dame with its mighty tower. From Boulevard É. Peynot the graceful Yonne looks especially peaceful and enticing (OPPOSITE BELOW).

Two of the impressive and elegant gateways of Villeneuve-sur-Yonne: the Porte de Sens (ABOVE), seen here from the Rue Carnot, dates from the thirteenth century; the Porte de Joigny (LEFT), was rebuilt in the sixteenth century; they guard exquisite half-timbered houses. The Porte de Joigny also houses a museum of local history and nineteenth- and twentieth-century art.

Romanesque Architecture of Burgundy

Characterized by rounded arches, barrel vaults, round and clover-leaf apses, by powerful, simple piers, magically carved capitals, towers often enhanced with arched colonnades, and by side chapels in the chancel, Burgundy's Romanesque churches constitute an unrivalled ecclesiastical patrimony. Those who built them were inspired above all by two abbeys, those of Tournus and of Cluny.

At Tournus the abbey-church of Saint-Philibert was built when the monks of Noirmoutier fled there in the early eleventh century to escape the Norman invaders. They brought with them the relics of their founder, Philibert. By the mid twelfth century they had created a magnificent church to shelter his bones. Its twin spires, one over the crossing, the later one over the north tower, look over the river Saône.

Monastic architecture in the Romanesque era was designed to dominate the surrounding countryside. At Anzy-le-Duc a three-tiered octagonal tower, pierced with twin openings, rises above a church with a central apse with four apsidal chapels. Of Cluny, alas, only the belfry and part of the transept have survived to our day. The abbey of Saints-Pierre-et-Paul was founded here in 910. In time, some thousand daughter churches and around ten thousand monks owed their allegiance to the mother monastery. Between 1088 and 1109 the abbot of Cluny, St. Hugues, set about building a monastery worthy of this renown. His church stretched for 187 metres, the distance from the ground to the pinnacle of the vault being some thirty metres. In 1798 the Revolutionary government declared that the abbey was public property; it was dismantled and its stones used elsewhere. What remains, especially the belfry and spire, still indicate the glory of the Romanesque style, with the openings of the belfry becoming more complex as it rises. The *porte d'honneur* boasts a double Romanesque colonnade.

The church of Saulieu is another masterpiece of Cluniac architecture. The early twelfth-century basilica of Saint-Andoche (named after a third-century Greek missionary and martyr who lies in its crypt) has an exquisite

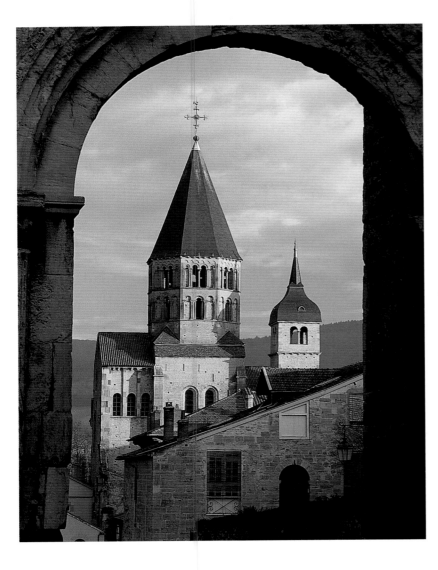

The abbey-church of Cluny (LEFT), now a much reduced complex, still boasts an exquisite octagonal belfry beside another, less elaborate Romanesque tower.

The nave of the abbey church of Sainte-Madeleine at Vézelay (OPPOSITE), seen through the porch, above which is its superb tympanum, depicting Jesus and his apostles and many other figures.

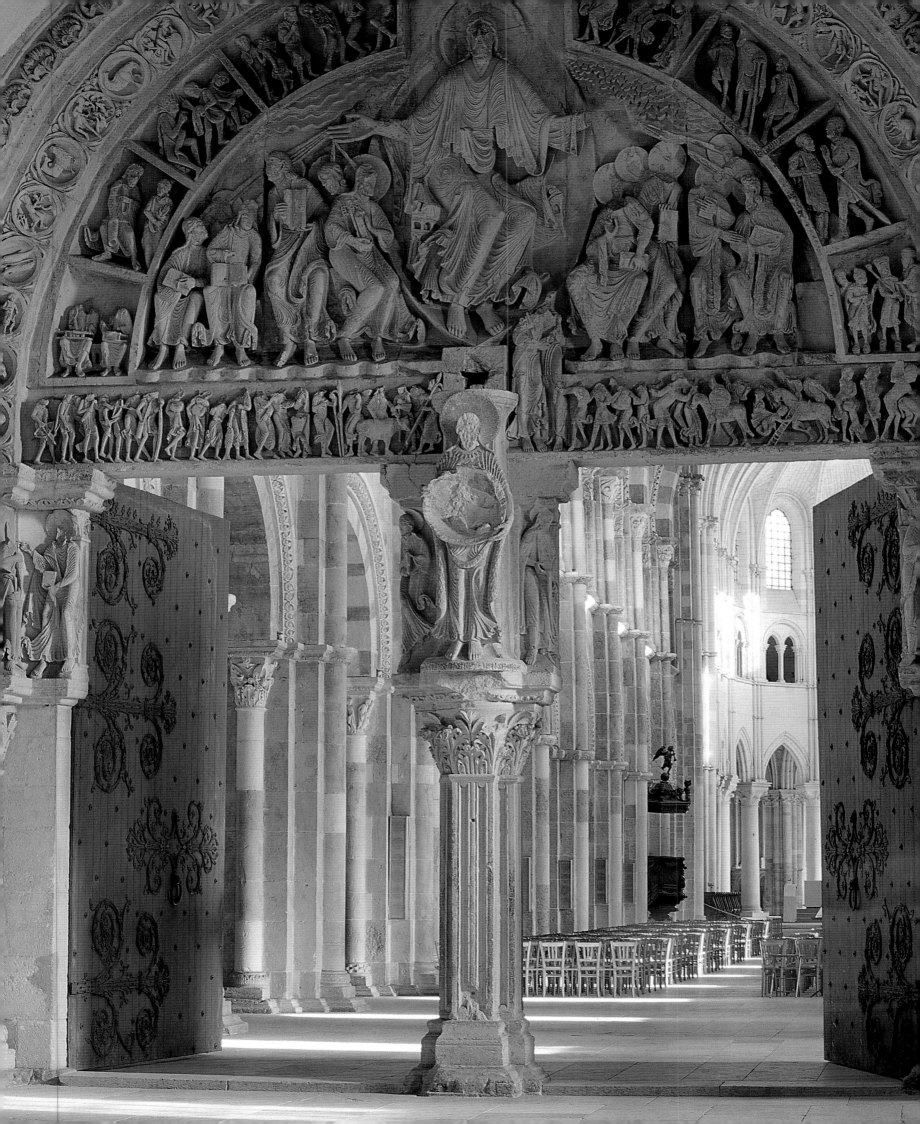

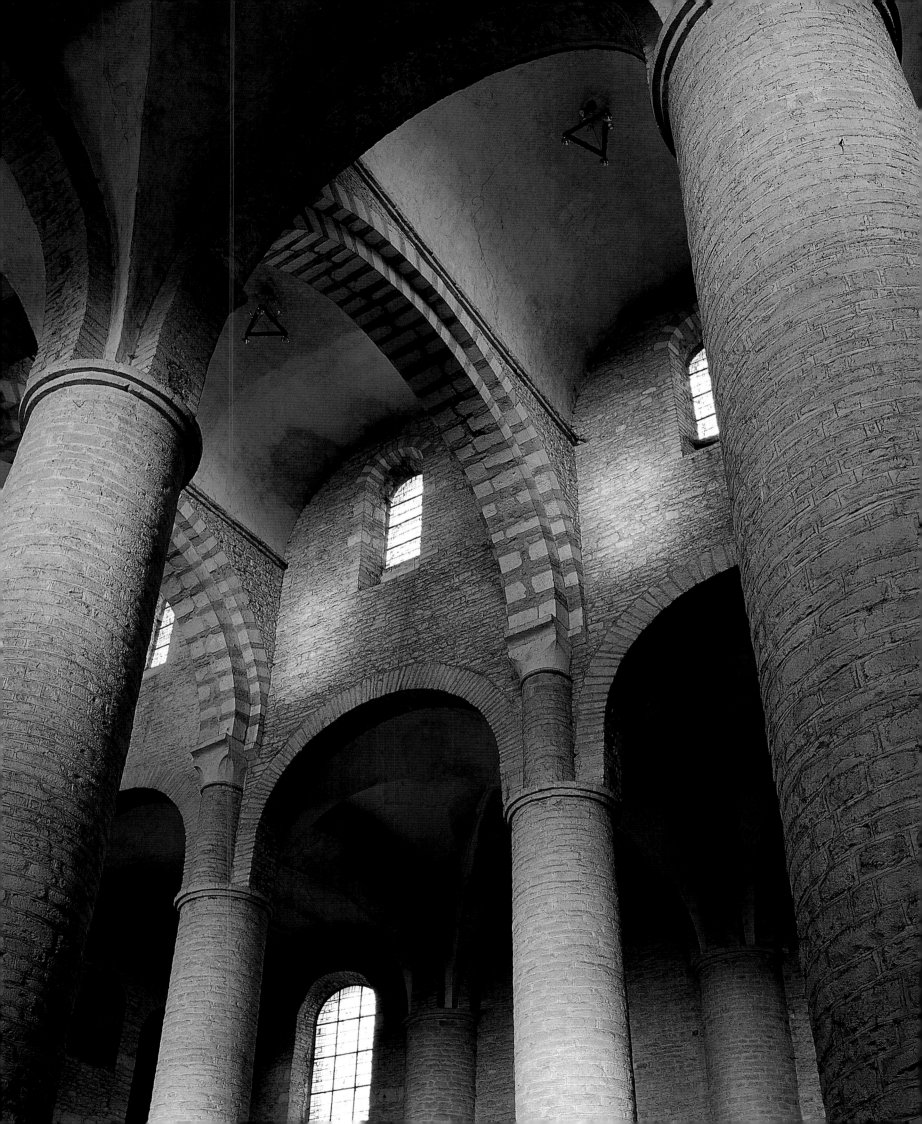

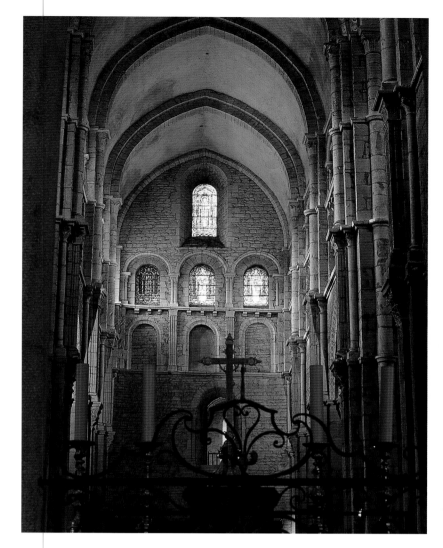

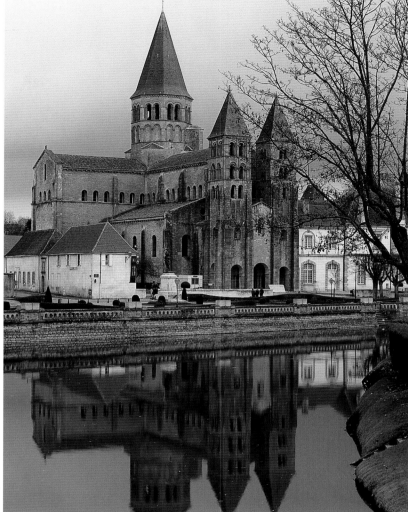

The tympanum of the main doorway of the cathedral of Saint-Lazare, Autun (BELOW); in the centre is Christ in majesty, flanked by four angels and judging the saved and the damned. The damned are consigned to hell, on his left, the blessed to heaven, on his right. At the foot of the Christ figure, the sculptor of this world-famous Romanesque carving incised the words, GISELBERTUS HOC FECIT ('Giselbertus made this'). The mandorla surrounding Jesus bears the words, OMNIA DISPONA SOLUS MERITOS (QUE) CORONO QUOS SCELUS EXERCET ME JUDICE POENA COERCET ('I alone order everything. I alone crown the deserving, apprehend crimes, judge and punish them'). At Tournus, Saône-et-Loire, the arches of the eleventh-century church of Saint-Philibert (OPPOSITE) are breathtaking because of their very simplicity. At Paray-le-Monial (ABOVE LEFT and RIGHT) the twelfth-century basilica of Sacré-Cœur, also in Saône-et-Loire, has a couple of sturdy square towers at the entrance to the narthex and a delicate octagonal tower over the crossing. The interior is deliciously cool and calming.

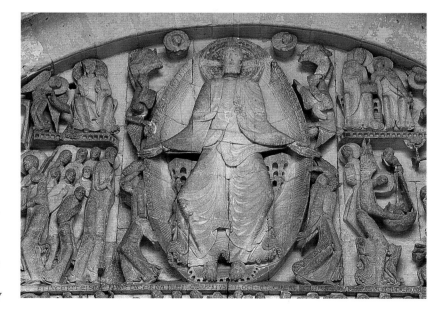

porch, the arch of which rises from differently patterned Romanesque pillars. A couple of rectangular towers (one topped in the eighteenth century with a lead dome) flank its façade. Among the finest scenes sculpted on the capitals of its Romanesque nave are fighting Centaurs, the Flight into Egypt of Mary, Joseph and the Infant Jesus (Joseph on a donkey carrying his carpenter's hammer, Mary likewise seated, anxiously clutching her baby), Jesus and Mary

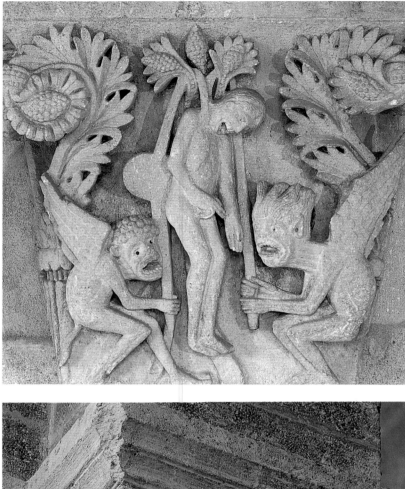

Magdalen, bears fighting, the Resurrection and Judas hanging himself - with the devil rejoicing. The choir stalls date from the late fourteenth century and are carved with scenes from Biblical history.

Cluny inspired the early twelfth-century architecture of the collegiate church of Notre-Dame at Beaune, with its ambulatory and radiating chapels. Visit the basilica of the Sacré-Cœur at Paray-le-Monial to discover a Cluny in miniature. Visit Autun to find a cathedral, dedicated to St. Lazare, which has a fifteenth-century spire but was for the most part built in only ten years, between 1120 and 1130. The capitals are carved with scenes from the Bible, some of them dismantled and displayed in the cathedral chapter house. On the tympanum and lintel of the central doorway is carved a magnificent Last Judgment.

In Burgundy the Romanesque era has also bequeathed us splendid frescoes, notably those in the monks' chapel at Berzé-la-Ville. And as an example of a Romanesque abbey which survived the Revolution intact, Notre-Dame at Fontenay has retained its exquisite cloister.

One especially dramatic feature of Romanesque architecture is the tympanum, the space enclosed by a semi-circular arch above the lintel of the main door. This arch, the continuation of the pillars of the porch, encloses superb sculptures, brilliant compositions which bring together Old Testament and New Testament figures with their counterparts among the saints of Christendom. There are especially fine examples at Vézelay and Autun.

Carvings play an essential role in the iconography of Romanesque churches. At Saint-Romain (ABOVE), devils triumph over the hanged Judas. Stylized leaves decorate a capital of the basilica of Saint-Andoche, Saulieu (LEFT).

In Saint-Lazare, Autun, a Romanesque sculptor has depicted the flight into Egypt of the Blessed Virgin Mary, who tenderly clasps her divine son (OPPOSITE).

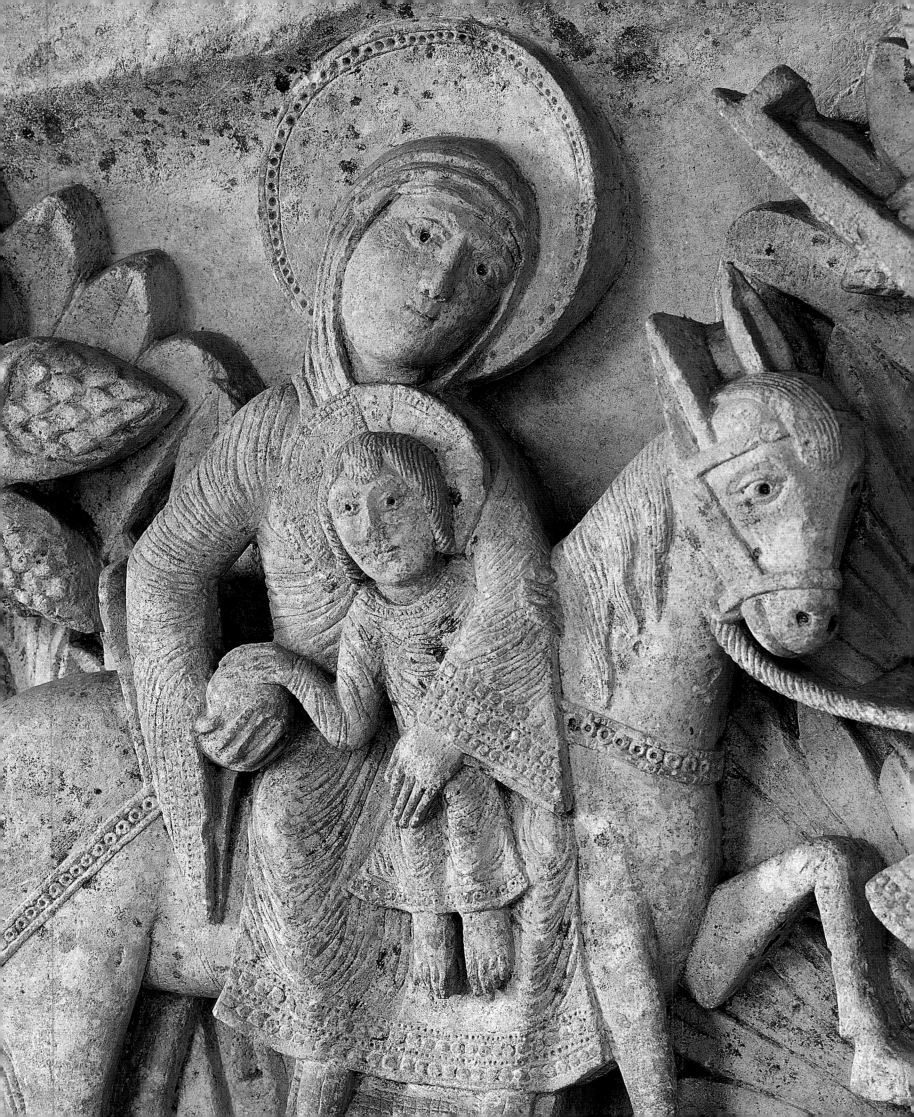

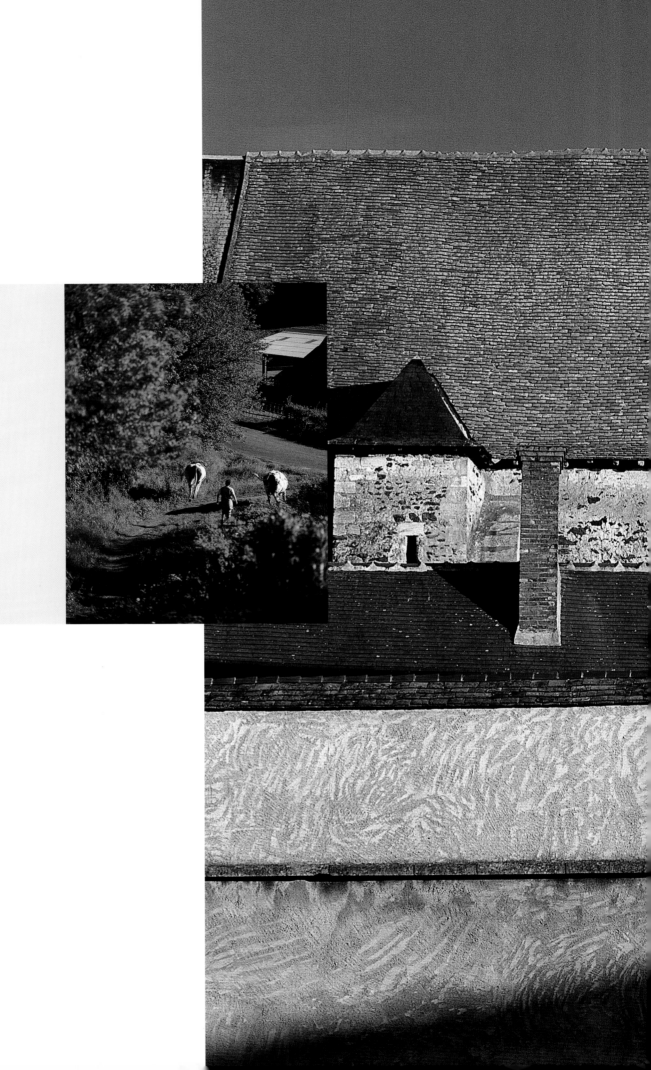

Nièvre

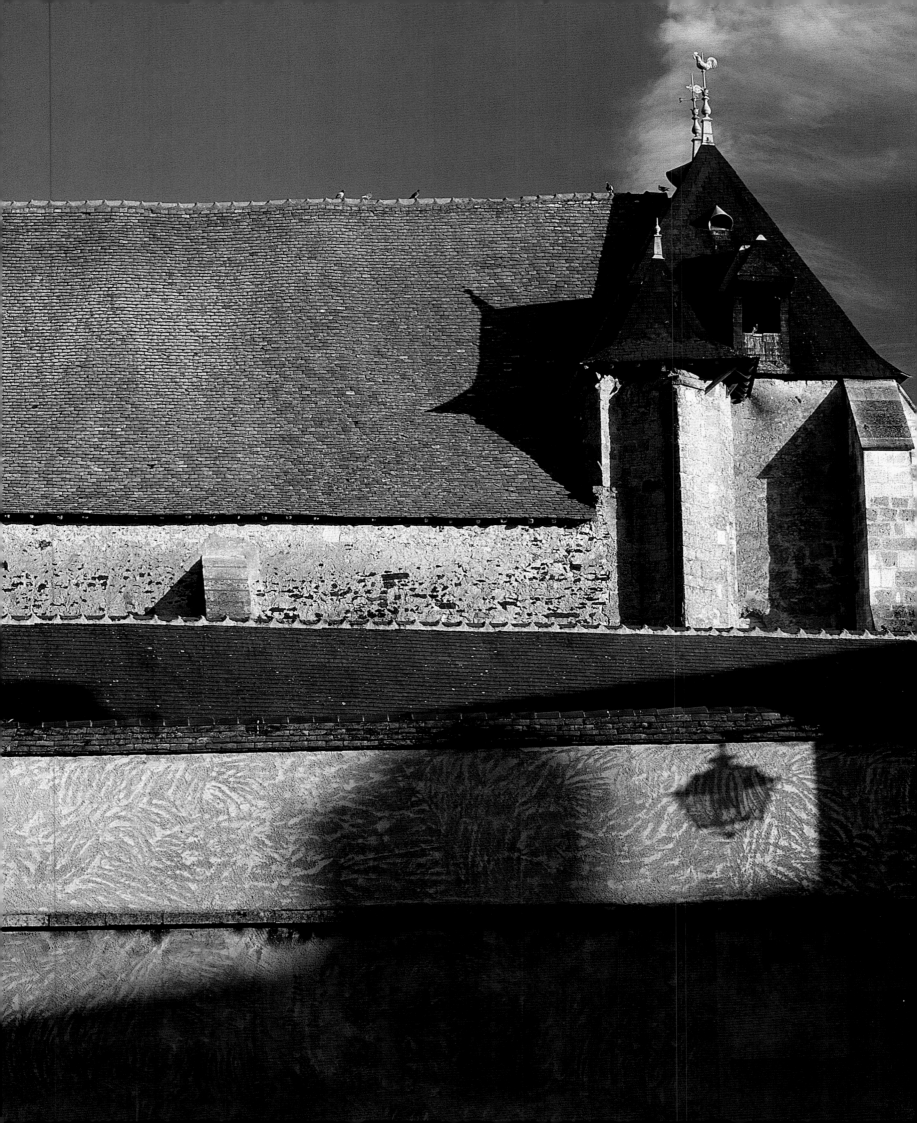

The sparsely populated *département* of Nièvre is blessed with mountains, valleys and vine-covered slopes, and is watered principally by the rivers Nièvre, Yonne, Loire and Cure, as well as by canals and minor currents. Oaks, larches, beeches, spruce and silver birches enrich its forests. Lakes add to its charm. And the Nièvre also embraces the larger part of the huge natural park of the Morvan. For centuries its citizens have cultivated the arts of ceramics and pottery. It was famous in the nineteenth century for the quality of its wet-nurses, who were much recruited by the great Parisian families.

At the north-western tip of the park is Vézelay, with its celebrated abbey-church. At the south-eastern tip (which stretches into the *département* of Saône-et-Loire) the village of Saint-Léger-sous-Beuvray lies at the foot of the 821-metres-high Mont Beuvray, centre of pagan cults until St. Martin of Tours arrived in the fourth century, converted the region to Christianity and expelled the heathen. On Mont Beuvray can be seen remains of a pre-Roman *oppidum* built by the Eduen tribe.

Another such site in the Morvan natural park is Château-Chinon, situated on a wooded hill and boasting what was once a Gaulish *oppidum*. Here the forests of oaks, beech trees and hornbeams are the habitat of wild boars, roe deer and fallow deer. Château-Chinon profited in the Middle Ages from the trade between Autun and Nevers, protected by a fortress and fortifications. Traces of both still remain - of the château, the Porte Notre-Dame, of the fortifications, a couple of round towers. Both failed to prevent the ravaging of the village in later tumultuous times. The Armagnacs and the Burgundians fought over it. In 1591, during the Wars of Religion, Château-Chinon was pillaged by the forces of the Duke of Nevers. The environs of Château-Chinon are also delightful. Close to the heights of Mont Beuvray and Haut-Folin, as well as the lakes of Pannesière and Les Settons, the village is a tourist gateway into the Morvan natural park.

Geographically, this is a diverse region, with plains and river valleys as well as mountainous parts. Of the couple of canals which cross it, one of them, the romantic Canal du Nivernais, begun in 1784 and finished only in 1843, links the Seine with the Loire.

The toll of Romanesque churches is superb - to mention but two, that of Saint-Parize-le-Châtel and the priory church of La Charité-sur-Loire, a daughter house of Cluny, begun in 1059, with cloisters, chapter house, refectory and monks' cellar. As for Gothic churches, there are masterpieces at Saint-Amand-en-Puisaye, at Varzy, at Prémery. Beside these, the wars of the Middle Ages and the Hundred Years' War resulted in the construction of fortresses, some of which were later transformed into less aggressive homes, such as the sixteenth-century Renaissance château at Saint-Amand-en-Puisaye, built of brick and stone on the site of a thirteenth-century fortress.

In the countryside between the Loire and the Allier are nurtured the white and succulent beef cattle, the Charolais. Finally, this is wine country, perhaps the best known vintages being those produced in the vineyards around Pouilly-sur-Loire.

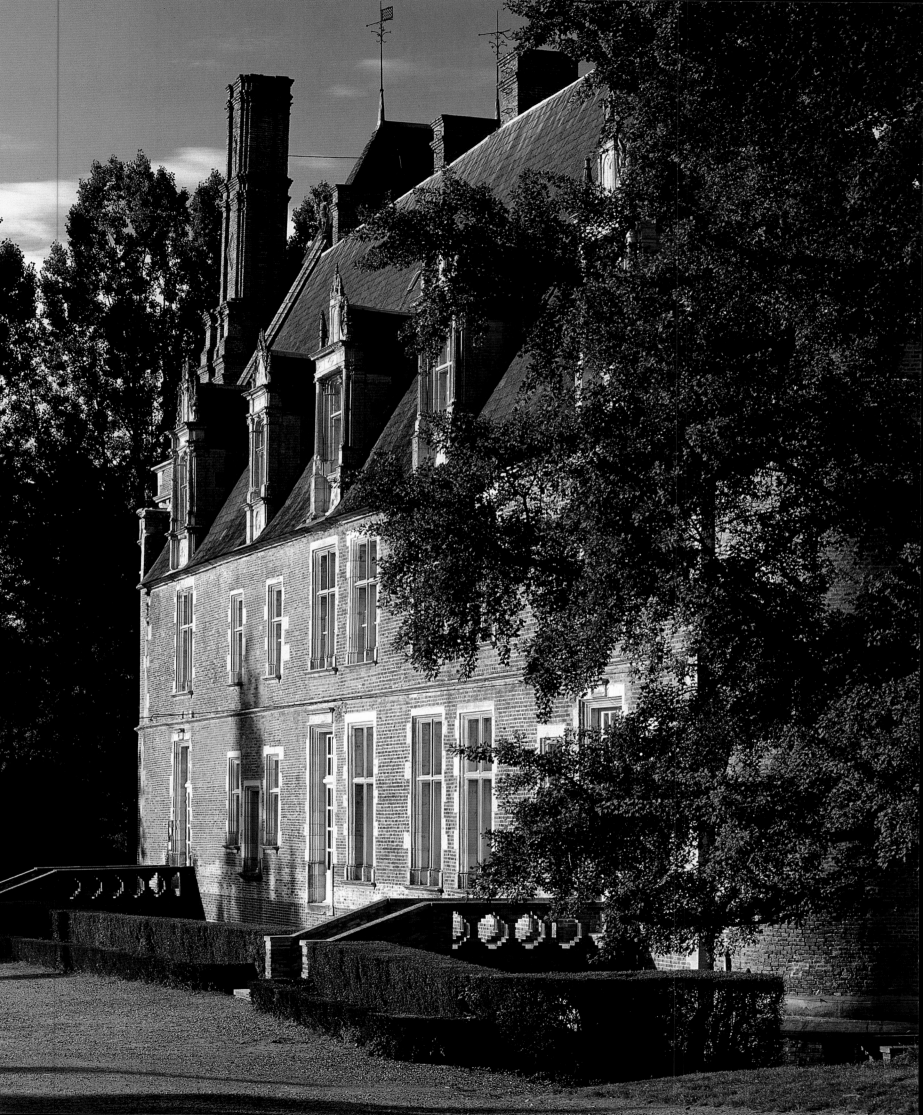

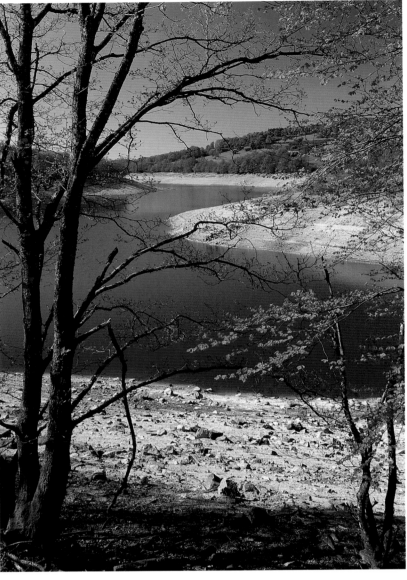

Typical of the sleepy villages of the département of Nièvre is Saint-Amand-en Puisaye (ABOVE LEFT). Indeed, the region abounds in peaceful, bucolic scenes, like the beautiful Lac de Pannesière just north of Château-Chinon (ABOVE RIGHT), the countryside around Saint-Martin-du-Puy (RIGHT) and this mill stream at Donzy (OPPOSITE).

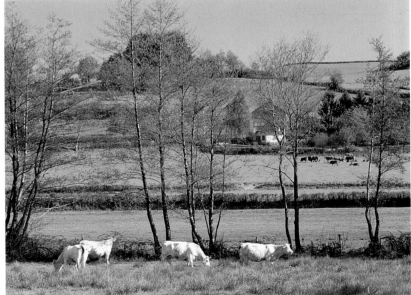

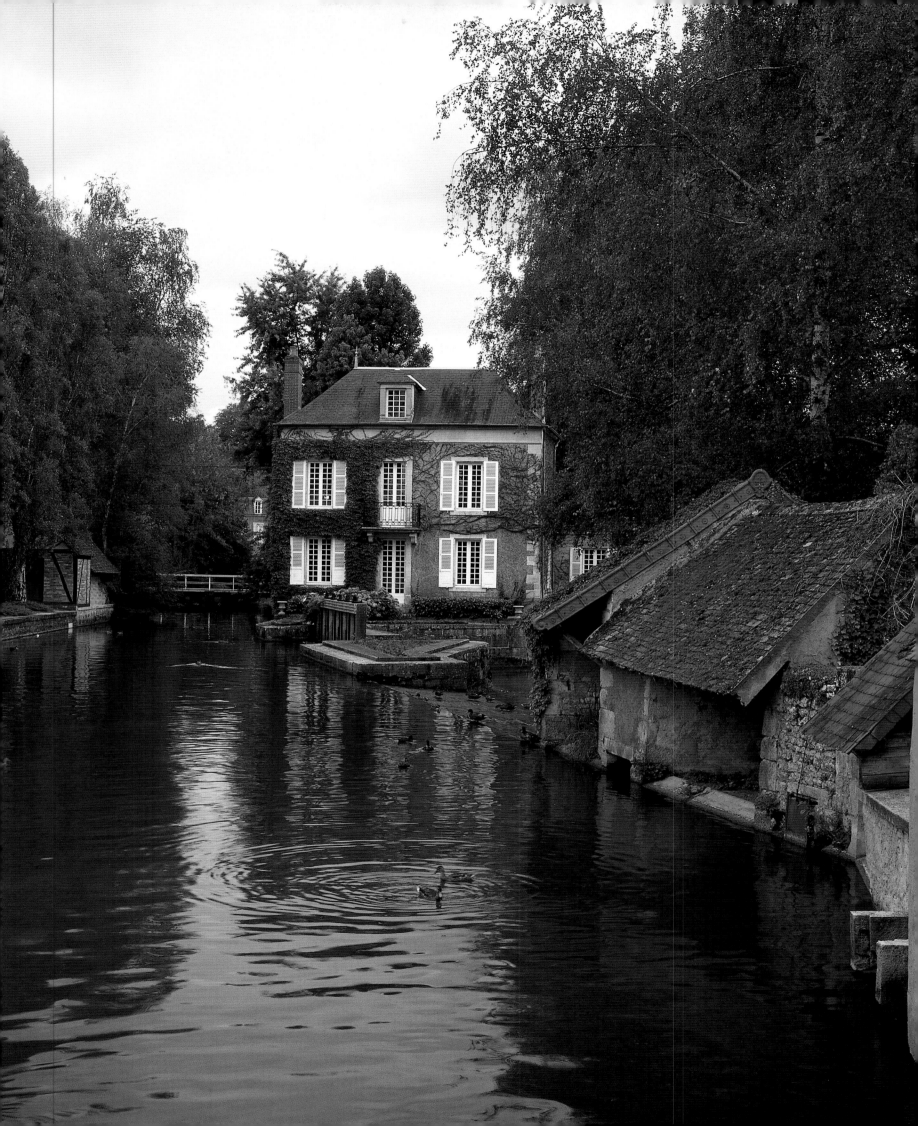

Champallement

*B*etween the first and late fourth centuries A.D. a Gallo-Roman camp flourished at Compierre on the Roman road between Entrains and Autun. Its remains can still be seen near Champallement: a forum; a theatre; houses; workshops; a sanctuary, octagonal on the outside, circular inside. These remains testify to the antiquity of the tiny village of Champallement, delightfully perched on a rocky hill. The village square, planted with a locally cherished lime tree dedicated to Sully, the famous minster of Henri IV, offers a view over the Morvan. A splendidly-sited château dominates the village. Once a feudal fortress, it was in part rebuilt in the fifteenth century, and retains a circular tower and a square main building.

The parish church is dedicated to St. Eustache, patron saint of the huntsmen and women who for centuries have pursued their prey in the nearby Champallement forest. Begun in the eleventh century and finished in the sixteenth, part-Romanesque, the belfry of this church is solid and square and its widows have Gothic and flamboyant Gothic tracery. Its treasures include a sixteenth-century thurible. And some Gallo-Roman remains are desplayed there.

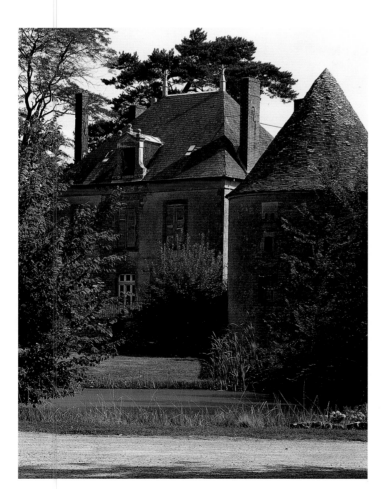

These quiet corners of the village (RIGHT and OPPOSITE), whose name derives from the Latin 'Campus Allemannus', suggest a place utterly content with itself and with the Burgundian way of life. The square tower of the church of Saint-Eustache, begun in the eleventh century and finished in the sixteenth, overlooks the green by the village pond. Another engaging aspect of Champallement is its château and its siting, splendidly perched on the side of the hill and built over the foundations of a medieval fortress (OVERLEAF).

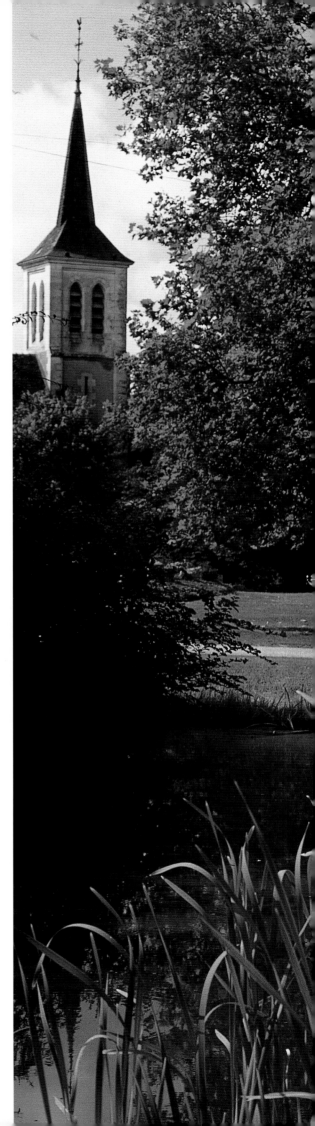

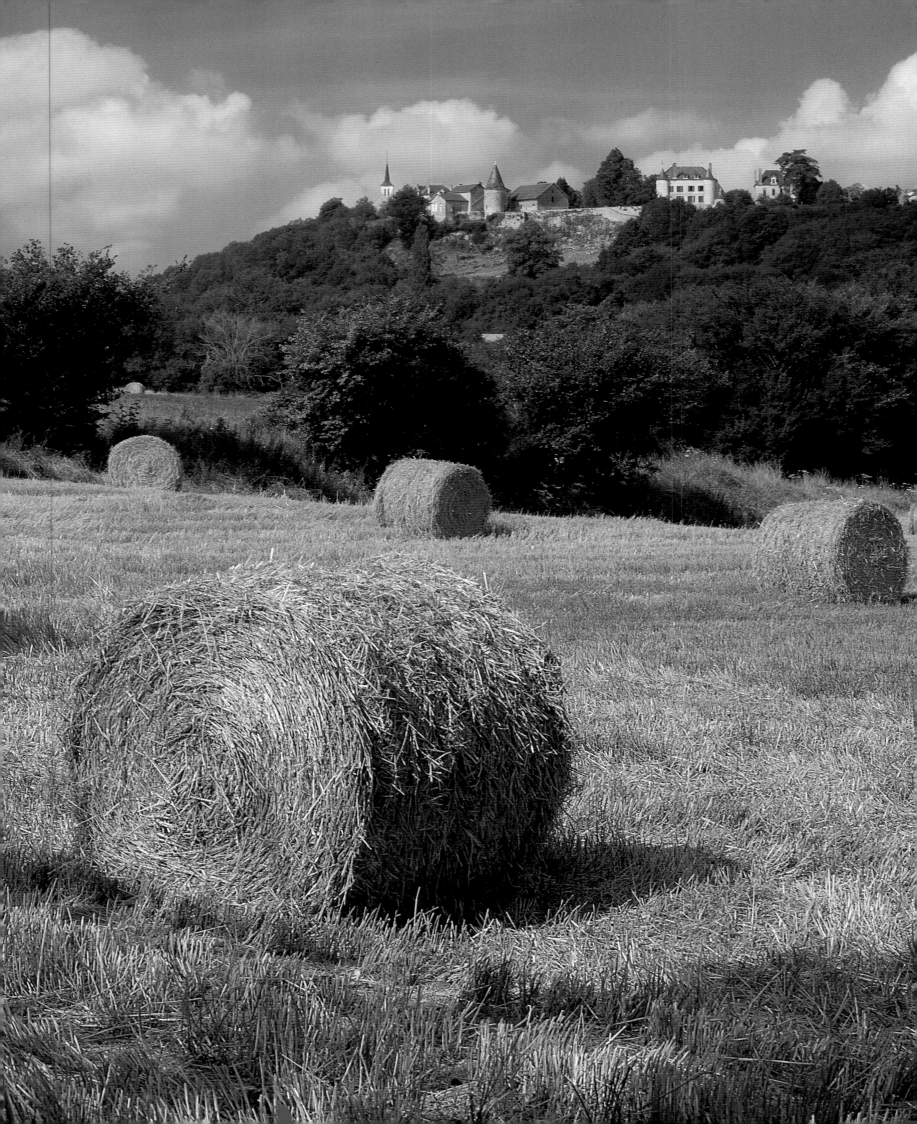

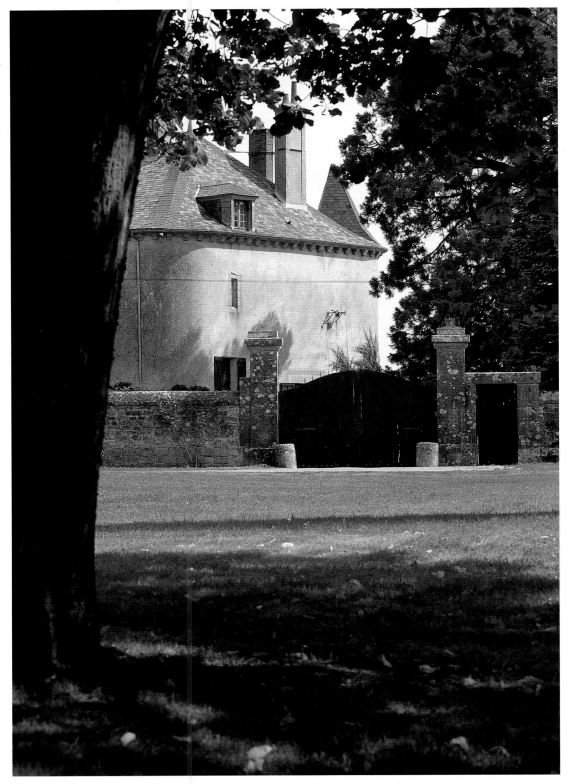

Much more ancient
than the château (LEFT)
are the Gallo-Roman
remains of Compierre
(OPPOSITE), which lie
in woods close to
Champallement,
another testimony to the
munificent historical
patrimony of Burgundy.

Moulins-Engilbert

*B*ecause of its situation at the confluence of the rivers Garat and Guignon, its environs washed also by the river Dragne, Moulins-Engilbert is known as the Venice of the Morvan. These waters are also the reason for the numerous mills, which gave the village half of its name (though few remain today). With so much water, the village is naturally famed for its fish dishes, but it also has an important cattle-market. The community originally developed around a Roman crossroads and camp (named Enjubertum) where in the fifteenth century the lords of Nevers built themselves a château, today in ruins but still approached through a tumbledown twelfth-century gate.

Some of the fifteenth- and sixteenth-century fortifications of the village still survive, as does the machicolated fourteenth-century Château de Villains, with its keep and drawbridge. Here too stand the sixteenth-century Château de Marry, and some lovely old houses, dating from the fourteenth to the sixteenth centuries and flanking narrow streets, as well as an old hospital in what was once a convent of the Ursulines. The former salt-barn dates from the sixteenth century. An ancient well still bespeaks the past in the Place Lafayette.

As for the late Gothic parish church of Saint-Jean-Baptiste, it was first built in the eleventh century but was restored five hundred years later after a fire. The sixteenth-century stained-glass is superb. Its square belfry, topped by a spire, its fourteenth-century crypt and its Gothic pulpit help it to rival another fine church, the nearby twelfth-century Romanesque one at the hamlet of Commagny, a couple of kilometres south-west of the village, which once was the chapel of a Benedictine priory, built by monks from Autun.

Elegant houses, a splendid church and mill streams make Moulins-Engilbert a place to be savoured at length (ABOVE and OVERLEAF).

The Rue des Fosses yields a splendid view (OPPOSITE) of the monumental square tower and spire of the village church, built originally in the eleventh century, then rebuilt in the sixteenth after a fire.

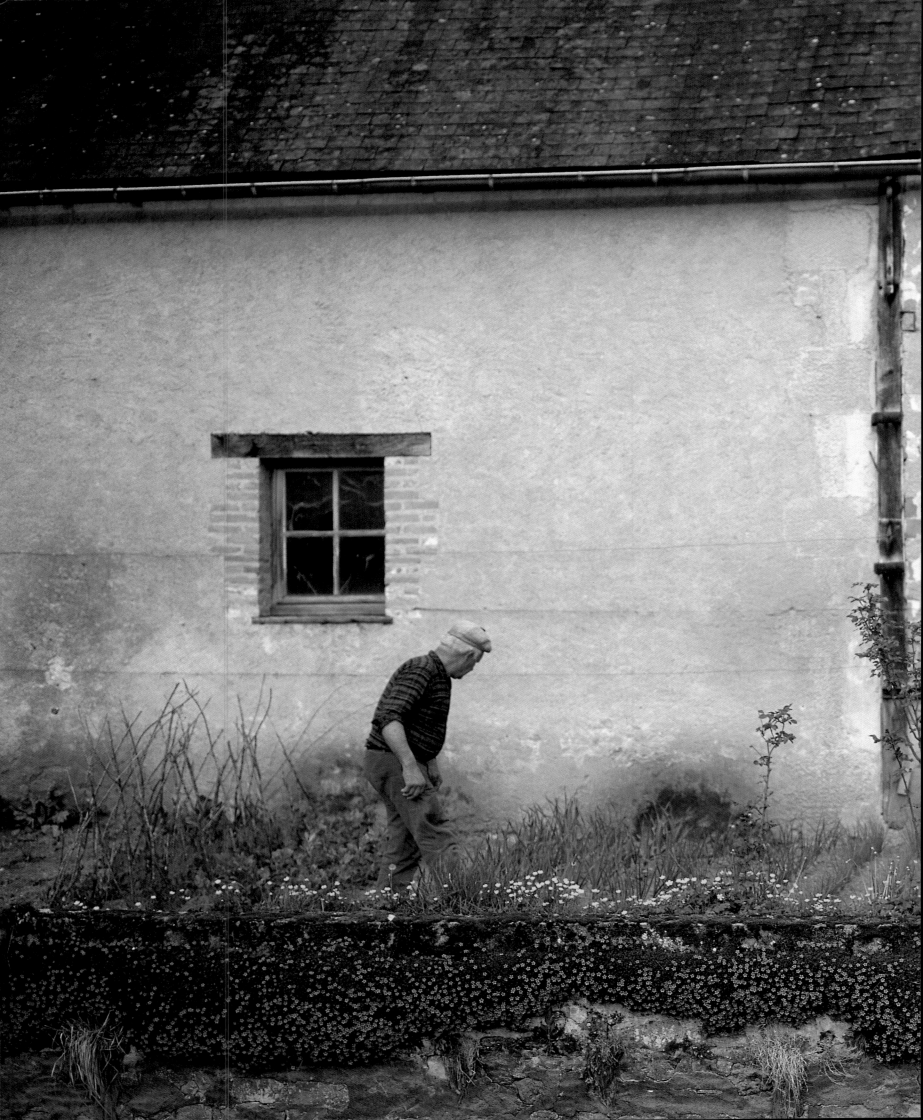

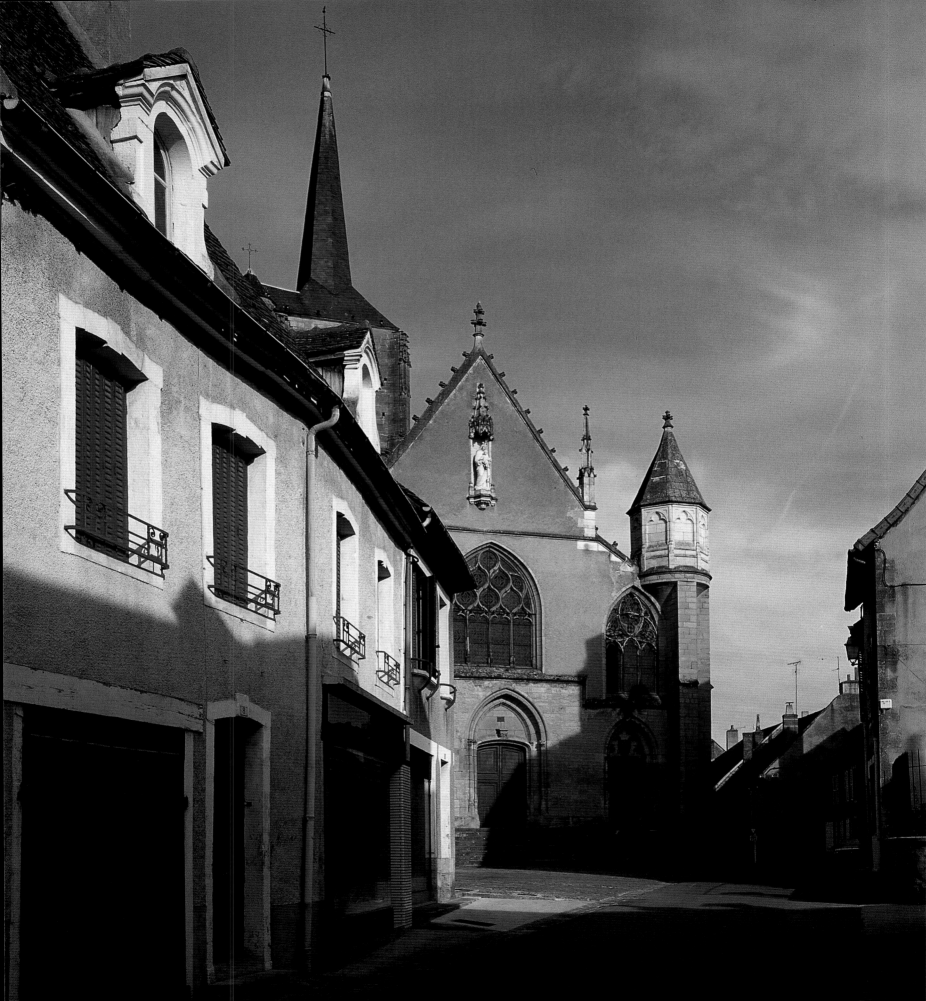

The late Gothic, crocketed church of Saint-Jean-Baptiste (OPPOSITE) has a delightful flamboyant Gothic west window and sculpted porch, features which piquantly contrast with the powerful square belfry of the church. A quiet cranny of the village is the Rue Saint-Antoine (BELOW). Alas, the mills which gave the village its name have virtually all disappeared.

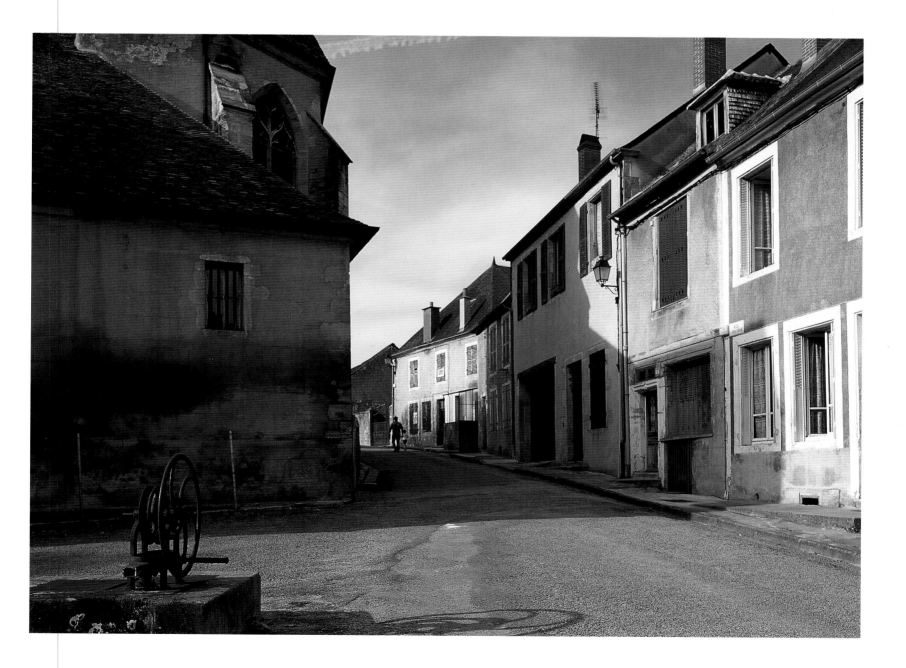

Prémery

*T*he village is much older than its present aspect hints. Its name derives from two Celtic words - *prema*, meaning 'close to', and *ry*, which means 'river'.

In the fourteenth century, at the heart of a massive forest, where the river Nièvre meets the Petite Nièvre, the Bishops of Nevers (who were also secular lords of Prémery) built themselves a fortress which they transformed in the seventeenth century into a summer residence. Much of it still stands: the daunting fourteenth-century circular tower; a towered entrance of the same era; polygonal fifteenth-century towers; encorbelled lodgings.

Saint-Marcel, the former collegiate church of Prémery, seems almost as formidable as the château once was. Begun in the thirteenth century, its belfry is like a keep, though it becomes gentler as the eye reaches the octagonal top, while as the church expands eastwards flying buttresses lend a less stern aspect to this house of God. Inside are treasures: twelfth-century capitals; a late fifteenth-century Pietà, sculpted in stone in the workshop of the celebrated Claus Sluter; the sixteenth-century chapel of Bishop Jean d'Albret; classical choir stalls. Prémery is also proud of the Blessed Nicolas Appeleine, a saintly man of the fifteenth century; the home where he first saw the light of day still stands.

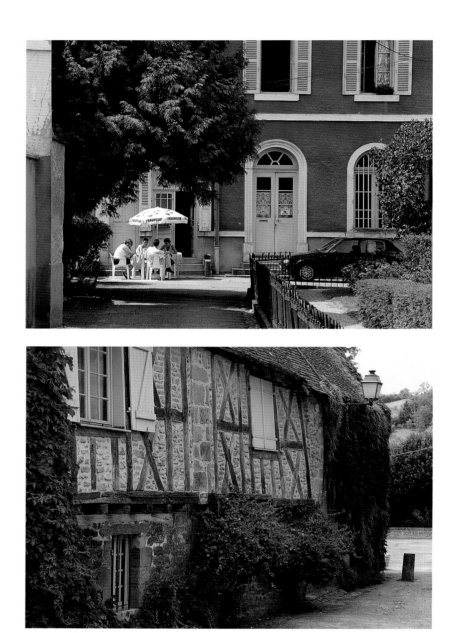

Prémery is notable for splendid houses of all periods (ABOVE); this half-timbered example was once the birthplace and home of the Blessed Nicolas Appeleine (d. 1466), the most famous son of the village. But Prémery is also a centre for rearing Burgundy's celebrated beef cattle (OPPOSITE). Its surroundings are redolent with sylvan peace: forests and fields of sunflowers (OVERLEAF).

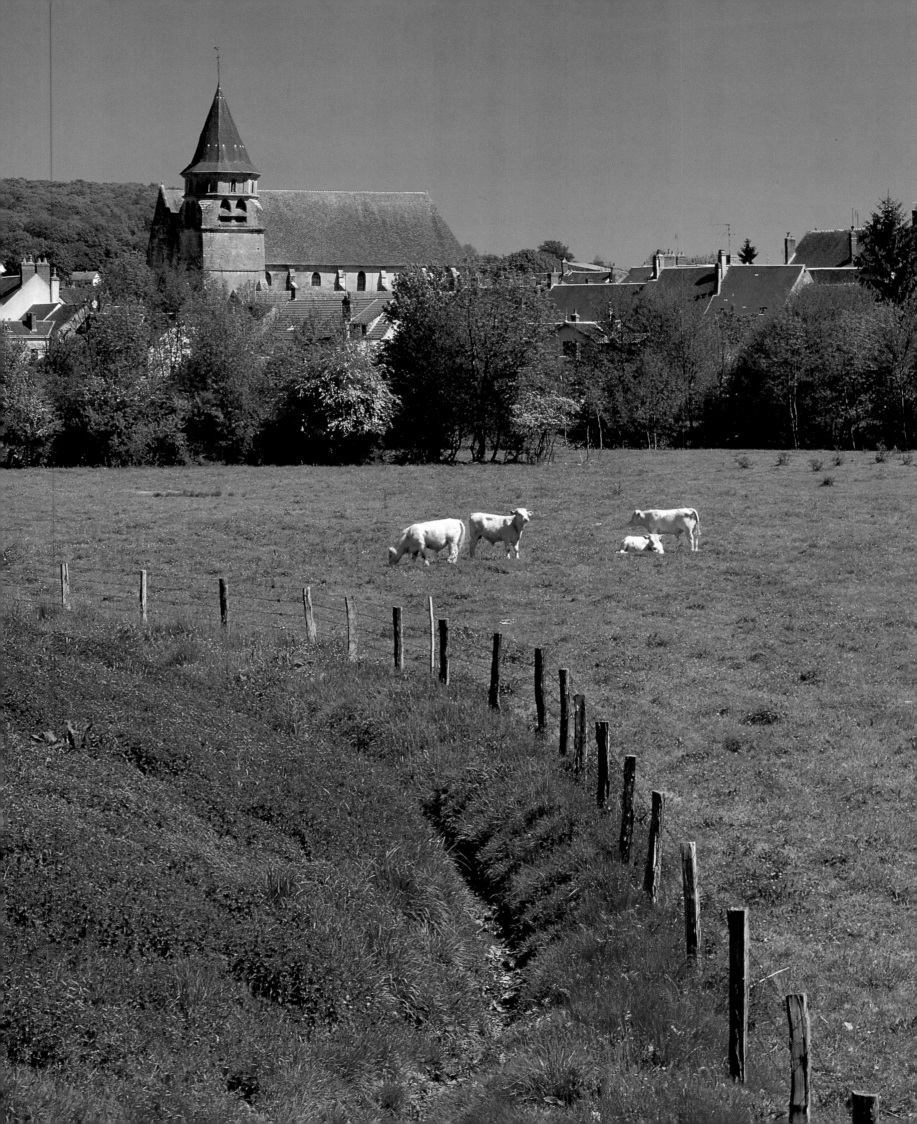

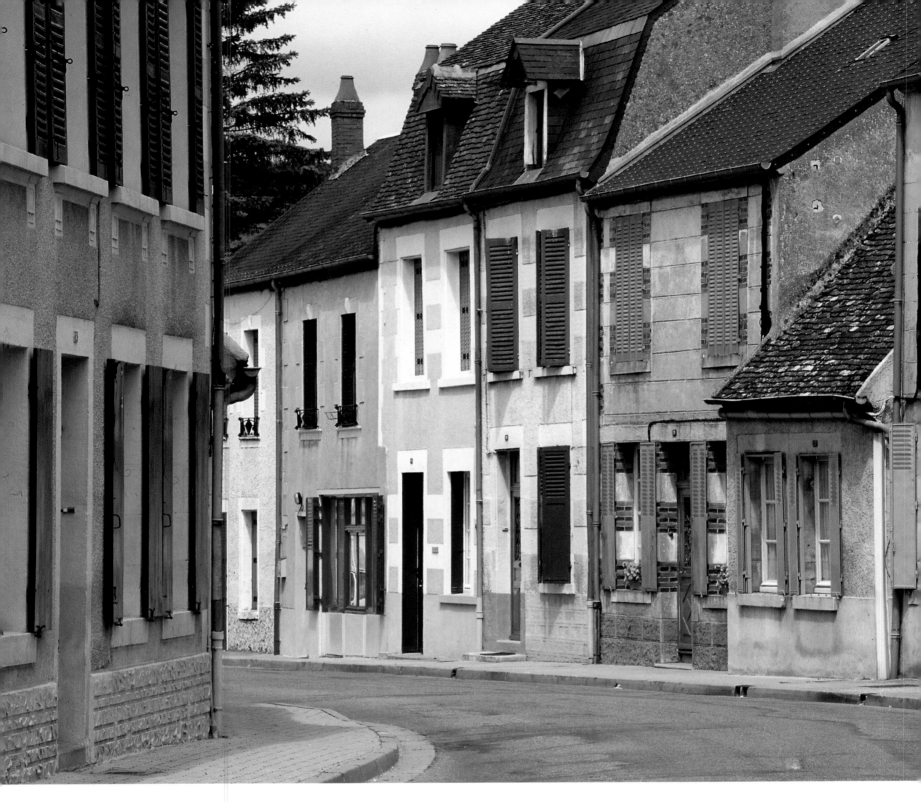

*Quiet delights of
Prémery (THESE PAGES):
the houses seem to have
evolved placidly over the
centuries. This is a
village by the river
Nièvre, sheltered in the
hills, which has slowly
grown from its Celtic*
*origins throughout the
whole Christian era, yet
remains small and
intimate, cared for by
its former collegiate
church of Saint-Marcel
and the fourteenth-
century château of the
Bishops of Nevers.*

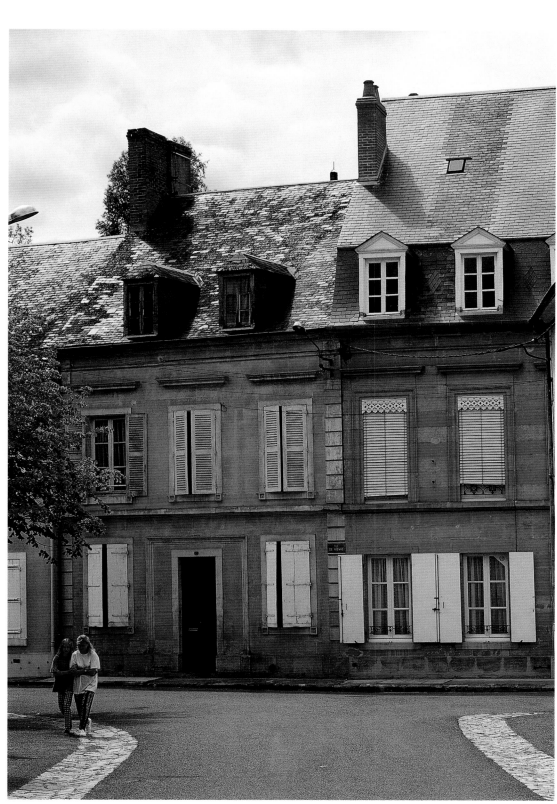

Sémelay

*L*ate in the tenth or early in the eleventh century the monastery of Cluny founded a priory here. The priory bequeathed to Sémelay the present Romanesque church of Saint-Pierre, which dates from the eleventh century, though the classical façade was added in 1782 and its flanking tower in the nineteenth century. The belfry has twin bays. Three-aisled, with a fine curved apse, the glory of this church consists in its superb medieval carvings and splendid capitals. Another delight is a rustic, polychrome statue of St. Anne carved from wood in the fourteenth century.

Although fewer than four hundred people live in Sémelay, the village boasts three châteaux. The finest of the three, the Château de la Bussière, east of the village, dates back to the fifteenth century, and has retained its square central lodging, a hexagonal tower and a square one, a spiral staircase, its gatehouse and an impressive fifteenth-century chimney.

Like many a Burgundy village, Sémelay is exquisitely sited among green, wooded hills. It lies in the valley of the river Alène. In the distance can be seen the summits of the Morvan and, nearer, the Vieille Montagne, a former *oppidum*. Not surprisingly, this entrancing spot was inhabited long before the monks came from Cluny, and certainly in Celtic times. And later the Gallo-Romans were to build themselves a camp on the right bank of the river.

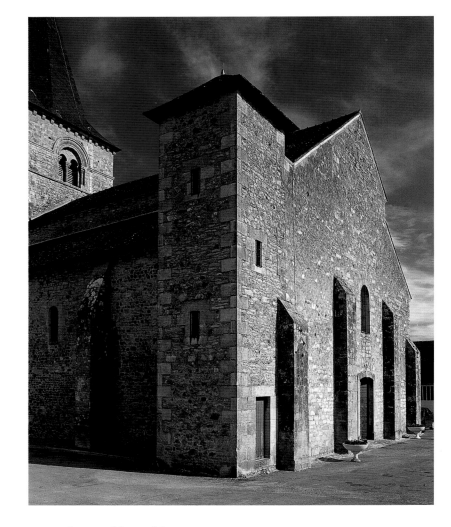

Stern and beautiful, the parish church of Saint-Pierre (ABOVE) blesses the village of Sémelay.

This is yet another Burgundian village founded on a Gallo-Roman site; seen from the north (OPPOSITE), it is dominated by the church spire. Verdant and wooded hills shelter it, while the Alène waters the surrounding land.

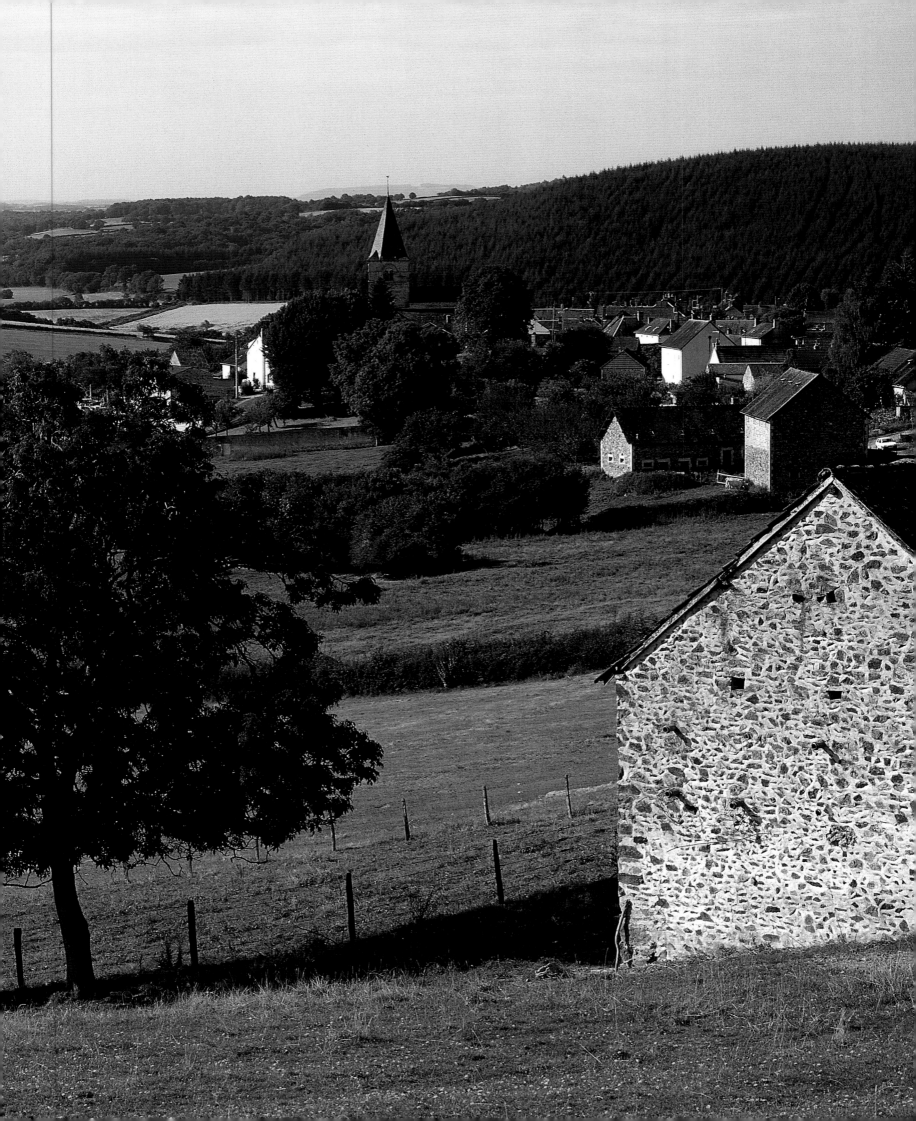

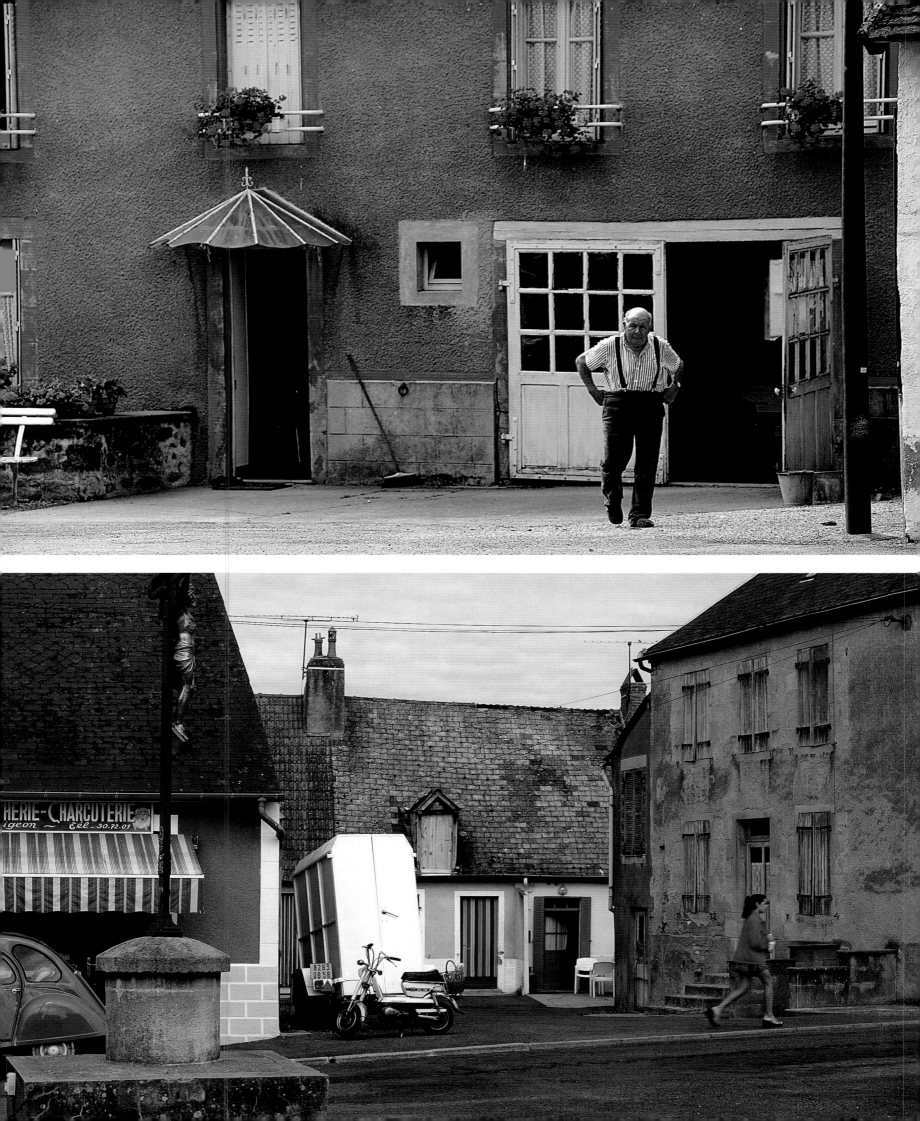

*Two essential
ingredients of
Burgundian village life
are the sellers of
brocante and
charcuterie (OPPOSITE
ABOVE and BELOW).*

*More splendid, however,
are the delicious
country houses which
punctuate the land
around Sémelay
(BELOW).*

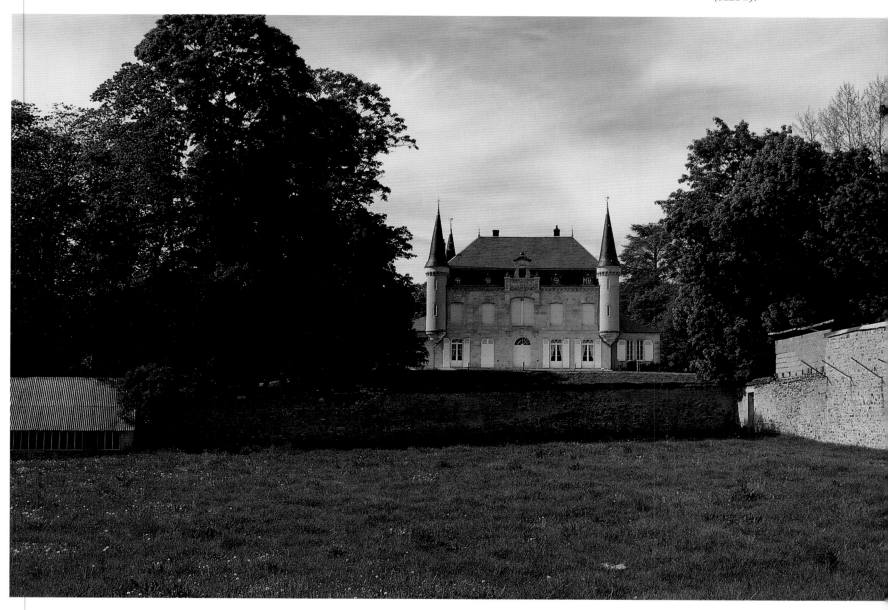

Tannay

*I*n the Gothic church of Saint-Léger at Tannay is a bas-relief representing the legend of St. Hubert, the patron saint of hunters, who was about to shoot a stag when he perceived in its antlers a crucifix.

The village rests on a wooded hill beside the Yonne, in a land still teeming with game and amid vineyards producing fine white wines. Once a collegiate church, Saint-Léger was begun during the first years of the thirteenth century (the choir) and finished in the sixteenth century; the square belfry dates from the fourteenth. Inside are revered relics of St. Léger himself (who was Bishop of Autun) and of the martyr St. Agatha.

No longer do canons worship here; but their former home, the Maison des Chanoines, built in the fifteenth century, still stands. Water-mills, medieval and Renaissance houses (particularly a couple dating from the sixteenth century in the Rue d'Enfer) and one of the ancient gateways of Tannay add further lustre to this village on the Nivernais canal.

Other delights of Tannay are its views of the heights of the Morvan and its reputed white wines. As for the name Tannay, it derives from the word *tan*, which referred to the bark of oaks used for tanning, and in past times Tannay was indeed a centre of the tanning industry.

A very French emblem struts in silhouette above the ancient roofs of Tannay (RIGHT). Medieval houses of rough-hewn stone (BELOW) are indicative of the antiquity of this Morvan village. Double doors recall a time when livestock would have shared such habitations with the human occupants.

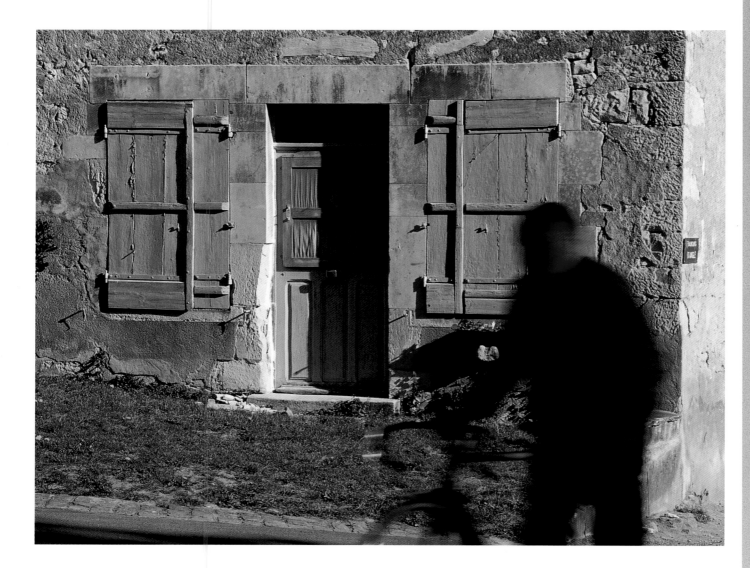

A fifteenth-century carving (BELOW) in Tannay church depicts the legend of St. Eustache. A servant of Pepin of Heristal, Eustache was out hunting when he saw a crucifix between the horns of a stag. He renounced the chase and became a priest. Paradoxically, in consequence he also became the patron saint of hunters. This carving outlines these events in almost comic fashion.

Some of the streets of Tannay have an almost organic quality in the irregularity of their architecture, although the village looks orderly enough when viewed from a distance across its surrounding fields (OPPOSITE ABOVE and BELOW).

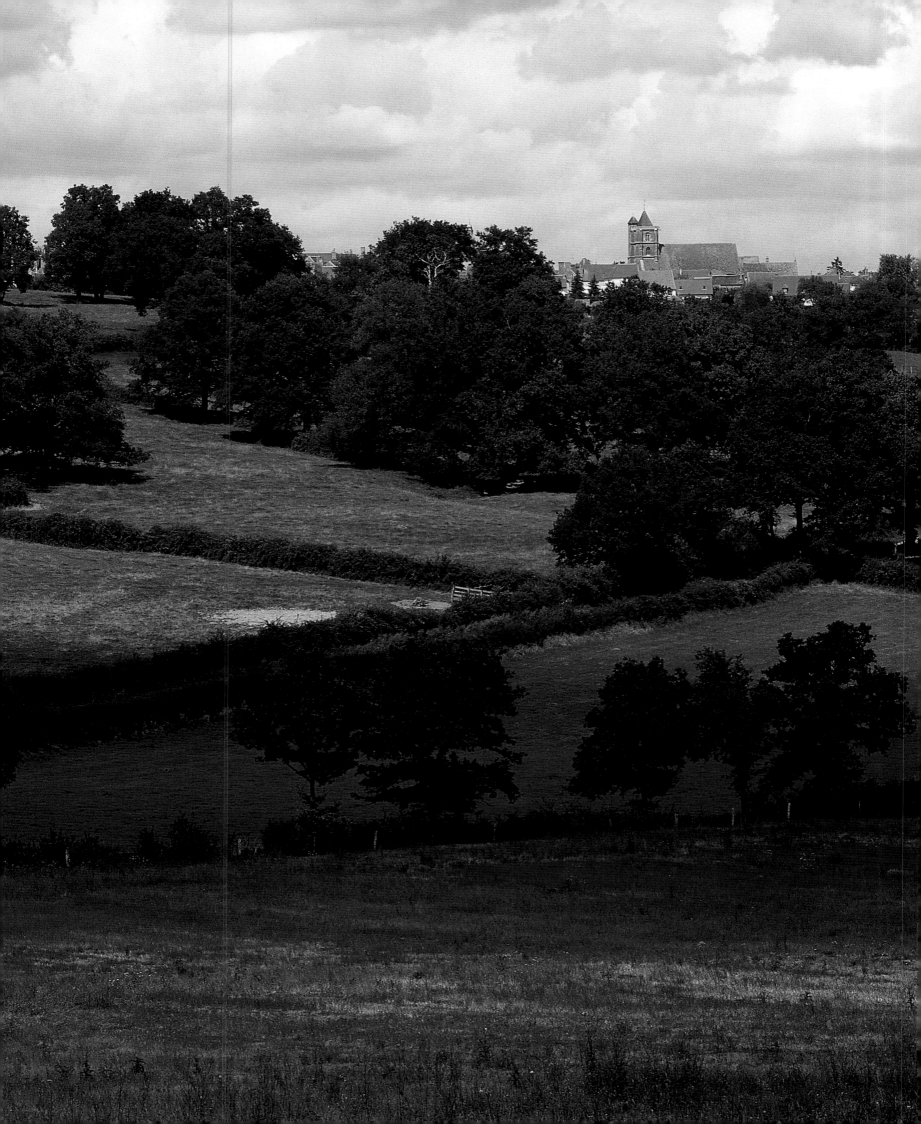

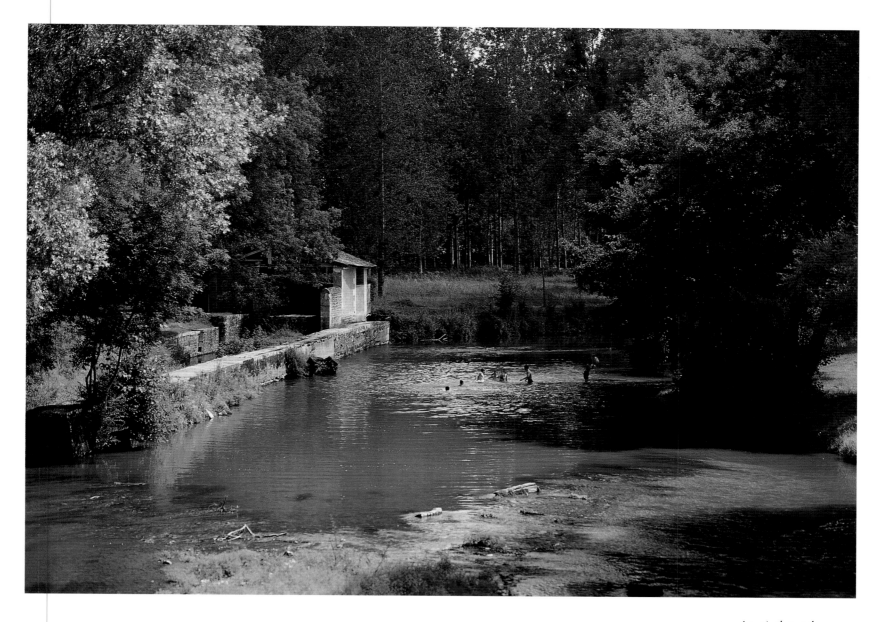

A typical stretch of the gentle river Yonne (ABOVE) at Cuzy, near Tannay, provides all the desired conditions for a swim on a summer's day.

From south of Tannay, the splendid church of Saint-Léger appears prominent on the skyline (OPPOSITE). It was begun in the thirteenth century and finished in the sixteenth, its style mostly high Gothic. Its clearly visible belfry dates from the fourteenth century. Although the church rises high above the village, for the most part its houses are protected by the flank of a rolling hill.

Varzy

*H*ere, in a circular village of which they had been lords since the fifth century, the Bishops of Auxerre built themselves a fifteenth-century château, modified in the seventeenth and eighteenth centuries, whose classical lodgings and polygonal tower still stand, the central pavilion dating from 1760. There are also other fascinating secular buildings, including the old wash-houses, the Porte de Vézelay, with seventeenth-century staircase towers, a seventeenth-century Franciscan convent which is now the Hôtel de l'Écu, and the fifteenth-century Hôtel de Guitton, once the town-hall.

The collegiate church of Varzy, served by a dozen canons, possessed the bones of St. Eugénie of Alexandria and thus became a noted pilgrimage centre, a staging-post on the pilgrims' road to the shrine of St. James the Great at Santiago de Compostela in Spain. Today, most of this church lies in ruins, though enough remains to evoke its past glory. Happily, the relics not only of St. Eugénie but also those of St. Regnobert, Bishop of Bayeux, both housed in fine shrines, have been transferred to the treasury of the church of Saint-Pierre, a noble high Gothic building dating from the thirteenth and fourteenth centuries and boasting a couple of bell-towers and a fifty-metres-long nave. Alongside the shrines of its two major saints, this church houses no fewer than twelve other delightful reliquaries. Among its other gems are a Renaissance pulpit, thirteenth-century stained-glass in the middle window of its choir and several sixteenth- and seventeenth-century triptychs, including one, painted in 1525 by a Flemish artist, depicting scenes from the life of St. Eugénie.

The streets of Varzy (LEFT and RIGHT) reveal many pleasing details: the cluttered window display and signage of a general store; weathered houses lining a charmingly uneven street.

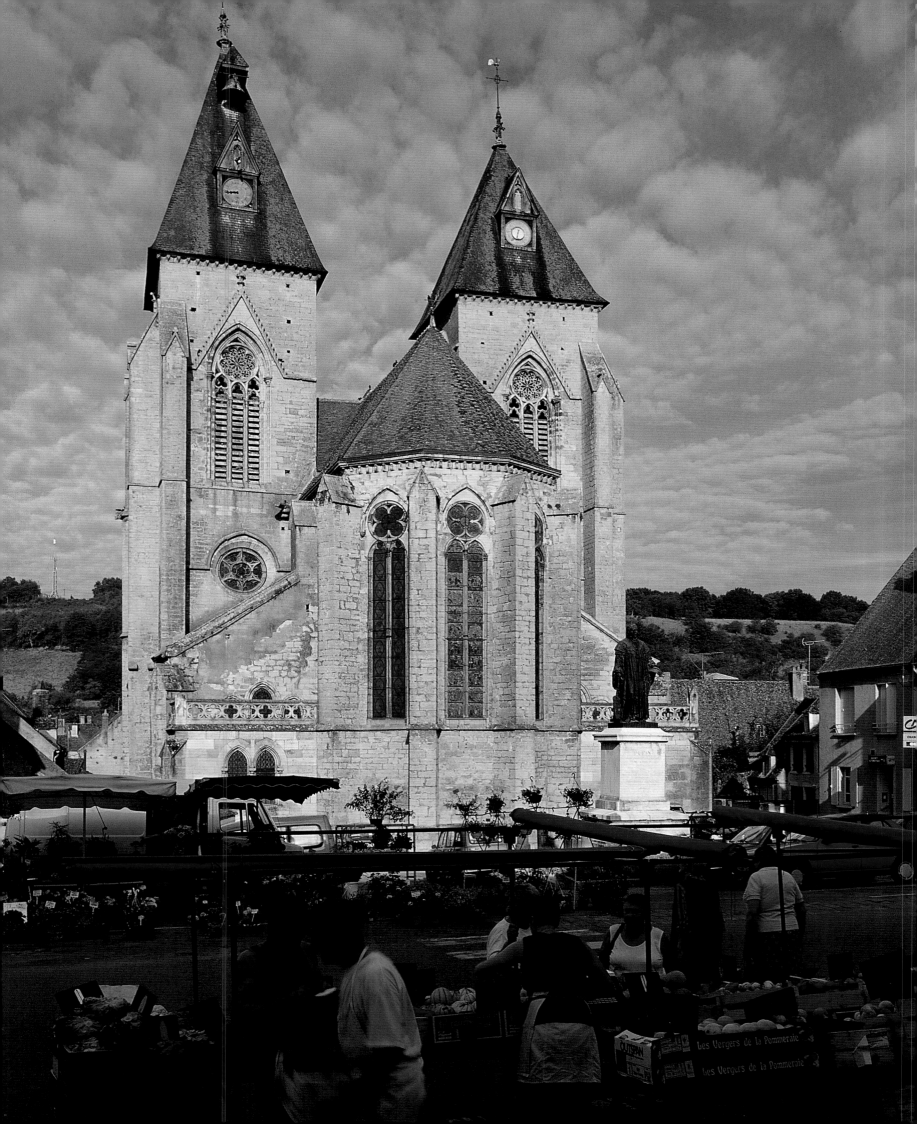

Venerable gateways and doors (*LEFT* and *BELOW*) add a fascinating network of details to this picturesque village.

Seen across the marketplace, the thirteenth-century church of Saint-Pierre (*OPPOSITE*) at Varzy displays its splendour: a polygonal apse, with supporting buttresses; a couple of superb towers rising above the transepts; the magical tracery of its windows. In the Middle Ages Varzy was a noted centre of pilgrimages because of the many relics in the church.

Standing in a promenade *which encircles Varzy (ABOVE) is a Holocaust memorial fashioned by students at the local technical* lycée. *The village harbours many fascinating houses, great and small (OPPOSITE ABOVE and BELOW).*

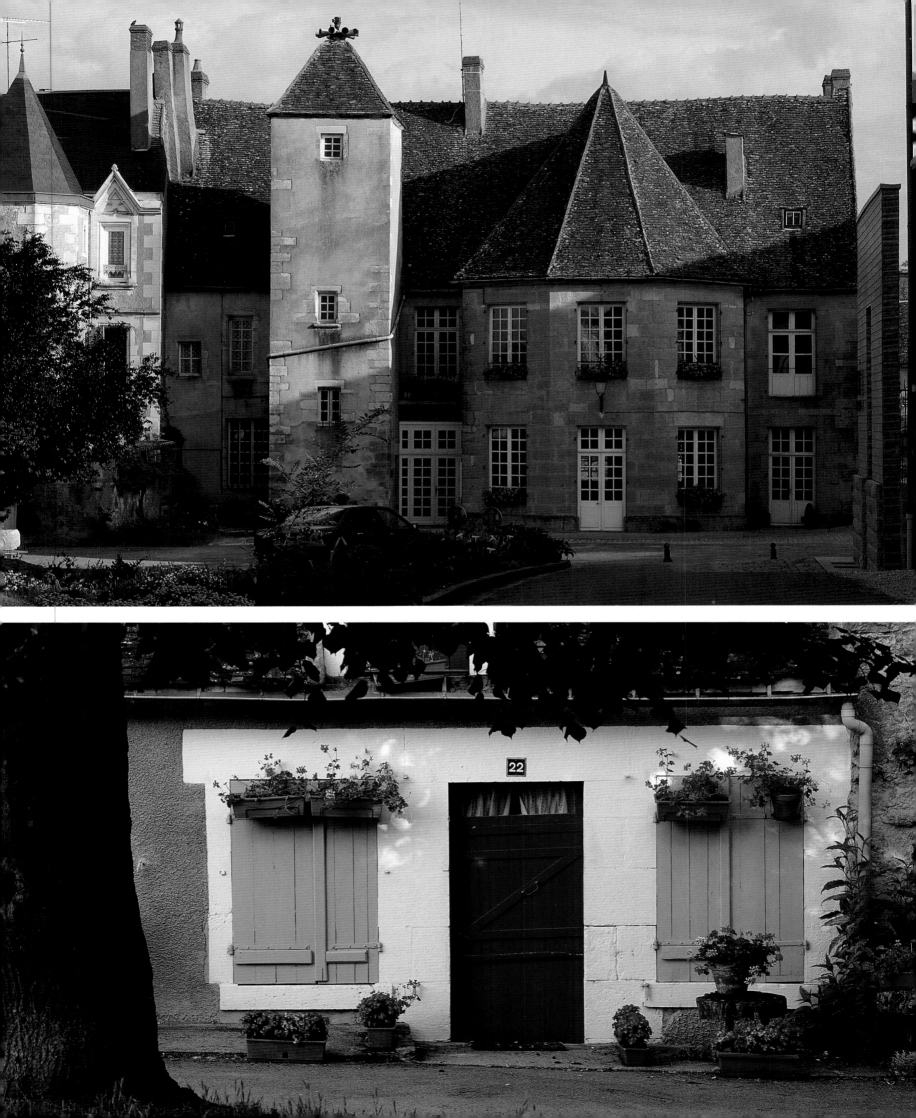

Gastronomic Burgundy

After the phylloxera blight of the late nineteenth century had destroyed a huge swathe of vines covering the hillsides between the Yonne and the Côte d'Or, replanting was carefully managed in Burgundy. Only those regions able to produce wines of the highest quality were selected. Chablis emerged as one of the greatest of dry white French wines, though in fact its colour is pale green.

The vineyards of Nuits-Saint-Georges, situated roughly half-way between Dijon and Beaune, cover approximately three hundred hectares. They lie at the heart of the Côte d'Or. Naturally, the soil varies, chalky in the north, predominantly clay in the south, giving subtle variations to the taste of these superb wines - of which the annual production of reds is far higher than that of the whites. In truth, as soon as one begins to mention the other *appellation contrôlée* wines of Burgundy, it becomes apparent that Chablis and Nuits-Saint-Georges are only part of the story. The capital of Burgundy wines is Beaune, and the *crus* of the Côte de Beaune are famed. Here the vineyards produce more red wines than those of Nuits-Saint-Georges, as well as (south of Meursault) some of the finest whites of Burgundy.

A strip of land, never more than ten kilometres in width, stretches for thirty-five kilometres along the low hills on the right bank of the river Saône, nourishing grapes which produce the wines of the Mâconnais. Undoubtedly the greatest white wine of this region is Pouilly-Fuissé, green-gold in colour. Other splendid white Mâcon wines include Mâcon-Villages. And this part of

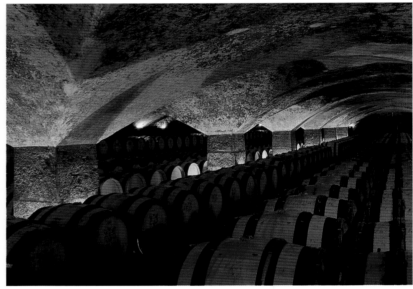

A scene typical of the wine-producing slopes of the famous Côte d'Or: these vineyards (OPPOSITE) lie near Saint-Romain, twelve kilometres west of Beaune. The grapes produce the appellation d'origine contrôlée *wine of 'Saint-Romain'. The village is also a centre of barrel-making, revealed in the workshop of Claude Gillet (LEFT).*

Some idea of the sheer grandeur of Burgundy wine-making can be gained from a visit to the splendid cellars of Château Meursault (ABOVE).

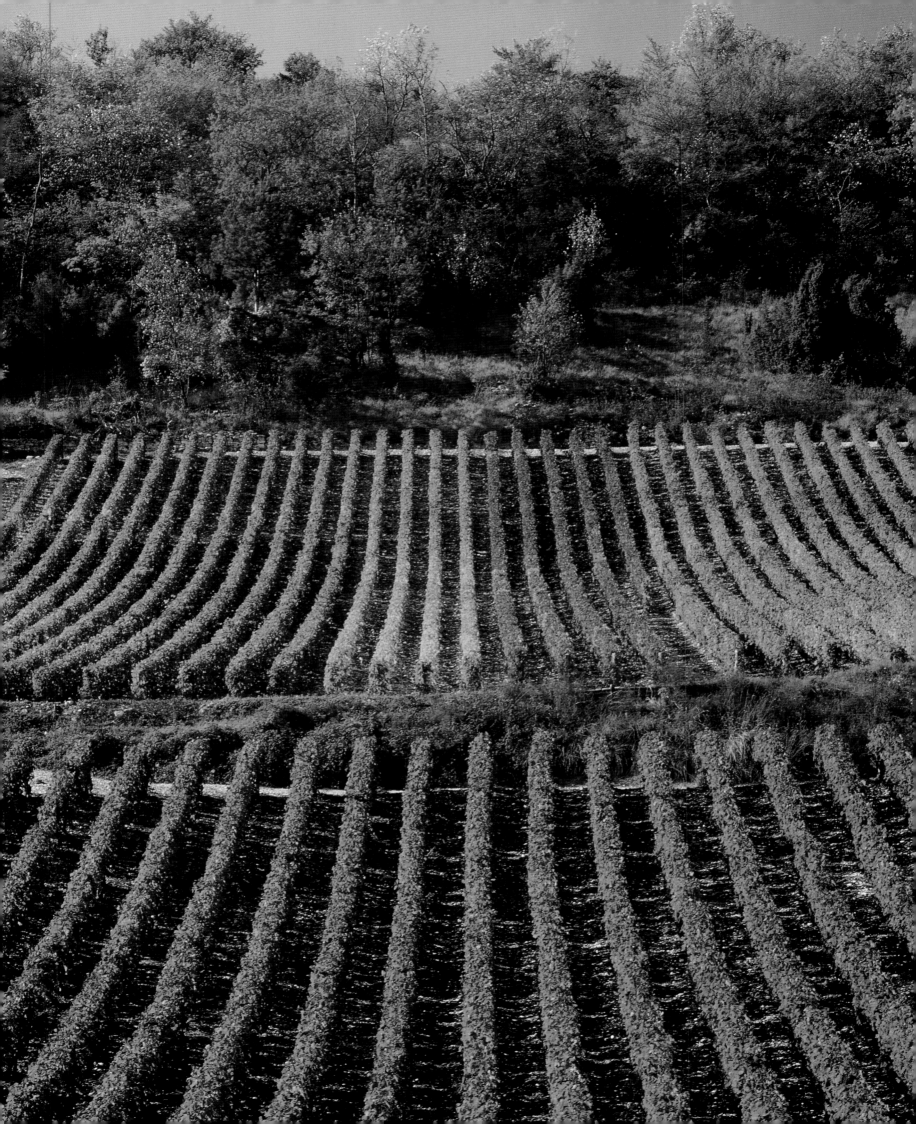

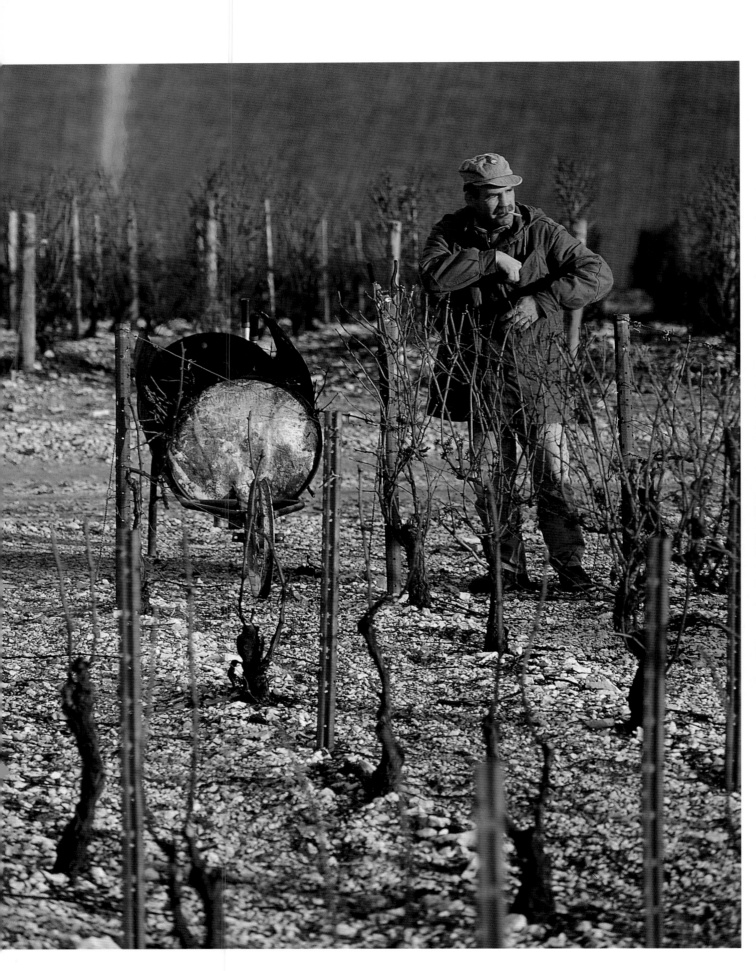

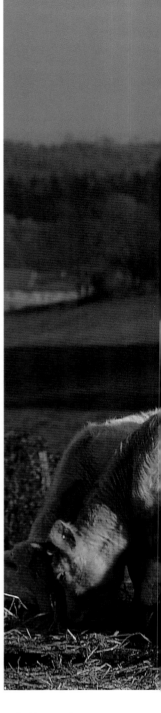

Chablis grand cru *vineyards after the harvest* (LEFT). *The finest of the Chablis wines comes from a thirty-six hectare slope north-east of the small town; the dry white wines are of enormous finesse, being created solely from the Chardonnay grape. The lesser Chablis wines are also great, created from grapes grown in a region of fewer than 5,000 acres and washed by the river Yonne.*

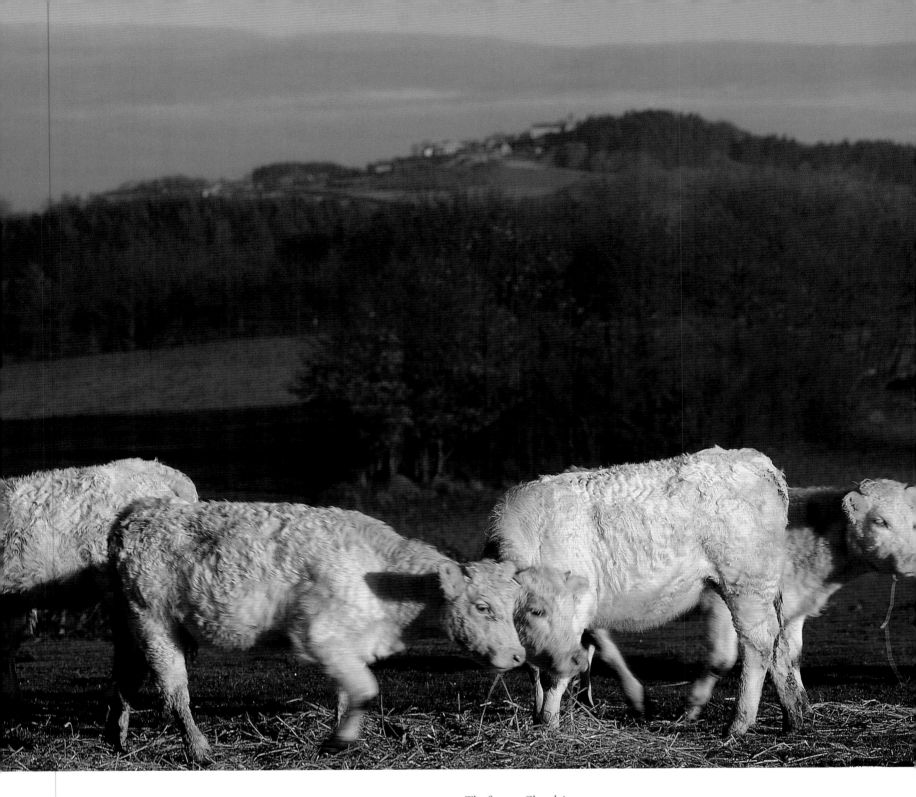

*The famous Charolais
beef cattle are unique to
Burgundy; here, part of
a herd graze near Suin
in Saône-et-Loire.*

Burgundy also produces a red Mâcon as well as a Mâcon rosé.

The Beaujolais vineyards spread themselves for forty kilometres in southern Burgundy. Their situation is startlingly beautiful, with the Jura and the Alps in the background, and their name known world-wide. Less well known are the wines of the Mercurey region, grown in the north of the *département* of Saône-et-Loire. Both reds and whites are produced here; and

one of the whites, Bourgogne Aligoté, is the favoured wine to mix with blackcurrant to produce *kir*.

For those who wish to savour these wines extensively, the Burgundians have created a wine route, which begins in the south at Villefranche-sur-Saône and runs north to Tournus, before moving west to Cormatin and further north through Beaune and Nuits-Saint-Georges as far as Dijon.

VOLAILLE DE BRESSE

Appellation d'Origine Contrôlée

Burgundians are also blessed with food worthy of their wines. Two celebrated animals help: the *poulets de Bresse* and Charolais cattle. The first are the only poultry to be classified *appellation d'origine contrôlée*. Each one must be fed on brown wheat, white cornmeal and milk. Each one must be reared in at least ten square metres of its own space. As for the creamy-white Charolais cattle, their pedigree is also impeccably kept in a register at Nevers. Scarcely any fat infests their lean meat. *Boeuf à la bourguignonne* is created from the flesh of these beasts, stewed for three hours in red wine and embellished by carrots, onions, *champignons* and butter. The poultry are cooked in white wine with onions. As for the fish which teem in the rivers of Burgundy, tench from the Saône, plus eels, carp and perch from the Doubs and its tributaries, combine in a Burgundy *pôchouse*, the local equivalent of *bouillabaisse* soup. This is also a region of snails, pungent cheeses and eggs, the last succulently poached not in butter but, appropriately, in wine.

A placard (ABOVE) proudly promotes volaille de Bresse *(a region in Saône-et-Loire dotted with lakes and forests), the only fowl in France to be entitled to the accolade* appellation d'origine contrôlée. *Cheese from Époisses in Côte d'Or (RIGHT) is another famed delicacy of Burgundy. For centuries the Burgundians have been known as gourmands and gourmets; delicacies here are poultry in white-wine and cream sauce or* fondue à la bourguignonne *made with Charolais beef.*

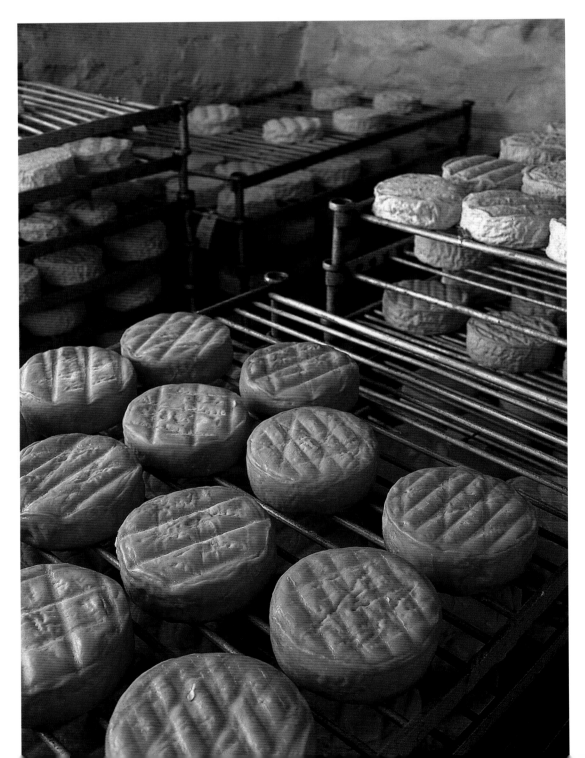

Mixed produce from the generous earth of Burgundy at the Thursday market of Châtel-Censoir in Yonne (RIGHT and BELOW); much of it comes from neighbouring Clamecy, a picturesque old town at the confluence of the rivers Yonne and Beuvron and well-known for its gastronomy.

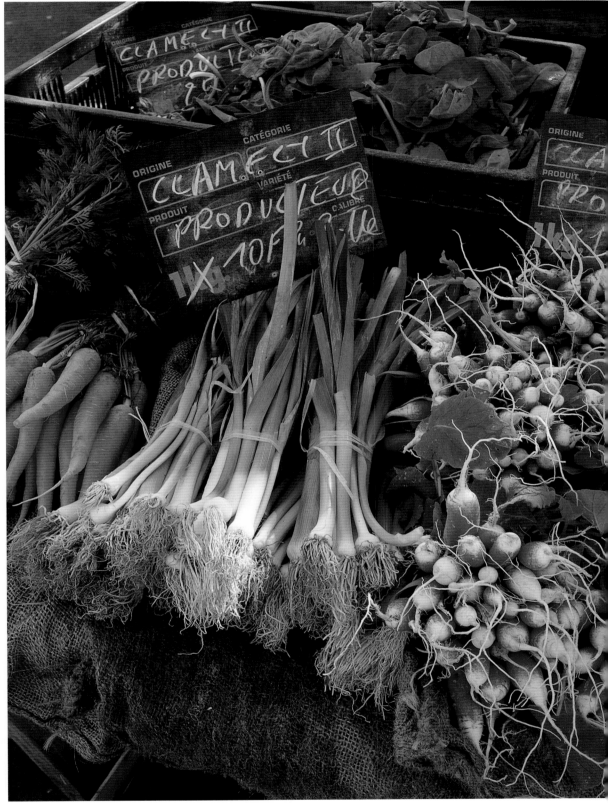

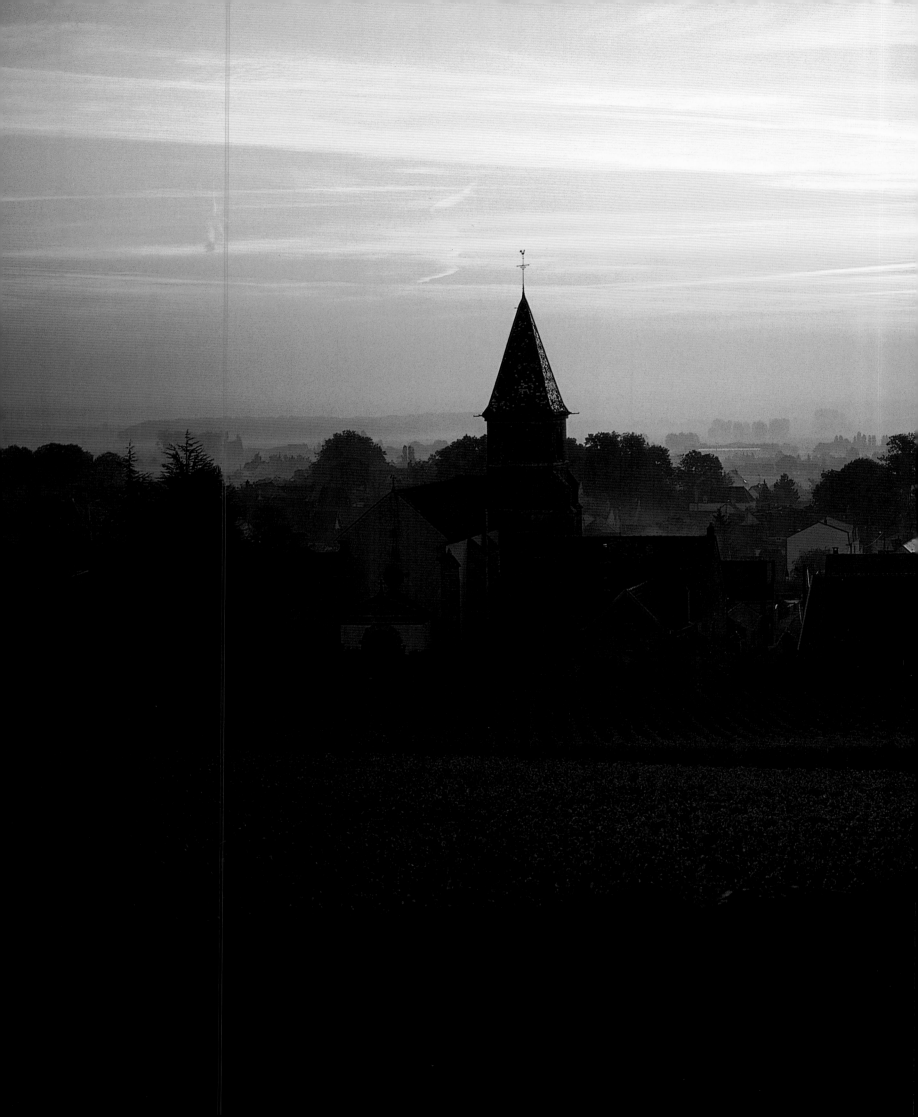

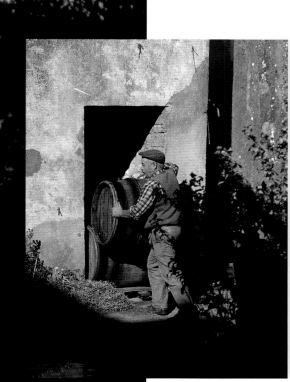

Côte-d'Or

Chassagne-Montrachet and
Puligny-Montrachet

Châteauneuf

Fixin

Flavigny-sur-Ozerain

Fontenay

Nolay

Pommard

Santenay

Semur-en-Auxois

The rivers Saône and Ouche, the Canal de Bourgogne, the canal which links the Saône with the Marne and another linking the Rhône with the Rhine offer many varied kilometres of waterway in this golden *département*. For visitors with a taste for higher land, the plateau of the Saône rises in the west to mountains. Not all the land is cultivated; some is wooded; but this part of France is especially renowned for its wine.

The celebrated Burgundy wine route begins at Fixin, south of Dijon. Its tiled parish church, built in the fourteenth century, provides for only nine hundred villagers, yet they produce four classified *crus*. From there the route runs south, through villages with such evocative names as Gevrey-Chambertin, Morey-Saint-Denis, Chambolle-Musigny, Clos de Vougeot, Vosne-Romanée, Nuits-Saint-Georges, Bouilland, until it reaches Beaune, then Pommard, Volnay, Saint-Romain and Meursault. Some of these villages are described later in this book; but all of them are well worth a pause. The vineyards of Gevrey-Chambertin owed much in past times to monks; from the seventh century they were linked to the abbey of Bèze and to Saint-Bénigne in Dijon. In the eighteenth century their prestige was revived, supervised by a locally renowned merchant, Claude-Jobert de Chambertin, who died in 1768 and today rests tranquilly in his tomb in the church. The village derives its name from a thirteenth-century wine-grower named Bertin, and his home, the Champ de Bertin. This is where the Côte-de-Nuits begins, twelve kilometres from Dijon. Gevrey-Chambertin has preserved its thirteenth- and fourteenth-century cellar (which was also used for collecting tithes), and on the Route des Grands Crus, on its outskirts, you may see the former home of Claude-Jobert.

Morey-Saint-Denis has a church with a fine eighteenth-century façade, with a thirteenth-century part inspired by the nearby Cistercian abbey of Cîteaux. Its houses date from the sixteenth to the nineteenth centuries. Vines cover the slopes around Chambolle-Musigny, whose houses, with their brown-tiled roofs, cluster around a delightful sixteenth-century church.

Clos de Vougeot has a château built in 1551 by the monks of Cîteaux, its roof punctuated by tall dormer-windows. Until the French Revolution, the monks also owned its thirty hectares of vineyard. Today the château is the seat of the Chevaliers of the Tastevin, a group dedicated to the world-wide promotion of the local wine. Their name derives from the small, silver wine-tasting cup, the *tastevin* (which is pronounced 'tâtevin'). Their ceremonial robes are red and gold, their motto, 'Jamais en vain. Toujours en vin'. They host banquets in a twelfth-century Romanesque cellar, its roof supported on stone pillars, and proudly show visitors their four magnificent thirteenth-century wine-presses.

Vosne-Romanée, a village of some 530 souls, has the distinction of producing the rarest and most expensive of burgundies, the Romanée-Conti, produced by vines first planted here by monks of nearby Saint-Vivant-de-Vergy in the thirteenth century and now growing on less than two hectares of land.

South of Beaune lies Saint-Romain, with picturesque remains of a medieval castle and lovely late medieval and Renaissance houses. The village is dramatically sited on a chalky bluff, and overlooked from the west by an escarpment of the Burgundy mountain. The location of Volnay, at the foot of a pine-clad hill, is also enchanting, offering a fine view of the Saône valley. Its parish church, dedicated to St. Cyr, dates from the fourteenth century and harbours a statue of Our Lady of the Vines and another of St. George destroying the dragon.

The white wines of Meursault are mostly green-gold in colour. They have been produced here since Christmas 1098, when Robert de Molesme, Duke of Burgundy, gave to the twenty-one monks of the abbey of Cîteaux, founded nine months previously, a vineyard situated close to the château of Meursault. The countryside around is delightful, surrounding a village part of whose former fortress, begun in 1337, rebuilt many times up to the nineteenth century, is now the town-hall and boasts an impressive square tower. Its roof is covered with

(PREVIOUS PAGES)
This is wine country, typified by the church tower of Fixin rising above the vineyards of the village (MAIN PICTURE). *At Puligny-*

Montrachet, a vigneron *is the human face of the process which has made that village synonymous with greatness in white wines* (INSET).

Typical of the villages of the Côte is Saint-Romain, a place of steep slopes leading from the upper to the lower village (OPPOSITE).

122 CÔTE D'OR

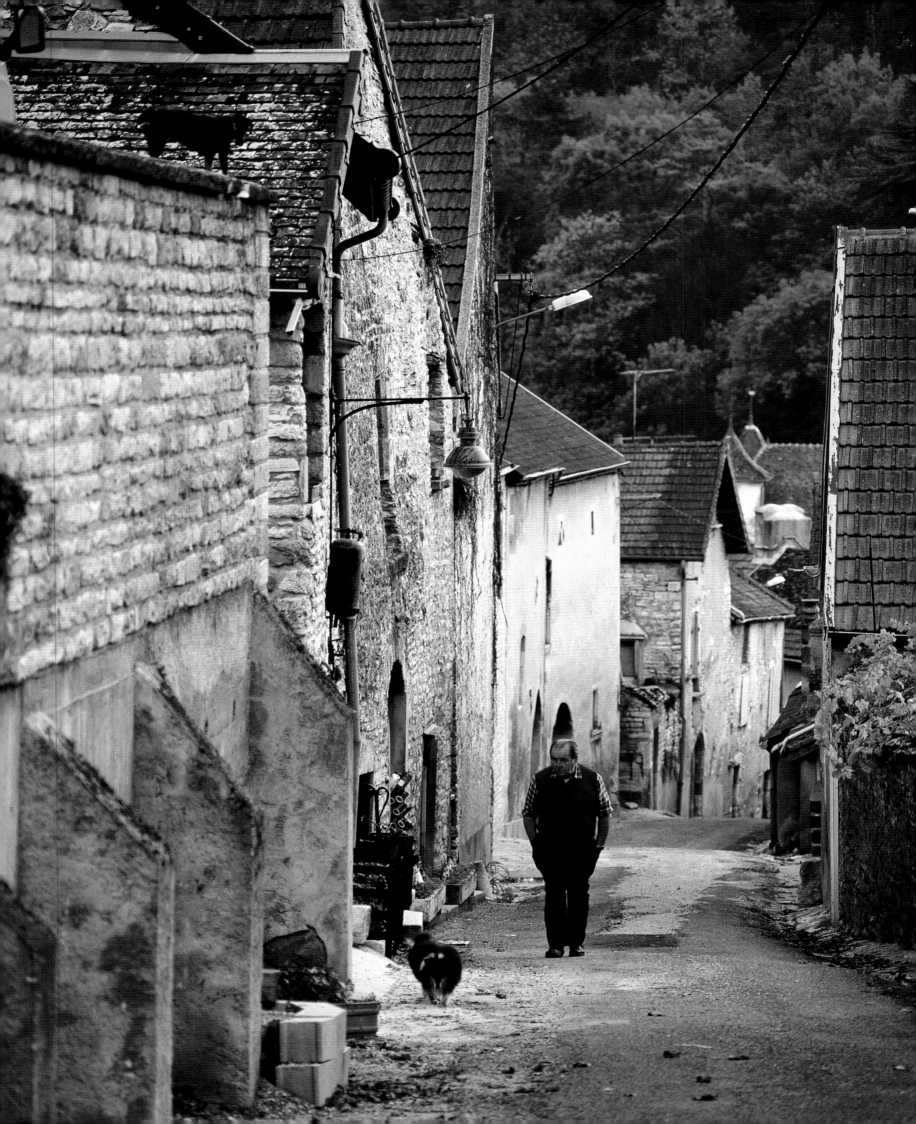

the celebrated varnished tiles of Burgundy. Meursault's former leper-house is a twelfth-century foundation with a Romanesque portal. In the Rue de la Velle stands the thirteenth-century Castel de la Velle, with a bread-oven (roofed in lava) and exterior walls. The present château of Meursault was built in the eighteenth century, and sits happily amidst the vineyards.

This is a region of lovely gardens and châteaux. The parterres and alleys of the park at Bussy-Rabutin are breathtakingly beautiful. The château there is majestic, with two sixteenth-century wings defended at the corners by formidable round towers of the same era. The interior is sumptuous and includes the hall of mottoes (with allegorical paintings), the chamber of military heroes, the King's Gallery and the Bussy room. Apart from its rich furniture, there are paintings and portraits by such masters as Mignard, Lebrun and Rubens. Two celebrated

sculptures, both by Coysevaux, depict respectively St. Jeanne de Chantal and Colbert. One of the round towers houses the impressive chapel of the château, in which are a sixteenth-century reredos and paintings by Andrea del Sarto and Poussin. The château garden was originally laid out by André Le Nôtre, but has now been completely restored to resemble more closely an idealized French garden of the seventeenth century. Eight parterres ringed with box, a labyrinth, copses and alleyways set out in the pattern of stars, water ringed with roses make an alluring ensemble.

At the heart of these treasures of the *département* is Dijon, its capital. The city was an important centre six centuries before the birth of Jesus. The Capetians, who ruled France from 987 to 1328, made it the capital of Burgundy. Of their successors, the Valois, three kings were born there.

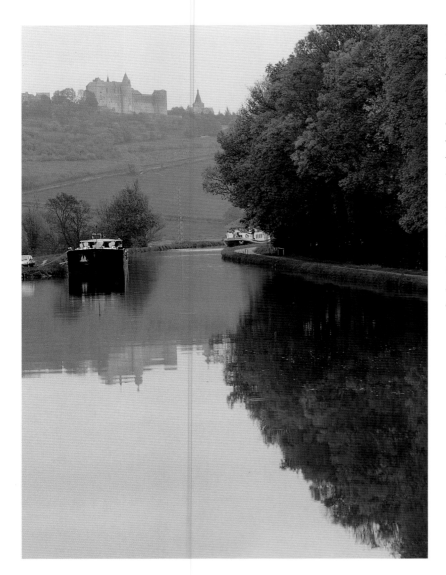

The Canal de Bourgogne (LEFT), south of Châteauneuf; this is one of the main waterways of the duchy. This peaceful scene belies the sometimes heated history of a village in whose château in the fifteenth century Catherine de Châteauneuf poisoned her husband, after which Philippe le Bon confiscated the château.

Two of the finest architectural gems of the département, *one ecclesiastical, the other secular: the massively vaulted chapter house of Fontenay is but one of the delights of this magnificent Cistercian abbey complex (OPPOSITE ABOVE); the château of Bussy-Rabutin (OPPOSITE BELOW), originally the home of one of the most mischievous courtiers of the court of Louis XIV, has now been restored to its original splendour.*

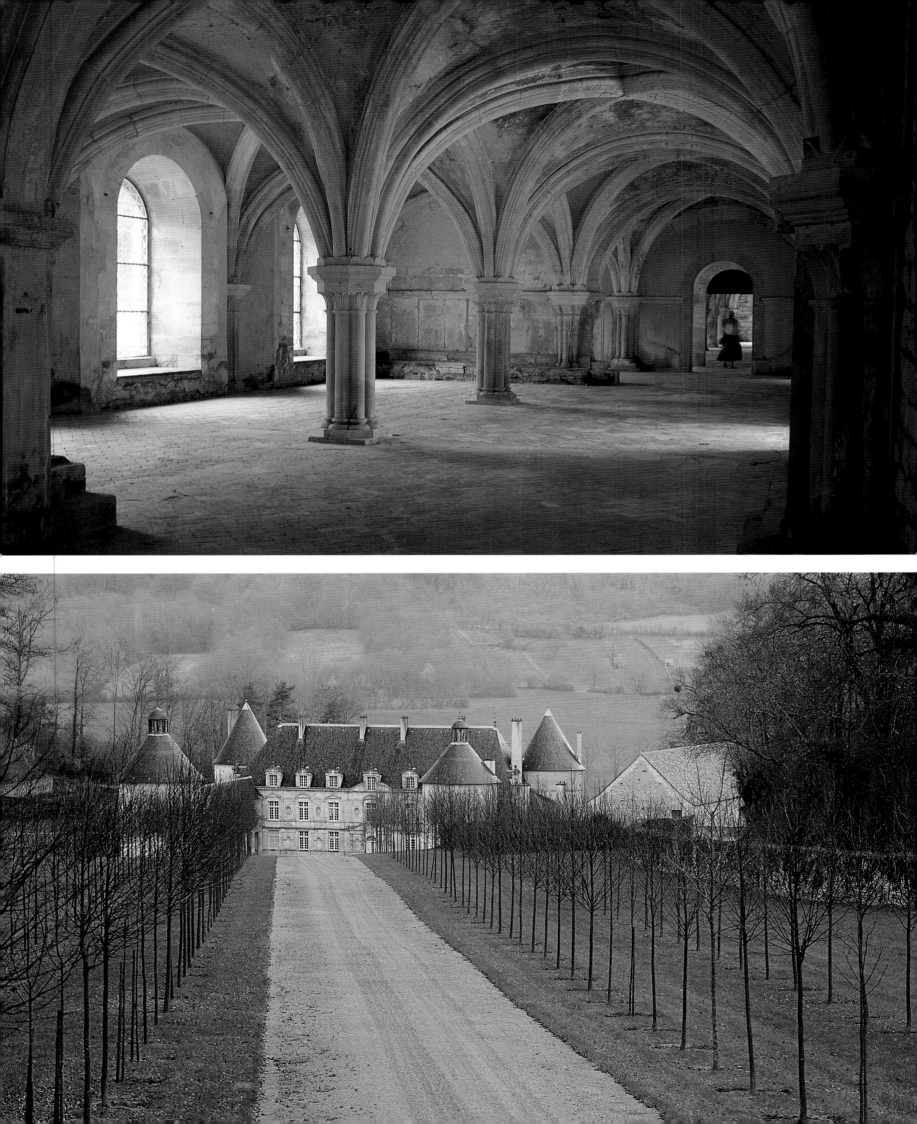

Chassagne-Montrachet / Puligny-Montrachet

These two neighbouring villages, nestling in superb countryside, produce some of the most highly-regarded white wines in the world. Tiles and lava roof their ancient vintners' houses. The Château de la Maltroye at Chassagne-Montrachet has fifteenth-century cellars. Their churches are just as magnificent. That at Chassagne-Montrachet was built in 1484 and has flamboyant Gothic windows and a seventeenth-century nave. The little village is defended by a none-too-threatening fortified gateway.

At Puligny-Montrachet the thirteenth-century church, in part rebuilt in the seventeenth and nineteenth centuries, has a fifteenth-century eagle lectern as well as fifteenth-, sixteenth- and seventeenth-century statues. Today the oldest part is the nave, the choir the latest. The village also has a Renaissance château (now a museum of the Napoleonic era), with an attractive hexagonal staircase tower and lodgings added in the eighteenth century.

The tranquil aspect of these villages conceals a sometimes turbulent past; they suffered much, for example, during the hostilities between the Kingdom of France and the Duchy of Burgundy. Because its lord took up the cause of Marguerite de Bourgogne, Chassagne-Montrachet was put to the torch in 1480 by the troops of Louis XI. It rose from the ashes. First François de Ferrières built a chapel dedicated to St. Mark which eventually blossomed into the present parish church. Then Cistercian monks came to the rescue, founding a priory (the abbey of Morgeot, of which vestiges remain) and above all replanting the vines, to the subsequent benefit of the whole wine-drinking world.

A friendly rivalry still exists between the two villages; an Englishman (Simon Loftus), who spent a year in Puligny-Montrachet, quotes one local grower as observing, 'Puligny is more bourgeois, Chassagne more peasant.'

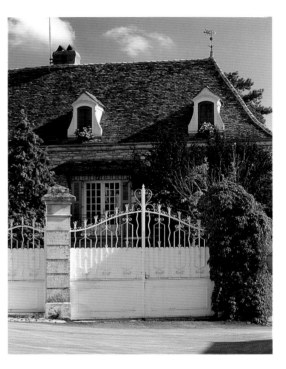

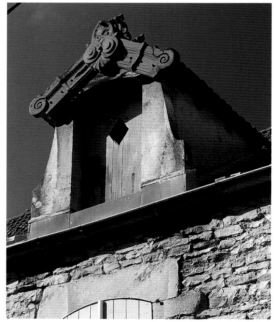

These two wine villages of the Côte reveal variegated roofs and windows of great vintage (LEFT ABOVE and BELOW). It is likely that their owners work in the local vineyards, such as this one (belonging to the Château de la Maltroye) outside Chassagne-Montrachet, where Monsieur and Madame Reigny are working on their fortieth vendange (OPPOSITE).

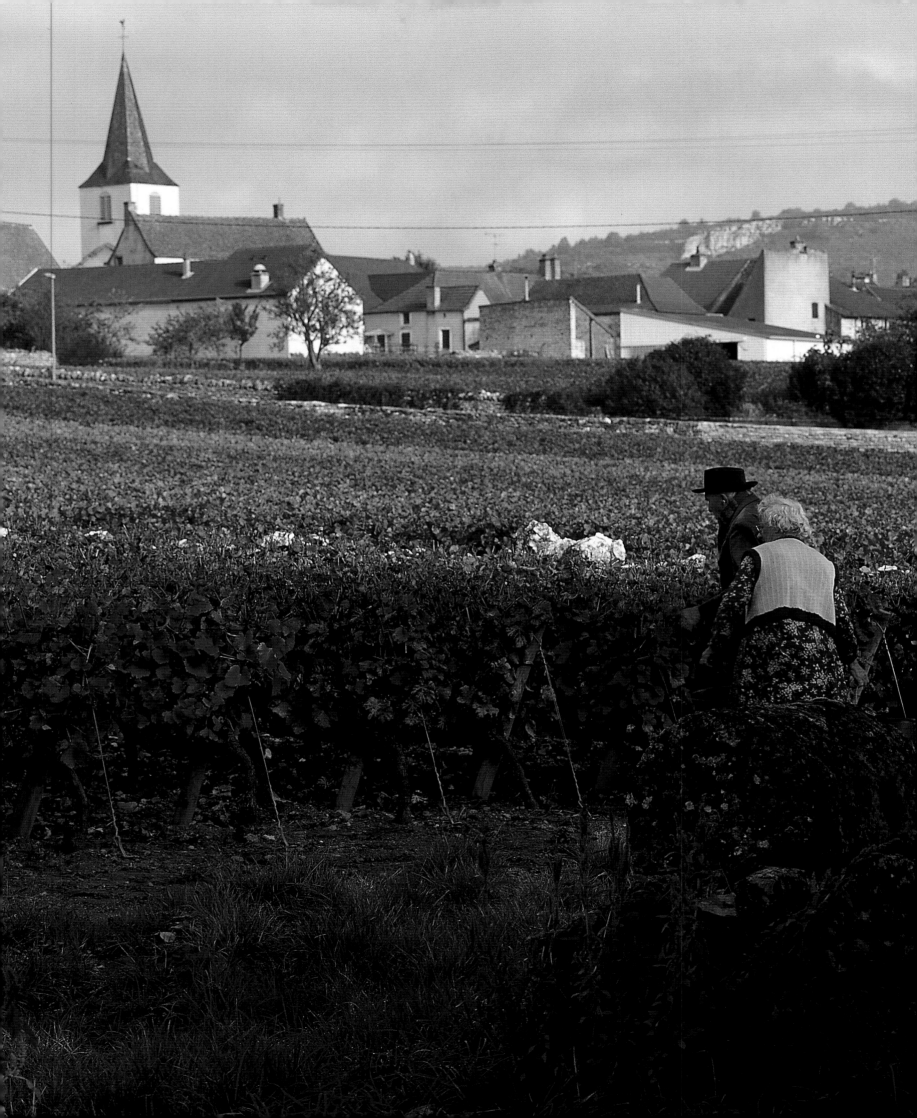

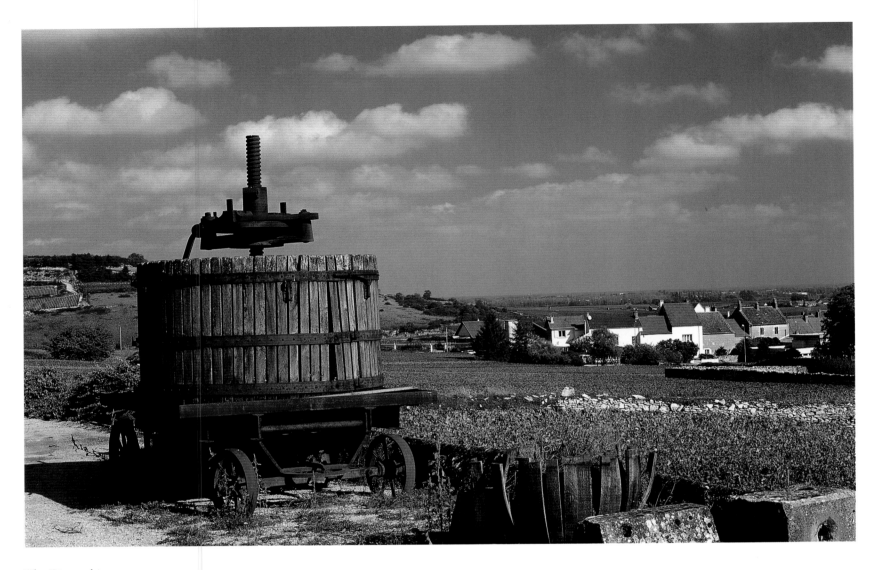

The Côte and its
villages are justifiably
proud of the history of
distinguished wine-
making of the region;
this ancient wine-press
(ABOVE) is preserved in
the vineyards of
Chassagne-Montrachet.

It is hard to imagine,
seeing this peaceful
scene of the village
sitting amidst its
vineyards (OPPOSITE),
that Chassagne-
Montrachet was partly
destroyed by the troops
of Louis XI in 1480.
However, the
architectural legacy of
this destruction delights
us today in the form of
graceful vintners' houses
dating from the
sixteenth century.

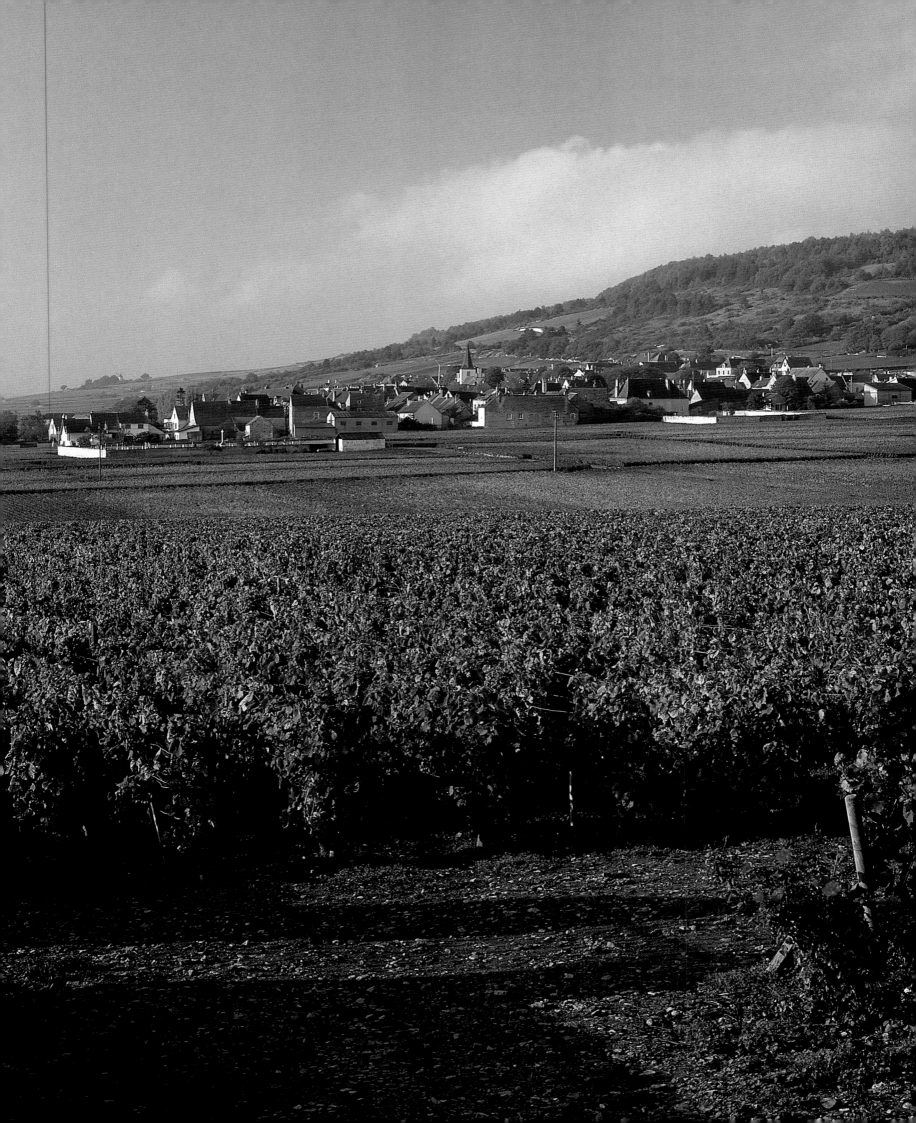

The vineyards of
Puligny-Montrachet
tightly surround the
village itself, so valuable
is the land on which the
serried lines of the vines
grow (ABOVE).

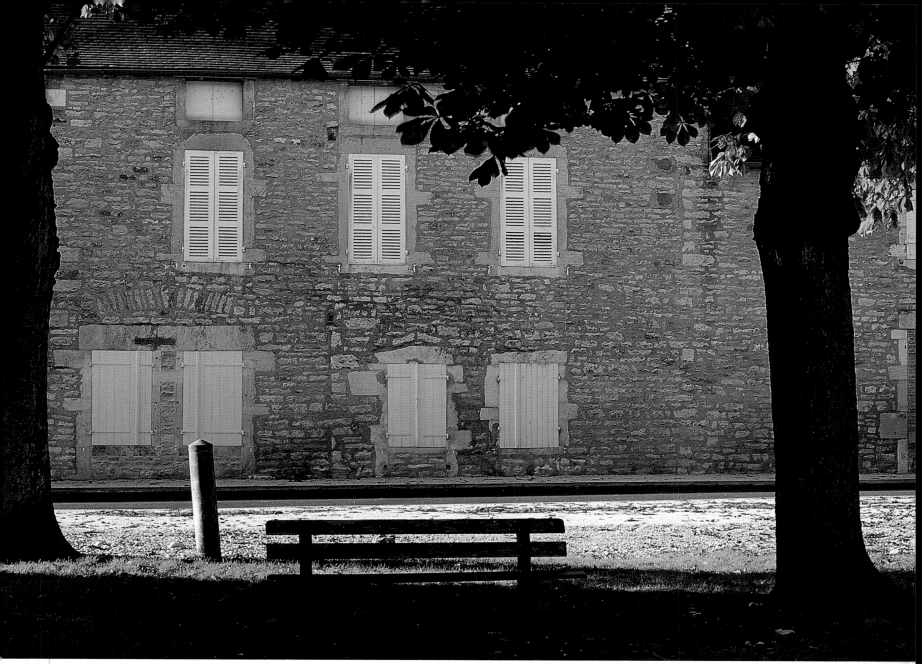

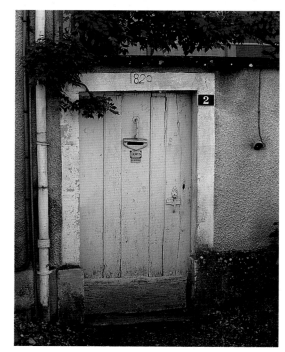

Within the village substantial buildings on the Place des Marronniers (ABOVE) and ancient doorways (BELOW LEFT and RIGHT) testify to the long-standing, wine-inspired prosperity of the Côte.

Châteauneuf

*I*n the second half of the twelfth century Jean de Chaudenay created a *seigneurie* and gave it to his younger son, Jean. He and his successors defended their lordship above all by means of their château, one of the masterpieces of Burgundian military architecture.

Its polygonal walls, built in the thirteenth century, are flanked by five tall circular towers. The square keep dates from the twelfth century. When the fifteenth-century châtelaine, Catherine de Châteauneuf, was found guilty of poisoning her husband, Philippe le Bon, Duke of Burgundy, seized her château in 1457 and gave it to his courtier, Philippe Pot, to whom we owe the fifteenth-century transformations. Philippe was a Knight of the Golden Fleece and later became seneschal of Louis XI. Of his living quarters, both of which were built in the fifteenth century, the east one lies today in ruins. From the era of Philippe also dates the Gothic chapel of the château, with a contemporary wall-painting of

Jesus and his apostles. His tomb in the château is a replica, the original now one of the major gems of the Louvre in Paris.

The château defends a seductive hill-top village rich with houses dating from the fourteenth to the seventeenth centuries. Some have turrets; some are sculpted with the coats of arms of those who once owned them. As for important fairs of past times, they are recalled here by such names as the Grange aux Ânes, the Place aux Bœufs, the Place aux Chevaux, the Place du Marché, the Place aux Cochons and the Place aux Moutons.

The fifteenth-century parish church of Châteauneuf has a massive belfry, added in 1526. The bays are flamboyant Gothic in style; the *piscina* dates from the fourteenth century, as does a statue of the Virgin and Child, while the pulpit was created in 1583. Other statues include a magnificent fifteenth-century St. John the Baptist and a sixteenth-century depiction of St. Philip and St. James, patron saints of this church.

Two houses with decorated doorways enliven the main street of the village (BELOW). More monumental than such domestic

decoration are the mighty fortifications of the place (RIGHT), viewed here from the contrastingly peaceful Canal de Bourgogne.

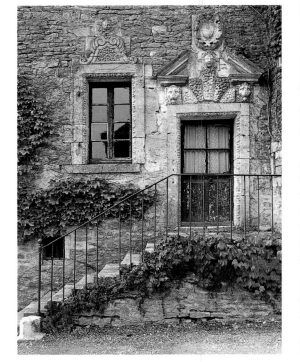

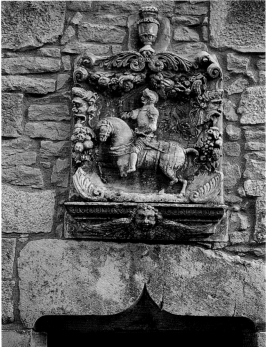

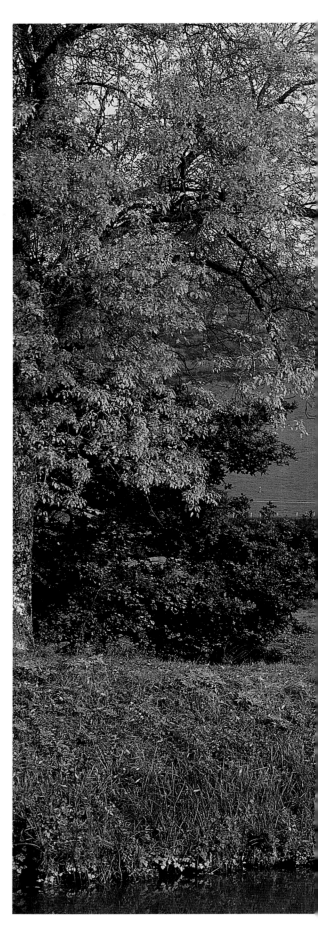

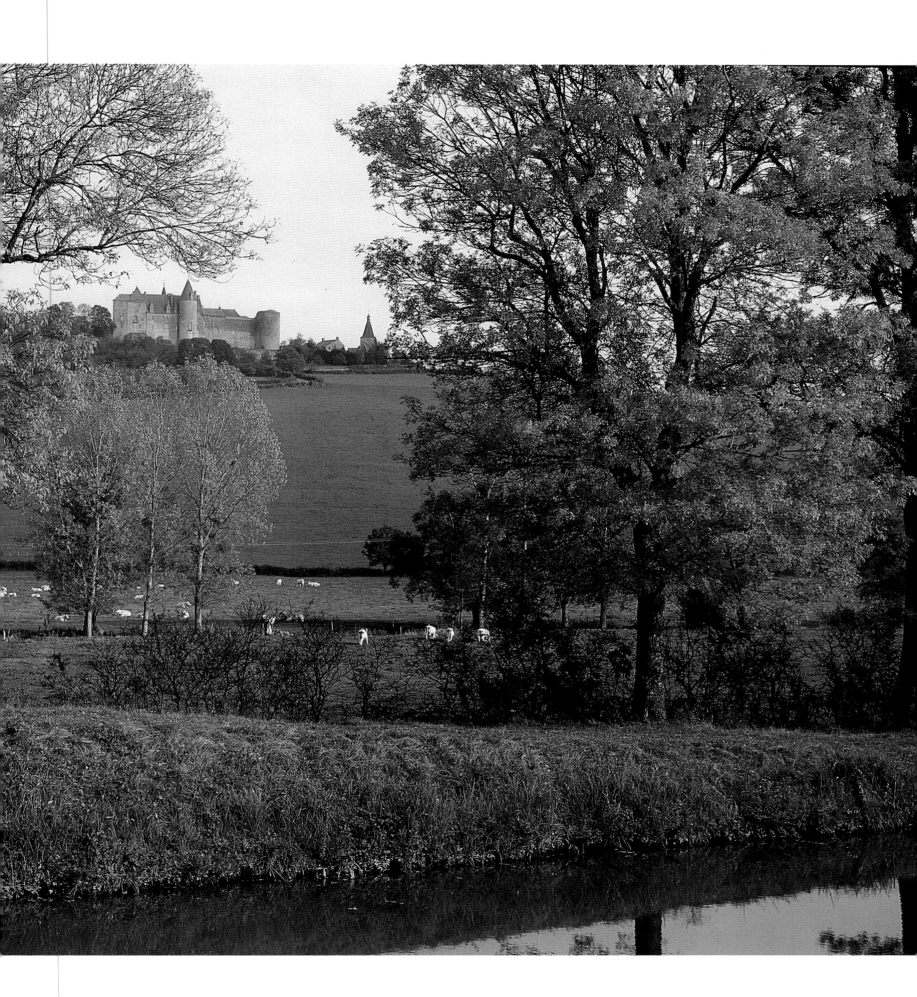

*As with many a
Burgundian village,
there is a rustic
congruity here; the
houses of the main street
stand happily with these
traditional farm
implements (ABOVE
LEFT and RIGHT).
Nearby, peering out
across the Grande Rue,
is a more substantial
home, given nobility by
an ancient round tower
(OPPOSITE).*

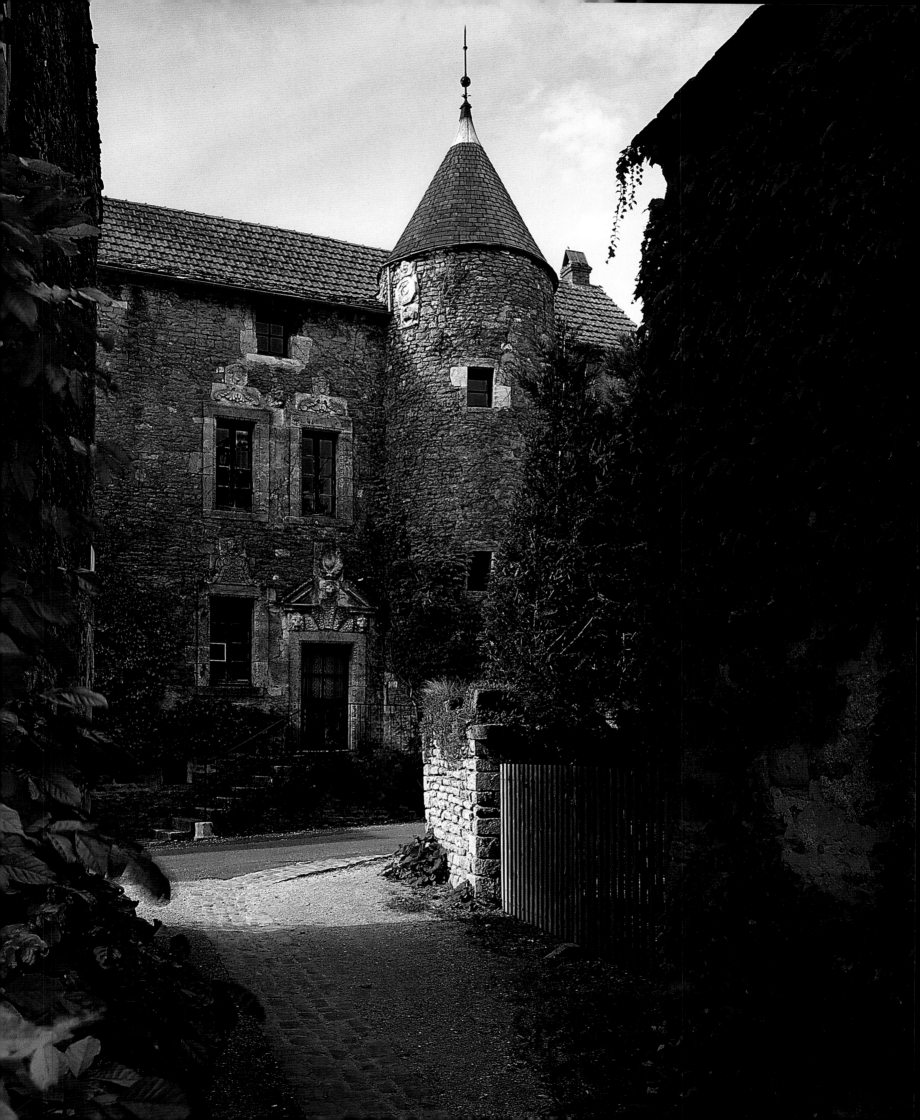

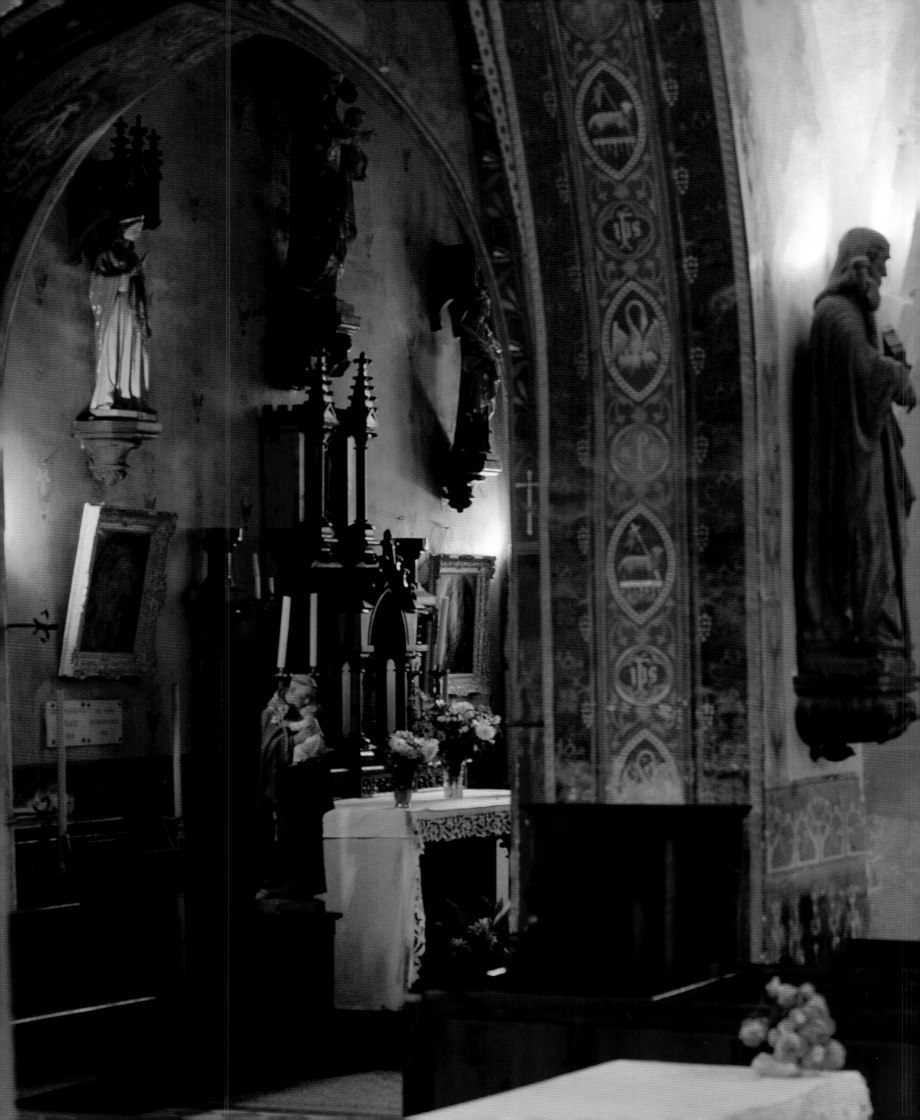

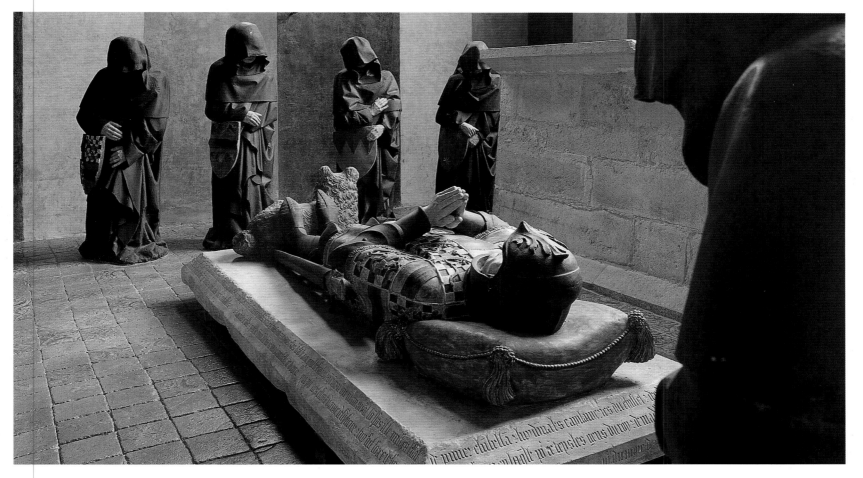

The wealth and splendour of the statuary inside the fifteenth-century church of Saint-Jacques-et-Saint-Philippe. Another magical house of God at Châteauneuf is the fifteenth-century chapel of the château (ABOVE), with its wall-paintings and more statuary. Moreover, wood-carving still plays a part in the economy and creativity of village life, as the interior of this local craftsman's workshop demonstrates (RIGHT).

Fixin

*T*he tiled spire of Fixin's fourteenth-century parish church rises above a village housing fewer than nine hundred souls. This pyramid spire, added in the fifteenth century, tops a square tower whose bells call villagers to worship in a fine Gothic church. The church harbours sculptures carved in the fifteenth and sixteenth centuries as well as its chief gem, a seated Madonna from the thirteenth century.

Fixin is close by such celebrated vintners' towns and villages as Nuits-Saint-Georges and Gevrey-Chambertin, and its thirteenth-century wine-press bespeaks its own long history of viticulture.

There is also a museum devoted to Napoleon Bonaparte, a legacy of Claude Noisot, an officer of the imperial guard who retired here in 1837. Noisot commissioned the Dijon sculptor François Rude to create for Fixin a bronze statue in honour of his emperor, the much-visited *Réveil de Napoléon* of 1847 which depicts the Emperor awakening to eternal life. A hundred steps symbolize the hundred days between Napoleon's escape from Elba and his defeat at Waterloo.

Here we are in the wine region known as Côte de Nuits, its name deriving from the celebrated wine town, Nuits-Saint-Georges. The wines of Fixin were given the status *appellation contrôlée* in 1936. Today Fixin (which the locals pronounce as 'Fissin') boasts a couple of *premier cru* vineyards, Clos de la Perrière and Clos du Chapître. Close by is the hamlet of Fixey, with a church founded in the Romanesque era.

The fourteenth-century church of this village on the Côte de Nuits rises above its vineyards, which lie at the beginning of the most famed wine-producing area of the world (RIGHT).

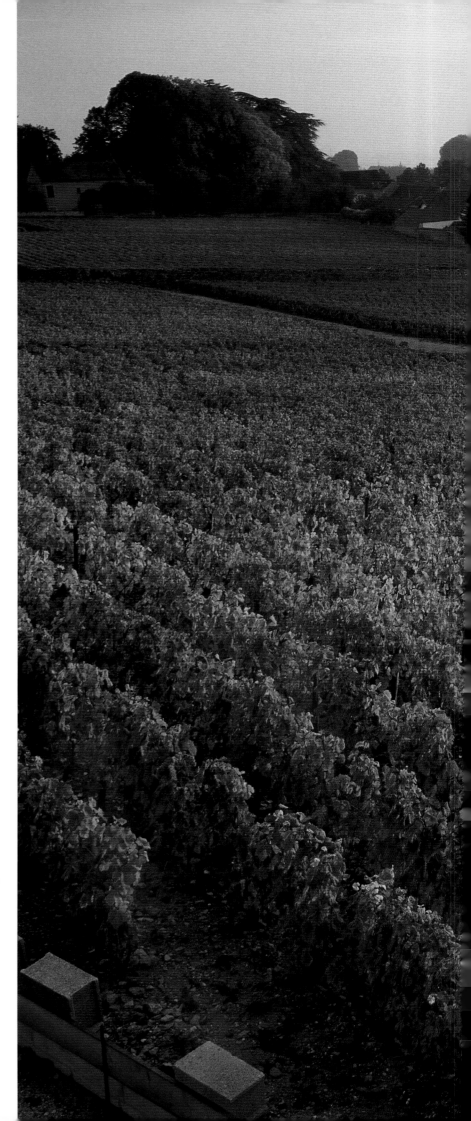

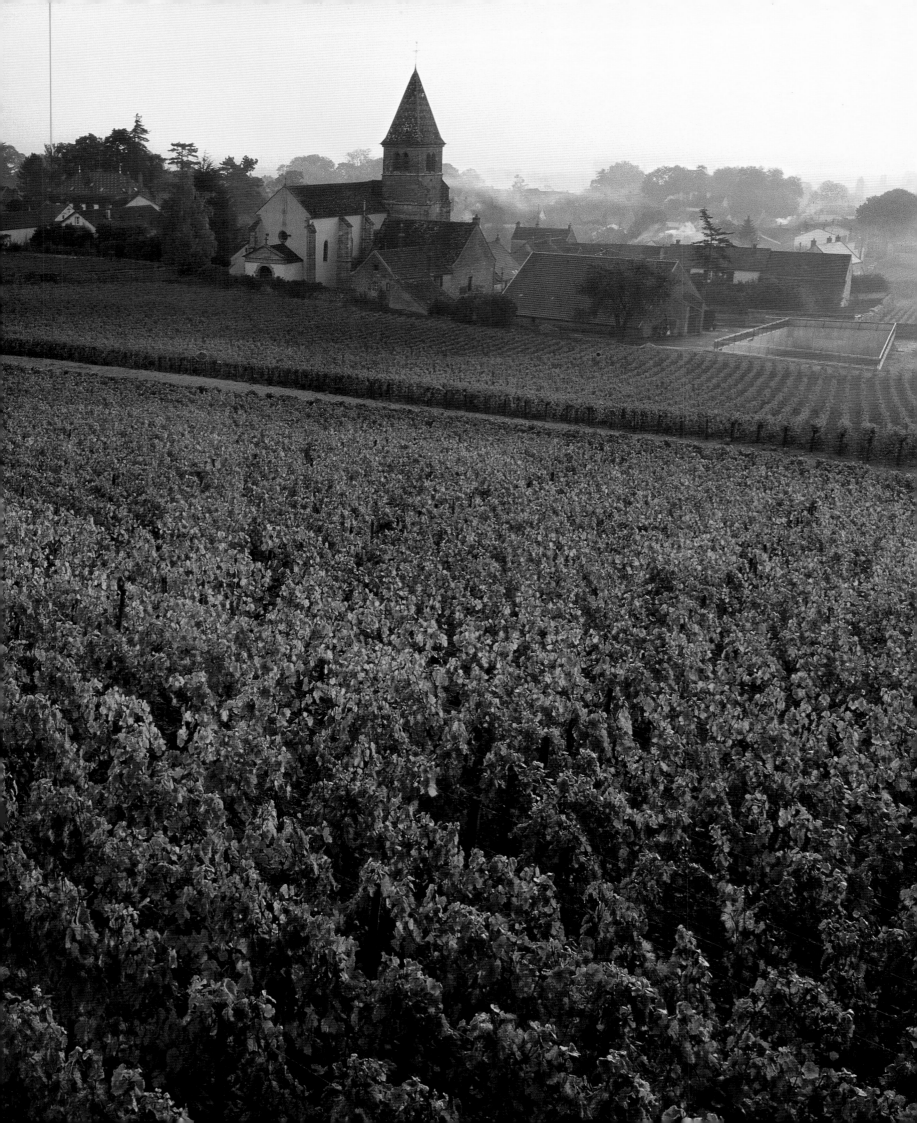

The venerable stones of this unassuming corner of Fixin (LEFT) provide a pleasantly textured contrast to the grander vistas of church and vineyard. Another distinguished wine domaine of the area is the Clos de Vougeot (BELOW), fifteen kilometres north of Nuits-Saint-Georges, world-renowned for its red wines. Cistercian monks from Cîteaux planted the vineyards here around 1100. Though the present château dates from the sixteenth century, its wine-cellar is four centuries earlier in origin. And Clos de Vougeot boasts no fewer than four ancient wine-presses. Less distinguished but equally picturesque is this vineyard on the outskirts of Fixin (ABOVE).

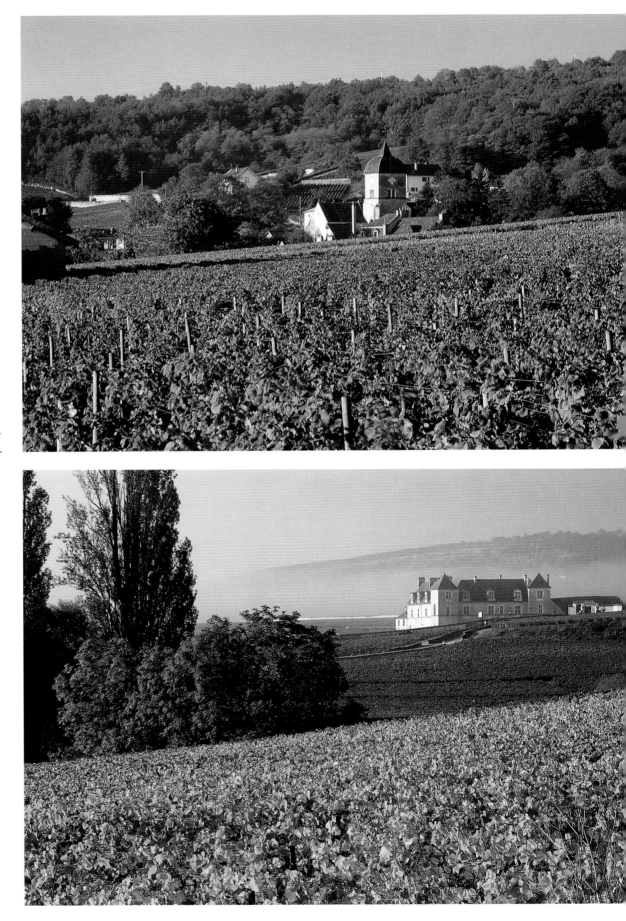

Flavigny-sur-Ozerain

*T*his exquisite medieval village, perched on a
wooded spur above the valley of the
Ozerain, has a history dating back to Gallo-
Roman times. Here in 719 was founded a
Benedictine abbey which became increasingly
important, particularly when it acquired the relics
of St. Reine a hundred years later and thus
attracted many pilgrims; yet by the time of the
Revolution the number of its monks, once 300,
had declined to thirty. The abbey was sold to the
villagers, the stones of its church used for building
until nothing seemed left. Then in 1959 the
Carolingian crypt was rediscovered. The following
year a nearby tenth-century hexagonal chapel,
Notre-Dame-des-Piliers, with an eighth-century
crypt, was also found. Today, the former abbey is
used for the manufacture of the renowned little
oval *anis* sweet of Flavigny, its base aniseed, its
gown sugary, its annual production 250 tonnes, of
which thirty per cent is exported abroad.

In spite of its ramparts, which include two
mighty medieval gateways (the machicolated Porte
du Bourg, with a Virgin in its niche, and the
Porte du Val, with its massive circular towers), the
English managed to capture the village in 1359,
holding it for several weeks. The walls surround
some exquisite medieval and Renaissance houses,
built of pale ochre stone, as well as classical
buildings, some of them with turrets and staircase
towers, the earliest dating from the thirteenth
century. So does the church of St. Genest though
it was extended two centuries later. Inside are
notable carvings, particularly an early sixteenth-
century Angel of the Annunciation, sculpted in
stone, and the late fifteenth-century carved choir
stalls. Another former convent was established
here by the Ursulines in the eighteenth century.

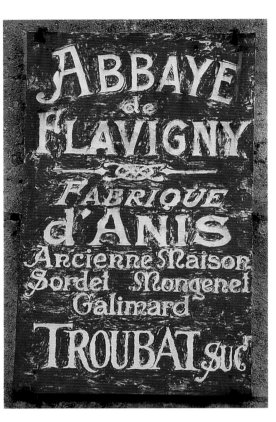

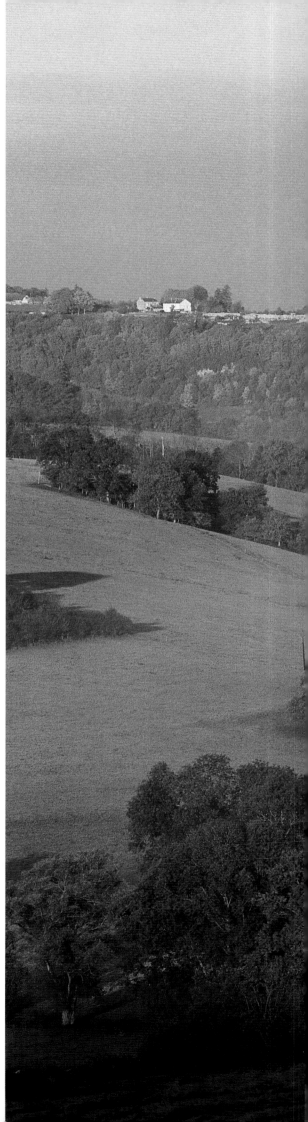

*As well as being famous
for its exceptional
beauty, Flavigny is also
a household word
because of the oval* anis
*sweets which are
produced there in the*
*former abbey (*ABOVE
and RIGHT*). Seen from
the east, across the
valley of the Ozerain,
the defensive siting of
the village is clearly
apparent (*RIGHT*).*

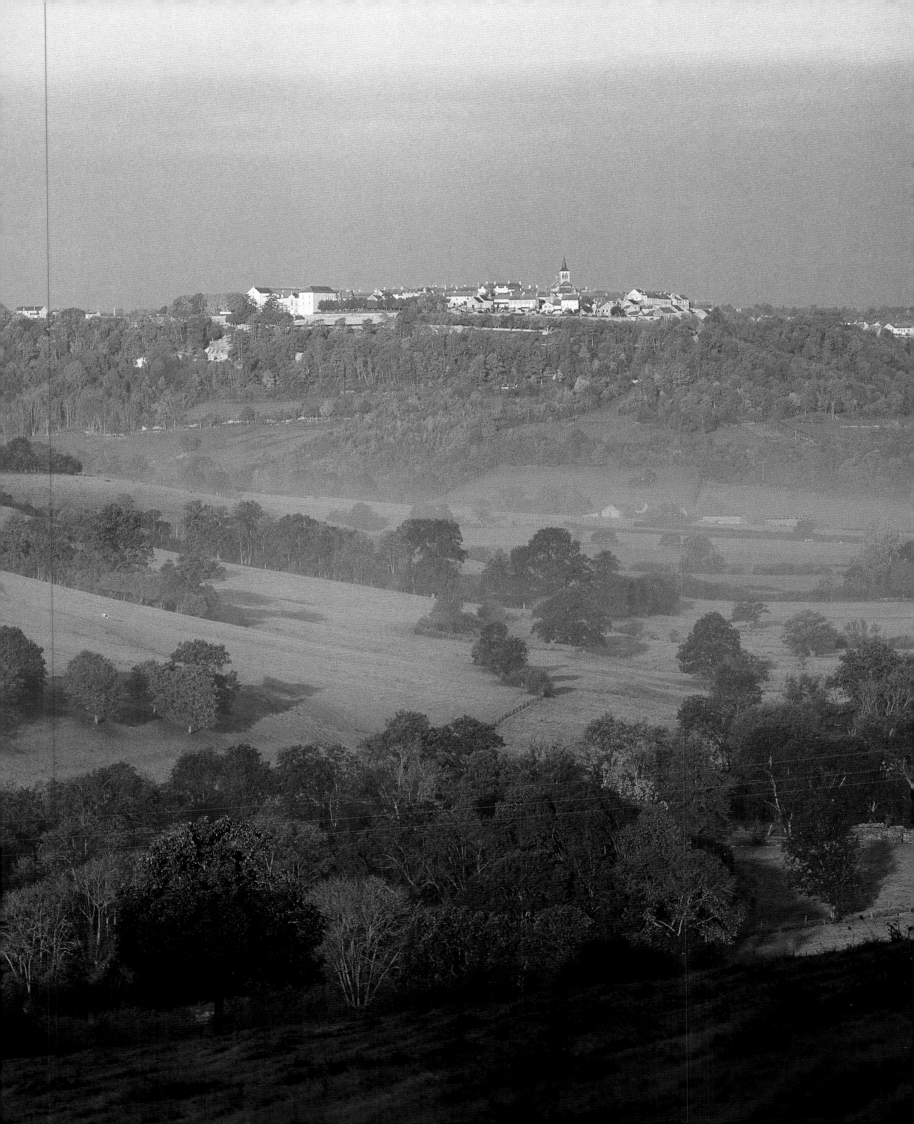

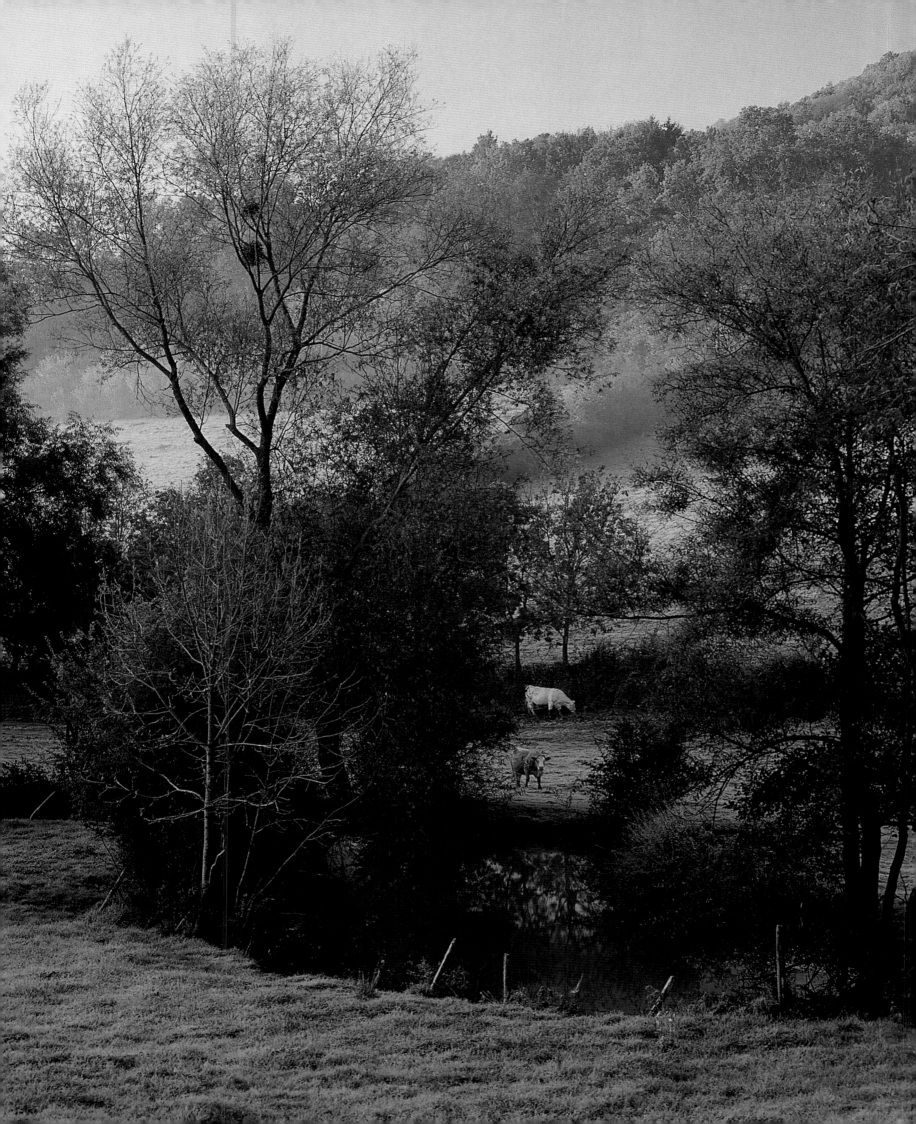

Cattle graze in the rich valley of the river Ozerain (OPPOSITE), near Flavigny. A variety of ancient houses graces the narrow, tortuous streets of the village. Gothic and Renaissance styles, dating from the thirteenth to the sixteenth century, are abundant, embellished with towers, ornate façades, high gables and half-timbering (ABOVE LEFT and RIGHT).

This strange carved face graces the corner of the Rue Mirabeau and the Rue Labourey. The streets of the village wind and twist within the great walls, punctuated by three gates, one of which is the splendid machicolated Porte du Bourg, which dates from the fifteenth century and is decorated with a statue of the Virgin Mary in the central niche (*FAR RIGHT*).

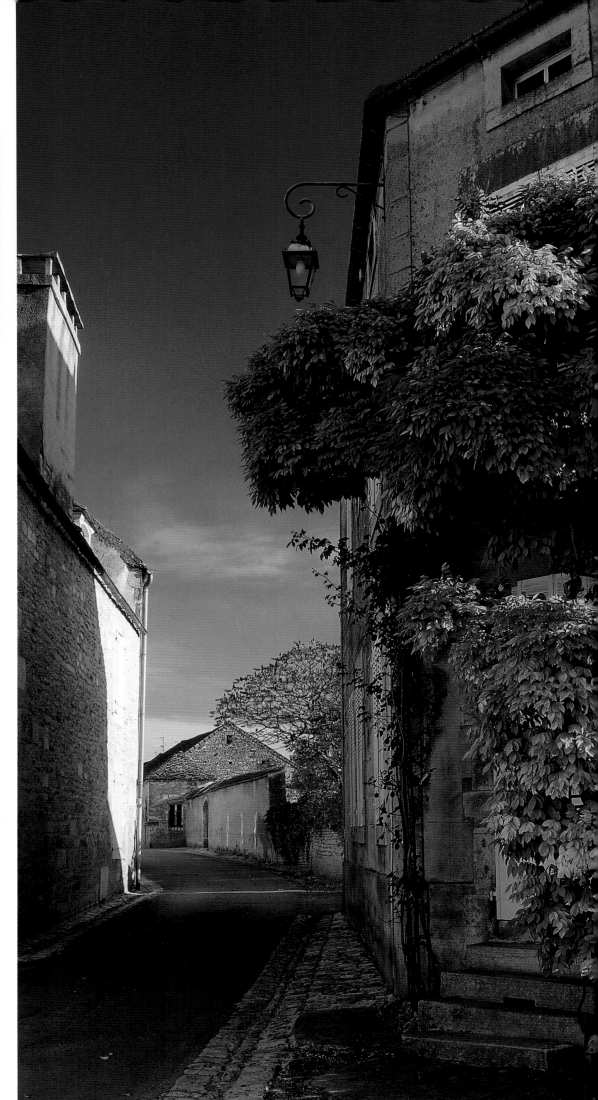

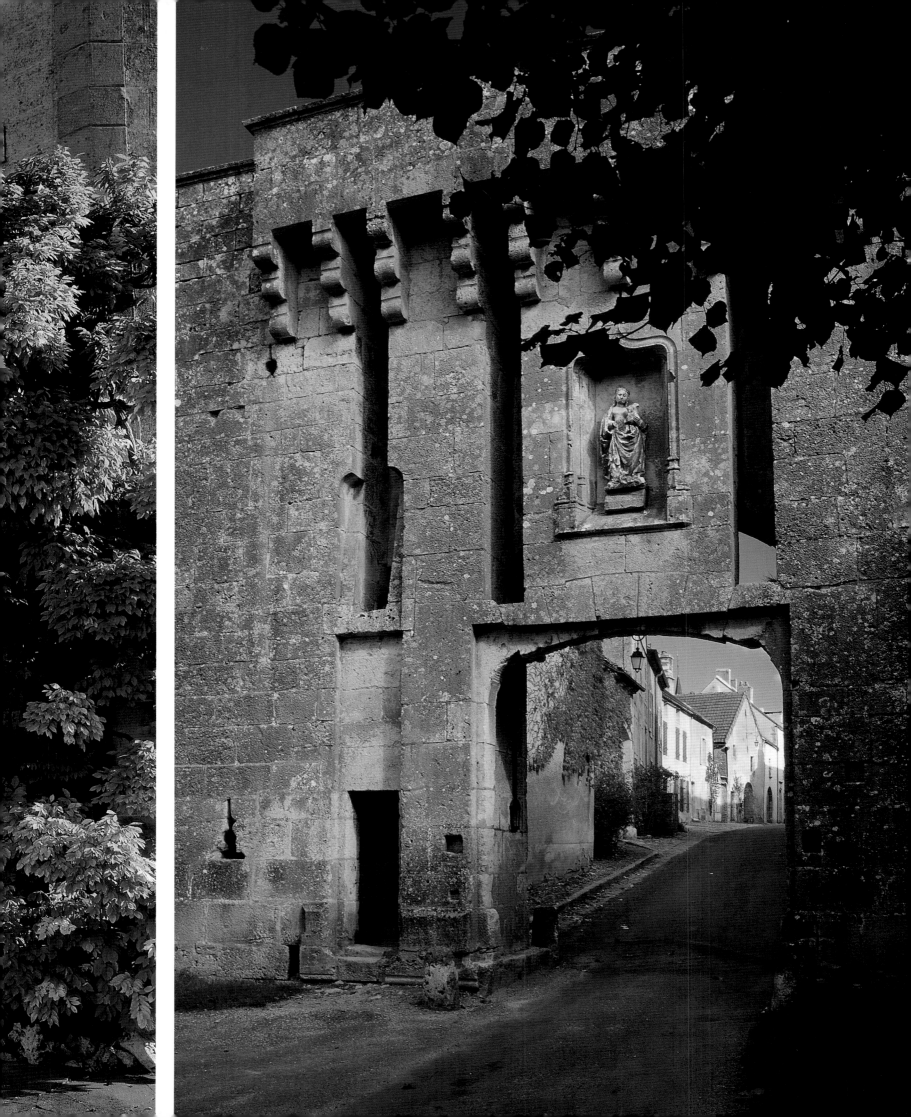

Fontenay

Situated just outside Marmagne, the Cistercian abbey of Fontenay is a remarkable survival of medieval architecture. Founded in 1118 by St. Bernard, abbot of Clairvaux, it was built speedily and its buildings therefore constitute an unusual and charmingly harmonious ensemble forming, as it were, a monastic village.

Cistercians believed in austerity in architecture as well as in worship, and Fontenay perfectly illustrates this, especially in its cloisters and its abbey-church. The latter is the oldest complete church still standing from the time of the Cistercians. Sixty-six metres long, a twelfth-century Romanesque masterpiece, it has a thirteenth-century reredos (alas, mutilated) with scenes from the life of Jesus and the Blessed Virgin Mary. Here, too, are fourteenth-century tombs, a chapter house (with ogival vaulting), the great hall, the monks' dormitory, their warming room, their infirmary, their bakery, their dovecote and their forge. The abbots' house was added in the eighteenth century.

Yet these venerable buildings have survived many vicissitudes. They were looted during the Hundred Years War and during the Wars of Religion. At the time of the Revolution the monastery of Fontenay was secularized and became a paper-mill. In 1906 Édouard Aynard de Montgolfier came into possession of the abbey, closed down the paper-mill and restored the abbey to its former glory.

Since Cistercian monks desired to live apart from the world, their abbey is situated in a valley at the heart of a forest. But here is a park, with fountains and waters from which the monks fished trout. Indeed, the monastery garden, embellished over the centuries, now belies the ancient sobriety of the Cistercians.

In common with the rest of the buildings which make up this fascinating abbey complex, the sturdy gatehouse and elegant gardens have been carefully restored (LEFT and OPPOSITE).

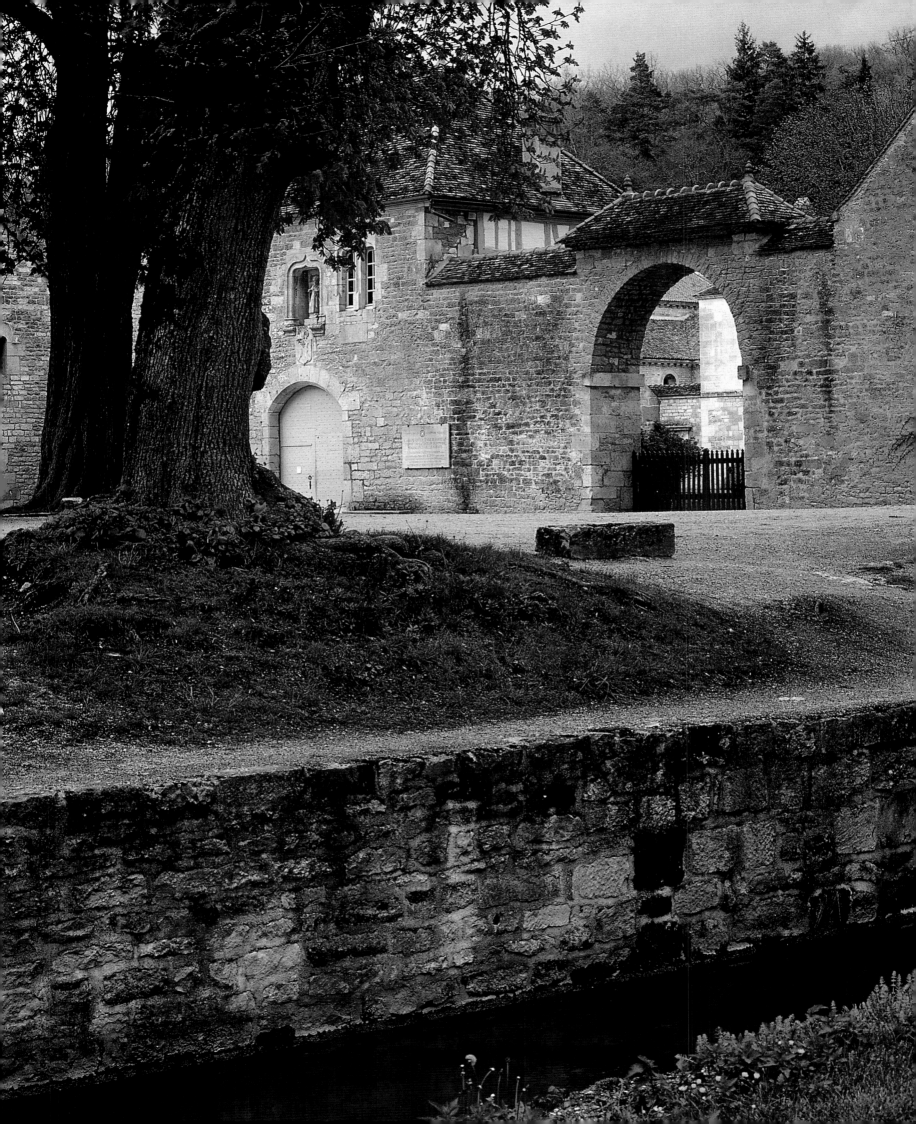

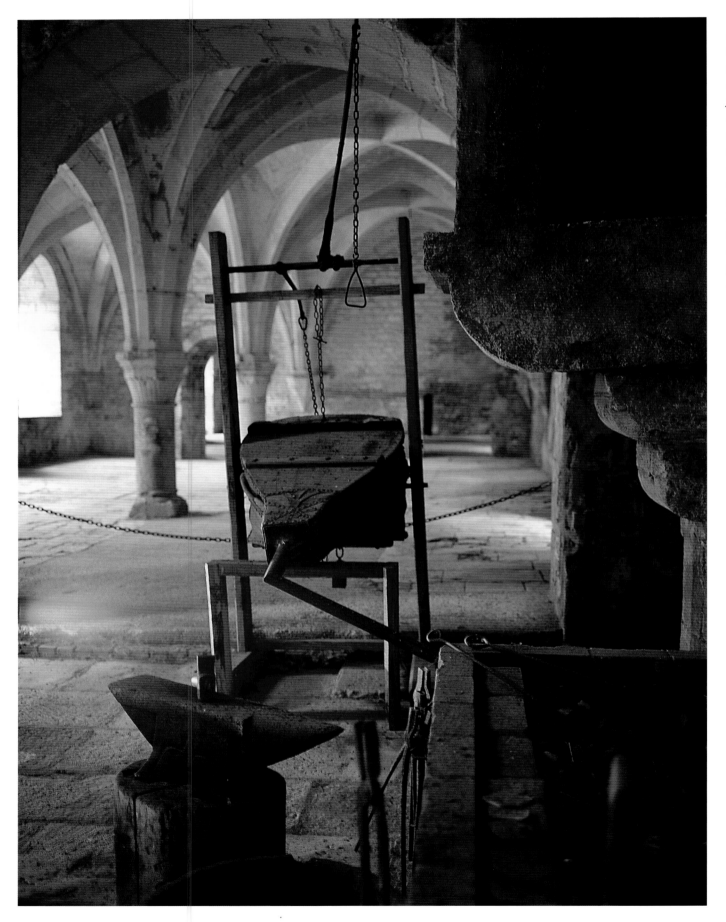

Self-sufficiency was an important consideration in medieval monastic life, and the restored forge (LEFT) at Fontenay reveals just how complete were the resources of the former Cistercian inhabitants of the abbey. But more important to the opus Dei *were study and meditation which the monks would have practised in the stern but lovely cloister (OPPOSITE).*

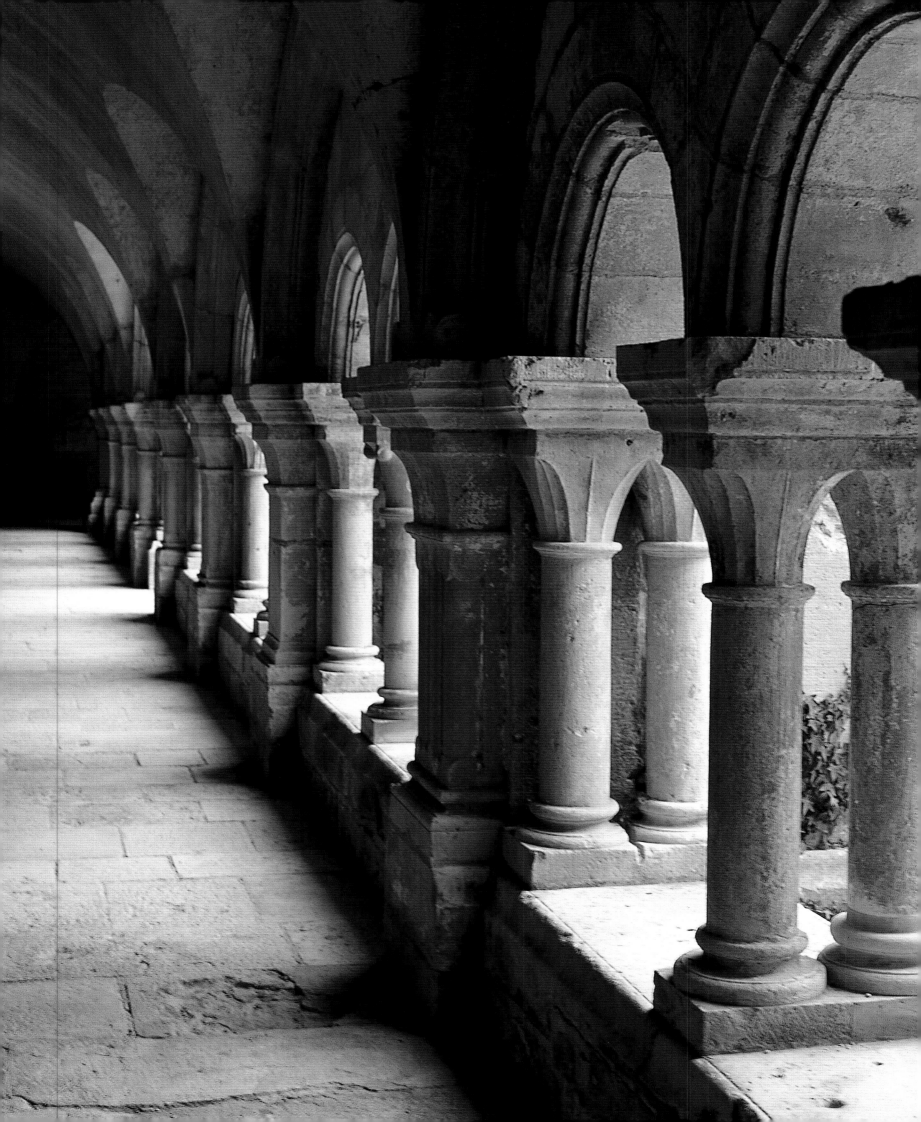

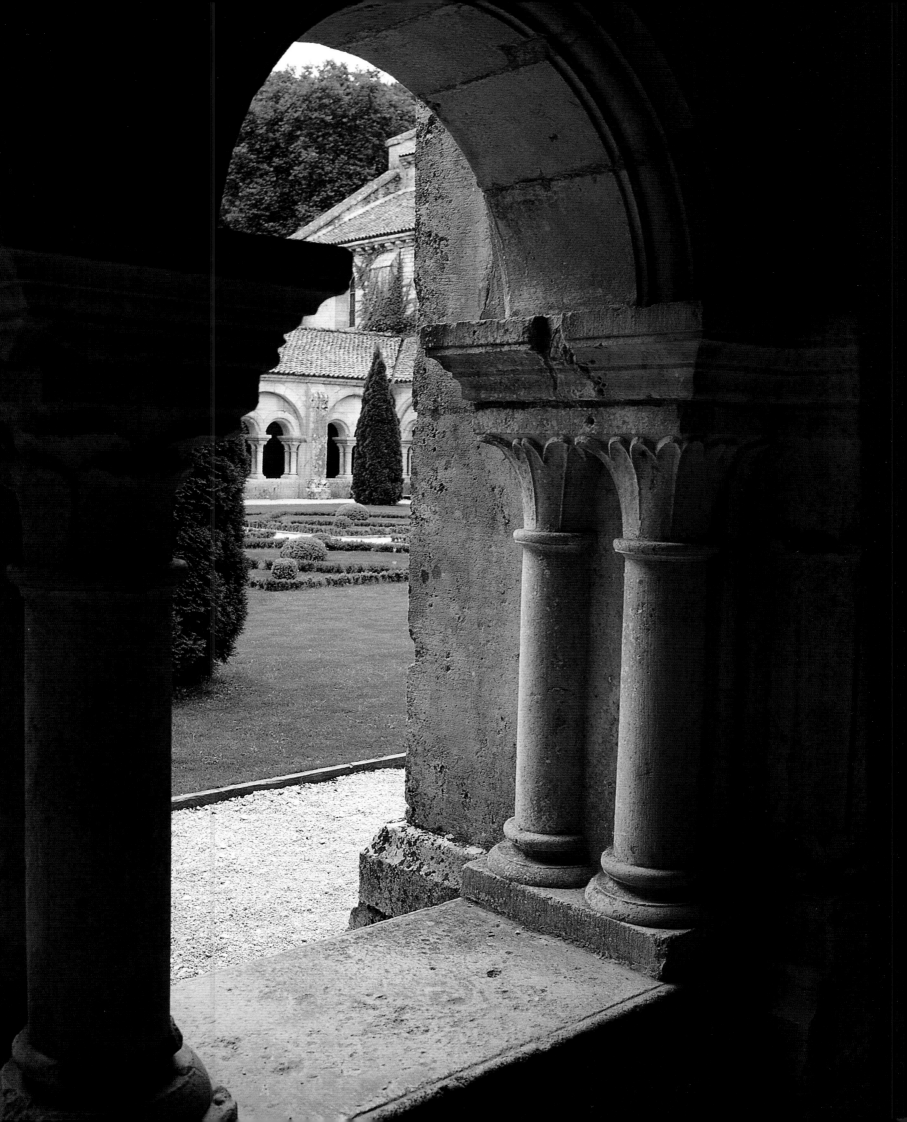

Although their daily lives were strict, Cistercian monks were not blind to the beauty of nature, and at Fontenay they displayed this love of nature in their monastery garden, glimpsed here through the pillars of the cloister (OPPOSITE). In later eras their tastes grew more elaborate, revealed by their sumptuous water-garden (RIGHT).

The abbey was originally founded in 1118, but the abbot's lodgings, seen here on the right, were not built until the eighteenth century, next to the more austere end of the Romanesque church; this group of buildings is completed by two others indicative of the completeness of life at Fontenay: the dovecote and the kennels.

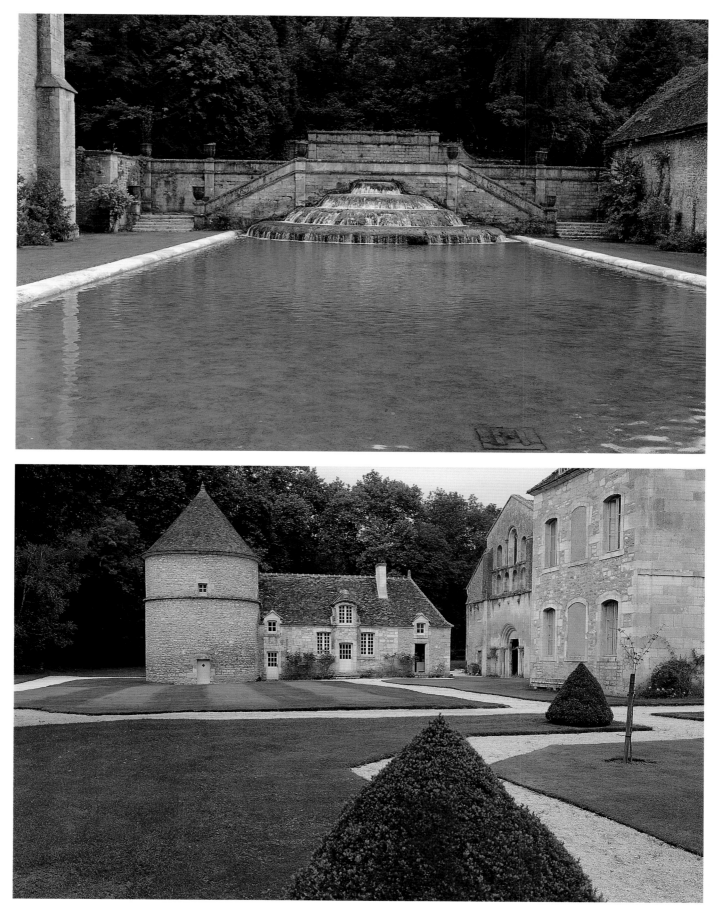

Nolay

*T*he charm of this village derives first from its site in the valley of the Cusanne, overlooked by rocky cliffs, and secondly from its cluster of ancient houses, many half-timbered, some encorbelled, others bearing coats of arms. One of the village's most impressive houses was built in the fifteenth century for the lords of the abbey of Saint-Jean-d'Autun.

Look out for the house of the Carnot family, with its eighteenth-century balcony. The military engineer and statesman Lazare Carnot was a native of Nolay, born here in 1753 and famous for his part in organizing republican forces during the French Revolutionary Wars. The village is embellished with statues of Lazare and also of his son Sadi, in his day a renowned expert on steam-engines. Lazare's grandson, Marie-François Sadi Carnot, became President of the French Republic and was assassinated in 1894. A fountain of 1889 was built partly as a celebration of the centenary of the French Revolution and partly as a memorial to the first two of these distinguished republicans.

Nolay's parish church was rebuilt in the seventeenth century, but retains a flamboyant Gothic chapel, built a century earlier, as well as wooden carvings of the same era. Inside is an ambulatory designed for pilgrims to worship in various chapels, and a seventeenth-century Madonna. Visit, too, the chapel of Saint-Philippe, a fifteenth-century house of God from which you have a splendid view of the surrounding countryside and the Côtes de Beaune. And the market-hall, designed in 1388 for selling grain, has beautifully carpented beams and is roofed in stone.

The curious belfry of Nolay's parish church and one of the village's ancient half-timbered houses, this one near the market square, give some idea of the highly individual appearance of this village. In past times many of these houses sheltered pilgrims, some on their way to Santiago de Compostela, and the parish church of Saint-Martin shelters a fifteenth-century statue of the patron saint of pilgrims, St. James the Great, whose body lies at their destiny in the cathedral of Santiago de Compostela. Nolay's most famous family, that of Carnot, is celebrated in this statue (LEFT).

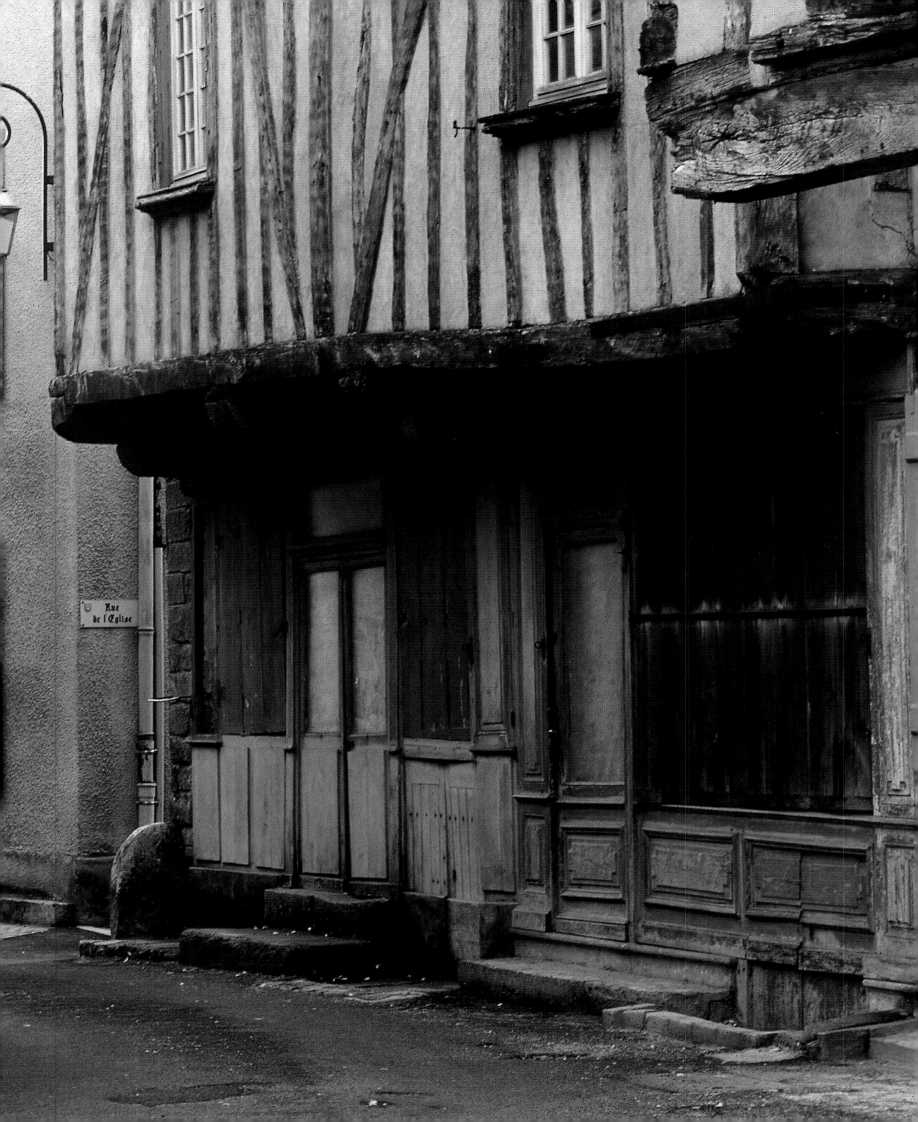

Shop and café fronts lend a certain old-fashioned elegance to the Rue de la République in Nolay (OPPOSITE and BELOW).

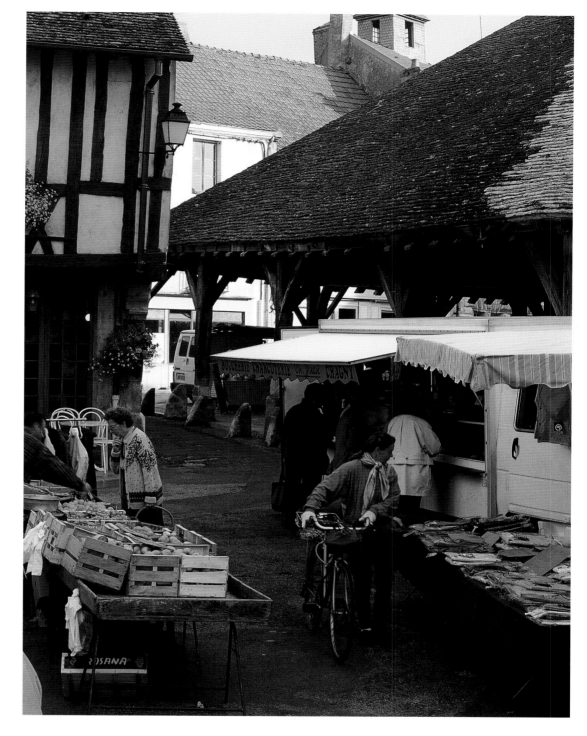

The late fourteenth-century market-hall of Nolay is the picturesque setting for the lively Monday market (ABOVE).

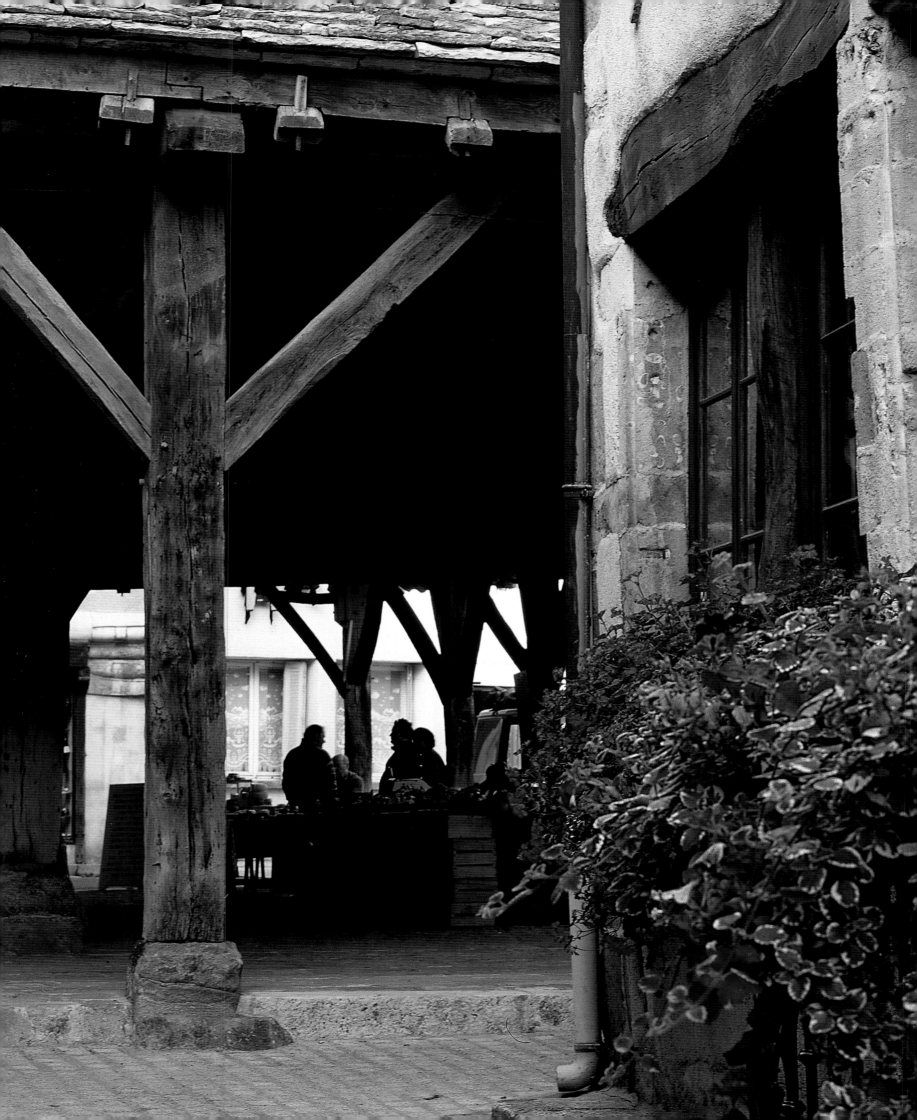

A corner of the market-hall (OPPOSITE); note that the roof is made of heavy, flat, sliced stones, but the pillars and beams, erected in 1388, look more than strong enough to support them. A villager strolls home along one of the gently curving streets off the market square with the freshly baked bread of the morning (RIGHT).

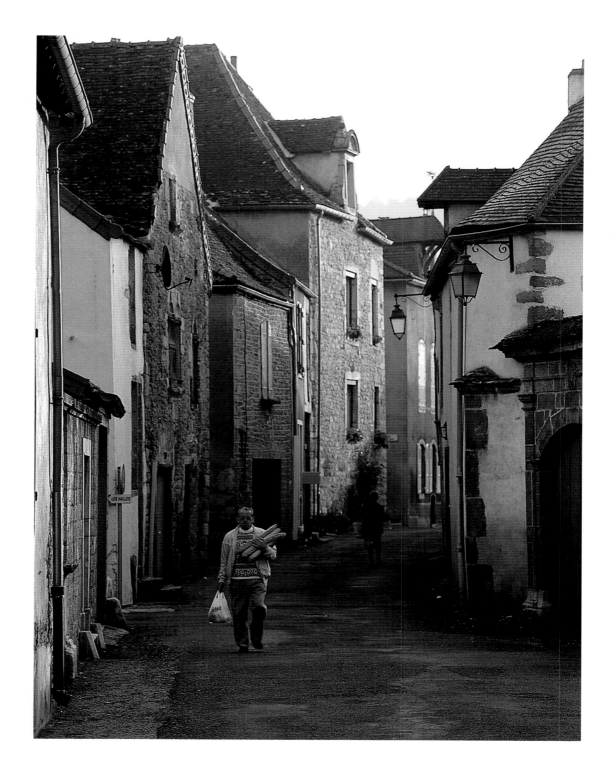

Pommard

The attractions of this village, which lies three kilometres south-west of Beaune, are manifold, not least its wines and winelore. The late eighteenth-century Château de Pommard has a wine-press dating from the sixteenth century. A fourteenth-century cellar, where you can taste wine, can be found at the Château de la Commaraine. Inevitably, an association of wine buffs has been established here, the Confrèrie du Souverain Baillage. The remains of the former fortress of the village also include a fourteenth-century vaulted cellar.

Inside Pommard's eighteenth-century church, with its square belfry, is an exquisite Virgin of Sorrows, painted in the sixteenth century, along with sixteenth- and seventeenth-century statues. Some of the vintners' houses, roofed with brown tiles, still have galleries and Romanesque chimneys. And this is a starting-point for a visit to the vineyards of the Côtes de Beaune.

This route takes visitors through the hamlet of Nantoux, five kilometres north-west of Pommard, where there is a splendid view of the mountain of La Chaume and a fifteenth-century church with sixteenth-century statues. Two kilometres further north-west is Meloisey, a village of fewer than three hundred inhabitants, set amid the vine-covered slopes. Once again the traditional stone-built houses of this village have lower floors of wine-cellars.

Pride in wine is the first emotion of Pommard; behind these gates (BELOW) is one of the closed vineyards of the village; a mélange *of vintners' houses, ancient châteaux and a fine church are here viewed from the west (RIGHT).*

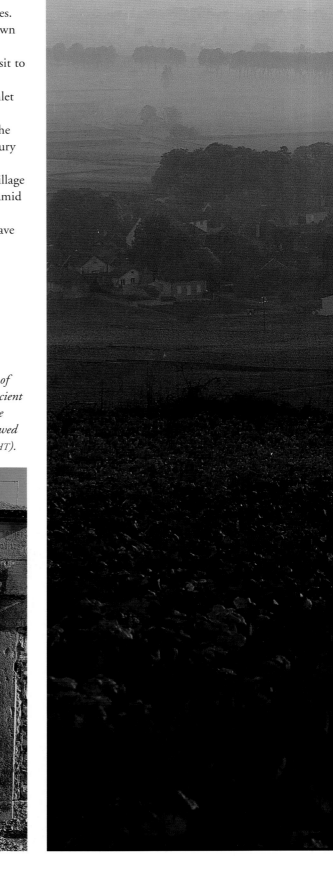

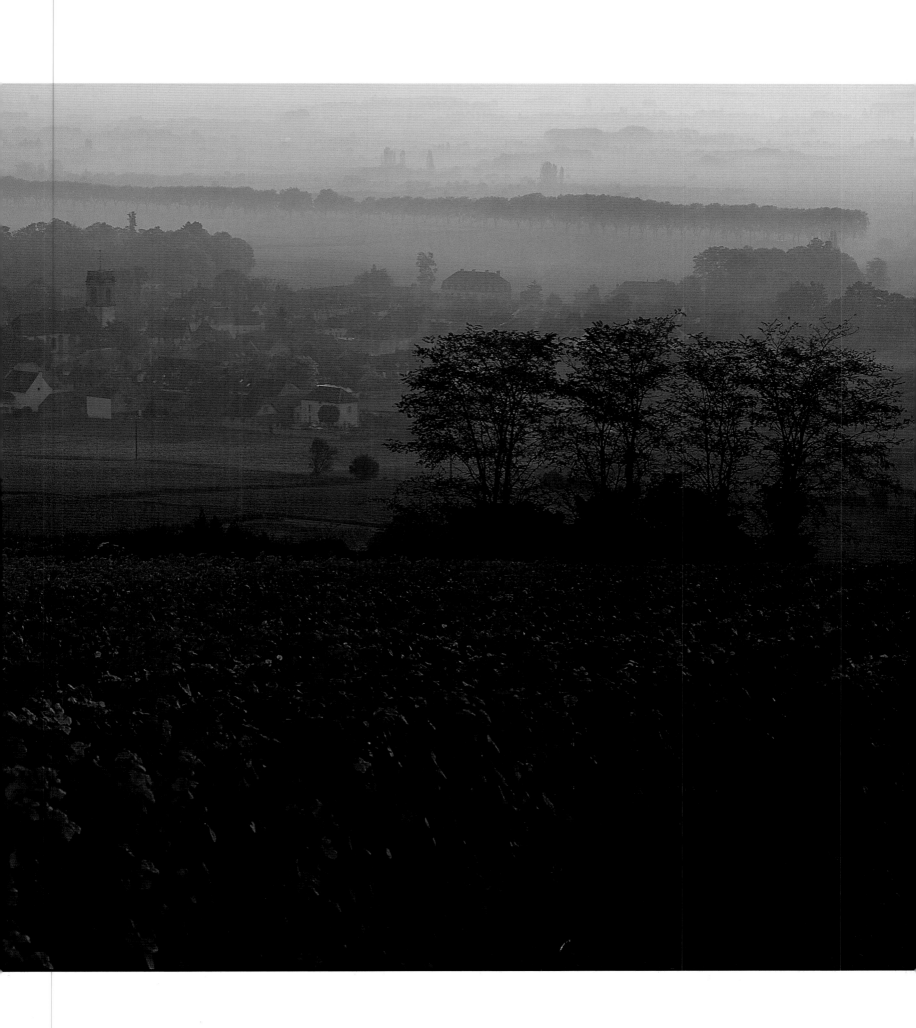

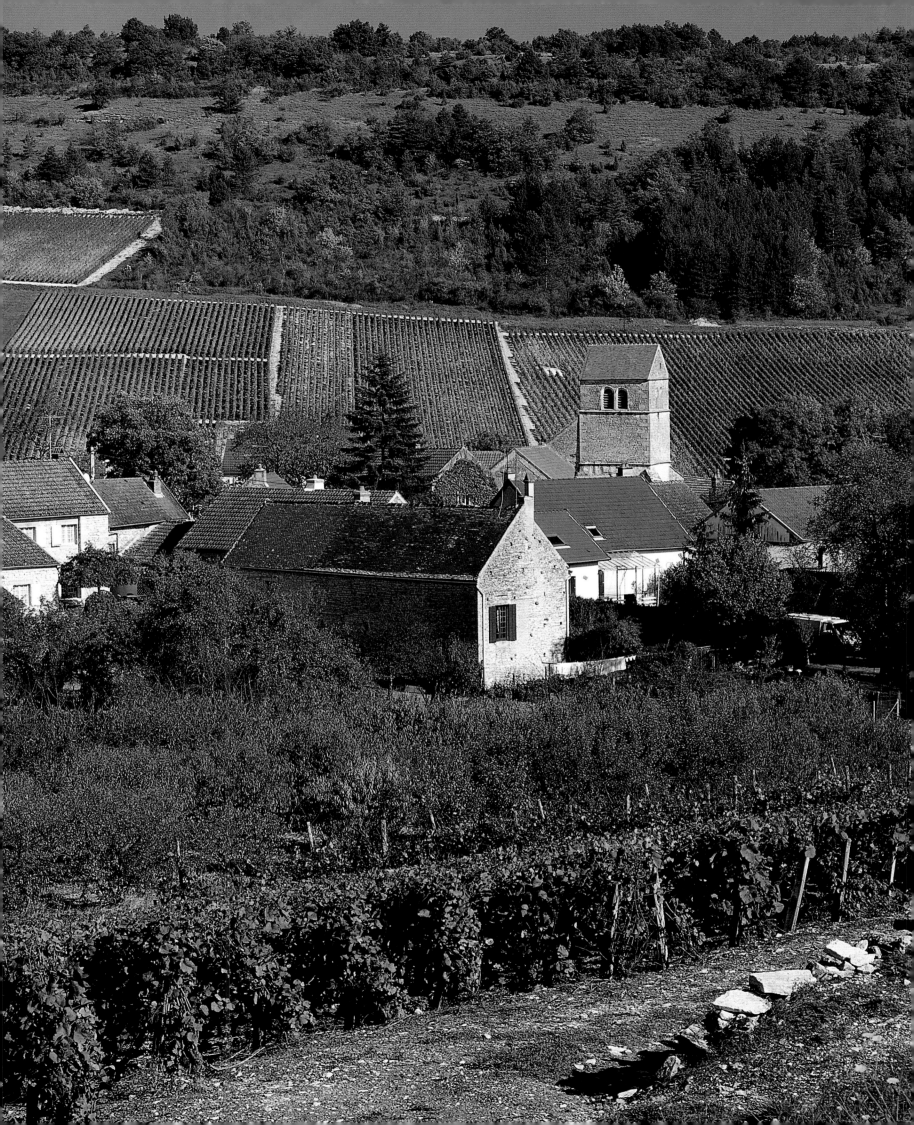

Both the centre of the village (RIGHT) and its immediate surroundings offer the visitors scenes of infinite charm. The hamlet of Meloisey, just to the north of the main village, slumbers in its vineyards beneath a simple yet elegant sixteenth-century belfry (OPPOSITE).

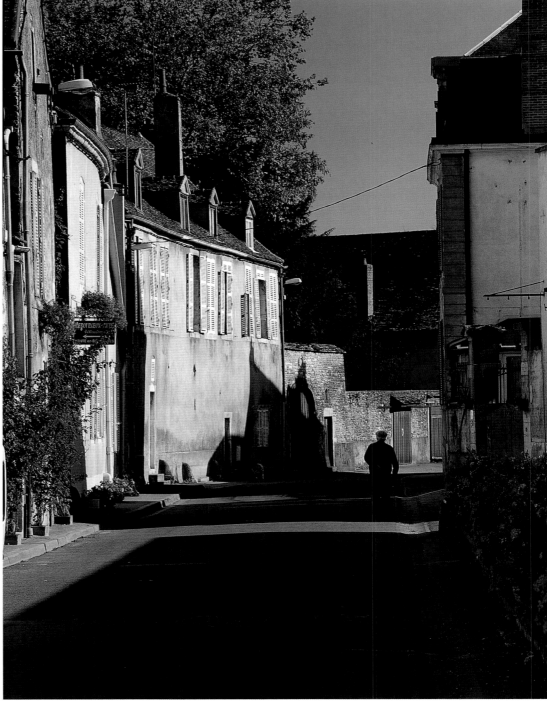

Even apart from its distinction as a wine-producing village, Pommard is an inordinately pretty place (LEFT). The winding streets around the Place de l'Église appear agreeably textured in the light and shade of a summer's day (ABOVE).

Santenay

Philippe le Hardi, brother of the King of France and Duke of Burgundy from 1364 to 1404, is remembered here by a château dedicated to him, roofed with varnished tiles and housing both a huge twelfth-century cellar and a wine museum. Its keep dates from the fifteenth century; the living quarters were rebuilt in the eighteenth century. Here, too, are ancient water-mills and a disused windmill, as well as seventeenth- and eighteenth-century houses.

On the Montagne des Trois Croix stands the little twelfth-century chapel of Saint-Jean-de-Narosse, overlooking the valley of Saint-Jean. It is embellished with statues of medieval saints and excellent stained-glass windows. Do not miss its Romanesque and Gothic capitals. A Renaissance sculptor carved for the church a stone statue of St. Michael. Later, in 1660, a local sculptor named Besulier added a statue of the Virgin Mary and the Dragon.

The name of the village derives from the Latin 'Sentilliacum', referring to a spring of salty mineral water whose healing properties, particularly for those suffering from rheumatism and digestive disorders, were renowned long before the wine of this region. So Santenay remains a spa, and like many another, boasts a casino, with roulette, blackjack, baccarat and the rest.

Its origins are earlier than Roman times. The Montagne des Trois Croix is the site of a Stone Age necropolis. But it is Santenay's white wines which remain its chief attraction today, the vines growing on 380 hectares, most of them Pinot Noir, though white wines are also made from Chardonnay grapes. The vintages are promoted by the local wine confederation, the Confrérie des Grumeurs de Santenay.

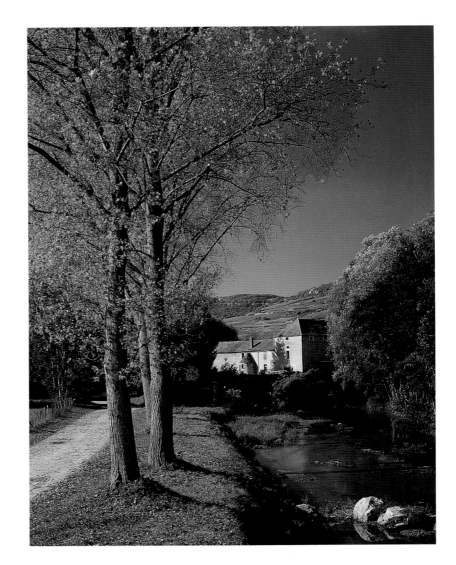

Viewed from the Mont de Sène, the villages of the Côte appear neatly sited in the vineyards which cover every available hectare of this magical land (OPPOSITE). Santenay is at the southern extremity of the Côte de Beaune and is a place of fascinating architectural detail, like this former water-mill on the river Dheune.

The vineyards of
Santenay (RIGHT), on
the banks of the
Dheune, yield sturdy,
long-lived red and
white wines.

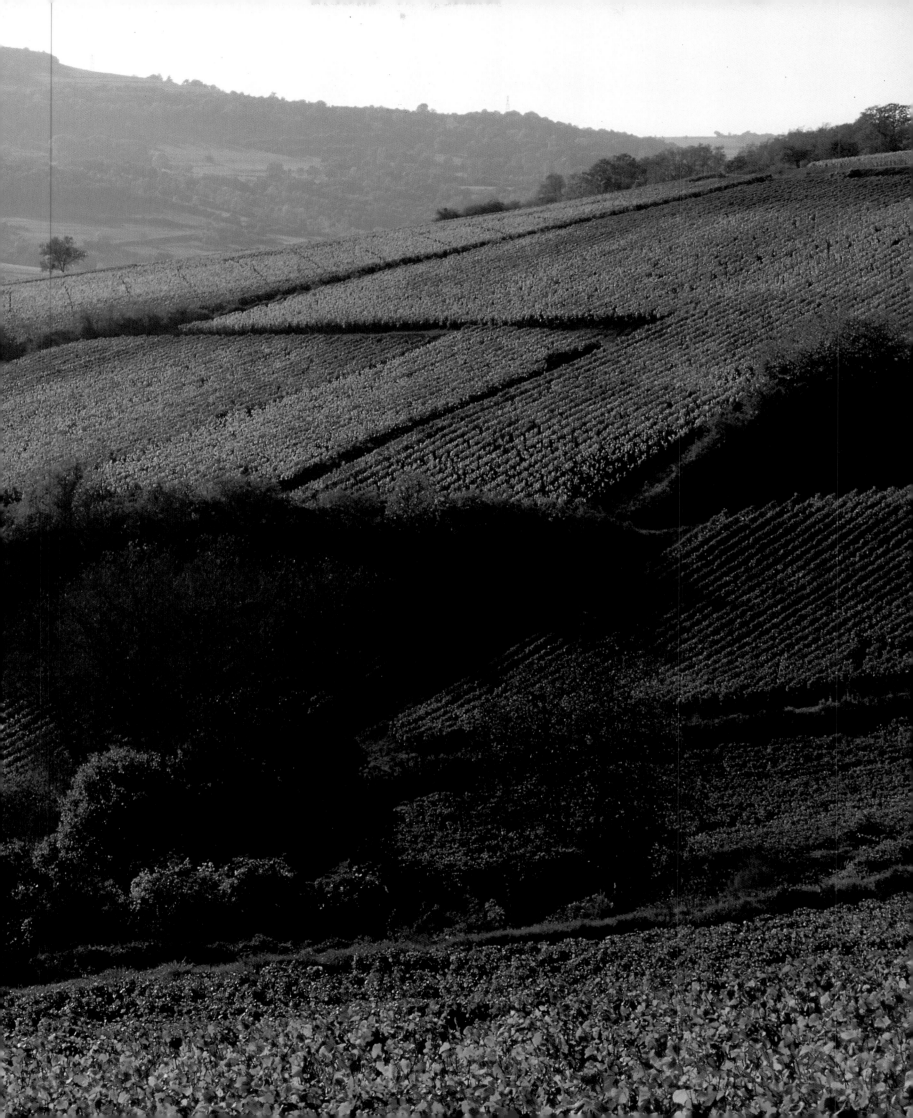

*More details of
Santenay: a leafy
gateway in the Grande
Rue (LEFT); one of the
ornate gates of the
château (BELOW); one of
the remaining
windmills close to the
village (OPPOSITE).*

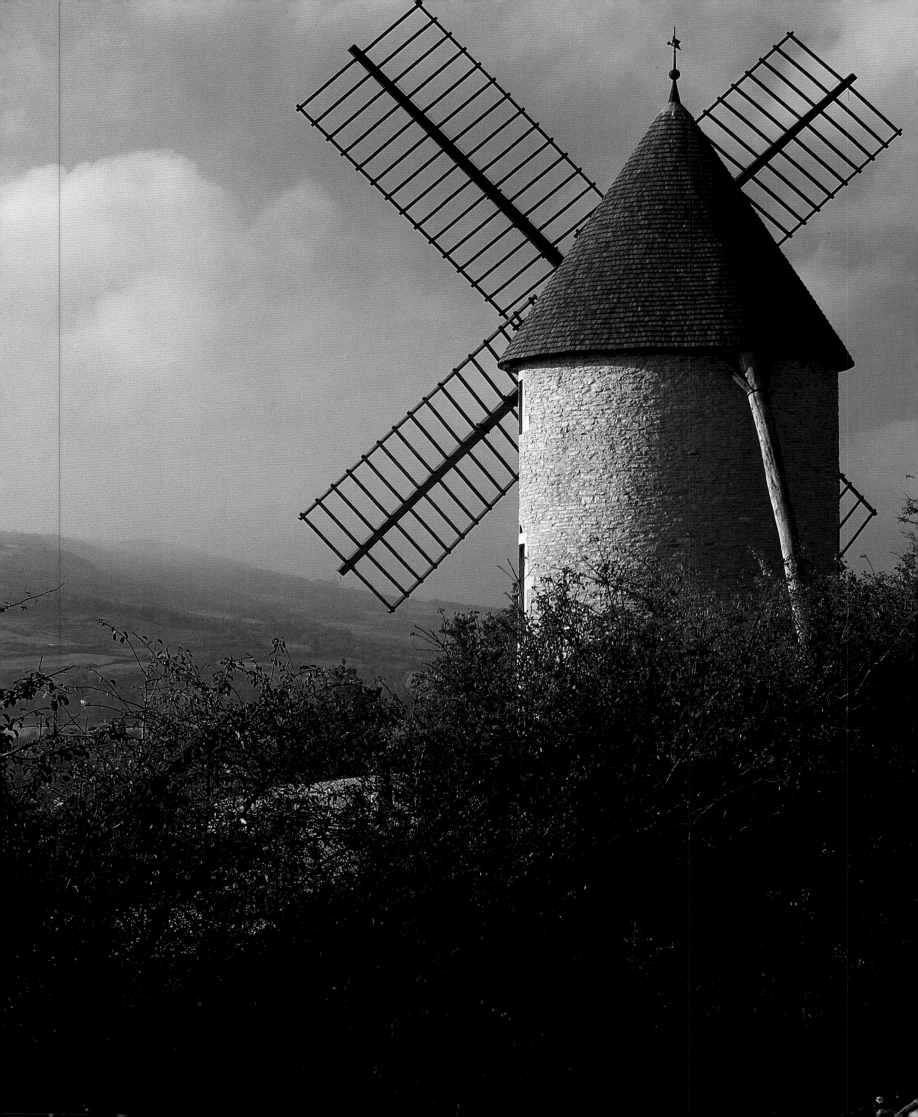

Semur-en-Auxois

This medieval jewel perches on a pink cliff above a curve of the river Armançon. The oldest part is reached through the splendid Porte Sauvigny, a gateway of 1417 which was pierced through the fourteenth-century ramparts. The Rue Buffon, commemorating the great French naturalist from neighbouring Montbard, is flanked by houses whose façades date from the Renaissance and the seventeenth century. It leads to the Place Notre-Dame and the thirteenth-century Gothic church of the same name, one of the finest in Burgundy.

The present church began life in 1225 as part of a priory. It was next staffed by a college of canons and finally became the parish church of Semur. Despoiled during the Revolution, it was beautifully restored in 1846 by Viollet-le-Duc. Its octagonal belfry, rising fifty-eight metres, was added in the fourteenth century. Its Porte des Bleds, in the Rue Notre-Dame, dates from the thirteenth century and boasts a finely carved tympanum depicting the legend of St. Thomas. One of the colonnettes is decorated with carvings of snails - a medieval reference to one of Burgundy's culinary delights.

Inside, the nave is elegant, tall and narrow. Its treasures include rare stained-glass windows depicting local trades - an early fourteenth-century one depicting butchers and another from the thirteenth century showing the work of clothmakers. The heroism and miseries of St. Barbara, including her torture and execution as well as her ascent into heaven, are the themes of another fourteenth-century window. And a celebrated masterpiece in the church is a polychrome Entombment, sculpted in the late fifteenth century. The vault of the apse carries a carving of the coronation of the Virgin Mary.

Dominating the village are four towers from its former fortress, the mightiest the forty-four-metres high Tour de l'Orle-d'Or. Since Semur-en-Auxois sided with the Catholics during the Wars of Religion, Henri IV had its ramparts demolished. Today the Promenade des Remparts, overlooking the Armançon, is planted with trees.

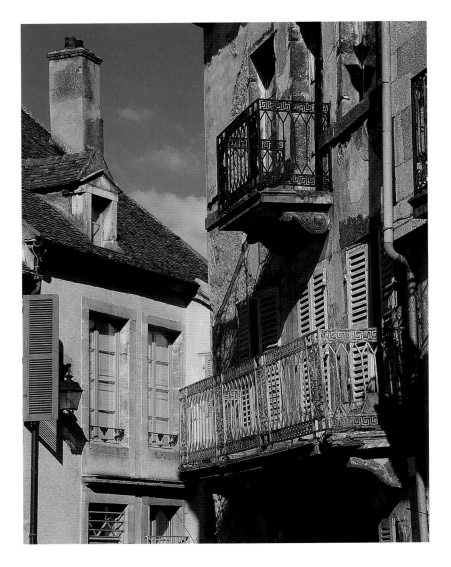

Forged iron decorates many a house in Semur-en-Auxois, a place which (legend has it) was founded by Hercules on his return from Spain. The church of Notre-Dame rises high above the river Armançon, with its gracious bridge (OPPOSITE) and fine houses which make this small town such a delight (OVERLEAF).

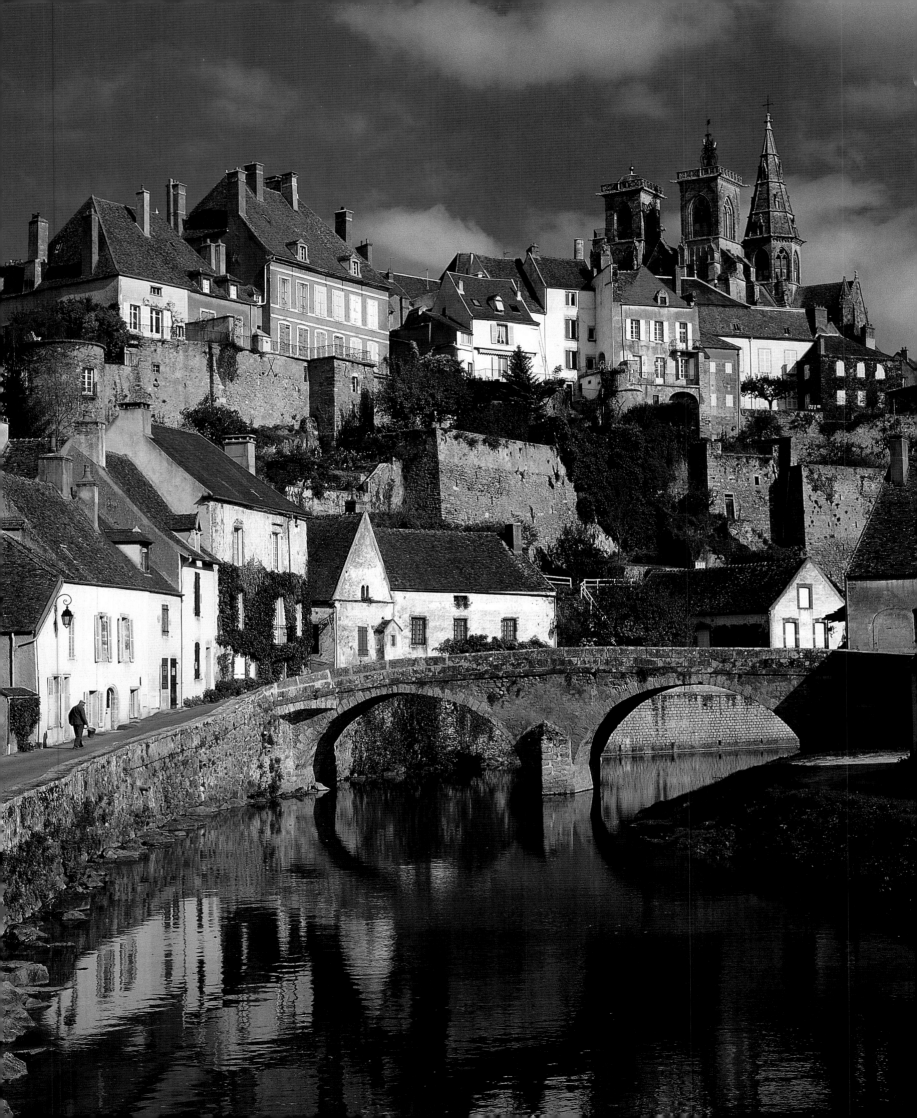

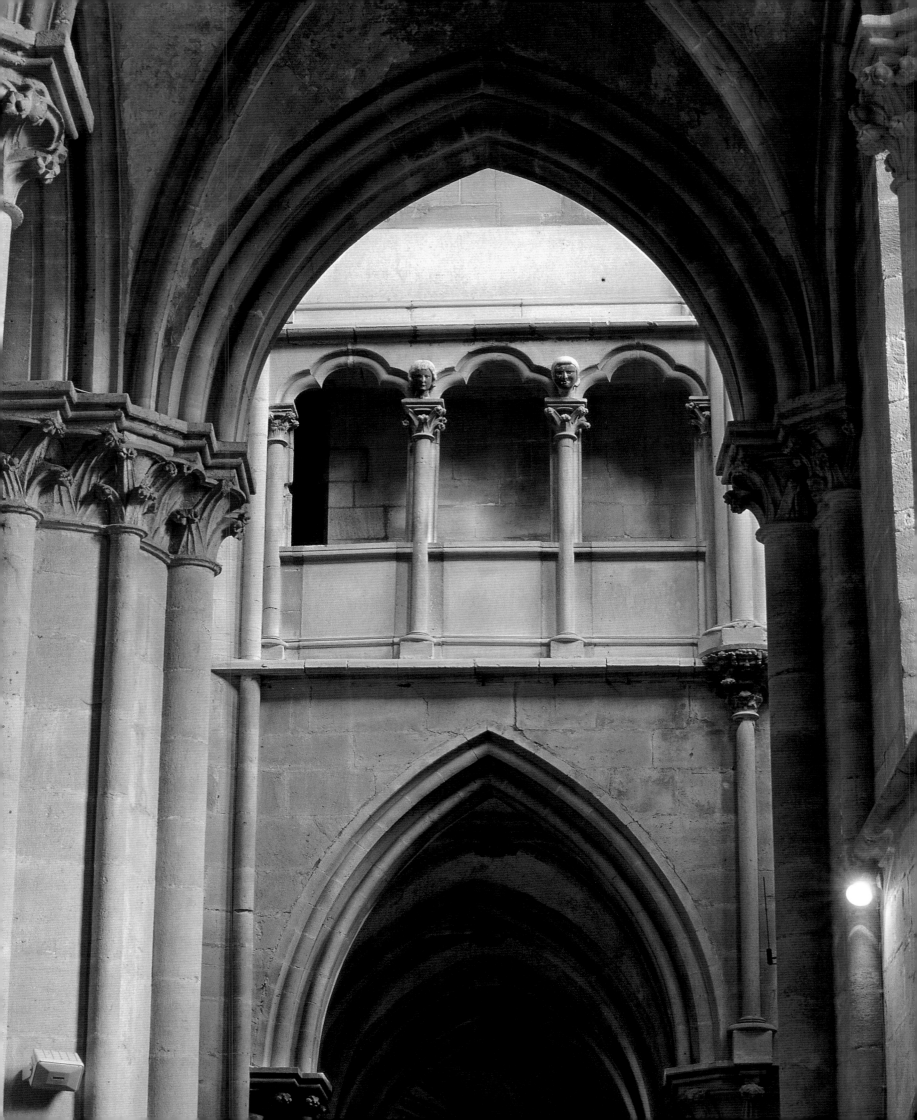

The nave of the church of Notre-Dame is one of the finest in Burgundy (OPPOSITE); the church also has a fifteenth-century statue of Jesus scourged (BELOW) (one of several superb sculptures here). He wears his crown of thorns and reveals the wounds in his side. The high nave (RIGHT) is also remarkable for its Burgundian Renaissance pulpit.

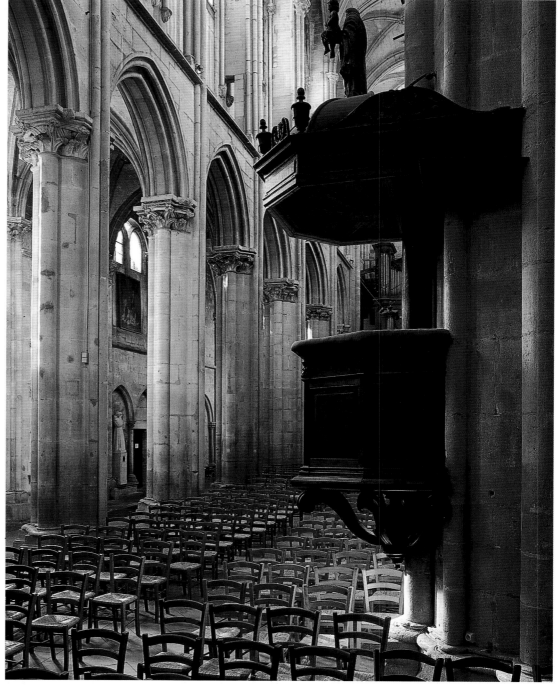

Semur-en-Auxois, although essentially medieval in plan, has many elegant houses from later centuries (ABOVE). The medieval aspect, though, is never far away: the mighty Tour Margot (OPPOSITE), one of four remaining in the village, rises gloweringly above the river Armançon.

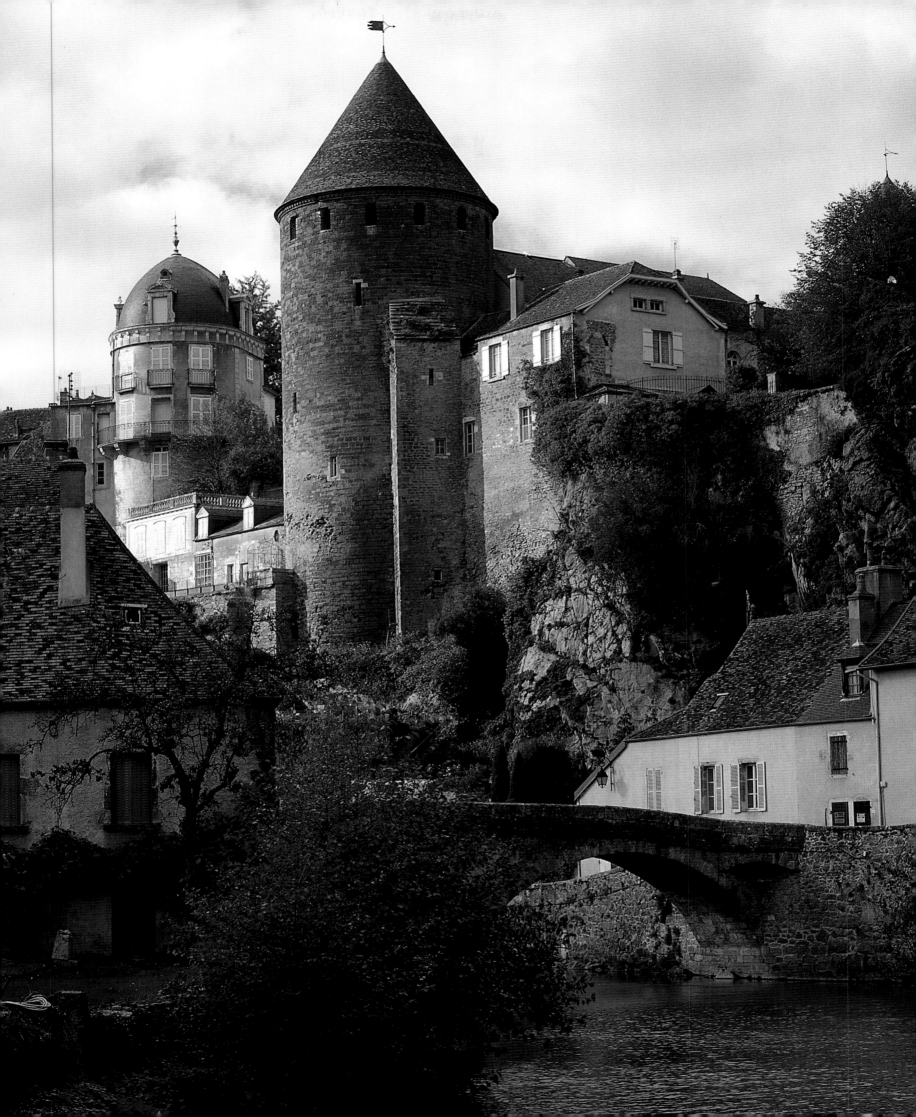

Patterned Roofs of Burgundy

Architectural historians have long speculated on the origins of these voluptuously patterned roofs, but the most favoured explanation is that they reveal a Flemish influence in Burgundy. At Beaune, for example, a city that grew and prospered because of its situation on the route from Flanders to Italy, the medieval hospital, which was founded in 1443, is magnificently roofed in this fashion, the coloured tiles arranged with extreme finesse to decorate dormer-windows and towers as well as the main roofs.

Though they decorate mostly ancient buildings, many of the patterned roofs of Burgundy date from the nineteenth and early twentieth centuries, or at any rate were restored in that era. The magnificent château at La Rochepot, south-west of Beaune, is a perfect example of such

Polychrome details from two houses at Montchanin in Saône-et-Loire (BELOW LEFT and RIGHT); the tile factories there reached the peak of production in the nineteenth century. The Palais Synodal at Sens in Yonne, built in the thirteenth century, offers a superb example of a Burgundy roof tiled like a patchwork quilt (RIGHT).

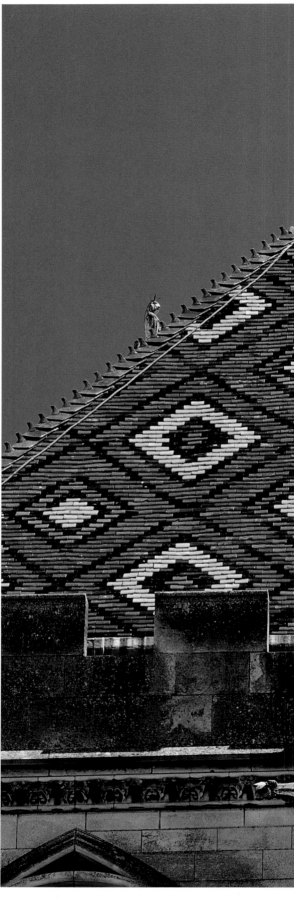

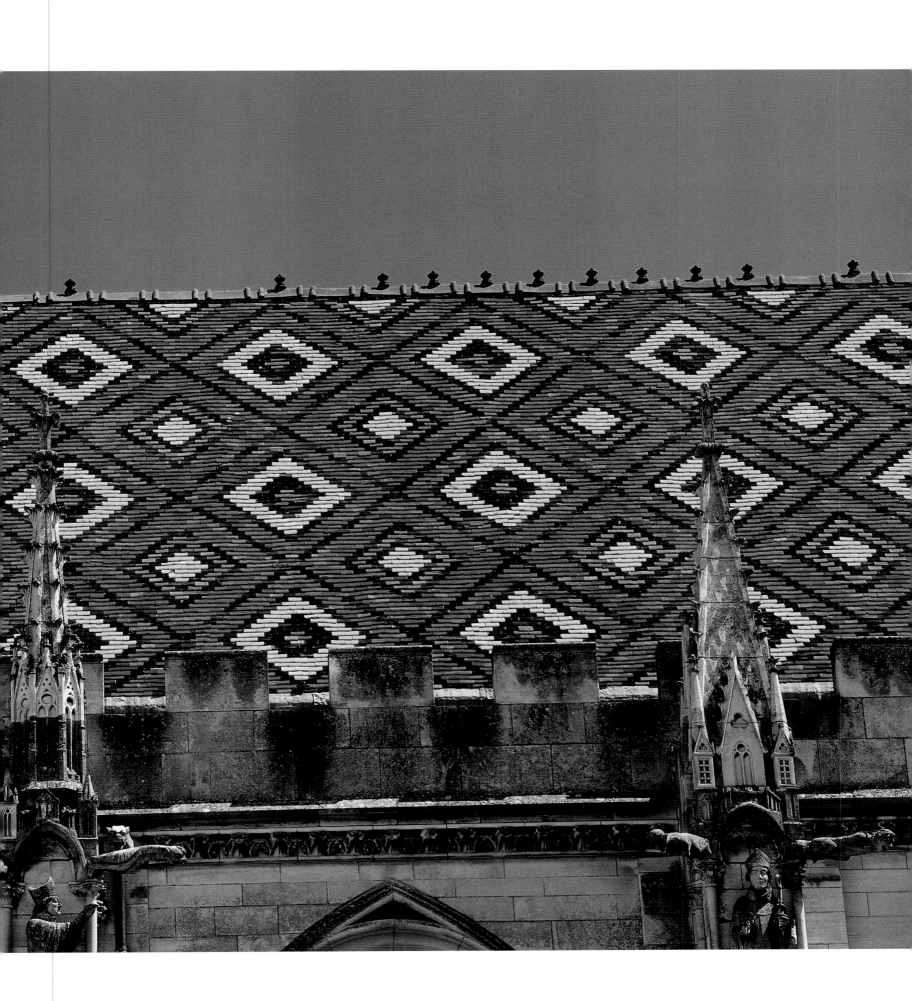

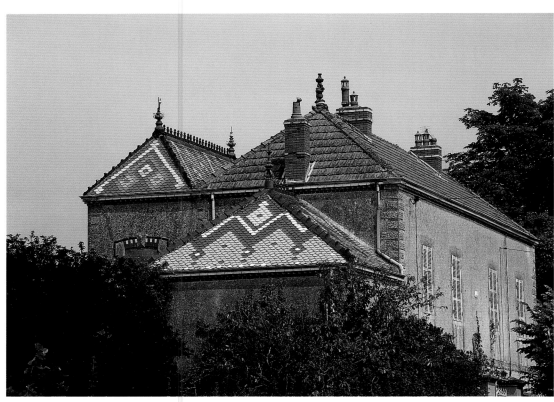
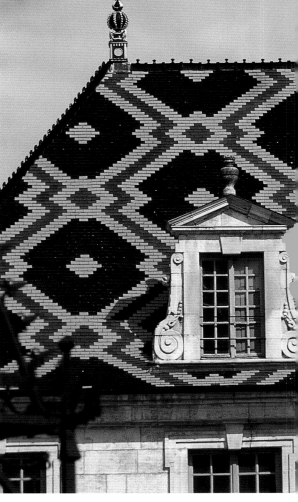
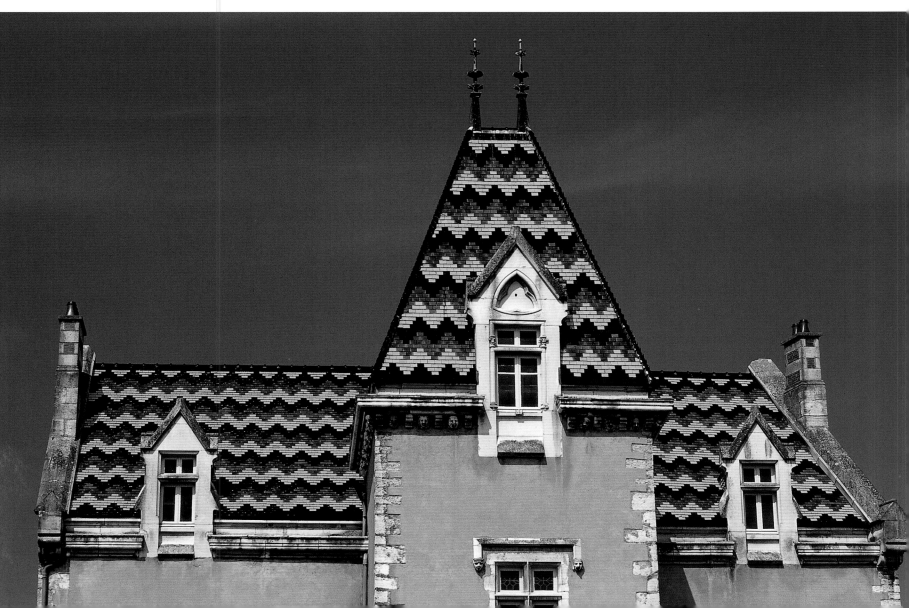

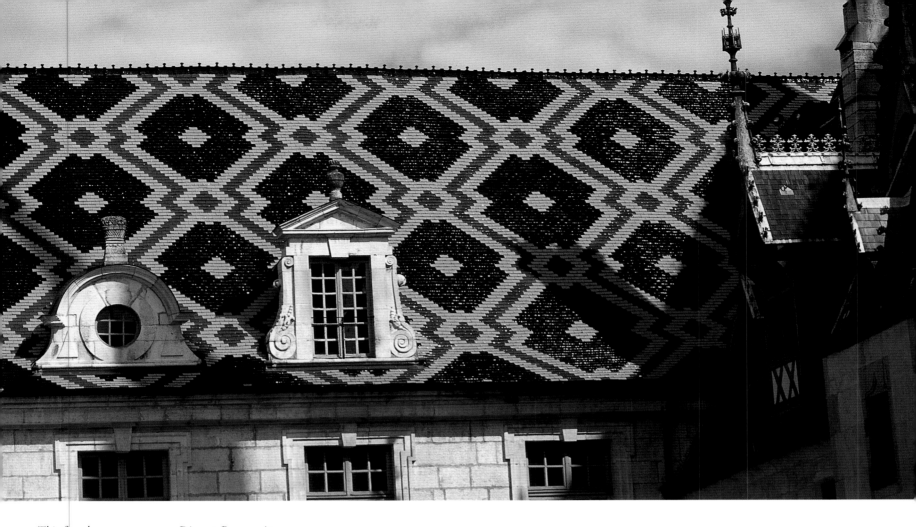

This farmhouse near Montchanin (OPPOSITE ABOVE) is a fine domestic example of Burgundian roofing in multi-coloured tiles. Much grander, however, is the magical Hôtel-Dieu at Beaune, its tiled roof rightly considered one of the finest of the whole region, as is that of the Hôtel de Ville of Meursault (OPPOSITE BELOW).

renewal. Beginning as a medieval fortress, it was extended in the fifteenth century, but at the time of the French Revolution was plundered and fell into ruin. In 1894 the son of the French President, Sadi Carnot, employed the architect Charles Suisse and the sculptor Xavier Schanovski to restore it. They succeeded brilliantly, though creating a late nineteenth-century vision of the Middle Ages. Once again the geometrical, polychrome tiles of its roof and spires rise from woods above the little village, among hills and vineyards which produce the *appellation* Côte de Beaune-Villages.

Likewise at Sens, the thirteenth-century Palais Synodal next to the cathedral, with its magical pattern-tiled roof, was restored in the nineteenth century by no less an architect than Viollet-le-Duc (who, incidentally, once said he would not mind falling ill if he could be cared for in the medieval hospice of Beaune).

In the same century, the town of Montchanin in the *département* of Saône-et-Loire became famous throughout Burgundy when H.-P. Schneider founded here a tile factory. Montchanin prospered, the skills of its tile-makers still in evidence here as elsewhere in the form of ostentatious but also practical and aesthetically delightful patterned roofs.

Like La Rochepot, the wine village of Meursault in Côte d'Or boasts such a roof. Its town-hall began life in 1337 as a château. Beautifully restored, its tiled roof is magnificent, as are the wines of the vineyard it overlooks. This ambience of architectural splendour and wine so impressed the novelist Stendhal when he passed through Burgundy in the eighteen-thirties that he noted that not only did the stones of the region display a remarkable delicacy; but also the faces of the people. 'The people whom I encountered near Dijon, were little, dry, vivacious and coloured,' he wrote, adding, 'One perceived that the good wine governed their temperament.'

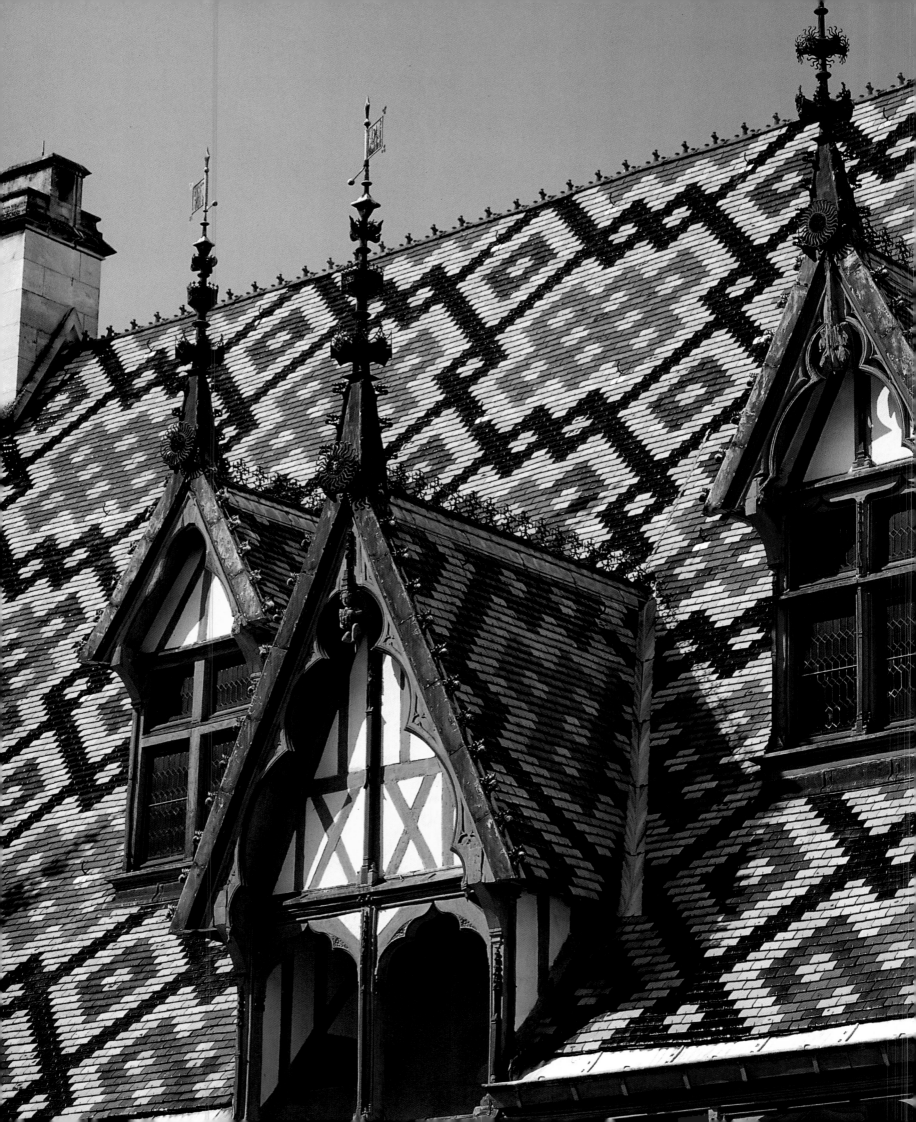

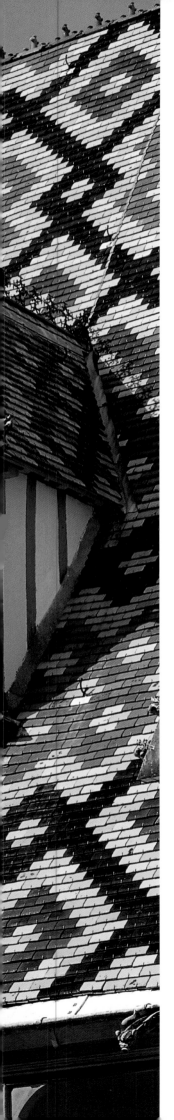

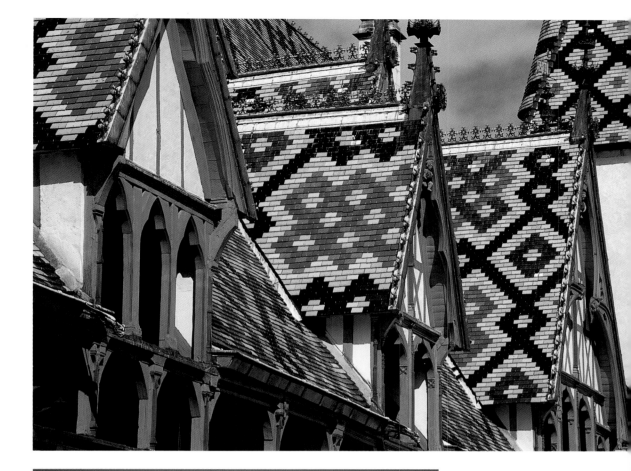

The Hôtel-Dieu at Beaune is a complex building, a complexity reflected in the many surfaces of its superb patterned roof (*LEFT* and *RIGHT ABOVE*). At La Rochepot is one of the finest châteaux of the whole of Burgundy; part of the main roof and some of the towers have been embellished with polychrome tiles (*RIGHT*).

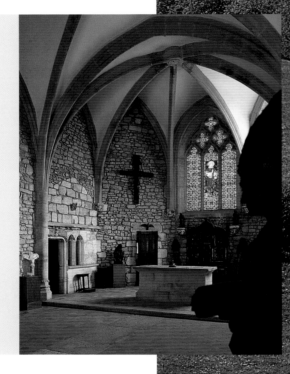

Saône-et-Loire

Anzy-le-Duc
Buxy
Couches
Cuiseaux
Semur-en-Brionnais

As its name implies, the *département* of Saône-et-Loire is crossed by rivers. And the Canal du Centre, finished in 1793, links the Saône with the Loire. Once a major artery for cargoes, today this canal delights visitors with pleasure boats. At almost every confluence of river and canal stands an ancient town or village. This is the southernmost part of Burgundy and for the most part rural country. Rich in history, it has on Mont Beuvray the remains of the impressive Celtic settlement of Bibracte, surrounded by battlements, and today the largest archaeological site in Europe. Later, the Romans enjoyed the spa at Bourbon-Lancy, with its hot baths (reputed to alleviate arthritis and rheumatism, as well as cardio-vascular problems), and around the year 10 B.C. the Emperor Augustus founded the town of Autun. As the centuries passed, formidable fortresses (the oldest one, the fortress of Saint-Hugues at Semur-en-Brionnais), fortified farmhouses, superb châteaux and magical churches (among the finest Romanesque examples in France) embellished the varied landscapes of the region.

The pastures of this area have long nourished white beef cattle, sheep and goats, the latter especially in the Brionnais countryside. They ensure that many markets, such as the Monday one at the lovely village of Marcigny, offer splendid goats' cheeses. For this part of Burgundy is diverse, an amalgam of entrancing aspects, so that successive explorations of the *département* continually reveal new facets. Haut-Folin and Mont Beuvray, the highest peaks of the Morvan mountains, are situated here in Saône-et-Loire. Here are dark forests, lakes, valleys cleaving their way deep through the countryside, barren moorlands, the temperate patchwork of the Bressan *bocage*, with its half-timbered houses, rivers and ponds, the pastures of the Charolais-Brionnais, and vineyards, rising on the eastern side of the river Saône as its flows from north to south of the *département*. Here the traditions of wine-making are treasured, with only four types of grape cultivated: Chardonnay, Aligoté, Pinot Noir and Gamay. The houses of the *département* are often picturesquely garlanded with vines.

(PREVIOUS PAGES)
Saône-et-Loire is a land of many architectural gems, such as this fifteenth-century Gothic chapel in the château of Couches (INSET), and of rolling agricultural land, famous for its Charolais cattle (MAIN PICTURE).

The varied abundance of this part of Burgundy is revealed at the Monday market of Marcigny (OPPOSITE).

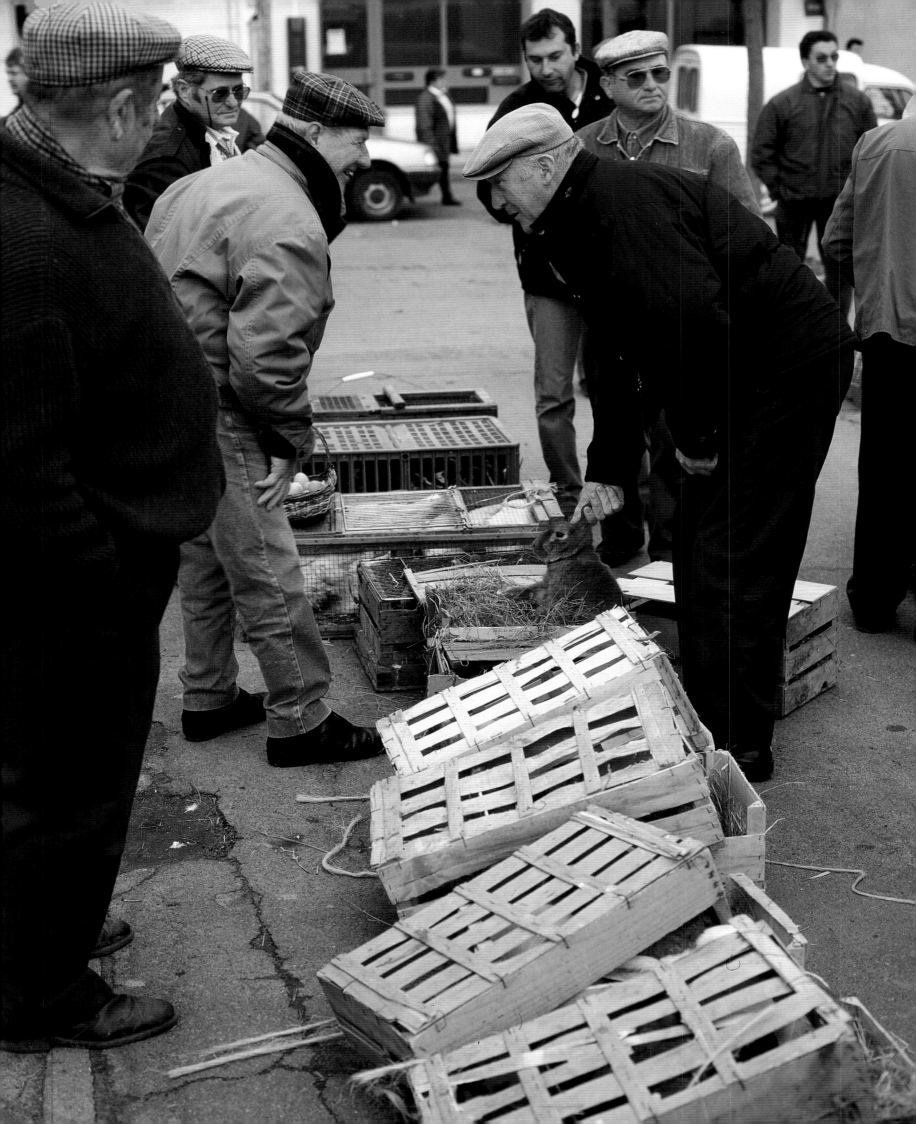

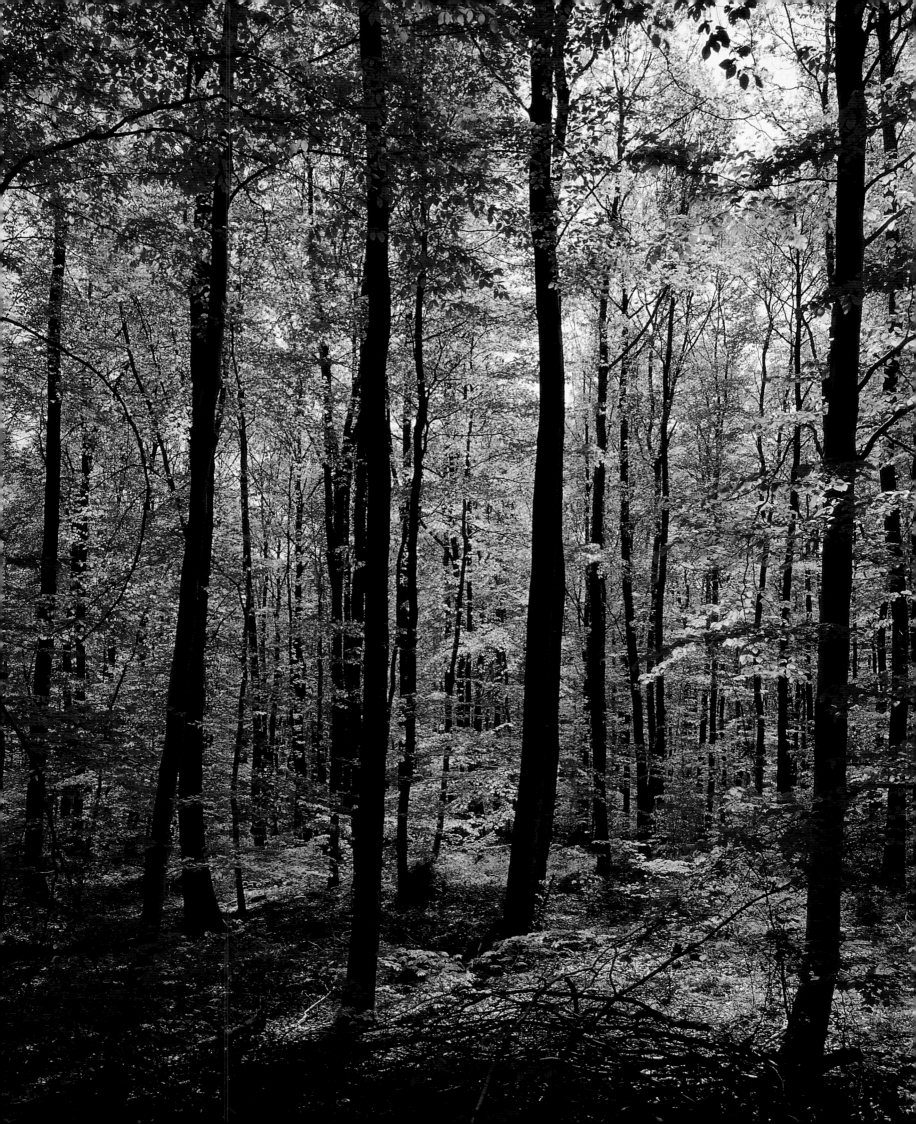

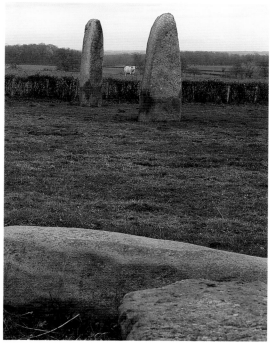

Saône-et-Loire's bounty - natural, architectural, historical - is amply revealed in these images: the Planoise forest (OPPOSITE); the postern house at Semur-en-Brionnais (FAR LEFT); menhirs at Epoigny (LEFT); and the entrancing main square of Cuiseaux (ABOVE).

Anzy-le-Duc

*T*his village boasts one of the finest Romanesque churches in southern Burgundy. Its three-tiered octagonal tower rises majestically above the Brionnais countryside and the green valley of the Arconce. Each tier is pierced with twin openings, and decorated Lombardic arcades add to its charm.

Built of deep-ochre limestone in the eleventh century, this church, dedicated to Our Lady in her Assumption, began life as a priory dependent on the monastery of Saint-Martin-d'Autun. This is a perfect example of Cluniac religious architecture, and served as a model for Sainte-Madeleine in Vézelay. Its frescoed central apse has four apsidal chapels and stretches further because of an axial chapel. The nave, which stretches over five bays and which is enlarged with side aisles, has entrancing groined vaulting. By contrast, the opposite end of the apse is unassumingly rustic.

But the glory of this church is its Romanesque carvings, enlivening its tympana, cornices and capitals. A particular treasure depicts the sacrifice of Abraham. The scenes sculpted on the west side of the church represent sinful human beings, dominated by evil, which is frequently represented by animals. This is where pilgrims would enter the church, to make their way to the crypt, in which lay the bones of the Blessed Hugues, the Benedictine monk who came here to found the priory. His remains were venerated here until 1576, when the Huguenots profaned his tomb and burned his sacred bones. The west porch also displays an enthralling carving of 1118 depicting Jesus enthroned.

Vestiges of the former priory still stand in this village. Its history has not always been placid. The Black Prince ravaged Anzy-le-Duc in 1366, the Huguenots did the same in 1576 and the Catholic League added their depredations in 1594. The stones of the priory were sold as national goods in 1791, but the citizens of Anzy-le-Duc speedily bought them back. Some of the old twelfth-century ramparts also remain, as well as eighteenth-century houses.

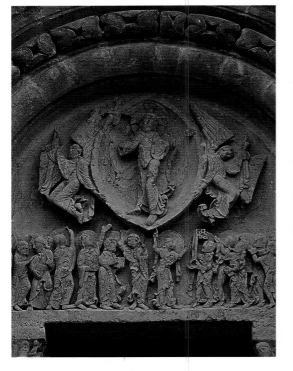

The octagonal belfry of the priory church of Anzy-le-Duc rises nobly above the other buildings (RIGHT) which include many delightful houses. This church has an outstanding Romanesque tympanum (LEFT) over its south gate, depicting the adoration of the Magi and the temptation of Adam and Eve. At nearby Montceaux-l'Étoile is another fine tympanum of Jesus in majesty, flanked by angels (FAR LEFT).

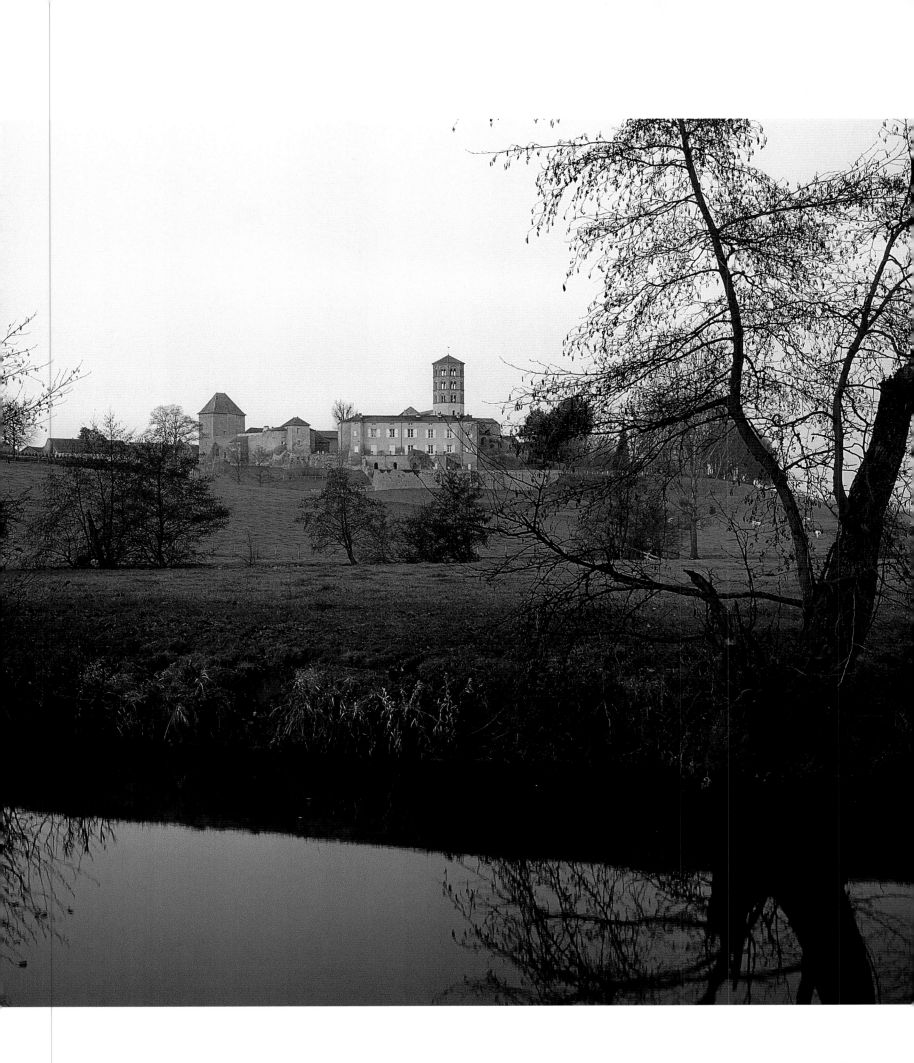

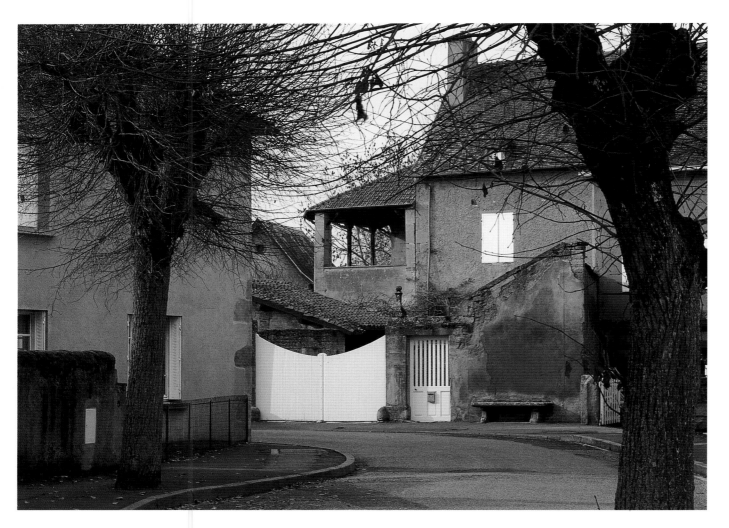

*The traditional craft
of Burgundian
metalwork is still alive
in Anzy (OPPOSITE),
a village of many
quiet and seductive
corners (ABOVE).*

Buxy

Set on the wine route from Beaune to Cluny fourteen kilometres south-west of Châlon-sur-Saône, the upper village of Buxy is a delightful *mélange* of houses with grey-tiled roofs, in a spot which was once fortified and protected by a fortress. Today the fortress is in ruins as are most of the former defences, the most impressive survivals being a couple of round towers - the Tour Rouge and the Tour Saccazand. Many of the vintners' houses date back to the fifteenth and sixteenth centuries. The Château de Buxy was begun a century earlier and completed in the sixteenth, apart from the addition of an Empire-style façade.

As for the parish church, parts are Romanesque, while the façade dates from the fourteenth century and the clock-tower from the sixteenth. Renowned for their white wines, particularly Bourgogne Aligoté, the vineyards around Buxy, which are part of the Côte Chalonnaise wine-growing region, also produce a fine Bourgogne Rouge, as well as the sparkling Crémant de Bourgogne. Wine-tasting here, especially of the copper-coloured Montagny, is particularly agreeable in the cellar of the Tour Rouge.

Aspects of a wine village: on this advertisement for the wines of Buxy the whole village seems to have succumbed to bucolic excess (BELOW LEFT) yet the grapes are still being trod; in another sign (BELOW RIGHT) a young man, a traditional grape-holder on his back, tempts one of the village maidens with a fragrant glass; a traditional half-timbered house on the Place de l'Église (OPPOSITE).

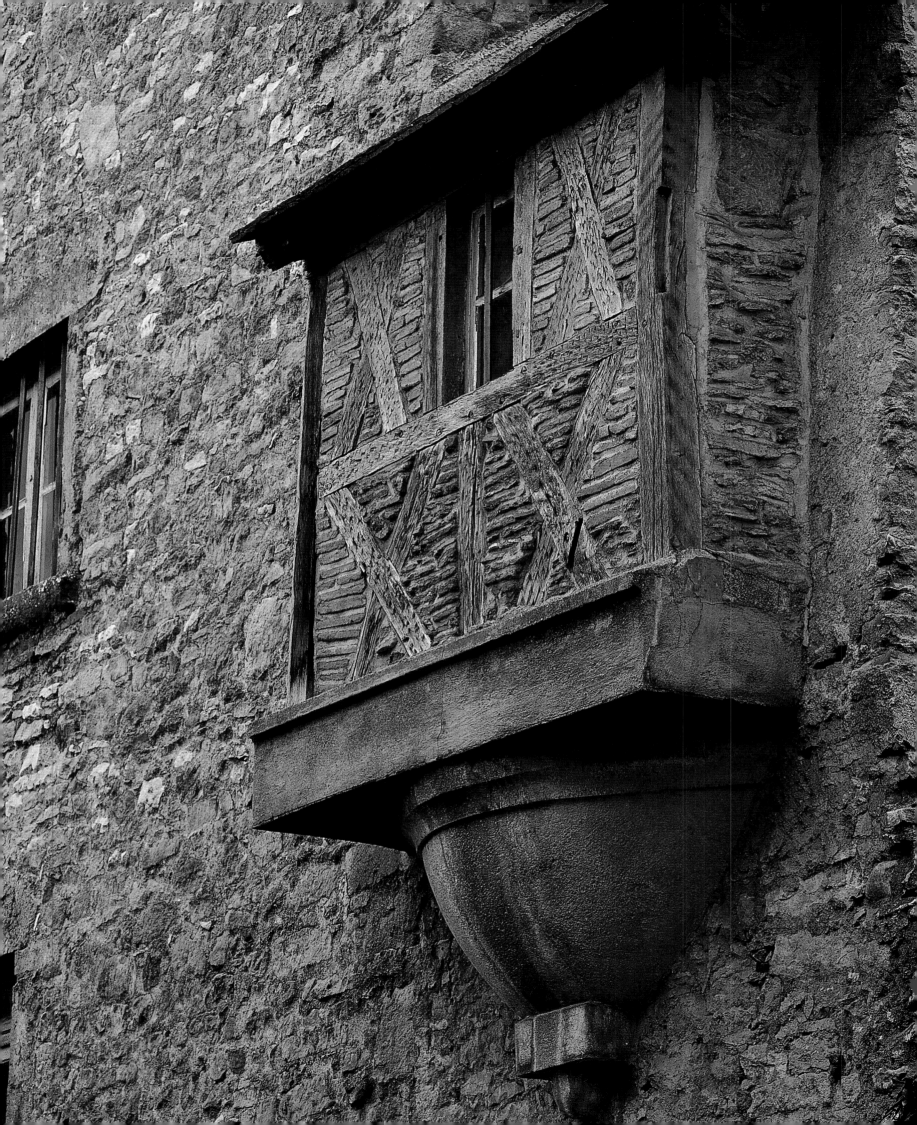

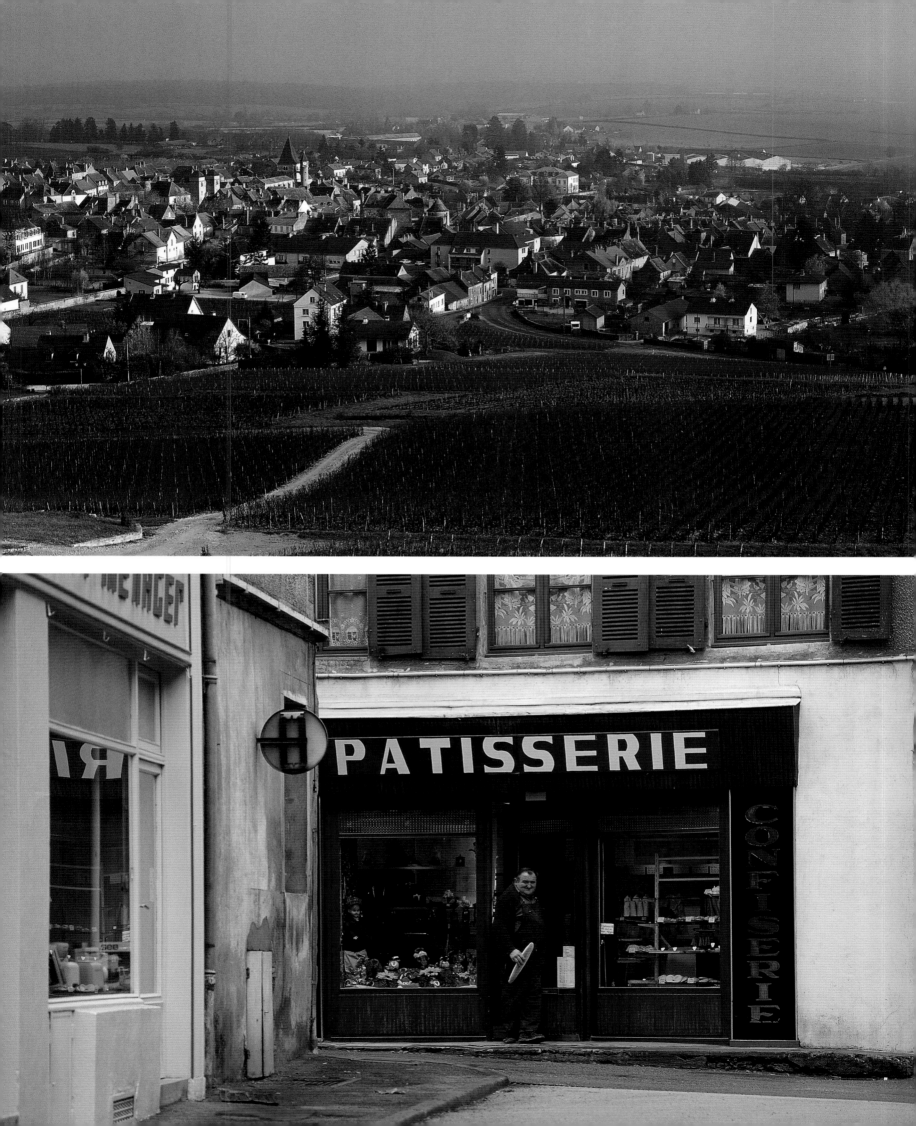

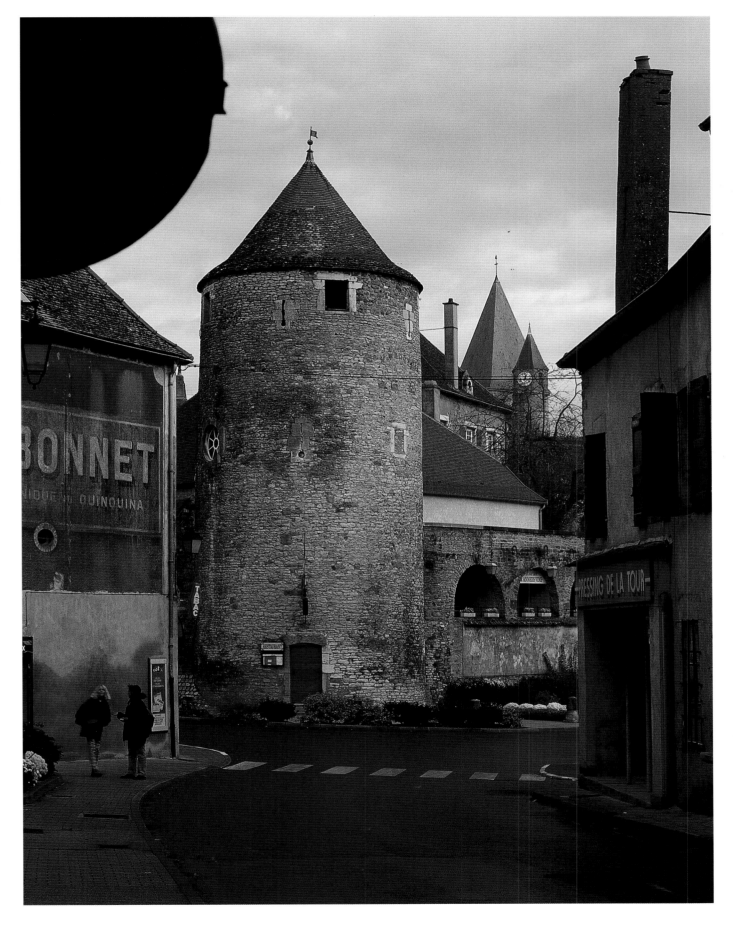

*More details of Buxy:
the village is viewed
here from the west
(OPPOSITE ABOVE); a
villager looks out at the
Rue du Moulin as he
emerges from a bakery
with his daily bread
(OPPOSITE BELOW); and
one of the two
remaining round towers
of Buxy's former
fortifications (RIGHT).*

Couches

Couches, sometimes known as Couches-les-Vignes because of its vineyards, dominates the valley of the Creuse and is itself dominated by the château of Marguerite de Bourgogne, granddaughter of St. Louis. She retired here in 1315 when, accused of committing adultery, she was repudiated by her husband Louis X. Marguerite died in the château, forgotten, in 1333.

Just outside the village, thirteenth-century quadrilateral walls, circular towers and a drawbridge defend a square, eleventh-century keep, machicolated, with a polygonal staircase tower, fifteenth-century dwellings (roofed with polychrome tiles), underground passages and a fifteenth-century Gothic chapel. Ancient houses, some with towers, lend an age-old distinction to the village; these include one built by the Knights Templar in the seventeenth century, its striking façade flanked by fifteenth-century square towers. Both the priory church of Saint-Georges (with its Romanesque apses) and the parish church of Saint-Martin date from the fifteenth century.

The peaceful aspect of Couches today belies a strife-torn past. The village suffered greatly during the sixteenth-century disputes between Catholics and Protestants. In the seventeenth century Catholics quarrelled among themselves, the Jesuit order claiming ascendancy over the local priests.

The architectural showpiece of Couches is the château of Marguerite de Bourgogne, wife of Louis X (who died here in 1333); its twelfth-century keep is brilliantly illuminated in the evening (RIGHT), and its sumptuous interior can also be visited (BELOW).

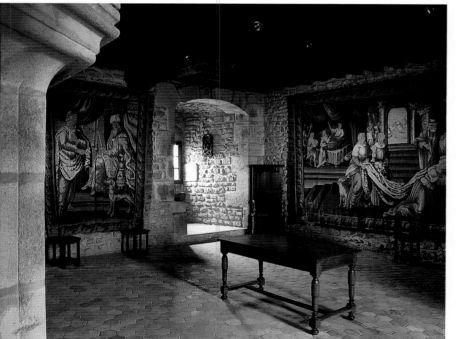

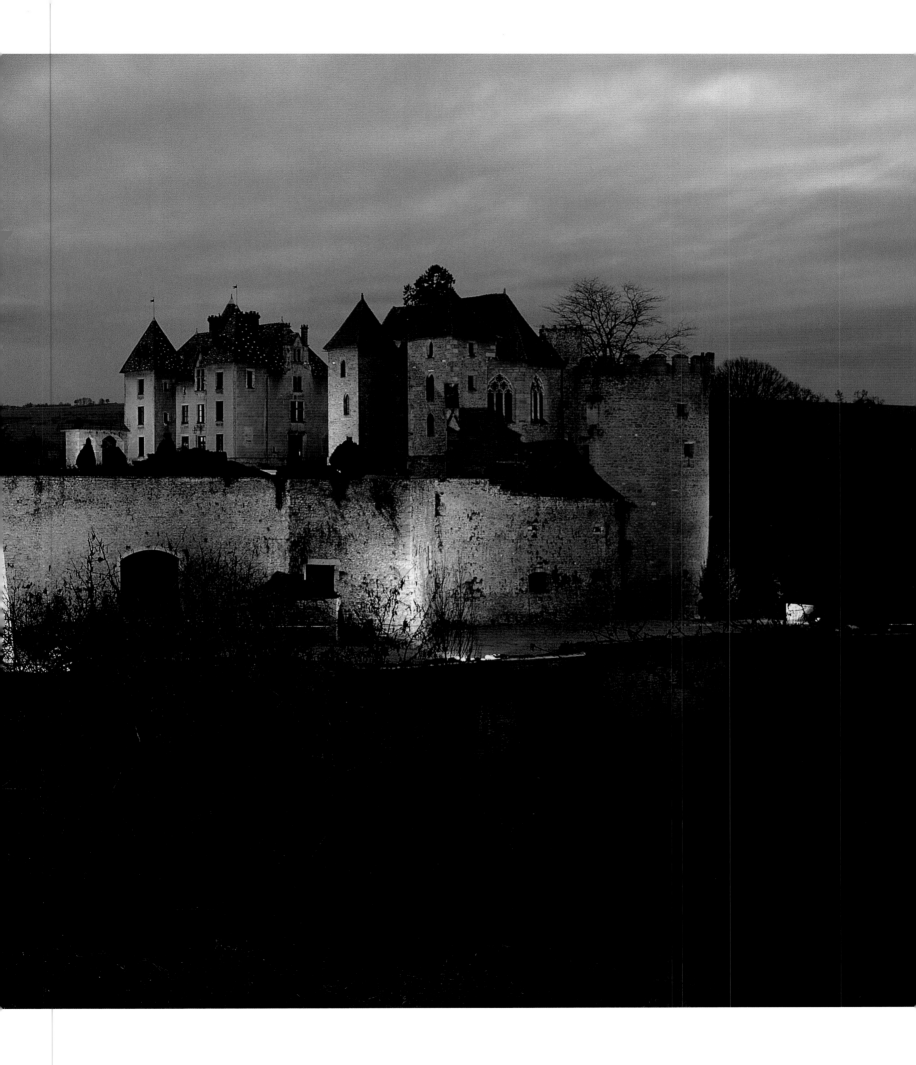

The villages of Burgundy are often enlivened by detailing in wrought iron, as in this deliciously observed corner of Couches (*LEFT*). A much grander, but completely Burgundian effect is made by the portal of the former hospital, which dates from the seventeenth century (*OPPOSITE*).

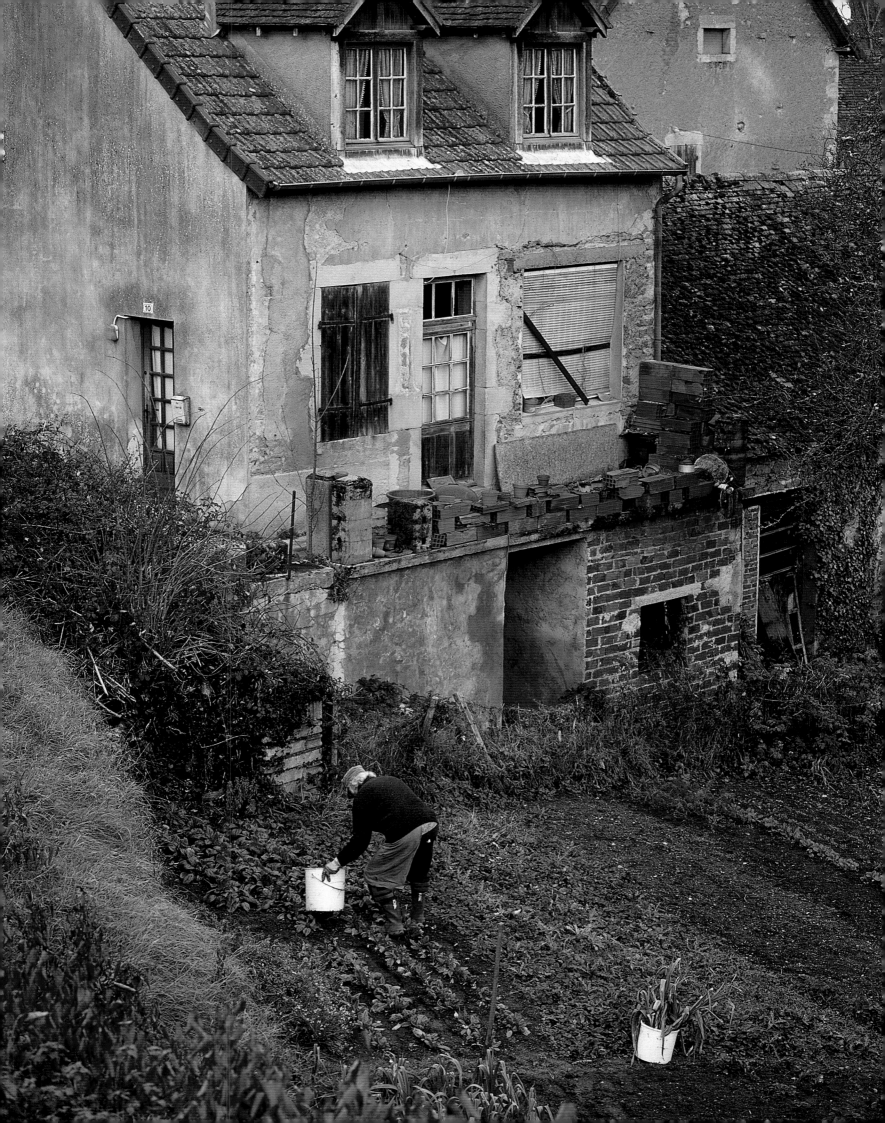

Burgundy is a land of culinary delight, and the potager, *or kitchen garden, is an essential adjunct to many dwellings* (OPPOSITE). *Indeed, Couches seems to revel in fascinating detail which never ceases to surprise, as this venerable doorway* (RIGHT).

Cuiseaux

*L*ying at a point where Bresse and Jura meet, Cuiseaux is a place of narrow, tortuous streets defended by the remains of its ancient ramparts. Note, in particular, the square tower and the Porte du Verger, last survival of the eleventh-century fortifications. Inside the village, the main square is picturesquely arcaded, has a well in its centre and is dedicated to the most famous son of Cuiseaux, the nineteenth-century painter Pierre Puvis de Chavannes. (Its second most famous son was the lithographer and painter Édouard Vuillard.) Some of the Renaissance houses have exquisite windows. Fountains bear witness to a prosperous past. The château of the Princes of Orange, with its mullioned windows, dates from the fifteenth and sixteenth centuries, the time when they owned much of the region. It now houses a museum, dedicated to 'the vintner and his wine'.

A frontier village (between Burgundy and Franche-Comté), Cuiseaux suffered for this, ravaged for example by the troops of Louis XI on 25 June 1477. It rose again. Its parish church, dedicated to St. Thomas Becket, dates from the nineteenth century, but boasts some splendid treasures once contained within its predecessor. They include: statues from the thirteenth to the sixteenth centuries, one of them a Black Virgin; choir stalls carved in the sixteenth century (depicting saints carrying their characteristic symbols); and early Italian paintings. Look out for the cemetery chapel, stone-roofed and built in the fifteenth century, and the Calvary. A tourist route through the village streets is marked with yellow arrows.

A humble doorway (LEFT) contrasts with the arcaded main square of Cuiseaux, the sixteenth-century Place de Puvis de Chavannes (RIGHT). This is a village of narrow streets and of Renaissance houses (ABOVE). Some of the old walls remain, and both the fifteenth-century château of the Princes of Orange and the nineteenth-century parish church are well worth a visit.

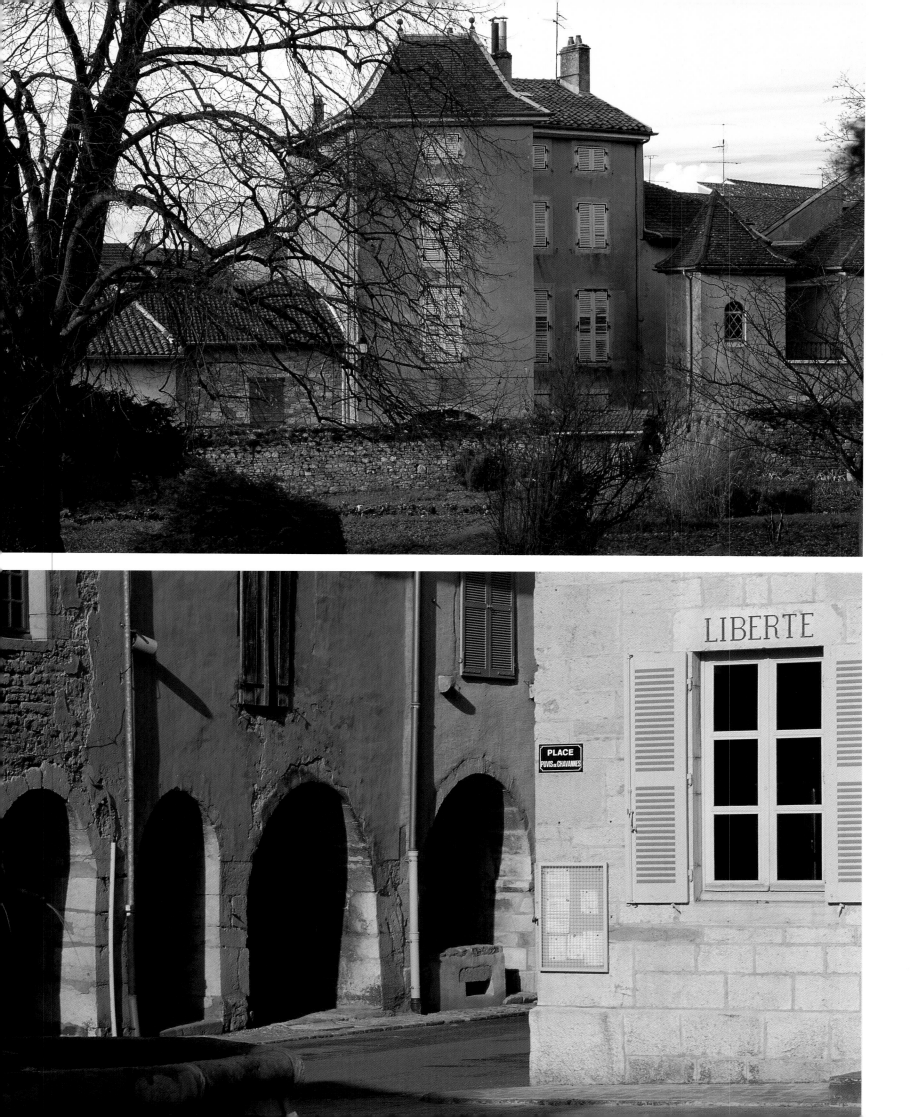

Cuiseaux, here viewed
from the cemetery,
gathers its ancient
streets around the
commanding tower of
its church (LEFT and
BELOW).

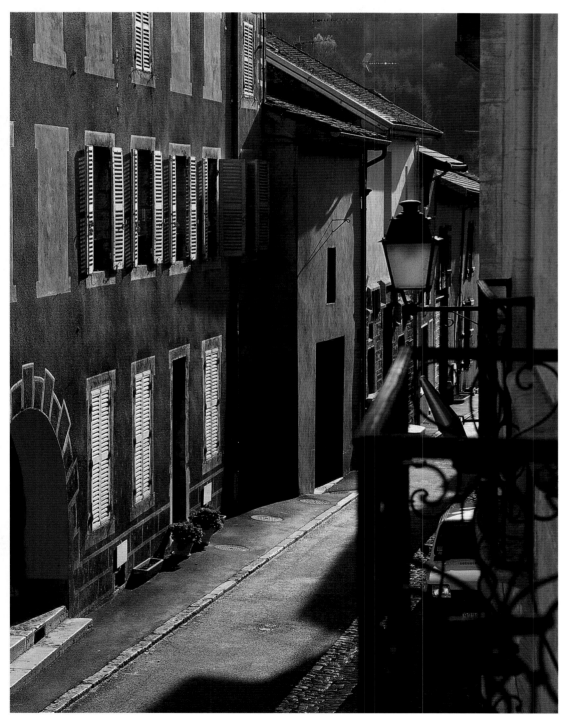

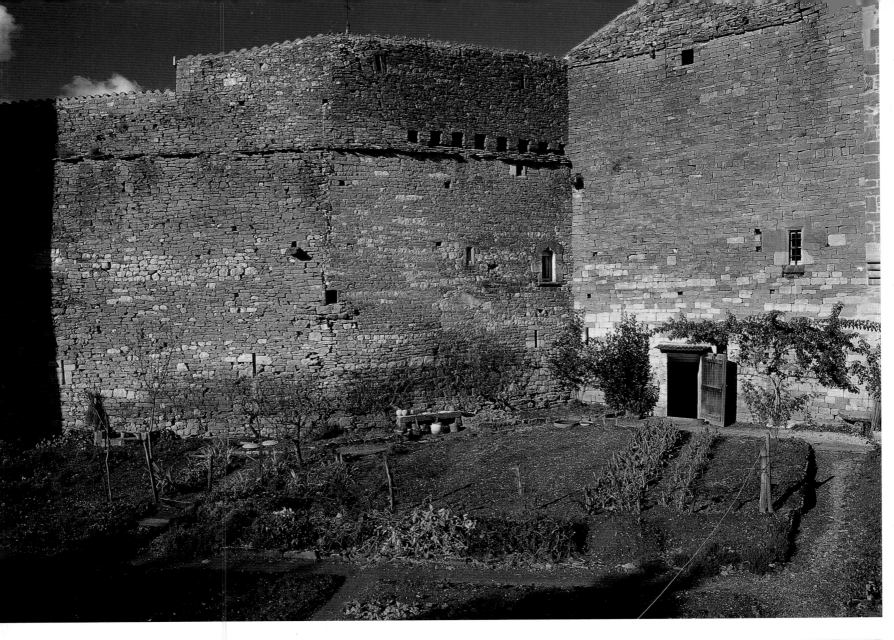

More charms of Cuiseaux: its ancient walls, near the Porte du Verger (ABOVE); a humble home with a delightfully embellished doorway in the Rue Saint-Thomas (RIGHT); a closer view of the parish church, again taken from close by the Porte du Verger (OPPOSITE).

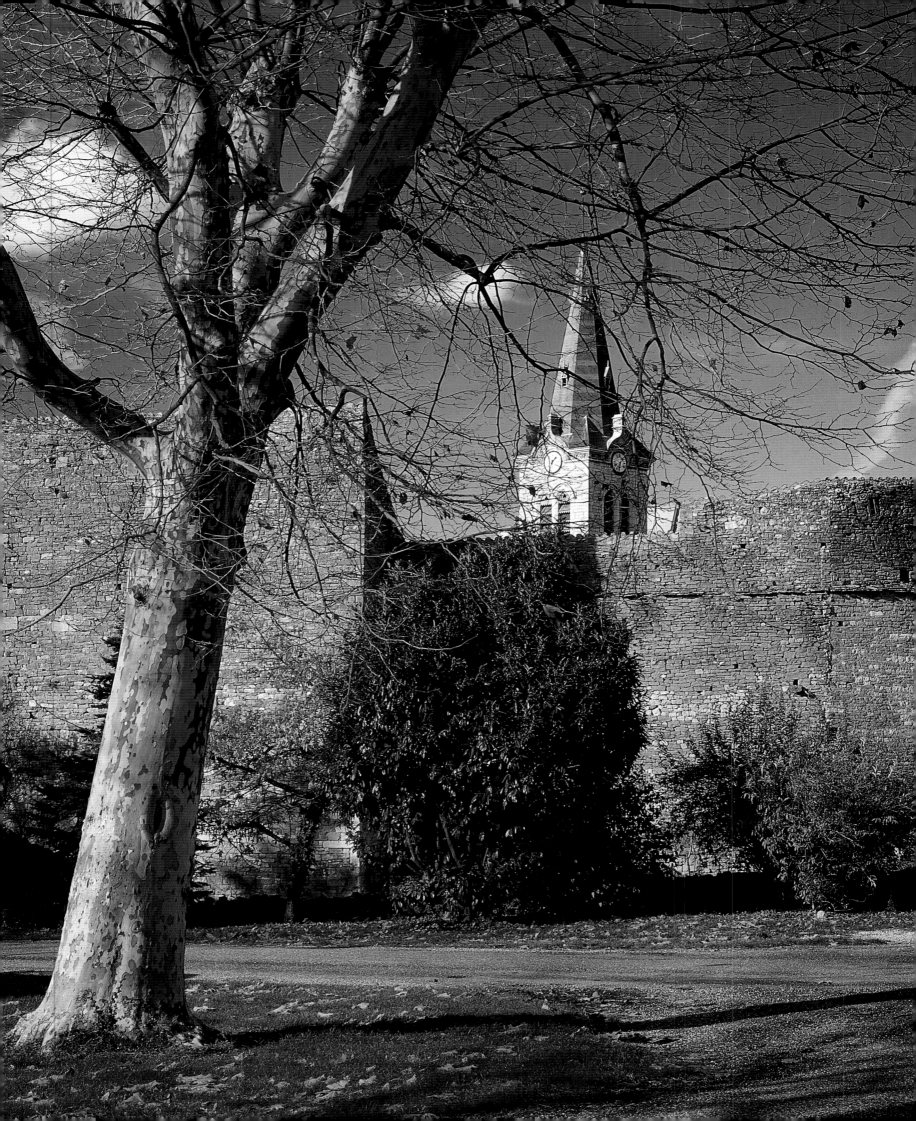

Semur-en-Brionnais

This rocky hill-top community derives its name from *sno*, a Gaulish adjective meaning 'old', and the Latin *murus*. Formidably defended in the Middle Ages, some of its fortifications remain: two village gates and two circular towers of the château of St. Hugues. From the top of the tenth-century Romanesque keep of this twelfth-century château (in which prisoners detained during the French Revolution have left their traces) you can view the mountains of La Madeleine and of the Forez. The village also boasts an eighteenth-century Hôtel de Ville as well as houses from the sixteenth to the eighteenth centuries. Some of the opulent seventeenth-century ones were once lived in by fortunate canons of the church, a reflection of Semur's importance as a religious centre.

The three-aisled twelfth- and thirteenth-century church of Saint-Hilaire at Semur-en-Brionnais is outrageously beautiful, its design inspired by the abbey-church of Cluny. It was built during the Cluniac era, its choir and transept dating from the end of the twelfth century and the first third of the thirteenth century, and the rest from the second half of the thirteenth century. Its doorway is decorated with delicately carved coils of flowers and braids. The tympanum is sculpted with Jesus in Majesty, set in a mandorla. The lintel is decorated with the legend of St. Hilaire. The apse is shaped like a three-leaved clover, with narrow Romanesque windows. As for the octagonal tower, its lower arches are blind, the upper storey pierced, with sixteen openings flanked with colonnades.

The door of the eighteenth-century town-hall of Semur-en-Brionnais (RIGHT); note the scales of justice over its lintel. Local inhabitants play boules in a quiet corner of the village on a Saturday afternoon (OPPOSITE).

More tranquil moments
in the streets of Semur-
en-Brionnais (ABOVE);
and seen from Saint-
Martin-de-la-Vallée
(RIGHT) the octagonal
belfry of the parish
church of Semur-en-
Brionnais seems
dwarfed by the square
tower of its neighbour.
The fortifications of the
village, though, still
look formidable enough.

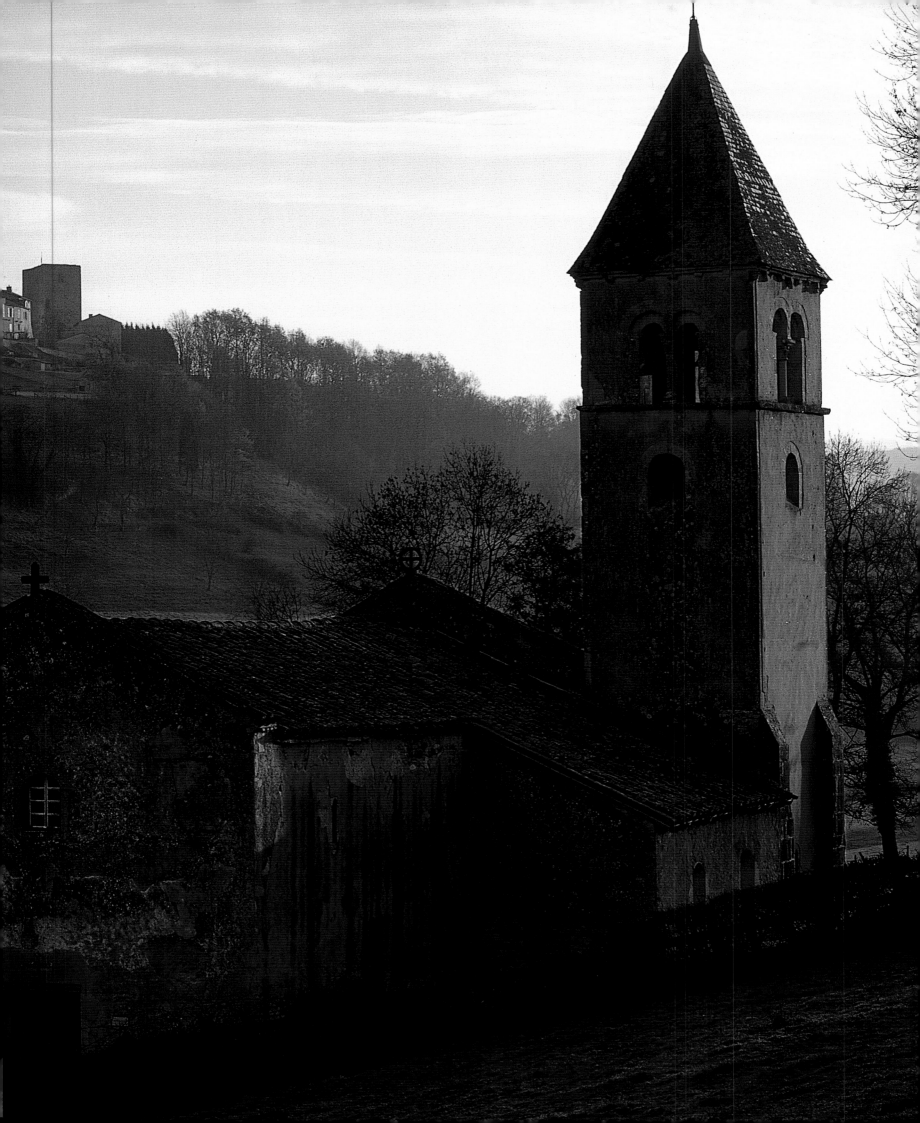

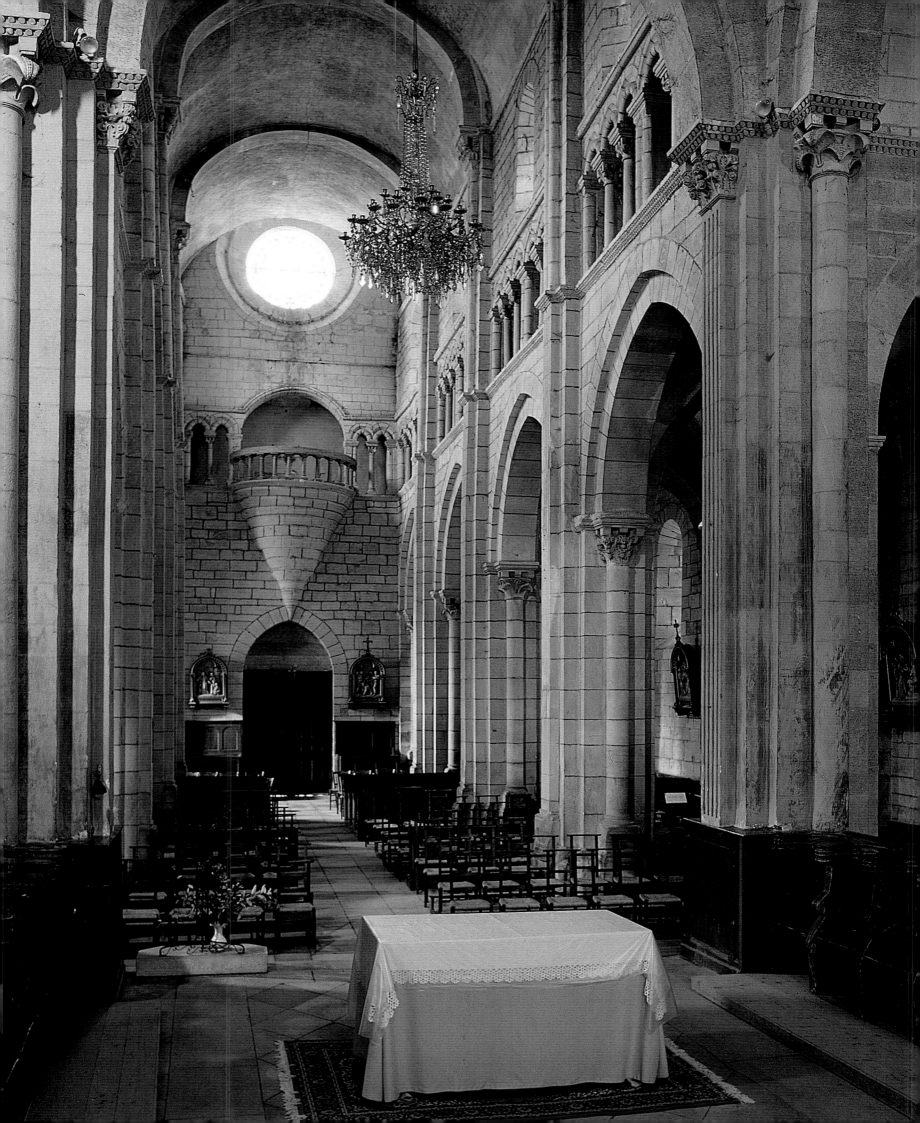

Inspired by the abbey-church at Cluny, the twelfth-century church of Saint-Hilaire at Semur-en-Brionnais is a Romanesque masterpiece *(OPPOSITE)*. Two side aisles flank the tall nave. As at Cluny, at the west end a pulpit juts out from the triforium.

Cluny had a special interest in this village, for in its château one of the most celebrated of its abbots, Hugues, was born in 1024. Over the west doorway, beneath a carving of Christ in majesty, are scenes from the life of St. Hilaire *(RIGHT)*.

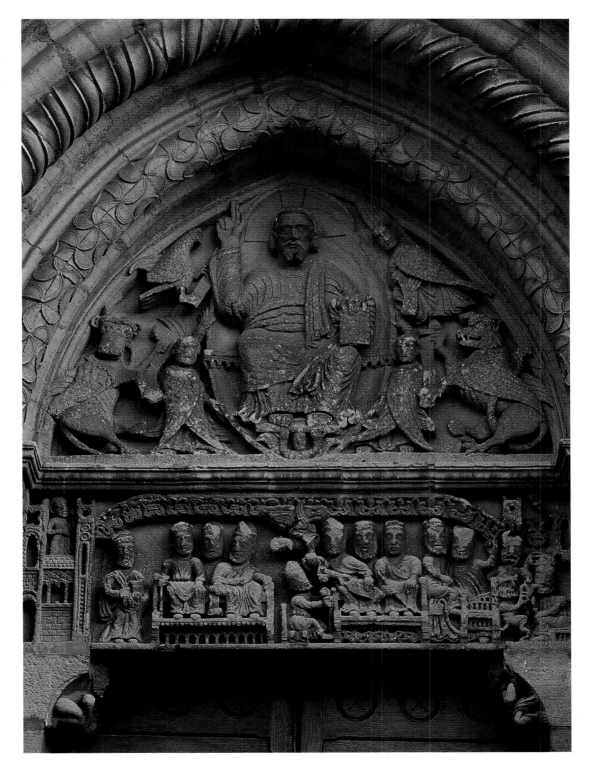

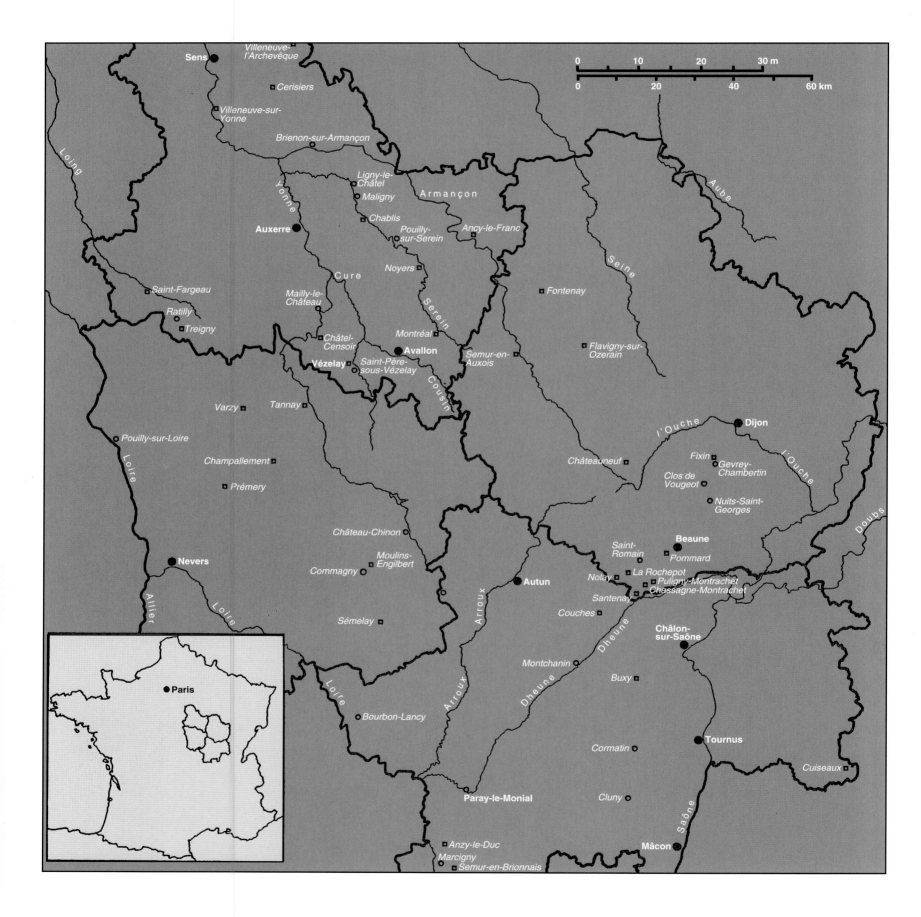

Sens
Villeneuve-l'Archevêque
Cerisiers
Villeneuve-sur-Yonne
Brienon-sur-Armançon
Ligny-le-Châtel
Maligny
Chablis
Armançon
Ancy-le-Franc
Pouilly-sur-Serein
Auxerre
Noyers
Seine
Cure
Fontenay
Saint-Fargeau
Mailly-le-Château
Ratilly
Treigny
Serein
Châtel-Censoir
Montréal
Flavigny-sur-Ozerain
Avallon
Semur-en-Auxois
Vézelay
Saint-Père-sous-Vézelay
Cousin
Varzy
Tannay
l'Ouche
Dijon
Pouilly-sur-Loire
Châteauneuf
Fixin
Gevrey-Chambertin
Champallement
Clos de Vougeot
l'Ouche
Prémery
Nuits-Saint-Georges
Doubs
Château-Chinon
Beaune
Saint-Romain
Nevers
Moulins-Engilbert
Pommard
Commagny
La Rochepot
Autun
Nolay
Puligny-Montrachet
Chassagne-Montrachet
Santenay
Loire
Couches
Sémelay
Dheune
Châlon-sur-Saône
Montchanin
Loire
Buxy
Dheune
Paris
Arroux
Bourbon-Lancy
Loire
Arroux
Tournus
Cormatin
Cuiseaux
Saône
Paray-le-Monial
Cluny
Mâcon
Anzy-le-Duc
Marcigny
Semur-en-Brionnais
Allier
Loing
Yonne
Aube

0 10 20 30 m
0 20 40 60 km

A Traveller's Guide

USEFUL INFORMATION

While every effort has been made to ensure that the information given in the following entries is correct, the author and the publisher cannot be held responsible for any inadvertent inaccuracies; ratings for hotels, etc. are those given by the French Tourist Board.

Please note that all telephone numbers in Burgundy now have the prefix 3.

LOCAL TOURIST AUTHORITIES
(See under individual *départements* and villages for more detailed information.)

Comité Régional du Tourisme de Bourgogne, Conseil Régional, 21035 Dijon; tel. 80 50 90 00.
Archaeological Centre of Mont Beuvray, 58370 Glux-en-Glenne; tel. 86 78 69 00.
Gallo-Roman Museum of Alésia, Alise-Sainte-Reine; 22 March-30 June, 10.00-18.00; July and August, 09.00-19.00; September and November, 10.00-18.00; tel. 80 96 10 95.

YONNE
Comité Départemental du Tourisme de l'Yonne, 1-2, Quai de la République, 89000 Auxerre; tel. 86 52 26 27.

Ancy-le-Franc
Festivals and Fêtes
Fair, third weekend of June. Fête, first Sunday of May.
Markets
Thursdays.
Sights
Renaissance château; April-mid November, 10.00-12.00 and 14.00-18.00; tel. 86 75 14 63.
Car and Carriage Museum; tel. 86 75 12 41.
Hotel-Restaurants
Hôtel de la Poste; tel. 86 75 14 13.
Hostellerie du Centre; tel. 86 75 15 11.
Hôtel de l'Écluse; tel. 86 75 18 51.
Camping
Camping Municipal; tel. 86 75 13 21.
Information
Former *faïencerie* of the château; tel. 86 75 03 15.

Cerisiers
Festivals and Fêtes
Patronal festival, Cerisiers, Sunday following Ascension day. Communal festival, Cerisiers, 29 August. Patronal festival, Brienon-sur-Armançon, first Sunday of September (when the heart of St. Loup is displayed). Fair, Brienon-sur-Armançon,

Sunday closest to 25 November.
Markets
Thursdays, Cerisiers. Tuesdays and Fridays, Brienon-sur-Armançon.
Hotels
Le Relais de Saint-Loup, Brienon-sur-Armançon; tel. 86 56 11 93.
Restaurants
Crêperie d'Othe, Cerisiers; tel. 86 96 21 33.
Camping
Camping Municipal, Brienon-sur-Armançon; tel. 86 43 00 67.

Chablis
Festivals and Fêtes
Wine fair and fête of St. Vincent, fourth Sunday of November. Patronal festival, Épineuil, 24 June. Carnival, Épineuil, 15 August. Patronal festival, Maligny, first Sunday of September. Communal festival, Maligny, 8 September.
Markets
Sundays.
Sights
Jean-Paul Droin; 14 bis, Rue Jean-Jaurés, 89800 Chablis; tel. 86 42 16 78.
Maison de la Vigne et du Vin de Chablis; tel. 86 42 80 80.
Domaine Alain Geoffrey; tel. 86 42 13 30; wine-tasting by appointment.
Cave William Fèvre; visits daily (except Sunday afternoons and Mondays); tel. 86 42 12 06.
Hotel-Restaurants
****Hostellerie des Clos*, tel. 86 42 10 63.
***Hôtel de l'Étoile*, tel. 86 42 10 50.
***Hôtel-Restaurant Ibis*, tel. 86 42 49 20.
***Le Vieux Moulin de Chablis*, tel. 86 42 47 30.
***Au Vrai Chablis*, tel. 86 42 11 43.
Camping
Camping Municipal, tel. 86 42 44 39.
Information
1 Rue de Chichée; tel. 86 42 80 80.

Châtel-Censoir
Festivals and Fêtes
Fair, second Thursday of the month. Patronal and communal festival, Sunday after 19 October.
Markets
Thursdays.
Camping
Camping Municipal Le Petit-Port; tel. 86 81 01 98.

Montréal
Festivals and Fêtes
Patronal festival, Palm Sunday. Communal festival, Sunday following the feast of the Assumption (15 August).
Restaurants

Les Deux Compères, tel. 86 32 19 47.
Noyers
Festivals and Fêtes
Patronal festival, 24 April or the following Sunday. Music festival, Whitsun weekend. Summer concerts.
Sights
Municipal Museum; holds a collection of prehistoric finds and local treasures. Museum of Naïve Art; 1 June-30 September, daily; tel. 86 82 89 09; housed in an eighteenth-century mansion.
Hotel-Restaurants
Hôtel de la Vieille Tour, Place du Grenier-à-Sel; tel. 86 82 87 69; receives guests from Easter to All Saints.
Restaurants
Auberge La Beursaudière, 9 Chemin de la Ronde, 89310 Nitry (10 km from Noyers on the D49); tel. 86 33 65 21.
Information
Mairie; tel. 86 55 83 72. Easter Monday-1 September, guided tours of the medieval quarter available on request (up to three weeks notice required).

Saint-Fargeau
Festivals and Fêtes
Saint-Fargeau château is the venue for lavish *son-et-lumière* spectacles in July and August. Patronal festival, second Sunday of September.
Markets
Fridays.
Sights
Château; Palm Sunday-11 November, daily 10.00-12.00 and 14.00-19.00; tel. 86 74 05 67; guided tours last 45 minutes.
La Ferme du Château; 1 April-11 November, daily 10.00-19.00; tel. 86 74 03 76; a typical Puisaye farm depicting country life at the beginning of the century.
Boutissaint Wildlife Reserve; mid July-mid August, 08.00-20.00; tel. 86 74 71 28.
Hotels
***Le Relais du Château*, 24 Rue Saint-Martin, Promenade de Grillon; tel. 86 74 01 75.
Chambres d'Hôtes
Rolaz, Dominique-Marie-Odile, 10 Rue Porte Marlotte; tel. 86 74 12 28.
Camping
Camping Municipal La Calanque, Réservoir du Bourdon; tel. 86 74 04 55.
Restaurants
La Boule d'Or, Place de Lattre-de-Tassigny; tel. 86 74 01 18.
Information
Place du Château; tel. 86 74 15 72.

Tanlay
Festivals and Fêtes
Communal fête, second Sunday of September.
Sights
Château; April-mid November, guided visits daily (except Tuesdays) 09.30-11.30

and 14.15-17.15; other times of the year by appointment; tel. 86 75 70 61; the château has a nine-hole golf course (tel. 86 75 72 92) and may be approached through an attractive avenue of lime trees.
Hotel-Restaurants
Auberge du Château, tel. 86 75 71 76.

Treigny
Festivals and Fêtes
Fair, second Sunday of March. Pottery festival, mid August. Boutissaint festival of nature and wild animals, July and August.
Markets
Sunday mornings.
Sights
Canonry; mid June-mid September, 14.00-19.00; exhibition of local pottery and other work in the former canonry. Boutissaint Natural Park; tel. 86 74 07 08.
Château de Ratilly; Easter-All Saints Day, 10.00-12.00 and 15.00-18.00; mid June-mid September, 10.00-18.00; other times of the year, 14.00-17.00; tel. 86 74 79 54.
Information
Place de la Mairie; tel. 86 74 66 33.

Vézelay
Festivals and Fêtes
Festival of St. Mary Magdalene, second fortnight of July. Pilgrimage to the abbey, 22 July. Concerts in the abbey, June-September; tel. 86 33 26 73.
Sights
Abbey; in season, 07.00-19.00; out of season, sunrise-sunset, save when the monks are saying their offices.
Morvan Natural Park; information from the Maison du Parc; tel. 86 78 70 16.
Museum of the Work of Sainte-Madeleine's Basilica; 21 June-end of

The walls and roofs of Vézelay.

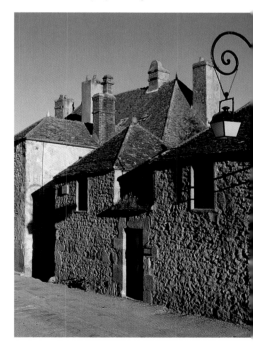

September, daily; tel. 86 33 24 62.
Hotel-Restaurants
***Hôtel de la Poste*, tel. 86 33 21 23.
***Le Compostelle*, tel. 86 33 28 63.
****Résidence-Hôtel Le Ponton*,
tel. 86 33 24 40.
***Relais du Morvan*, tel. 86 33 25 33.
Camping
Camping Municipal La Croix-Sainte,
tel. 86 33 24 18.
Restaurants
Brasserie La Dent Creuse, tel. 86 33 36 33.
Le Bougainville, tel. 86 33 27 57.
Information
Rue Saint-Pierre; tel. 86 33 23 69.

Villeneuve-l'Archevêque
Festivals and Fêtes
Patronal festival, second Sunday of
September. Fair, second Sunday of
December.
Markets
Saturdays
Hotel-Restaurants
Auberge des Vieux Moulins Banaux,
tel. 86 86 72 55.
Camping
Camping Piscine de Courgenay,
tel. 86 86 82 07.

Villeneuve-sur-Yonne
Festivals and Fêtes
Patronal festival, 15 August.
Markets
Tuesdays and Fridays.
Hotels
Hostellerie du Dauphin, tel. 86 87 18 55.
Auberge La Lucarne aux Chouettes,
tel. 86 87 18 26.
Chambres d'Hôtes
Domaine de Cochepie, tel. 86 87 39 76.
Camping
Camping du Saucil, tel. 86 97 00 69.

NIÈVRE
Comité Départemental du Tourisme de la
Nièvre, 3 Rue du Sort, 58000 Nevers;
tel. 86 36 39 80.
Gaulish city, 18 June-end of September,
guided tours 10.00-15.00; other times by
appointment; tel. 86 78 61 55.
Boat trips on the Lac des Settons during
the tourist season; tel. 86 84 51 97/81.

Champallement
Festivals and Fêtes
Fair, Saint-Révérien, first Tuesday
of the month. Horse fair, Saint-Révérien,
30 May. Fête, Crux-la-Ville, first Sunday
after 24 June.
Sights
Compierre, Romano-Gaulish site; daily;
tel. 86 29 03 38.
Gîte
La Comme, Crux-la-Ville; tel. 86 58 30 34.
Camping
L'Étang du Merle, Crux-la-Ville;

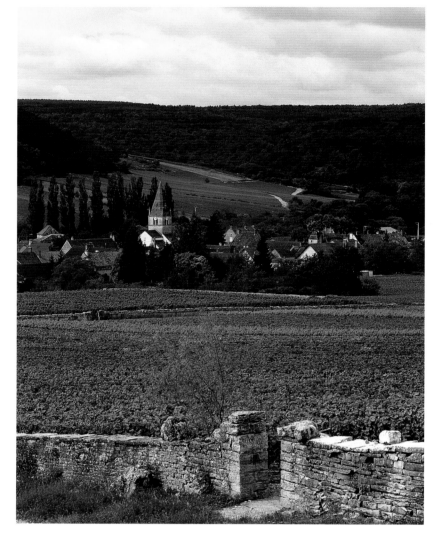

tel. 86 58 38 42.
Information
Mairie, Champallement; tel. 86 29 03 38.

Moulins-Engilbert
Festivals and Fêtes
Fairs on the first Tuesday of each month.
Fête, 14-15 June. Fishing festival and
competition at the end of July. Harvest
festival in August.
Markets
Tuesdays and Thursdays. Sheep auction on
Mondays; cattle auction on Tuesdays. For
visits, tel. 86 84 28 75.
Hotel-Restaurants
**Au Bon Laboureur*, tel. 86 84 20 55.
Gîtes
Les Levées, tel. 86 59 14 22.
Restaurants
Le Cadran, tel. 86 84 33 44.

Prémery
Festivals and Fêtes
Foals and fillies fair, first Tuesday of the
month. Calf fair, 5 November. St.
Nicholas poultry fair, 6 December.
Communal fête, last Sunday of May.
Patronal festival, first Sunday of September
(the feast of St. Marcel). In nearby

Montenoison, communal festival, 24 June.
Patronal festival, 15 August.
Markets
Tuesday and Saturday mornings.
Sights
Giry; notable for its superb fourteenth-
century château (open for visits in the
summer), a forest of ancient oak trees and
a twelfth-century Romanesque church.
Montenoison; home to a ruined
thirteenth-century château and an
ancient church.
Hotel-Restaurants
***Manoir des Terres Blanches*,
tel. 86 37 96 01.
Hotels
Le Routier, tel. 86 37 97 59.
Central Hôtel, tel. 86 37 93 55.
Chambres d'Hôtes
Mme. Taylor, tel. 86 60 15 08.
M. et Mme. Fayolle, tel. 86 68 06 77.
Gîtes
M. et Mme. Fayolle, tel. 86 68 06 77.
Mme. Gilles, tel. 86 68 06 81.
Camping
Les Prés de la Ville, tel. 86 37 99 42.
Restaurants
Café du Centre, tel. 86 68 10 85.
Les 4 Saisons, tel. 86 68 10 91.

A view of Sémelay.

Le P'tit Prémery, tel. 86 68 11 96.
Le Vénus, tel. 86 37 94 96.
Information
Mid June-mid September, Tour du
Château; tel. 86 37 99 07; other times, the
Mairie; tel. 86 68 12 40.

Sémelay
Festivals and Fêtes
Patronal festival, second Sunday of July.
Fishing competition, last Sunday of July.
Chambres d'Hôtes
Domaine de la Chaume, tel. 86 30 91 23.
Le Martray, tel. 86 30 91 51.
Gîtes
La Bussière, tel. 86 30 01 28.
Le Martray, tel. 86 30 91 51.

Tannay
Festivals and Fêtes
Feast of St. Vincent, third or fourth
Sunday of January. Spring festival, second
Sunday of May. *Boules* tournament and
ham festival, second Sunday of August.
Fishing festival, 15 August. Feast of St.
Catherine, third or fourth Sunday of
November. Fair, fourth Sunday of the
month.
Markets
Sundays.
Sights
Mont-Sabot; the chapel of this former
fortress, sited at 416 metres above sea-level,
affords a magnificent view over the
Morvan.
Hotel-Restaurants
**La Margelle*, tel. 86 29 33 44.
Le Relais Fleuri, tel. 86 29 84 57.
Gîtes
Tel. 86 29 84 53.
Camping
Les Grandes-Ilôtes, tel. 86 29 84 53.
Restaurants
Le Sélect, tel. 86 29 74 05.
Bar La Taverne, tel. 86 29 31 87.
Information
Mairie; tel. 86 29 84 53.

Varzy
Festivals and Fêtes
Fairs, third Sunday of each month. St.
George's fair, nearest Sunday to 23 April.
Holiday fair, nearest Sunday to 15 August.
Communal fête, Whit Sunday and
Monday. Patronal festival, penultimate
Sunday of July.
Markets
Thursdays.
Sights
Auguste Grasset Museum; 1 March-30
October, daily (except Tuesdays); other
times of the year, Sundays, holidays and
school holidays (except January); tel. 86 29
72 03. Created by a nineteenth-century
humanist between 1862 and 1879, this

museum houses a collection of 3,500 works including earthenware, furniture, Egyptian masterpieces, Oceanic curiosities, paintings, *objets d'art*, arms, sculpture and Aubusson tapestries illustrating Virgil's *Aeneid*.

Hotel-Restaurants
M. Langlos Restaurant-Hôtel; tel. 86 29 41 72.
Hôtel-Restaurant de la Gare; tel. 86 29 44 16.

Camping
Camping du Moulin-Naudin; tel. 86 29 43 12.

Information
Tel. 86 29 43 73.

CÔTE D'OR

Comité Départemental du Tourisme de la Côte d'Or, Hôtel du Département, 21035 Dijon; tel. 80 49 90 97.
Château du Clos de Vougeot; April-September, 09.00-18.30; other times of the year, 09.00-11.30 and 14.00-17.00; tel. 80 62 86 09.

Chassagne-Montrachet and Puligny-Montrachet

Festivals and Fêtes
Patronal festival, last Sunday of April. Communal fête, Sunday following 25 April.

Sights
The following establishments offer wine-tasting:
Domaine du Château de Chassagne-Montrachet; tel. 80 21 30 22.
Domaine Bechelet Ramonet; Chassagne-Montrachet; tel. 80 21 32 49.
Domaine Marc Morey et Fils; Chassagne-Montrachet; tel. 80 21 30 11.
Domaine Gérard Chavy et Fils; Puligny-Montrachet; tel. 80 21 31 47.

Hotel-Restaurants
Le Montrachet; Puligny-Montrachet; tel. 80 21 03 06.

Chambres d'Hôtes
Robert and Margaret Jarlaud ; Chassagne-Montrachet; tel. 80 21 36 09.

Châteauneuf

Festivals and Fêtes
Fêtes, first Sunday of May, first Sunday of October, 2 November. Mass celebrating St. Hubert (with a blessing of horses and dogs). Christmas Eve mass with a living crèche.

Sights
Château; May-September, tours 09.30-11.30 and 14.00-17.00; October-April, 10.00, 21.00, 14.00 and 15.00; closed Tuesdays, Wednesdays, 1 January, 1 May, 1 and 11 November and 25 December.

Hotel-Restaurants
Hostellerie du Château; tel. 80 49 22 00.

Gîtes

Annie Bagatelle; tel. 80 49 21 49.

Information
Association Les Amis de Châteauneuf, Pouilly-en-Auxois; tel. 80 90 74 24.

Fixin

Festivals and Fêtes
Fête, second Sunday of June.

Sights
Fixey; visits by arrangement on Saturdays and Sundays; tel. 80 52 45 52; tenth-/twelfth-century church.
Noiset Museum; tel. 80 52 45 33.
Domaine Clos Saint-Louis; tel. 80 52 45 51; wine merchants.
Manoir de la Perrière; tel. 80 52 47 85; wine merchants; possesses an ancient wine-press.

Hotel-Restaurants
***Hôtel Chez Jeannette*; tel. 80 51 45 49.

Hotels
Domaine de Saint-Antoine; tel. 80 52 50 04.

Chambres d'Hôtes
Ferme des Champs aux Pierres; tel. 80 52 45 73.

Restaurants
Restaurant au Clos Napoléon; tel. 80 32 45 63.
Restaurant La Courte Paille; tel. 80 52 46 00.

Flavigny-sur-Ozerain

Festivals and Fêtes
Fête, second Sunday of June.

Sights
Anis Factory; Monday-Friday (except August), 08.30-10.30; tel. 80 96 20 88.
Medieval Flavigny; for guided visits, tel. 80 96 25 34.
Crypt of Sainte-Reine; tours 08.15-11.15 and 13.30-17.15; Sundays 10.00-12.00 and 14.00-18.00.

Hotel-Restaurants
Le Relais de Flavigny.

Chambres d'Hôtes
Couvent des Castafours; tel. 80 96 24 92.

Gîtes
La Licorne Bleue; Rue de la Poterne; tel. 80 96 20 59.

Ferme-Auberge
La Grange de Flavigny; tel. 80 96 20 62.

Restaurants
La Grange; tel. 80 96 20 62.

Information
Maison au Donataire (built in the fifteenth and sixteenth centuries); tel. 80 96 24 65.

Fontenay

Sights
Cistercian Abbey; guided tours daily throughout the year, 09.00-12.00 and 14.30-18.30; tel. 80 92 15 00.
Buffon Park; June-September, daily (except Tuesdays) 10.00-12.00 and 14.30-18.00. This splendid park, situated in nearby Montbard, is named after the pioneering eighteenth-century naturalist Buffon.

Buffon Museum; April-November, daily (except Tuesdays) 10.00-12.00 and 15.00-18.00, closing one hour earlier during the rest of the year; situated by the entrance to the park.

Hotel-Restaurants
**Hôtel Le Vieux Jambon*; Marmagne; tel. 85 78 20 32.
****Hôtel de l'Écu*; Montbard; tel. 80 92 11 66.
***Hôtel de la Gare*; tel. 80 92 02 12.
***Le Cyclamen*; tel. 80 92 08 62.
Château de Malaisy; Fain-lès-Montbard; tel. 80 89 46 54.

Ferme-Auberge
Ferme-Auberge Morvandelle; tel. 80 84 33 32.

Information
Montbard; tel. 80 92 03 75.

Nolay

Festivals and Fêtes
Communal festival, first Sunday of May. Patronal festivals, 22 January and the second Sunday of September.

Markets
Monday mornings.

Hotel-Restaurants
***Hôtel du Chevreuil*; tel. 80 21 71 89.
***Hôtel Sainte-Marie*; tel. 80 21 73 19.
***Hôtel du Parc*; tel. 80 21 84 12.
**Le Relais de Nolay*; tel. 80 21 85 98.
**Motel Le Carnot*; tel. 80 21 70 73.

Chambres d'Hôtes
Cherau, Yves et Marie-Odile; tel. 80 21 77 55.
Biton, Jean; tel. 80 21 73 59.
Loret, Hélène; tel. 80 21 85 06.

Camping
Camping Municipal; Route de Couches; tel. 80 21 79 61.

Restaurants
Le Burgonde; tel. 80 21 71 25.
La Dent Creuze; tel. 80 21 81 02.

Information
Tel. 80 21 80 73.

Pommard

Festivals and Fêtes
Fête, first Sunday of July.

Sights
The following establishments offer wine-tasting:
Domaine André Mussy; tel. 80 22 05 56.
Maison Brzezinski; tel. 80 22 23 99.
Domaine Virily-Arcelin; tel. 80 22 19 71.
Château de Pommard; end of March-third Sunday of November, daily; tel. 80 22 07 99.

Restaurants
Café-Restaurant du Pont; tel. 80 22 03 41.

Santenay

Festivals and Fêtes
On the penultimate Saturday of January the Grumeurs de Santenay host an animated banquet. They hold another on the fourth Saturday of June, when they honour a writer. Their third annual dinner

takes place on the third Friday of November, to celebrate the *vin nouveau* of Santenay. Fête, 6 June.

Sights
Château of Philippe le Hardi; open 10.00-12.00 and 14.00-17.00; tel. 80 20 61 87; notable for its wine-cellars and wines.
Confrèrie de St. Vincent et des Grumeurs de Santenay; secretariat; tel. 80 20 60 56.
Domaine Fleurot-Larose; daily; tel. 80 20 61 15; wine-cellars.

Hotels
Le Lion d'Or; tel. 80 20 60 24.

Chambres d'Hôtes
Rémy-Thevenin, Yves-Eric; tel. 80 20 66 13.

Camping
Camping Municipal des Sources; tel. 80 20 66 55.

Restaurants
Restaurant l'Ouillette; tel. 80 20 62 34.
Restaurant Le Terroir; tel. 80 20 66 45.

Information
Tel. 80 20 63 15.

Semur-en-Auxois

Festivals and Fêtes
Course de la Bague, the oldest horse race in France, dating from 1369, 31 May. Fair, third Thursday of the month and 31 May. Patronal festival, 15 August.

Markets
Tuesday, Thursday and Saturday mornings.

Sights
Municipal Museum and Library; mid June-mid September, tel. 80 97 24 25; housed in a former Dominican convent, the library holds around 30,000 volumes, some of them precious (guided tours by appointment).

The vineyards of Pommard.

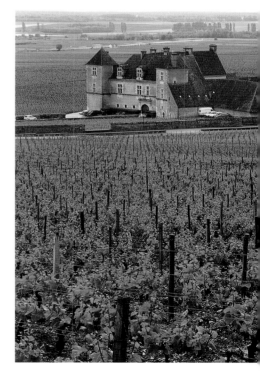

Château de Flée; tel. 80 97 17 17; once the home of Louis XV's treasurer.
Tour de l'Orle d'Or; tel. 80 97 24 25; the most imposing of the four towers of the former fortifications.

Hotel-Restaurants
***Hostellerie d'Aussois*, Route de Saulieu; tel. 80 97 28 28.
**Hôtel de la Côte d'Or*, 3 Place Gaveau; tel. 80 97 03 13.
Le Relais de la Vie, 10 Rue du Couvent; tel. 80 97 03 81; situated in a former eighteenth-century convent.
**Hôtel Les Cymaises*, 7 Rue du Renaudot; tel. 80 97 21 44; eighteenth-century building.
Hôtel du Commerce, 19 Rue de la Liberté; tel. 80 96 64 40.
Hôtel-Restaurant des Gourmets, 4 Rue Varenne; tel. 80 97 09 41.

Youth Hostel
Maison Amie, 1 Rue du Champ de Foire; tel. 80 97 10 22.

Holiday Village
VVF-Gîclair de Flée, tel. 80 97 12 99; apartments and four-star camping.

Information
2 Place Gaveau; tel. 80 97 05 96.

SAÔNE-ET-LOIRE

Comité Départemental du Tourisme de la Saône-et-Loire, 389 Avenue de Lattre-de-Tassigny, 71000 Mâcon; tel. 85 38 94 36.

Anzy-le-Duc
Festivals and Fêtes
Summer music festival, July and August (information from the tourist office, Marcigny; tel. 85 25 39 06). Patronal festival, first Sunday of August.

Sights
Priory buildings; tel. 85 25 08 21; renovated eleventh-century stables, boasting a timbered ceiling.

Hotel-Restaurants
Auberge du Prieuré, tel. 85 25 01 79.

Chambres d'Hôtes
Lamy, Geneviève, Le Bourg; tel. 85 25 17 21.

Romanesque Anzy-le-Duc.

Information
Marcigny; tel. 85 25 39 06.

Buxy
Festivals and Fêtes
Fair, second Thursday of the month. Fête, last Sunday of July.

Sights
Buxy-Saint-Gengoux-le-National; visits Tuesday-Saturday, 0800-12.00 and 14.00-1800; tel. 85 92 03 03; wine-growers' cellar.

Hotel-Restaurants
Le Relais de Montagny, tel. 85 92 19 90.

Chambres d'Hôtes
Thierry Daventure, tel. 85 92 04 92.

Restaurants
Aux Années Vins, tel. 85 92 15 76.

Information
Tel. 85 92 00 16.

Cluny
Festivals and Fêtes
Annual fair, first Saturday of November. Patronal festival, Easter and Whitsun. The abbey is illuminated in summer.

Markets
Saturdays.

Sights
Benedictine Abbey; open all year (except 1 May, 1 and 11 November and 25 December); tel. 85 59 12 79.
Ochier Museum of Medieval Art and Archaeology; tel. 85 59 23 97.
National Stud Farm; visits 09.00-19.00, arranged through the tourist office.

Hotel-Restaurants
***Hôtel de Bourgogne*, tel. 85 59 00 58.
**Hôtel Saint-Odilon*, tel. 85 59 25 00.
**Hôtel Le Moderne*, tel. 85 59 05 65.
Hôtel Commerce, tel. 85 59 03 09.

Chambres d'Hôtes
Alamagny, Liliane; tel. 85 59 10 70.
Donnadieu, Noelle, tel. 85 59 05 10.

Camping
Camping Saint-Vital, tel. 85 59 05 87.

Restaurants
Le Potin Gourmand, tel. 85 59 22 58.

Information
6 Rue Mercière; tel. 85 59 05 34.

Couches
Festivals and Fêtes
Fair, 10 January. Patronal festival, 22 January. Communal festival, Sunday following 14 July.

Sights
Château de Marguerite de Bourgogne;

July-September, guided tours daily, 10.00-12.00 and 14.00-18.00; April-June, Sundays and holidays, same times, and group visits by appointment; tel. 85 49 68 02.

Hotel-Restaurants
**Hôtel des Trois Maures*, tel. 85 49 63 93.

Camping
Camping Municipal de la Gabrelle, tel. 85 49 63 79.

Restaurants
Restaurant de la Tour Bajole, tel. 85 45 54 54.

Cuiseaux
Festivals and Fêtes
Chestnut fair, 29 October. Fête, second Sunday of July.

Sights
Old Cuiseaux; a tourist route marked by yellow arrows.
Wine museum; daily (except Mondays), 15.00-19.00.

Hotel-Restaurants
**Hôtel Vuillot*, tel. 85 72 71 79.
**Hôtel du Nord*, tel. 85 72 52 40.

Information
In the château of the Princes of Orange; tel. 85 72 71 27, July-September, 15.00-19.00.

Semur-en-Brionnais
Festivals and Fêtes
Patronal festival, Sunday before 22 July.
Son-et-lumière, Thursdays and Saturdays mid July-end of August.

Markets
At nearby Saint-Christophe-en-Brionnais an important Charolais cattle-market is held each Thursday morning.

Sights
Château; March-mid October, daily 10.00-12.00 and 15.00-19.00.
Old Semur-en-Brionnais; information on group visits available from the château; tel. 85 25 13 57.

Hotel-Restaurants
Hôtel Saint-Antoine, Marcigny; tel. 85 25 11 23.

Chambres d'Hôtes
Couvent des Récollets, Marcigny; tel. 85 25 05 16; built in 1624.

Restaurants
La Taverne Charolaise, Marcigny; tel. 85 25 21 93.

Information
Marcigny; tel. 85 25 39 06.

Reflections in the Yonne (OPPOSITE).

Select Bibliography

BAZIN, Jean-François and TINGAUD, Jean-Marie, *Bourgogne*, Paris, 1990.

BAZIN, Jean-François, *Dijon et la Côte Viticole*, Paris, 1992.

COLOMBET, Albert, *Bourgogne*, Paris, 1985.

DELAFORCE, Patrick, *The Country Wines of Burgundy and Beaujolais*, London, 1987.

DE LA TORRE, Michel, *Côte d'Or*, Paris, 1990.

DE LA TORRE, Michel, *Nièvre*, Paris, 1990.

DE LA TORRE, Michel, *Saône-et-Loire*, Paris, 1990.

DE LA TORRE, Michel, *Yonne*, Paris, 1990

DUIJKER, Hubrecht, *Touring in Wine Country: Burgundy*, London, 1996.

DUNLOP, Ian, *Burgundy*, London, 1990.

EPERON, Arthur and Barbara, *Champagne and Burgundy*, London, 1996.

GUNN, Peter, *Burgundy, Landscape with Figures*, London, 1976.

Guide Bleu Bourgogne, Paris, 1987.

LOFTUS, Simon, *Puligny-Montrachet. Journal of a Village in Burgundy*, London, 1992.

MEHLING, Marianne (editor), *Knaurs Kulturführer in Farbe Burgund*, Munich, 1990.

Nuits-Saint-Georges en Bourgogne, Saint-Georges-de-Luzençon, 1989.

OUSBY, Ian, *Blue Guide, Burgundy*, London and New York, 1992.

PHILPOTT, Don, *Visitor's Guide to Burgundy and Beaujolais*, Ashbourne, 1995.

RENVOSE, Guy, *Guide des Vins de Bourgogne*, Paris, 1982.

SPEAIGHT, Robert, *The Companion Guide to Burgundy*, 2nd edition, revised by Francis Pagan, London, 1996.

Author's Acknowledgments

I must express my gratitude to the Comité Régional du Tourisme de Bourgogne, the Comité Départemental du Tourisme de l'Yonne, the Comité Départemental du Tourisme de la Côte d'Or, the Comité Départemental du Tourisme de la Saône-et-Loire and the Comité Départemental du Tourisme de la Nièvre, as well as to M. Xavier Dufouleur, the mayor of Nuits-Saint-Georges.

The text of this book is dedicated to Jimmy Davson, who entertained me in France during my research and writing.

Photographer's Acknowledgments

The people of Burgundy have a long-established reputation for welcoming the traveller, and as I explored their countryside I found a friendliness that surpassed my expectations. Thank you to all those who met my intrusions with such patience and helpfulness, and especially to the cooks and wine-makers whose superb productions refreshed the soul and expanded the waistline as I travelled round. Overdue thanks also go to the great food writer Marie-Pierre Moine, with whom I first travelled in France and who initiated me into that great French contribution to civilization - stopping for lunch. She also introduced me to her wonderful father, Pierre Moine, to whose memory the pictures in this book are respectfully dedicated.